Art for Travellers

PRAGUE

*The Essential Guide to Viewing Art
in Prague*

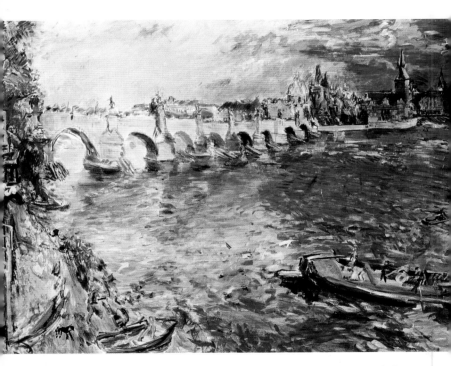

Oskar Kokoschka (1886–1980), Charles Bridge in Prague (*oil on canvas*), *private collection*

Art for Travellers

PRAGUE

*The Essential Guide to Viewing Art
in Prague*

DEANNA MACDONALD

DIAGRAMS AND MAPS BY PAUL TAYLOR

Interlink Books

An imprint of Interlink Publishing Group, Inc
Northampton, Massachusetts

First published in 2007 by

INTERLINK BOOKS
An imprint of Interlink Publishing Group, Inc.
46 Crosby Street, Northampton, Massachusetts 01060
www.interlinkbooks.com

Text copyright © Deanna MacDonald 2007
Photography copyright © Deanna MacDonald 2007
Edited and designed by Ed 'n' Art, Scotland Island, Sydney

Library of Congress Cataloging-in-Publication Data
MacDonald, Deanna.
 Prague : the essential guide to viewing art in and around Prague /
by Deanna MacDonald.
 -1st American ed.
 p. cm.
 ISBN 1-56656-622-3 (pbk.) ISBN 13: 978-1-56656-622-3
 1. Art, Czech-Czech Republic-Prague-Guidebooks. 2. Art-Czech
Republic-Prague-Guidebooks. 3. Museums-Czech
Republic-Prague-Guidebooks. 4. Prague (Czech Republic)-Guidebooks.
 I. Title: Essential guide to viewing art in and around Prague. II. Title.
N6833.P72M33 2005
709'.4371'2-dc22
 2005013186

All paintings are used in this book with the kind permission of the
Bridgeman Art Library.

Printed and bound in China

To request our complete 40-page full color catalog, please call us toll free at
1-800-238-LINK, visit our website at **www.interlinkbooks.com**, or send
us an e-mail: **info@interlinkbooks.com**

Cover pictures:
front: Alfons Mucha, *Princess Hyacinta*, 1911 (color litho), Mucha Trust
spine: Claude Monet, detail from *Women in the Flowers*, 1875 (oil on canvas)

ACKNOWLEDGMENTS

Many people have assisted me in completing this guide, foremost my helpful editors, Carol and Gordon Floyd. Richard Drury and Katka Tomkova were of incalculable aid in Prague, providing me with everything from a home-cooked meal to insights into Czech contemporary art. Richard Drury also very bravely read through the entire first draft, greatly improving the final product. Paul Taylor worked tirelessly on the illustrations and Gracie Taylor helped provide the inspiration. Nothing would have ever been finished without the support of Matthew Starnes who read and re-read every section and, along with Troy McEachren, spent several days walking the trails for the first time. The Czech National Gallery, Nelahozeves Castle, the Kampa Museum, the City Gallery of Prague and other museums in and around Prague kindly gave me access to collections, libraries, and archives. Thank you to all.

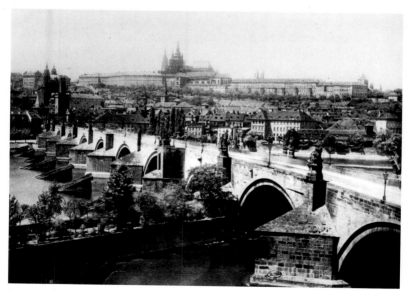

French photographer, view of Prague showing Prague Castle (Hradčany) and the Charles Bridge, late 19th century (Bibliotheque des Arts Decoratifs, Paris, Archives Charmet)

A baroque beauty in the Old Town

Table of Contents

Introduction: Prague, a City and its Arts **1**
About the Trails 1
Tips for Travellers 3
A Brief History of Prague 3
Prague's Layout and Development 14
Art and Architecture in Prague 16

Trail 1: The Old Town (Staré Město) **35**
Along the Royal Route 36
Old Town Square 52
Southern Old Town 69
Josefov (The Jewish Quarter) 76

Trail 2: The Little Quarter (Malá Strana) **105**
Charles Bridge and North of Mostecká 106
South of Mostecká 120
Up to the Castle 130

Trail 3: Prague Castle (Pražský hrad) **135**
History of the Castle 135
First Courtyard 138
Second Courtyard 138
Third Courtyard 146
Eastern Citadel and Castle Gardens 166

Trail 4: The Castle District (Hradčany) **171**

Trail 5: The New Town (Nové Město) **197**
 Wenceslas Square (Václavské náměstí) 198
 Northeast of Wenceslas Square 202
 Southwest of Wenceslas Square 214

Trail 6: Out of the Center **223**
 Southern Prague 223
 Northern Prague 229
 Eastern Prague 249
 Western Prague 251

Trail 7: Day Trips out of Prague **257**
 Nelahozeves Castle and the
 Lobkowicz Collections 257
 Karlštejn Castle 265
 Kutná Hora 272

Appendices
 Czech Artists, Architects, and
 Art Movements 281
 Mythology, History, and Religion 285
 Important Bohemian Rulers 288
 Glossary of Art and Architectural Terms 289

Index **291**

Introduction:
Prague, a City and its Arts

ABOUT THE TRAILS

It is no exaggeration to call *Praha* (Czech for Prague) one of the most beautiful cities in the world; few places possess such atmosphere, history, and magnificent art and architecture. Part of its allure comes from its extraordinarily eclectic layers: a single vista can encompass soaring Gothic turrets, voluted baroque gables, colorful art nouveau mosaics, and jutting cubist façades. Its museums and galleries hold everything from masterpieces of medieval painting to the latest in contemporary art and many are found in buildings as fascinating as their collections.

Prague is the capital of that fabled land, Bohemia, a small country known through history by several names—Bohemia, Czechoslovakia, the Czech Republic. It is a place few Westerners have learned much about. In *The Winter's Tale*, Shakespeare gave landlocked Bohemia a coastline, and three centuries later Neville Chamberlain would call the Nazi invasion of Czechoslovakia "a quarrel in a far away country between people of whom we know nothing." Yet Bohemia has long been at the heart of most of European history: it was the birthplace of Protestantism; capital of the Habsburg Empire; catalyst for the Thirty Years' War; the most easterly democracy in Europe; the western border of the Soviet bloc, and now a new member of the European Union.

Though at the center of centuries of restless European history, Prague's historical core has miraculously survived in all its beauty. Everything new in Prague has grown from something older. It is one of those rare big cities with no skyscrapers and streets of pleasing human proportions. It has a timelessness but also an easy fluidity; street names have changed with the coming and going of regimes, and it isn't unusual for a building to have Romanesque cellars, a baroque façade, and a satellite dish tucked behind a rococo statue. It is, to quote Ivan Klíma, "a city of paradoxes." This complexity and depth is evident in more than just architecture: Czech artists have pioneered art movements as well as embracing international styles, often transforming them into something unique and wholly Bohemian.

Because of Prague's historical and stylistic layering, the following chapters are divided geographically, rather than by style or epoch. Each trail follows the most evocative and interesting routes, pointing out outstanding art, architecture, galleries, and museums and providing a historical context— history, style, patrons, artists, etc. So one route can take you to a baroque palace, a cubist museum, and a Gothic church, giving a sense of the postmodern mix of the contemporary city as well as an understanding of how it developed and how each route fits into the larger picture.

Since 1989 Prague has undergone many changes, no more so than in its art and architecture. Museums have been completely overhauled and new ones created, and artwork, some in storage for most of the Communist period, is now on view. The works of artists and architects that until recently were rarely seen or heard of outside of the Czech lands are now being discovered by the larger art world. Palaces and churches that were crumbling from neglect are being restored and opened to visitors. Some of these restorations have met with criticisms as being insensitive, even garish. And indeed, commercialization has generated too many gaudy souvenir shops in popular tourist areas. Yet these superficial changes cannot alter Prague's inimitable atmosphere and undeniable attraction for anyone with an interest in art and architectural history.

TIPS FOR TRAVELLERS

- The Czech language can be a challenge for any non-Slavic language speaker. The text will give both Czech and English translations of place names at the beginning of each topic, but visitors will quickly pick up frequently used terms, such as: *ulice* (street); *třída* (avenue); *náměstí* (square); *město* (city); *muzeum* (museum); *galerie* (gallery); *výstava* (exhibition); *kostel* (church) *klášter* (monastery); *hrad* (castle); *palác* (palace); and *zámek* (château).

- Most museums and galleries are closed on Monday (closed—*zavřeno*; open—*otevřeno.*) Many smaller churches only open for services. Attending classical music concerts in the churches is another way of visiting. Check for service and concert times (which are subject to frequent change) at the church entrances.

- For orientation, remember that churches generally have their main façades to the west and the choir to the east (toward the Holy Land.)

- For clarity, all references to floor level will follow the European system used in Prague: ground floor, first floor, second floor, etc.

- Late evening or early morning strolls, especially in the high tourist season, are the only way to avoid the crowds in popular locales such as along the Royal Route and Charles' Bridge. Hradčany, often packed with visitors during the day, is surprisingly empty in the evening (and wonderfully illuminated.)

A BRIEF HISTORY OF PRAGUE

In many ways, Prague's history is written in stone, and in the layers of architectural and decorative styles lining its streets, which, in turn, echo centuries of political and societal change. Style and taste usually in some way reflect the ruling powers and Prague has seen everything from heretical medieval kings to Habsburg emperors to communist apparatchiks. To understand what they created and why, a bit of historical background is needed.

The Legend of Libuše

The 11th-century chronicler Cosmas first recorded the legend of the founding of Prague/Praha by the Přemyslid dynasty, and it would be frequently recounted during the 19th-century Czech National Revival, even providing the subject for Smetana's opera, Libuše (1881). After Čech, the "father of the nation," had led his people to the "land flowing with milk and honey," his son Krok gave rule of the kingdom to his daughter, the prophetess Libuše. As her people did not want to be ruled by a woman, she married a plowman, Přemysl, and together they founded a city on the spot where a stone threshold (prah in Czech) was placed (today Vyšehrad in southern Prague). Libuše prophesied that it would be "a great city whose fame would reach the stars."

Early Beginnings and the Přemyslids (870–1306)

In the 4th century BCE, Roman records first mention the Boii, a Celtic tribe settled in the Prague region, a land they called Boiohaemum (the origin of the word Bohemia). The Celts were supplanted in the 6th century CE by Slavic tribes from the east.

The first recorded members of the Přemyslid dynasty, Prince Bořivoj and his wife Ludmila were converted to Christianity by the saints Cyril and Methodius, who had been sent from Byzantium to convert the Slavs in 863. However, Roman Christianity would soon supplant Byzantine Orthodox Christianity because Bohemia was already connected to the Frankish kingdoms of western Europe. Bořivoj also moved the family residence to Hradčany, overlooking an already existing Slavic trading settlement on the banks of the Vltava.

Ludmila was murdered by her pagan daughter-in-law, but not before instilling Christianity in her grandson, Václav I (Wenceslas in English, of Christmas carol fame), who was assassinated by his brother, Boleslav, around 929. Legend says Václav, like his grandmother, was killed because of his Christianity, though both killings probably had more to

do with power struggles within the family. Václav was soon venerated as a martyred holy figure and he and Ludmila were both canonized, becoming the first patron saints of Bohemia, sanctifying the Přemyslid dynasty and putting Bohemia on the Christian map.

Prague began to develop principally around the royal residence on Hradčany and the German merchant settlements near today's Old Town Square. In 965 an early traveller, Ibrahim ibn Ya'qūb, an emissary from the caliphate of Cordoba in Spain, recorded that Prague was smaller than a town but bigger than a village and had been "made richer by commerce" than any other place he had visited in central Europe.

Prague became a bishopric in 973 and in 993 the second bishop, Vojtěch (Adalbert), founded the first monastery at Břevnov. He was canonized in 999, becoming the third Bohemian patron saint. The fourth is Procopius (Prokop) who in 1032 founded the Sázava monastery and was canonized in 1204. Under Vladislav II (1140–1172) several monasteries were founded, such as Strahov, and the Knights of Malta built their monastic stronghold at the foot of the first stone bridge across the Vltava, named for Vladislav's queen, Judith.

In 1212 the Golden Bull of Sicily elevated Bohemia to a kingdom and named as its king one of the seven electors of the Holy Roman Empire, but it wasn't until the reign of Otakar II (1253–1278) that the Přemyslids reached their zenith. Otakar conquered from the Baltic to the Adriatic, was a candidate for emperor and made Prague a center of learning and architecture. He founded Malá Strana, inviting south German colonists to settle below the castle, while his sister Agnes (St. Agnes since 1989) founded a hospice and convent in the Old Town, of which she became abbess. The dynasty ended with the assignation of Wenceslas III in 1306.

The Golden Age of Charles IV

John of Luxemburg, son of Holy Roman Emperor Henry VII, married a Přemyslid princess and was elected King of Bohemia in 1310. Although in life he spent little time in Prague, in death he became a legendary Bohemian figure for fighting

to the death, despite complete blindness, on the side of the French at the Battle of Crécy in 1346.

At John's side was his son Charles, who would become one of Bohemia's greatest leaders. Born Václav in 1316, he became Charles at the French court where he was raised. Soon after becoming king of Bohemia, he was elected Holy Roman Emperor and set about transforming Prague into his imperial capital. After raising Prague to an archbishopric, he began construction of a new cathedral, St. Vitus, and founded the first university in central Europe, Charles University. He expanded the city, founding the New Town, constructing Charles Bridge, rebuilding Vyšehrad and part of the medieval fortifications. He also built Karlštejn castle to the south of the city as a repository for the crown jewels. Under Charles, Prague became one of the greatest cities in Europe, the evidence of which is still to be seen throughout the city today.

It all fell apart, however, after Charles' death in 1378. His son and successor, Václav IV, was an inept ruler, and unchecked social and religious tension soon led to cultural and economic decline and the rise of the charismatic Czech preacher, Jan Hus.

The Hussites

The Hussite period is one of the most dramatic in all of Czech, if not European, history. Jan Hus, a university professor and preacher strongly influenced by the ideas of John Wycliffe, promoted faith based on the Bible rather than on church hierarchy. His most radical belief was that all Christians, not just the clergy, should receive full communion—both the body and blood of Christ (until that point, only the clergy drank the blood). The chalice in which the wine representing Christ's blood was served became the symbol of Hus's followers, the Hussites (who are also called Utraquists ,from the Latin *sub utraque specie*—meaning "in both types," referring to communion). Anticipating Martin Luther a century later, Hus preached for church reform and against the sale of indulgences. Summoned to explain his actions at a church council in Constance, Hus was convicted of heresy and burned at the stake on July 16, 1415.

Hus's death galvanized his supporters and Bohemia became a hotbed of religious radicalism, triggering the Hussite Wars. Things boiled over in 1419 when Hussite demonstrators stormed the New Town Hall and, beginning that uniquely Czech tradition of defenestration, killed several Catholic councillors by tossing them out a window. The fighting that followed ransacked Malá Strana and Vyšehrad. The new, firmly Catholic King Sigismund led the first of five international crusades against the heretical Hussites but was soundly defeated by the one-eyed Hussite leader, Jan Žižka on Vítkov Hill (where a monumental statue of Žižka stands today).

Relative stability would not be achieved until the election (by the Bohemian Estates or nobles) of the first and only Hussite king, George of Poděbrady (Jiří z Poděbrad) in 1458. In order to end Bohemia's heretical status abroad and bring it back into Europe, on Poděbrady's death in 1471 the Bohemian nobles invited the Polish Jagiellon dynasty to take up the Bohemian throne. With his rule greatly restricted by the powerful Bohemian nobles, the Polish Vladislav II moved his capital to the more pliable city of Buda in 1490. When the last Jagiellon king died in 1526, the Bohemian Estates made the fateful choice of Ferdinand of Habsburg, the brother of the Holy Roman Emperor Charles V, as the next king. The Habsburgs would rule Bohemia until 1918.

The Habsburg Ascendancy and Rudolf II

By the early 16th century, the Habsburgs had amassed an empire that spread from the Low Countries to Spain and central Europe, and Bohemia was but another crown to be incorporated into their realm. An unwavering Catholic, Ferdinand I immediately set about re-Catholicizing the by now largely Protestant Bohemia. A revolt in 1547 by the Bohemian Estates and the city of Prague was defeated and the four towns of Prague were stripped of their privileges. Ferdinand then moved the capital to Vienna, further diminishing Prague's importance, and left his second son, Ferdinand of Tyrol, as governor. In 1556 the new Jesuit order was invited to Prague and the Counter Reformation was underway.

Prague experienced a revival during the reign of Rudolf II, who returned the imperial capital to Prague in 1583. Nobles drawn to the court built lavish residences, and artists and scientists from around Europe came to work for Rudolf, an avid patron and collector. However, his reign ended dismally. Having been forced by the Estates and his brother Mathias to guarantee freedom of worship to Protestants in 1609, Rudolf invited a Catholic army to invade Prague in 1611, hoping to punish the Estates and curb his brother's ambitions. Rudolf's army was defeated and he was forced to abdicate in favor of Mathias.

The Thirty Years' War and Habsburg Domination

Since 1526, the Catholic Habsburgs had tried to increase their power while limiting that of the Bohemian Estates and the 85 percent Protestant population. The resulting tensions exploded on May 23, 1618, when members of the Estates stormed Hradčany. The Protestant radicals seized Slavata and Martinic, two of the most intransigent Catholic governors, and threw them from the castle windows in the second Prague defenestration. Either through the miraculous intervention of the Virgin Mary (according to the Catholics) or because they fell on a dung heap (according to Protestants) the governors survived but the act nonetheless marked the start of the Thirty Years' War. In 1619 the Estates expelled the Jesuits from Prague, usurped Ferdinand II, and offered his crown to the German Protestant Frederick of Palatinate, also known as the "Winter King" for the short time he and his wife, Elizabeth Stuart, daughter of James I of England, spent in Prague. For on November 8, 1620, the pair would flee, after the imperial army of the Catholic League routed the Protestant forces at the infamous Battle of White Mountain (Bílá Hora) on the western edge of Prague. This was a final turning point for the Protestant Bohemian Estates whose 27 leaders were executed in Old Town Square. Catholicism was then imposed throughout Bohemia. Although Bohemia was defeated, Prague remained a forefront in the war and was attacked several times, the last time by the Swedes in 1648.

In the aftermath, those loyal to the Habsburgs became rich on the confiscated property of the losers. The Counter

St. John of Nepomuk (Jan Nepomucký)

In 1683 the Jesuits placed a statue of John of Nepomuk on Charles Bridge as part of a campaign to create a Bohemian Catholic martyr. The real Jan of Pomuk had been an ambitious vicar who was killed in 1393 in the power struggles between the King Vaclav IV and his archbishop. The Jesuits devised a more saintly tale, claiming he died for refusing to divulge the queen's confession (saying no, or "ne" in Czech, thus becoming Ne-Pomuk) and that when he was thrown from Charles Bridge, five stars appeared where he drowned. When his body was exhumed in 1719 his tongue (which became his saintly attribute) was found miraculously pink and fresh. He was made a saint in 1729 and his statue can be found on bridges throughout central Europe (although in 1963 the church admitted to the fabrication of the story). (See page 112 for more about him.)

Reformation and its signature style, the baroque, transformed the city's streets, churches, and palaces. Prague, however, would continue to decline, becoming a secondary provincial city within the Habsburg Empire. During the next 150 years the Czech language was marginalized and German became the language of government and advancement. Prague found itself in the middle of the Austrian and Prussian conflicts for supremacy over the German-speaking world and was occupied several times.

The Czech National Revival

The next century would see a Bohemian revival. It began under the reign of Joseph II (1780–1790) whose enlightened policies allowed a measure of religious and culture freedom and fostered economic and industrial development. This led to the growth of the educated middle class necessary for a national self-awareness and the pan-European currents of the Enlightenment, the French Revolution, and the Napoleonic Wars created the conditions for the development of Czech nationalism.

Detail of the façade of Municipal House, New Town

In 1848, as revolutions broke out across Europe, a pan-Slavic congress was held in Prague where František Palacký (1798–1876), the founder of Czech historiography, proposed a federated Austria with a strong Slavic role as a bulwark

against German nationalism. However, the same year saw a failed uprising of students, radicals, and workers that led the reactionary Habsburg regime to reassert their control of Bohemia. Though Hungary would achieve a large measure of autonomy with the creation of the dual Austro-Hungarian monarchy in 1867, the Czechs would not achieve any meaningful independence until the end of World War I.

Nonetheless, Czech culture revived throughout the 19th century, as Czech-speakers slowly began to outnumber the German-speaking population. By 1892 bilingual street signs were replaced by Czech-only signs: Ferdinandstrasse became Národní Třída; Zeltnergasse became Celetná; Am Graben became Na přikopě, etc. Several institutions to promote Czech culture were founded such as the National Theater (Národní divadlo, 1868), the Rudolfinum (1884) and the Municipal House (Obecní Dům, 1911). However, the Czech-speakers' gains were their fellow German-speaking citizens' losses and tensions between the linguistic groups grew.

World War II pitted the decaying Austro-Hungarian Empire against the Slavic Russians and Serbs and was not widely supported by the Czechs, tens of thousand of whom deserted and fought for the Allies. (*The Good Soldier Schweik*, Jaroslav Hašek's comic masterpiece, evokes the Czech's lack of enthusiasm for the war.) In exile, Tomáš Garrigue Masaryk and Edvard Beneš promoted the idea of an independent Czechoslovakia to the Allies.

The Czechoslovak Republic

The Czechoslovak Republic was declared on October 28, 1918, in Prague's Municipal House. The new country was a patchwork of nationalities with five million Czechs, 3.1 million Bohemian Germans (who began to call themselves Sudeten Germans), and 1.9 million Slovaks, as well as significant Jewish, Ukrainian, Hungarian, and Polish minorities. The country was a parliamentary democracy, one of the few to remain so in central Europe during the '20s and '30s, and was led by the popular and capable T.G. Masaryk until his retirement in 1935, when Edvard Beneš took over. The new

country inherited much of the industry of the former Austro-Hungarian Empire's industrial base and was the eighth largest economy in the world. Cultural life in Prague, an avant-garde center since before the war, thrived.

Despite these advantages, ethnic tensions simmered. The government pursued pro-Czech policies, looking to redress the Czech's disenfranchisement under the Austrians for the past 300 years, while the various national minorities looked to establish their place in the country. The Great Depression hit the industrialized Sudetenland particularly hard. Ethnic tensions were further exacerbated with the rise of Hitler in Germany and the Sudeten Germans' growing desire to join the Reich.

World War II

On September 28, 1938, despite having guaranteed Czechoslovakia's borders, Britain and France entered into the Munich Agreement with Germany, giving in to Hitler's demands to seize the Sudetenland. The Allies, having decided they did not want to go to war over, "a quarrel in a far away country between people of whom we know nothing" (as British Prime Minister Neville Chamberlain stated), hoped that their appeasement of Hitler would achieve "peace in our time." Rather than fight against hopeless odds, President Beneš resigned and went into exile. On March 15, 1939, the German army occupied the rest of Bohemia and marched into Prague.

The Nazis established the Protectorate of Bohemia and Moravia and ruled it like a colony. Although there was little actual fighting on Czech soil, the country suffered greatly. Of the 118,000 Jews in the Czech lands, 78,000 were murdered in death camps. In 1942, in retaliation for the assassination of the Nazi governor Reinhard Heydrich by Czech/British paratroopers, the Nazis annihilated Lidice, a northern Bohemia village. In May 1945, just before the liberation by the Red Army, there was a three-day uprising against the Nazis in Prague, in which the Old Town Hall was destroyed. In total 360,000 Czechs and Slovaks died in the war.

Communism

Following the war, the democratic government was re-established, which oversaw the deportation of 2.7 million Sudeten Germans. In 1948, a government crisis left the Communists with a majority in parliament, leading to a de facto coup d'état with Klement Gottwald as president. He imposed a Stalinist-style rule, complete with party purges. A month later the only independent member of government, Foreign Minister Jan Masaryk, son of the former president, was found dead below a window of the Černín Palace—an unsolved case of defenestration. The Czech Communist regime was one of the most hard-line in Eastern Europe and years of repressive policy followed.

There was a respite in the 1960s with the introduction of Alexander Dubček's "socialism with a human face," a period known as the Prague Spring, which ended abruptly with the invasion of Warsaw Pact troops on August 21, 1968. Five months later, student Jan Palach burned himself to death in protest. A period of "normalization" followed, driving all cultural and intellectual life underground. In 1977 a group of dissidents, including playwright Vaclav Havel, published Charter 77 calling for restoration of civil and political rights. Several, including Havel, ended up in prison.

The Velvet Revolution and Its Aftermath

The Communists' grip finally loosened on November 12, 1989, with the commencement of the Velvet Revolution, begun by a massive demonstration coordinated by the Civic Forum (Občanské fórum) and led by Havel, who also provided the catchphrase of this peaceful uprising: "truth and love will prevail over lies and hatred." Havel was elected president of the newly democratic country on December 29 (a title he would hold, almost uninterrupted, until retiring in 2003).

The 1990s saw the withdrawal of 75,000 Soviet troops that had been in the country since 1968, and the complicated process of restitution—returning property confiscated by the Communists to its original owners—and the privatization of state companies. It also saw the "Velvet Divorce," dividing the

country into Slovakia and the Czech Republic on January 1, 1993. Despite these difficulties, the Czech Republic has flourished, joining NATO in 1999 and the EU in 2004.

Prague's Layout and Development

Prague's location on a natural ford on the Vltava surrounded by small hills made it a defensible commercial site that was settled by the 9th century. By the 10th century royal strongholds had been built on Hradčany and Vyšehrad, although Vyšehrad was the principal court only from 1085 to 1140. Merchant settlements developed on both sides of the Vltava and were joined by a stone bridge (Judith Bridge) in 1170. Around 1230 the German trading settlement on the right bank, located in a walled Týn Court, was granted special privileges and the status of an independent town by the king. This area would become known as the Old Town (Staré Město). By this time Prague's Jewish community was centered within a ghetto just to the north of the Týn Court. To encourage further urban growth, Otakar II invited southern German merchants to settle the Little Quarter (Malá Strana) in 1247. These towns had their own marketplaces, churches or synagogues, and their own laws, although all were subjects of the Bohemian king.

But it was not until the 14th century that Charles IV turned Prague into an illustrious capital, building a great Gothic cathedral (St. Vitus), a new bridge (Charles Bridge) and the first university in central Europe, as well as expanding the city with a New Town (Nové Město). Laid out around three new marketplaces—one for cattle (today's Karlovo náměstí), one for horses (Václavské náměstí), and one for hay (Senovážné náměstí)—it was surrounded by a (2.1 mile/3.5 km) wall encompassing Vyšehrad and the Old and New Towns. Comprised of four independent towns (Old Town, New Town, Little Quarter, and Hradčany) Prague was now the capital of the Holy Roman Empire, and was one of the largest and most beautiful cities in Europe, with a population estimated by scholars to be anywhere from 40,000 to 100,000.

The 16th and 17th centuries saw Prague's cityscape embellished by numerous noble residences in Hradčany and Malá Strana and burgher houses in the New Town. However, after the Thirty Years' War the city declined and the population fell to as low as 25,000.

It was only in the 19th century that Prague expanded beyond the boundaries of its medieval ramparts, most of which had been rebuilt in the baroque period. Working-class and middle-class suburbs developed, such as Smíchov, Žižkov, and Vinohrady. The first railway station (today Masaryk Station) was opened in 1845 and around the same time, Old and New Town embankments were laid out as promenades and sites for fashionable apartment blocks. Since the Middle Ages Charles Bridge had been the only Vltava crossing but finally in the later 19th century several new bridges were built. The Czech National Revival saw the construction of many ambitious edifices, mostly in the Old and New Town, such as the National Theater (1883) and numerous public monuments such the massive St. Wenceslas on the eponymous square. Hradčany and Malá Strana were generally left untouched. In the 1890s the slums of Josefov, the former Jewish Quarter, were demolished and replaced by the Hausmann-like Pařížská (Paris) Boulevard, which linked Old Town Square and the riverside. The tram system was introduced in 1891.

In the early 20th century, development continued apace and before World War II the city's population approached one million. After the war the building efforts of the Communist authorities focused on suburban housing estates based on Soviet models and constructed of factory-built concrete panels with a metro system to link them.

Today the city's population hovers around 1.2 million. The historic core was given World Heritage status by UNESCO in 1992 and today is home to about 55,000—although about 200,000 work in the area and millions of tourists visit each year. Beyond this is the "inner city" (about ten times the size of the center) consisting of mostly 19th- and early 20th-century apartment blocks. Beyond that, about 500,000 live in gloomy Soviet-era paneláks, high-rise flats grouped in vast monotonous estates.

House Signs

Most buildings have two street numbers shown on modern art nouveau-styled enameled signs: the red sign is the district number, the blue sign the street number. The red district signs also show the street name and the district name and number. In Czech, the street number is written after the street name. Historic street signs can also be seen in older areas. Some 19th-century Gothic-script Czech/German signs have recently been uncovered, while some houses have baroque-era, stucco-relief signs with illustrations of the house's name: for example, three fiddles grace the house of a family of violin-makers, U tří housliček ("At the Three Little Fiddles," Nerudova 12/210 in Malá Strana).

ART AND ARCHITECTURE IN PRAGUE

Found at the physical and symbolic crossroads of European history and culture, Prague has been both an imperial capital and an inconsequential provincial city and has profited from

both stages. Certain eras saw it at the forefront of artistic development; in others, international trends were adapted for local conditions; and periods of isolation have had the fortuitous effect of preserving the splendor of earlier epochs. In the 14th century Charles IV rebuilt Prague as the capital of the Holy Roman Empire, initiating a golden age of Gothic art, architecture, and urban planning, which was brought to an end by the 15th-century Hussite Wars. It wasn't until the reign of Rudolf II (1576–1611) that Prague was again an artistic center, this time of Mannerism. After the Battle of White Mountain (1620), the art of the Counter Reformation gave the city a lively baroque countenance that it maintained over the quiet years that followed. As Czech nationalism grew in the 19th century, monumental public art and buildings in historicist styles emerged. By the turn of the century Prague was a center of central European Secession (art nouveau) style and with Czechoslovak independence, uniquely Czech forms of cubism and modernism flourished. The communist years stifled much creativity but also motivated dissident artists, and today, as Prague moves toward full EU integration, the city is dotted with galleries showing a new generation of artists.

Today visitors reap the benefits of the chances of history that have left the city "an epic poem of architecture" (to quote Prague-born poet Rainer Maria Rilke) and replete with galleries and museums. While first-time visitors might not be familiar with many of Prague's great artists and architects, they will soon come to appreciate the inimitable artistry of Bohemia.

The Romanesque

The term Romanesque was coined in the 19th century to refer to artistic production in Christian Europe between around 800 and 1200. The style was influenced by the forms of classical Rome (in particular the rounded arch) as well as by Byzantine and local traditions. From the 12th century each Prague quarter had a Romanesque church as well as noble and merchant town houses, but most were subsumed into later structures, although foundations and cellars survive in the Old Town, such as the **House of the Lords of Kunštát and Poděbrady**. Among

the earliest extant structures are a number of rotundas, small round chapels, dating from c. 900–1225, the oldest being **St. Martin's Rotunda** in Vyšehrad, which is the only surviving part of a palace built in the 11th century by the Přemyslid Prince Vratislav II. The Přemyslids also built at Hradčany and the foundations of their Romanesque Palace can be seen at **Prague Castle**. The most outstanding survival from the period is the austerely beautiful **St. George's Basilica** (Sv. Jiřího). First completed around 920 and reconstructed in the mid-12th century, under its present baroque façade it has been restored to its original Romanesque basilica form.

The Gothic

"Then arose new architects who after the manner of their barbarous nations erected buildings in that style which we call Gothic (dei Gotthi):" so wrote painter and historiographer Giorgio Vasari (1511–74) in a negative comparison of the Gothic to his own time's Renaissance style. Free of its original derogatory connotations, the term now refers to an art form based on the pointed arch, which emerged around Paris in the mid-12th century, and developed into the principal artistic language of Europe for most of the later medieval period.

The Gothic first arrived in Prague in the 1230s via the French Cistercian Order, whose influence can first be seen in **St. Agnes Convent** and soon after in the superb **Old-New Synagogue**, both of which were probably built by the same Cistercian builders. It was during the reign of Charles IV (1346–78), however, that Prague entered an artistic golden age. Determined to make Prague a worthy imperial capital, Charles developed a far-sighted urban and architectural plan that has given the city a layout it has kept to this day (see preceding section). Charles invited French architect **Matthew of Arras** to begin **St. Vitus** in the tradition of the great French cathedrals. After his death, construction was taken over by one of the outstanding builders of the middle ages, **Peter Parler** (Petr Parléř), who introduced elements of the German Sondergotik (late Gothic) and an inventive new system of net vaulting with freestanding ribs, achieving unparalleled interior spatial unity.

Under Charles IV an important Bohemian school of painting developed. Inspired by Italian and French illuminated manuscripts in Charles's collections and by foreign, particularly Italian, artists at his court, local painters, such as the **Master of the Vyšší Brod Altarpiece**, produced Bohemian panels of exceptional quality. The leading and most original figure was **Master Theodoric**, best known for his series of 129 panels for the Chapel of the Holy Cross in **Karlštejn Castle** and paintings in **St. Vitus' Wenceslas Chapel**, all completed with his characteristic softly molded figures, rich color, and sympathetic faces. The third principal figure of Gothic painting was the artist known as the **Master of the Třeboň Altarpiece**, who worked for Charles's son, Wenceslas IV. Influenced by contemporary Burgundian art, he is noted for his a strong sense of color, linear rhythm, and distinctive landscape and architectural backdrops.

The Renaissance

Most cultural production was halted in 1420 by the Hussite Wars and resumed under the rule of Vladislav II of Jagiellon (1471–1516), which saw the last flowering of the Late Gothic and the introduction of the Renaissance style (another 19th-century term for the rebirth or revival of classical influence in the arts which began in Italy in the 15th century). Around 1480 Vladislav invited German architect **Benedict Ried** to Prague to rebuild Prague Castle, battered after years of war. Among other things, Ried created the Royal Oratory in St. Vitus and the cosmological swirl of vaulting in **Vladislav's Hall** (Vladislavský sál) in which he brought the Late Gothic to new heights and introduced the city's first examples of Renaissance design.

After the Habsburgs came to power in 1526, art and architecture in Bohemia came under a stronger Italian influence. In the 1530s work began on the city's first truly Renaissance structure, the **Royal Summer Palace** (Kralovský letohradek), also called the **Belvedere**. With elegant arcades decorated with classical scenes, it is a piece of northern Italian architecture with a keel-shaped copper roof by **Bonifác**

Wohlmut, a Bohemian architect known for mingling Czech and Italian styles. Generally, Italian Renaissance styles were adapted to fit into local tradition, developing into a unique Bohemian Renaissance style, often seen in the aristocratic residences, such as the **Schwarzenberg Palace** on Hradčany with its tall voluted gables, deep cornices, and bold sgraffito.

Rudolfine Prague

When Rudolf II returned the imperial court to Prague in 1583 he set the stage for it to become one of the leading artistic centers on the continent. One of Europe's most influential and adventurous patrons and collectors, with a taste for the exotic and extraordinary, Rudolf attracted some of the most important European artists to his court, creating what is now known as the School of Prague, which includes such painters as **Bartholomeus Spranger**, **Hans von Aachen**, **Roelandt Savery**, and **Giuseppe Arcimboldo**; the sculptor **Adriaen de Vries**; and **Aegidius Sadeler**, who, as imperial printmaker, disseminated knowledge of Rudolf's collections throughout Europe.

Prague became the center of Rudolf's preferred mannerist style, characterized by elongated, ultra-refined forms, asymmetry and unusual juxtapositions. Landscape, still-life, and animal paintings were also popular at Rudolf's court, reflecting his interest in natural history. He amassed the largest Kunstkammer, or "cabinet of curiosities," in Europe. Reflecting a taste for Dutch and Italian art learned in the Spanish court where he was raised, Rudolf acquired masterworks by the likes of Veronese, Tintoretto, da Vinci, and Bruegel.

Although often critiqued as frivolous for his obsessive collecting, Rudolf understood the propagandistic uses of art, and his portraits as well as mythological and allegoric paintings were designed to promote the emperor's power, picturing him in the guise of god or hero dominating the celestial and terrestrial worlds. Arcimboldo's famous portrait of Rudolf as Vertumnus, the ancient Roman god of vegetation composed of fruits and flowers (in Sweden since 1648), is an allegory of perennial Habsburg rule and the peace and prosperity of his

reign. After his death, most of his some 3,000 works of art were dispersed with only a few, such as Dürer's masterpiece *Feast of the Rose Garland*, remaining in Prague today (see the National Gallery Sternberg Palace, Prague Castle Gallery, and Strahov).

Bohemian Baroque

The term "baroque" was coined in the later 18th century, during the vogue of neo-classicism, as a derogatory reference to the less rational style of the 17th and early 18th century. And indeed the baroque is emotional, even theatrical, filled with energy and tension. Baroque architecture is characterized by undulating surfaces, illusional spaces, exuberant decoration, and Catholic imagery replete with scenes of ecstasies, martyrdoms, or miraculous apparitions. Yet realism was an integral feature of baroque art; artists sought to portray the inner workings of the mind and the passions of the soul on the faces they painted and sculpted. The intensity and immediacy of baroque art can sometimes spill over into melodrama; but subtly done, it can be breathtaking.

Baroque art arrived in Prague in the political context of post-1620 Battle of White Mountain Prague. Thus the style was strongly associated with the enforced re-Catholicization of Bohemia and the Jesuits, who were invited into the country by the Habsburg rulers for just that purpose. The Jesuits reinterpreted Bohemian traditions within baroque Counter Reformatory artistic language and rebuilt Prague almost as a stage set for propagating the Catholic faith. Bohemian nobles loyal to the Habsburgs who suddenly found themselves in possession of the property of Protestant rebels remade their new townhouses and palaces in the Absolutist style of the empire, completing the transformation of the city of Jan Hus and Protestantism into one of the great baroque centers of Europe. At first most baroque artists and architects came from abroad, often northern Italy, but by 1700 local artists and architects developed a distinctly Bohemian baroque.

Architecture

The first tentative signs of the baroque in architecture can be seen in the oval plan of the Clementinum's **Italian Chapel** (1590–1597) and a little later in Prague Castle's western entrance, the theatrical **Mathias Gate** (Matyášová brána, 1614).

Como-born architect Carlo Lurago gave the Clementinum's **Church of the Holy Savior** (Sv. Salvátor) a baroque update around 1640, including one of the first domes on the Prague skyline. Another Como architect, Francesco Caratti, created what is perhaps the first early fully baroque structure, the **Černín Palace** (Černínský palác, 1669–1677) whose hugely long façade of applied columns inspired countless others throughout the city. The hegemony of Italian architects was challenged by Burgundian **Jean-Baptiste Mathey**, who came to Prague after 20 years in Rome; his Roman style, embellished by French motifs, is visible on structures such as Troja Chateau (Troyský zámek, 1679–1691). Troja was also given magnificent baroque gardens, an element also found in many Malá Strana palaces. Celebrated Viennese architect **Johann Bernard Fischer von Erlach** was also inspired by Italy, as evident in his classical Clam-Gallas Palace (1713–1730).

From about 1710 church architecture in Prague took a highly theatrical turn, inspired by the designs of the Italian architects Borromini (1599–1667) and Guarini (1624–1683). The defining building of this period is the lavish **St. Nicholas** (Sv. Mikuláš, 1703–1755) in Malá Strana, which reflects the characteristic dramatic style of its creators, prolific architects **Christoph and Kilian Ignaz Dientzenhofer**: undulating convex/concave surfaces, plans based on intersecting ovals, piers jutting into the nave, and gothic-inspired cross-vaulting. The Dientzenhofer's highly original contemporary, **Jan Balžej Santini-Aichel**, commissioned to restore neglected monastic churches in Bohemia, turned to medieval models and created an unusual synthesis: a Gothic-baroque style. His many works included the Cistercian abbeys in Zbraslav (1700–1724) and Sedlec (1700–1708), and in Prague he built palaces, such as the Thun-Hohenstein Palace (1716–1721), albeit in a more conventional style.

Sculpture

Baroque sculpture played a role in Prague as in no other European city. The city is a sculptural showplace with Herculean atlantes supporting palace balconies, cherub-covered "plague columns" offering thanks for deliverance, graceful goddesses inhabiting baroque gardens, and zealous saints adorning church façades and Charles Bridge. The first baroque sculptor of note is Johann Georg Bendl (c.1620–80), known for his dramatic realism influenced by Roman sculpture. Subsequent generations were also influenced by Roman baroque sculpture, adapting it to Bohemian traditions and materials, in particular coarse-grained sandstone. Several sculptors worked on the statuary for Charles Bridge, the two most brilliant being **Ferdinand Maxmilián Brokoff** (1688–1731) and **Mathias Bernard Braun** (1684–1731). Brokoff trained in Prague with his father, Jan (1652–1718), a converted Lutheran from Slovakia, and soon surpassed him in both technique and imagination, developing a style of vigorous and monumental realism. The younger Brokoff created many of the Charles Bridge statues as well as those on the Morzin Palace and the Mitrovice tomb in St. James. Braun came from the Tyrol, trained in Italy, and arrived in Prague in 1710, where his virtuoso, near painterly technique won him many commissions, such as his masterly St. Luitgard on Charles Bridge. He is sometimes called the Bohemian Bernini for his intensely emotional sculptures that in later life approach a near hysterical agitation. The principal sculptor of the late baroque was **Ignác František Platzer** (1717–1787), whose style reflected the more restrained, classical sculpture of contemporary Vienna.

Painting

One of the first celebrated painters of the Bohemian baroque was **Karel Škréta** (1610–1674). From a Protestant family that fled after the Battle of White Mountain, he trained in Italy, where he painted a portrait of his friend, Nicholas Poussin. He later converted to Catholicism and returned to his native Prague, where he became a noted painter of altarpieces. His style is wholly Italian, with dark, dramatic canvases and an impressive realism, particularly evident in his portraits, such

as that of the Miseroni family (in the National Gallery at St. George's). Another convert is **Michael Willmann** (1630–1706), who also served his adopted faith well, painting numerous altarpieces of great spirituality and realism, as did his stepson, **Jan K. Liška** (1650–1712) whose work is sometimes describes as proto-Rococo.

The leading painter of the high baroque was Prague native **Petr Jan Brandl** (1668–1735). He produced religious works and portraits for numerous Bohemian patrons using vivid color and bold chiaroscuro to create dramatic yet realistic effects.

An intriguing character is the remarkably perceptive portraitist **Jan Kupecký** (1667–1740), a Protestant artist who did not convert and thus spent most of his life abroad. He studied in Vienna and later Italy, enduring great hardships until finding success in Rome, where he had a workshop until 1729, when he moved to Vienna on the invitation of his friend and patron, Prince Adam von Liechtenstein. Described by a contemporary as combining the "power of Rubens, the delicacy and spirituality of Van Dyck, the somberness and magic of Rembrandt," his portraits have a startling realism and emotional depth.

Decorative frescoes and illusionistic paintings were all the rage in baroque Prague, particularly after the success of the trompe-l'oeil decorations of the Great Hall (1690s) at Troja Chateau by the **Godyn brothers** from Flanders. **Václav Vavřinec Reiner** (1689–1743) was perhaps its most popular practitioner (e.g., the Loreto and St. Thomas in Malá Strana). Famous Austrian painter **Franz Anton Maulbertsch** (1724–1796) executed the ceiling frescoes at Strahov Monastery near the end of his life. As baroque gave way to Rococo, **Norbert Grund** (1717–1767) gained popularity as a painter of tiny, playful "Gallant" scenes: pretty landscapes, genre and mythological paintings collected by middle-class and noble patrons for their cabinets. Sometimes dismissed as pure fluff, they nevertheless have a pleasing lyricism and grace.

The 19th Century: From Neo-classicism to National Revival to Art Nouveau

From the 1770s a French-inspired neo-classicism usurped the place of baroque, as evinced in the **Estates Theater** (Stavovské divadlo) that opened in 1783. Later the Empire style appeared: an example is the customs house **U Hybernů** (1808–1811) by Viennese architect **Georg Fisher**. However, the period saw little monumental building or art as Prague found itself a neglected second-tier city. With the expulsion of the Jesuits in 1775 and the dissolution of the monasteries in the 1780s, Bohemian artists lost their biggest patrons while the other major art market, the nobility, often spent more time at court in Vienna than Prague. However, a new source of cultural life and patronage was developing: nationalism. Determined to save Bohemia's patrimony, which they saw either neglected or sold abroad, a group of Bohemian nobles (both Czech and German speaking) founded the Society of Patriotic Friends of Art in 1796 and began amassing artwork that would later form the basis for the Czech National Gallery. They also founded the Prague Academy of Fine Arts, where the next generation would receive artistic training.

Architecture

The 19th century was the century of stylistic revivals, such as neo-Gothic or neo-Renaissance, developing out of Romanticism and the societal change brought about by the Industrial Revolution. Earlier, pre-industrial eras were seen as golden ages to be emulated. This nostalgia also often reflected rising nationalistic sentiment, particularly as the Habsburg Empire began to decline and peoples who for centuries had lived under imperial rule began to think of self-determination.

Czech nationalism found partial expression in the neo-Gothic. Gothic was considered the definitive Bohemian style from the ultimate Bohemian era, encompassing both the majesty of Charles IV and the independent spirit of the Hussites; it was also the antithesis of baroque Habsburg imperialism. One of the earliest neo-Gothic buildings was the romantically renovated **Governor's Summer Palace** (1804–1806) in Stromovka. In the later century the architect

Josef Mocker (1835–1899), Bohemia's answer to Viollet-le-Duc, set about restoring countless medieval monuments. Following his own interpretation of medieval plans, his sometimes inventive style has been criticized for destroying the authenticity of early buildings; nonetheless, he saved many monuments from ruin and has created much of the medieval Bohemia we know today, from the turreted spires that dot the city skyline to Karlštejn Castle.

From the 1860s the new public buildings of the Czech National Revival were in a neo-Renaissance style, such as the **National Theater** (1867–1881) by **Josef Zítek** (1832–1909) and **Josef Schulz** (1840–1917), which was lavishly decorated inside by several leading artists who would become known as the **National Theater Generation** (see next section). A Czech variant of neo-Renaissance also led to a fad for stepped gables and sgraffito, as seen in the **Wiehl Building** (1895–1896) on Wenceslas Square.

By the 1890s the endless recycling of historic forms had begun to fade and artists and architects gravitated to the movement known in France as art nouveau and in Vienna and Prague as Secession (Secese in Czech). The shining architectural symbol of this movement is the magnificent **Municipal House** (1903–1911) by **Osvald Polívka** and **Antonín Balšánek**, although numerous other examples dot the New Town such as the **Grand Hotel Europa** (1903–1905) on Wenceslas Square.

Painting

Despite the efforts of the Society of Patriotic Friends of Art, Bohemian art of the early 19th century was highly conventional. The first figures of note are from the **Mánes** family of painters. The father, **Antonín** (1784–1843), created Romantic landscapes, but it was his son **Josef** (1820–1871) who gained greater renown, one of his best known works being the **Astronomical Clock** of the Old Town Hall.

During the first half of the 19th century, Bohemian artists were drawn to Vienna and Munich, but by mid-century, Paris was the place to be, offering inspiration to many artists, such as the Courbet-inspired portraitist and still-life artist **Karel Purkyně** (1834–1868), Millet-inspired **Hippolyt Pinkas Soběslav** (1827–1901), and **Viktor Barvitius** (1834–1902),

who, inspired by Manet, abandoned history painting for portrayals of urban life. The only painter from this period to gain an international reputation was Paris-based Romantic painter **Jaroslav Čermák** (1830–1878), whose travels in Dalmatia inspired several interesting orientalist works.

By the 1870s, the situation for artists in Prague improved as the city once again began to thrive, drawing its artists back from abroad. Numerous ambitious building projects, such as the National Theater, provided work for all, giving this generation the sobriquet the National Theater Generation. The central figure of this period was **Mikoláš Aleš** (1852–1913), whose lively, decorative style was perfectly suited for his many depictions of Bohemian history and folklore in painting and graphic arts. History painter **Václav Brožík** (1851–1901) made a specialty of glorifying images of the Czech nation's mythologized past. The principal practitioner of the Impressionist style in Prague was **Antonín Slavíček** (1870–1910) who created wonderfully evocative images of the city and surrounding countryside. **Jakub Schikaneder** (1855–1924) painted moody post-Impressionistic canvases of almost disquieting solitude in an atmospheric Prague setting.

The fin-de-siècle looked toward modernism with the poetic symbolism, neo-Romanticism and introspection of the work of **Max Švabinský** (1873–1962), **Antonín Hudeček** (1872–1941) and **Jan Preisler** (1872–1918). Preisler also worked in an art nouveau style, most famously propagated by his countryman, **Alfons Mucha** (1860–1939).

Sculpture

After years of decline, Czech sculpture once again revived in the later 19th century. One of the most prominent sculptors was **Josef Václav Myslbek** (1848–1922) part of the National Theater Generation, known for his heroic Slavonic figures sculpted with a classical and rigorous Teutonic air, such as the noble equestrian **St. Wenceslas** on the eponymous square. Myslbek trained many Czech sculptors, including **Stanislav Sucharda** (1866–1916), celebrated for the dynamic **Palacký Monument**, which incorporates his painterly art nouveau, symbolist style. One of the few of this generation not to study with Myslbek, **Ladislav Jan Šaloun** (1880–1946) created one of

the most potent public sculptures of the early 20th century, the **Jan Hus Monument**, which is clearly influenced by the Prague Secession and the sculpture of Auguste Rodin. A more solitary figure, **František Bílek** (1872–1941) created powerful sculpture and graphic works infused with a deep sense of spirituality and symbolism, which can be seen in the **Bílek Villa**.

The 20th Century: from the Avant-garde to Communism

In the years before World War I Prague emerged as an important center of the avant-garde. Modernist tendencies first emerged with the Mánes Society of Artists (named after Josef Mánes) founded in 1887. Reacting to the parochial nationalism of the Prague Academy, Mánes sought to promote international styles in art and organized numerous significant exhibitions such as that of **Edvard Munch** in 1905, which was a catalyst for the formation in 1907 of Osma ("the Eight"), Prague's first specifically modernist group. Members, including **Emil Filla** (1882–1953) and **Bohumil Kubišta** (1884–1918), created an aesthetic vocabulary melding expressionism and primitivism to explore a sense of sociopolitical alienation (a theme explored in period writing, such as by Prague-based Franz Kafka). Four years later, inspired by the cubist works of Braque and Picasso seen abroad and in the collection of influential art historian and later director of the National Gallery **Vincenc Kramář**, Osma morphed into the Group of Plastic Artists (Skupina výtvarných umělců), marking the emergence of Czech cubism. Members included painters Filla, Kubišta, **Josef Čapek** (1887–1945), Antonín Procházka (1882–1945), Václav Špalá (1885–1946), and sculptor **Otto Gutfreund** (1889–1927).

Unique in Europe, cubist architecture also developed. Modernist architecture to that point had been represented in the proto-functionalist structures of **Jan Kotěra** (1871–1923). Feeling Kotěra's work to be too utilitarian, architectural members of the Group of Plastic Artists such as **Pavel Janák** (1882–1956), **Josef Gočár** (1880–1945), and **Josef Chochol** (1880–1956) developed a more artistic cubist architectural aesthetic (which they also applied to decorative arts), such as in Gočár's masterpiece, the **House of the Black Madonna**. Why cubist architecture found expression in Prague may

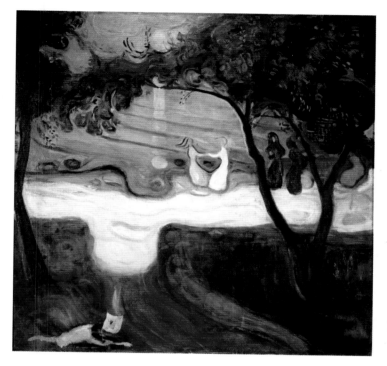

Edvard Munch (1863-1944), The Dance on the Shore, *1900-1902, National Gallery*

relate to earlier Bohemian architectural experiments, such as the dynamic Gothic vaulting of Parler and Santini-Aichel's unusual baroque-Gothic, whose influence can be seen in cubist multifaceted forms. Following the creation of Czechoslovakia in 1918, the search for a new national style led to another uniquely Czech style: rondocubism, exemplified by Gočár's Legiobank and characterized by segmented cylindrical forms and folkloric decoration. In art, civilism, also called objective realism, a style celebrating ordinary life and folk art, can be seen in the late work of **Otto Gutfreund**.

While cubism flourished in Prague, Czech painter and graphic artist **František Kupka** (1871–1957) exhibited the

world's first abstract painting at the Paris Salon of 1912. Based in France for most of his career, Kupka's style evolved from symbolism and lyrical abstraction to geometric abstraction, and he is easily one of the geniuses of his generation.

Prosperous, progressive, and at the heart of Europe, Czechoslovakia became a melting pot for the artistic fashions of Europe, appropriating and transforming various movements: constructivism from Russia; dadaism from Zurich and Berlin; futurism from Italy; the Bauhaus from Weimar; surrealism from Paris. Most avant-garde activity in the 1920s focused on the left-wing group Devětsil (literally meaning "nine forces," but also the name of a type of hardy plant), formed in 1920 with members from all artistic disciplines (even giving honorary membership to Charlie Chaplin) and experimented with all the modern "isms." Their leader was experimental poet and collage artist, **Karel Teige** (1900–1951), whose theoretical writings on art in the age of mechanical reproduction predates that of Walter Benjamin by a decade. Teige's aesthetic was based on the reconciliation of constructivism and poetism; Teige described the former as "a method with rigorous rules, it is the art of usefulness" and the latter as "its living accessory... the atmosphere of life... the art of pleasure." The Marxist utopianism of the group could not stand in the rising totalitarianism of the 1930s and it disbanded in 1931 with several members going on to form the Czech Group of Surrealists, who first exhibited in 1935 in the new functionalist Mánes Building. Prague was a center of the movement, with French surrealist André Breton calling the city "the magic metropolis of Old Europe." The Surrealists included the painters **Toyen (Marie Čermínová)** (1902–1980), **Jindřich Štyrský** (1899–1942), and **Josef Šíma** (1881–1971), collagist **Zdeněk Rykr** (1900–1940), and the highly original **Zdeněk Pešánek** (1896–1965), who worked with lighting and plastic forms to create kinetic art, winning international acclaim for his light-kinetic fountain at the Paris World Exhibition in 1937.

The influence of the avant-garde is also found in the pictures of **Josef Sudek** (1896–1976), who explored the

abstract qualities of everyday scenes, and **František Drtikol** (1883–1961) who specialized in female nudes in unsettling, geometric settings. From 1934–1938, fleeing the encroaching Nazis, Austrian artist **Oskar Kokoschka** (1886–1980) temporarily became a citizen of Czechoslovakia, where he painted expressionistic views of Prague.

While the poetics of Devětsil had some influence in architecture (such as the work of architect Jaromír Krejcar), it soon lost ground to the utilitarian and pure abstract elements of international functionalism. An early example was the 1928 **Trade Fair Palace** (Veletržní palác) designed by Josef Fuchs and Oldřich Tyl, which Le Corbusier stated had shown him how functionalism could be applied on a large scale. Other landmark projects include the **Baťa store** (1929) on Wenceslas Square, the **Baba Housing Estate** (1928–1940), an example of the domestic ideals of the German Werkbund of Mies van der Rohe and Moravian-born **Adolf Loos' Müller Villa**, a suburban family home built on Loos' principal, "ornament is crime."

Standing apart from this modernism was idiosyncratic Slovenian architect **Josip Plečnik** (1872–1957), who took his inspiration from classical forms and the historical setting of his work. His buildings are today considered to anticipate the postmodern. A close friend of President T.G. Masaryk, Plečnik renovated the courtyards, gardens, and interiors of Prague Castle from 1920–1934. His greatest individual work, however, is the **Church of the Sacred Heart** in Vinohrady, an eccentric mix of early Christian basilica and Egyptian temple.

Nazi occupation meant little artistic activity, although a few artists, such as painters **Kamil Lhoták** (1912–1990) and **František Hudeček** (1909–1990), and influential art theoretician and critic **Jindřich Chalupecký**, did come together to form Group 42 (Skupina 42), which, unsurprisingly, explored surrealism and existentialism. After the Communist coup of 1948, official art was to promote a Soviet-style socialist society and usually conformed to the monumental and idyllic principles of socialist realism, regularly involving robust, rosy-cheeked workers or heroic Communist leaders. Architecture was

equally lifeless, producing such structures as the Soviet-styled Hotel Intercontinental (now a Holiday Inn) based on Moscow's "Seven Sisters" and vast, impersonal housing estates around Prague. However, with the recent phenomenon of "ostalgia"—nostalgia for the objects and images of the Communist bloc—these relics of the Soviet age may yet be rehabilitated in art history.

The flip side is what is known as **"Art Informel"**—lyrical abstraction with powerfully existential tones that emerged in the late 1950s and early '60s, initially shown at unofficial studio exhibitions. The situation changed briefly during the comparative freedom of the Prague Spring when artists took to the streets in fluxus-style actions and happenings, such as those by Milan Knížák (today the controversial director of the National Gallery). In film, Jiří Menzel's (1938–) *Closely Watched Trains* (1966), based on a novel by Bohumil Hrabal, became the first international hit of Czech new-wave cinema. The Soviet invasion of 1968 and the subsequent period of "normalization" once more drove artists underground. By its clandestine nature, most unofficial artists have been little known in the greater art world, but since 1989, many have exhibited in major galleries and there are now permanent exhibitions of "unofficial art," such as in the National Gallery's Trade Fair Palace and the Kampa Museum. Some of the many artists of note are collagist and poet Jiří Kolář (1914–2000), conceptual artist Adriena Šimotová (1924–2004), graphic and performance artist Vladimír Boudník (1924–1968), sculptors Karel Nepraš (1932–2002), Aleš Veselý (1935–) and Eva Kmentová (1928–1980), and painter-printmaker Jiří Anderle (1936–). Although often dealing with issues of censorship, isolation, and dehumanization in a totalitarian state, many works have a characteristically Czech approach: fusing social criticism with black humor, gentle irony, and a well-developed sense of the absurd or grotesque.

Art in Prague since 1989

Without the looming presence of communism, many artists who began their careers under its oppressive shadow, and often in response to it, have had to search for meaning in the new capitalist commercial art market. In 1944, Sartre wrote: "we have never been so free as under the German Occupation," neatly summing up the artistic paradox experienced by those whose art emerged in relation to a repressive state that no longer exists. However the tension between the ambiguities of the present and the weight of a complex past is, on the other hand, yet another creative stimulus.

Many pre-1989 artists are still active, such as members of two groups founded in 1987: the "12/15 Better Late than Never" group" (including Jiří Beránek, Václav Bláha, Ivan Kafka) and "Tvrdohlaví" ("the Stubborn Ones," including Jiří David, František Skala, and Stanislav Diviš). The city itself is the backdrop for artworks by sculptor **Magdalena Jetelová** (the massive "Chair" by the Vltava River) and **David Černý** (the babies crawling up the Zizkov TV tower). A new generation of artists is also emerging and since 1990, the Jindřich

Where to See Contemporary Art

The Czech Museum of Fine Arts, Prague City Gallery, and Trade Fair Palace all hold temporary exhibits of contemporary artists. Also see:

- *Galerie Rudolfinum, Alšovo nábřeží 1, Prague 1, www.galerierudolfinum.cz*
- *Mánes Gallery, Masarykovo nábřeží 250, Prague 1, www.galeriemanes.cz*
- *Galerie Václava Špály, Národní třída 30, Prague 1, www.nadace-cfu.cz*
- *Galerie Jiří Švestka: Biskupský dvůr 6, Prague 1, www.jirisvestka.com*
- *Futura, Centre for Contemporary Art and Events, Holečkova 49, Prague 5, www.futuraprojekt.com*

Chalupecký Prize (the Czech version of Britain's Turner Prize), named for the eminent Czech philosopher and critic, has been awarded to promising young artists aged 35 and younger. Past winners include photographer Markéta Othová (2002), video artist Michal Pěchouček (2003) and conceptual artist Ján Mančuška (2004).

Most architectural projects since 1989 have involved restorations and renovations of long neglected historical buildings; a double-edged process for, although most of the work was long overdue, criticisms have arisen of shoddy and insensitive restorations aimed to please only the massive tourist market. One new project to gain international attention has been Frank Gehry's **"Fred and Ginger" building**, which dances along the banks of the Vltava.

Part of the citywide renovations, Prague's national museums have been completely overhauled, collections reorganized, and new museums opened, so anyone who visited in the early 1990s will find a very different museum system. The process is still ongoing, with, for example, the Schwarzenberg Palace on Hradčany presently undergoing renovations to become the new location of the Old Masters collection of the Sternberg Palace.

Trail 1:
The Old Town

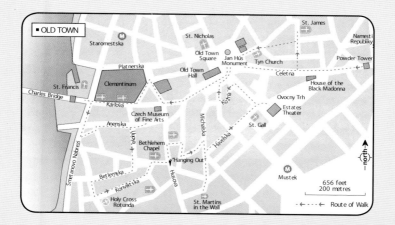

The layout of the Old Town (Staré Město) has essentially remained the same since medieval times. It is bordered by the Vltava to the north and west and to the south and east by the streets Národní, Na příkopě, and Revoluční, which follow the line of the original medieval fortifications. (These were removed in the 18th century.)

Within these boundaries are found some of Prague's most renowned sites: palaces, churches and synagogues dating from medieval to modern times, as well as several worthwhile museums (dedicated to modern Czech art, cubism, landscape painting, medieval painting, and decorative arts). Days could be spent simply wandering its atmospheric cobblestone

streets and squares. That said, the following trail leads to the principal sites along some of the Old Town's most picturesque routes. Plan at least a day to wander at leisure and longer for museum visits.

ALONG THE ROYAL ROUTE

The processional route followed since the Middle Ages by Bohemia's kings on their way to be crowned at St. Vitus Cathedral is called the Royal Route (Královská cesta). It followed Celetná Street to Old Town Square, along Karlova Street, across Charles Bridge, and up Mostecká and Nerudova Streets to Prague Castle. One of the Prague's best-known landmarks, the 213 ft/65 m Powder Tower, marks its beginning.

Powder Tower (Prasná brána)

Location: Náměstí Republiky, at the intersection of Na příkopě, Revoluční and Celetná

Opening hours: Daily 10 AM–6 PM

Although it has all the appearance of a defensive tower, by the time the Powder Tower was built in the mid-1470s, it was already superfluous. It replaced one of the thirteen gates forming the Old Town's defensive system, which itself had been made redundant after the expansion of the city with the founding of the New Town in 1348. Its function had always been more symbolic in any event. Commissioned by King Vladislav II of Jagiellon to symbolically stand guard over his adjacent Royal Palace (the remains of which were demolished to make way for the Municipal House in 1902) and the main road to Prague from the royal silver town of Kutná Hora, the tower reflected that unpopular king's relationship with the rebellious citizens of the Old Town. Trying to evoke the authority of his great predecessor, Charles IV, Vladislav chose a design based on Old Town Bridge Tower, which Charles had commissioned from Peter Parler. The tower did indeed create a suitably grand commencement for the Royal Route, but it didn't help Vladislav's popularity: in 1484 a revolt forced him to move his court to Prague Castle.

The work on the tower was abandoned and the incomplete structure, with only a provisional roof, was later used to store gunpowder (hence its name). Damaged in the Prussian siege of 1737, it was left in a near dilapidated state until Josef Mocker carried out extensive and imaginative restorations between 1875 and 1886. A civil engineer with a passion for the Gothic, it is Mocker's neo-Gothic vision that we see today. To the remaining fragments of medieval sculpture by Mathias Rejsek (after 1478), Mocker added an elaborate cycle of allegorical figures, saints, and rulers from Czech history. The steeply pitched roof, gallery, corner turrets, and golden finials are similar to other towers Mocker restored throughout the city in an attempt to "re-Gothicize" Prague, recreating Bohemia's golden age.

The bridge linking the tower's first floor and the Municipal House was added after the latter was built (1906–1911), but the original tower had a similar bridge to the royal palace, which was used for display and for protection from occasional revolts.

Inside the tower is an interesting exhibit on Josef Mocker and the history of the structure. Climb to the top for spectacular views of the entire city and a sense of the Royal Route to Prague Castle on the other side of the river.

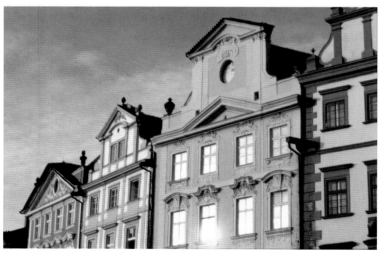

Old Town façades, Prague

Along the way is a sea of red tiled roofs, spires, and golden orbs. It is a seductive, fairy-tale view—thanks in part to Mocker— evocative of an age before concrete. It is easy to imagine a royal procession making its way below along Celetná.

The view encompasses a fascinating range of architecture, listed beginning to the north and proceeding clockwise: the art nouveau Municipal House; the early 19th-century Empire-style façade of Hibernian's House; the 1930s functionalist Czech National Bank (by František Roth, at Na Prikope 24– 26); Celetná Street's baroque houses, and the Gothic spires that dot the city. This effortless melding of styles and periods is found throughout the city and is what makes Prague's streets so fascinating to explore.

Leaving the Powder Tower, begin along Celetná Street. To your right on the corner at U Prašné brány 1 is a 1903–1904 apartment block with an elegant semi-circular staircase in its foyer by Bedřich Bendelmayer. The organic contours of this art nouveau structure meld effortlessly with the baroque curves found further along Celetná—both decorative styles of curves and organic forms. As the first leg of the Royal Route, Celetná has been a showpiece since the Middle Ages and is lined with houses of medieval origin sporting exuberant baroque façades (and unfortunately, a surfeit of tacky souvenir shops). The first building of major interest, however, is the Czech cubist masterpiece, the House of the Black Madonna (dům U černé Matky Boží), which very appropriately houses the National Gallery's Museum of Czech Cubism.

Museum of Czech Cubism at the House of the Black Madonna

Location: Corner of Celetná Street and Ovocný trh (fruit market)
Contact details: www.ngprague.cz
Opening hours: Daily 10 AM to 6 PM, closed Mon

Built as a department store with a first floor café in 1911– 1912 by Josef Gočár, the House of the Black Madonna was shockingly modern at the time, particularly compared to the nostalgically decorated Municipal House (see Trail 5, New

Town, completed just a few months earlier. The rust-colored exterior of reinforced concrete is articulated in prism-shaped forms, prominent cornices, and cubist detailing. Everything is very modern except for a solitary niche on the northeast corner that holds a copy of a 17th-century Black Madonna statue from which the building takes its name.

The museum is a showcase of cubist art. It was Pablo Picasso (with *Les demoiselles d'Avignon*, 1907) and Georges Braque who began the cubist movement. Inspired by Cézanne's innovative techniques, both artists were looking for a new method of depiction, presenting an image from multiple angles, not just one fixed perspective, in order to more closely approach the essence of a subject. Although controversial and many were inspired by the style, nowhere more so than in Prague.

By 1910, a unique form of Czech cubism—which was also influenced by the symbolic expressionism of Edvard Munch and the exuberant forms of the Bohemian baroque—was found in all fields of fine art: painting, sculpture and, unique to Bohemia, applied arts and architecture. Many of those involved with cubism were associated with the avant-garde group known as the "Group of Plastic Artists," founded in 1911. Artists such as Emil Filla, Bohumil Kubišta, Josef Čapek, Antonín Procházka, Václav Špála, Josef Gočár, Vlastislav Hofman, and Josef Chochol experimented with the cubist forms, creating everything from furniture to apartment houses. After World War I, most artists moved on to other styles, although a few, such as Filla, experimented with cubism for years to come.

The museum's exhibits are displayed over three floors (the second to fourth; the first is a cubist café) and explore Czech cubism between 1910–1919. As with most of the museums under the banner of the National Gallery, the exhibit is well documented in Czech and English. (Cubist works can also be seen on the third floor of the National Gallery's Trade Fair Palace and at the Kampa Museum).

SECOND FLOOR

This floor presents several works by three central figures of Czech cubism: Emil Filla, Bohumil Kubišta and Otto Gutfreund. Emil Filla remained a cubist most of his life but

it is his playful early compositions—such as *Smoker* (1913–1914) or the dynamic *Still-life with a Plate and Fruit* (1912), which is anything but still, bursting with kinetic energy—that made his reputation. These stand in contrast to *Kiss of Death* (1912), a more somber painting by Bohumil Kubišta, whose work often explored baroque forms and spirituality. Otto Gutfreund often played with the human form in his sculptures, such as in the portrait bust of the literary anti-hero *Don Quixote* (1912), composed of wild twisting angles and compressions.

Among the paintings and sculpture are scattered examples of applied arts, such as furniture and ceramics that help give a sense of the avant-garde atmosphere of the era. Inspired by the Weiner Werkstätte, Czech designers announced their intentions in a declaration stating that "...along with its prime purpose, furniture should not only comply with good taste... but should also be taken as serious art..." They experimented with cubist oblique planes and angles, looking for their inner dynamism and formative forces. Several architects designed cubist furniture, such as Josef Gočár (*Sofa* and *Armchair*, 1913) and Pavel Janák (displayed on the third floor). Several also dabbled in ceramics. Look for Janák's ultra-modern *Zig-zag Coffee Set* (1912), which looks just the kind of cup from which a silent movie star or Bohemian flapper would drink.

THIRD FLOOR
The third floor presents painted works by other cubist artists such as Špála, Kubín, Procházka, and several of the distinctively gentle paintings of Josef Čapek (*Head*, 1915 and *Female Figure (Lelio)*, 1913). There is a small display on cubist architecture with biographies of architects as well as layout designs and photos of various buildings, such as Pavel Janák's *Fara's House* in the town of Pelhřimov, a unique synthesis of cubist and baroque sensibilities and a striking example of the baroque influences on cubism.

FOURTH FLOOR

The fourth floor primarily displays prints and drawings (which are changed from time to time to protect them, as works on paper fade with prolonged light exposure) along with a few examples of the "primitive" African sculptures that influenced many of the cubists. There are also short biographies and pictures of the principal figures of Czech cubism.

Leaving the museum, continue west along Celetná, looking up above the tourist shops to the baroque façades, most of which conceal much older interiors or foundations. Many façades date from the late 17th century when Prague began to revive after the ravages of the Thirty Years' War. As the economy slowly recovered, the city underwent the most dramatic transformation in its history, with baroque façades appearing not only on new structures but also on existing medieval and Renaissance buildings. (Generally, a remodeled Gothic or Renaissance house is much narrower than a brand new baroque building.)

The **Langer (or Pachta) Palace** (no. 31/585) is the amalgamation of several older houses behind a 1740s baroque façade by K.I. Dientzenhofer. Opposite is the **New Mint** (no. 36/587) where coinage was produced until the 19th century; two of the atlantes supporting the balcony are Kutná Hora miners. The pale green, late 18th-century façade of **U Supa** ("At the Vulture," no. 22/563) still displays the original French and German signage of the royal jeweler "Grindle." No. 15/586 is the odd-man out, a functionalist building by Gočár, from his post-cubist period. The graceful **Hrzán Palace** (no. 12/558), Romanesque in origin, was remodeled by Giovanni Alliprandi in 1702. Note the prominent points of the cornices and pediments, which are surprisingly reminiscent of later cubist angles. Albert Einstein is said to have first explained the Theory of Relativity in the vivacious pink baroque house at no. 2/553, which must have been an inspirational location as Franz Kafka also once lived there (as well as at no. 3/602).

Before being drawn into the whirlwind of Old Town Square, backtrack to no. 17/595 and enter the covered passageway

(note the Gothic arches along the walls) and continue onto Malá Štupartská Street and the majestic St. James Church.

Church of St. James (Kostel sv. Jakuba)

Location: Malá Štupartská
Opening hours: Mon–Sat 9:30 AM–noon, 2 PM–4 PM; Sun 2 PM–4 PM

The church of St. James was part of the neighboring Minorite (Order of the Minor Friars) monastery founded in 1232 by Wenceslas I. The complex, built from 1292 through the 14th century, was one of the era's grandest pieces of architecture and was the venue for royal events such as the coronation feast of John of Luxemburg, reflecting the Minorite Order's powerful position and close ties to the monarchy. In 1689 the church was badly damaged by fire and was completely remodeled between 1690 and 1702 by Prague architect Jan Šimon Pánek, with further work on the interior in 1726–1739.

The church is a typical example of a Bohemian baroque adaptation of a medieval church. The original construction and outer walls were preserved, the windows expanded, a new vault raised and given stucco and fresco painting, and the movables (altars, paintings, etc) were changed. In St. James the tall west façade was greatly altered and decorated with three illusionistic baroque stucco reliefs by Ottavio Mosto (1695) representing (left to right): St. Francis contemplating a skull and surrounded by an outrageous jumble of cherubs; St. James in pilgrim's clothes bearing his symbol, the shell; and a young St. Anthony of Padua in Franciscan robes.

The interior has retained its medieval three-aisle plan and tall Gothic proportions (it is second only to St. Vitus in length), but the rest is given over to the baroque. A profusion of pink marble, stuccowork and gilding, the space is filled with ceiling frescoes by F.Q. Voget of the life of the Virgin (1736) and 22 highly embellished altarpieces covered with gilded saints and starbursts. Most are blackened with age and years of candle smoke, but are nonetheless the work of respected baroque painters, such as Václav Reiner, whose *Martyrdom*

of St. James fills the main altarpiece, and Petr Brandl, who painted three altarpieces along the south aisle (c. 1710).

The profusion of ornament can be overwhelming, but consider that every cherub and starburst was considered by the Counter Reformation to be instructive ornament, showing churchgoers the way to God. To appreciate some of the artistry that went into the structure, focus on one or two components. For instance, the main altarpiece is a perfect example of the theatricality of the baroque church. The frame alone has more action than a Broadway production; winged angels flutter about its flamboyant gold frame, and atop the Trinity (Father, Son and the Holy Spirit, in the form of a dove) encircle an *orbus mundus* before a cherub-filled starburst. Above, female angels hold a theatrical draping aloft, giving the impression of curtain that will fall when the performance/mass is over. At its center is the all-seeing eye of God.

In the north aisle is found one of Prague's greatest funerary monuments, the *Memorial to Jan Vratislav of Mitrovice*, the Grand Prior of the Maltese Order and High Chancellor of Bohemia. Designed in 1721 by Johann Bernard Fischer van Erlach with emotive sculpted figures by Ferdinand Brokoff, it has a classical simplicity that distinguishes it from its more flamboyant neighbors. A Pharaonic pyramid, upon which a trumpet-wielding angel inscribes the deceased epigraph, sits above the sarcophagus, where the dying Jan Vratislav, in armor and a long, fashionable wig, is supported by a beautiful female figure offering him a laurel of stars. At his feet stands an aged Father Time holding an hourglass, marking the end of Vratislav's earthly days. An inconsolable female mourner—a neo-classical update of the ancient *pleurant* or professional mourner found in antique art—weeps, head in hand, at the base of the tomb.

Of more of a curious, rather than artistic, value is the gnarled, 400-year-old severed arm hanging from a chain just to the south of the west entrance. Legend states that the arm belongs to a thief who was caught red-handed by the Virgin herself. Her statue would not let go of the man's arm, so a

butcher was called in to cut it off. Unsurprisingly this was originally the church of the butcher's guild.

Leaving the church, notice the cream and burgundy-colored **House at God's Eye** (dům U Božího oka) just to the right. Like many Prague houses, this is a mix of styles: a 1501 doorway next to the remnants of a Gothic arch, and the rest is baroque in style with decorative 19th-century portrait medallions of Prince Václav, his father Charles IV, and George of Poděbrady. The top gable depicts the all-seeing eye of God.

Opposite and just to the left of St. James, enter the covered passageway leading into the **Týn Court** (Týnské náměstí) also known as **Ungelt**, one of the first settlements in the Old Town. This pleasant square is lined with Renaissance and baroque buildings today occupied by shops and restaurants. From the 11th to 18th century, however, it was a customs house ("Ungelt" in German) and the headquarters of foreign merchants who filled the square with their goods and shops. The square retains its medieval layout (an enclosed courtyard—Týn means "enclosure"—with two entrances) and most houses date from this period, with Gothic remnants still evident at ground level, particularly in entranceways and windows. **The House of the Blue Eagle** (U modrého orla, no. 643) dates from the Renaissance, as does the impressive **Granovský Palace** (no. 1/639–40). Dating from around 1560, it has a Northern Italian-style loggia and is covered with chiaroscuro paintings of allegorical and religious scenes. For instance, between the lower windows are portraits of the personification of justice holding scales, and her protector, Charles IV, in armor. Above, scenes range from the Judgment of Paris to Judith and (the beheaded) Holofernes, to Cimon and Pera, a story popular with baroque artists.

Exiting the square at the opposite end via the Týnský dvůr (Týn entryway), look back at the impressive entrance gate of Granovský Palace with its rusticated gate, Renaissance windows and gable, pear-shaped defense windows, and fragments of sgraffito decoration, including images of Prince Václav and Charles IV (identified by his imperial crown). Next door is the House of the Golden Ring, which shines above the entrance.

House of the Golden Ring (dům U zlatého prstenu)
Prague City Gallery (Galerie hlavního města Prahy)

Location: Ungelt, Týnská 6

Contact details: Tel. 224 827 022, www.citygalleryprague.cz

Opening hours: Tues–Sun 10 AM–6 PM

Part of the Prague City Gallery, the House of the Golden Ring has a permanent exhibit of 20th-century Czech art as well as temporary exhibitions on the same theme. The building itself is also part of the attraction. Dating from the 13th-century, this long, twisting structure was built along the wall of the Týn Court and was remodeled around 1609 when its distinctive house sign was added. As you visit the modern exhibits look for fragments of medieval frescoes and the fantastic views out over the Týn Church from its windows.

In contrast to its Gothic portals and barrel vaulting, the gallery's collection offers a concise introduction to Czech modern art. Spread over three floors, it has three thematic sections: "Dream, Myth, Reality"; "In the Mirror, Behind the Mirror"; and "Utopia, Vision, Order." The following covers some of the collection's most interesting artworks; note, however, that pieces are occasionally changed (to allow more of the collection to be seen) or moved for temporary exhibits.

FIRST FLOOR: DREAM, MYTH, REALITY
This section presents artwork that looks beyond reality to dream, myth, and the ideal.

Max Švabinský (1873–1962)
Destitute Land—Variation, 1900
This large pastel canvas of an ethereal girl in a windswept, melancholic landscape brought Švabinský great artistic success from its first exhibition at Prague's Rudolfinium in 1900. The inspiration for this image was visits to Kozlov in the Bohemian-Moravian Highlands where Švabinský used to go in the 1890s with his future wife Ela's family. Speaking of this painting at the age of 85 in 1958, Švabinský said:

The autumn was always beautiful at Kozlov. Heather bloomed—great, spreading expanses of heather. The leaves on the birch trees had begun to turn yellow and there was usually a keen breeze. I had this feeling inside me that I should paint a picture to illustrate the harmony of the violet heather, the blue sky and the white clouds drifting across the horizon. And the girl who would symbolize this image. In this girl I saw the person most dear to me, Ela, my future wife.

The outline of the girl's head in white chalk against a vivid sky creates an aura about her. Her anxious gaze is as much inward as outward, reflecting the modern introspection underlying the image. He painted an oil version of this image (today displayed in the National Galley's Trade Fair Palace) as well as this pastel version soon after his return from Paris, where he had been influenced by symbolism, although the image's color still reflects art nouveau tendencies.

Josef Váchal (1884—1969)
Prayer, c. 1911; *Figure*, 1916
Although he was influenced by symbolism and primitivism, Váchal always followed his own unique vision and was often considered something of an anarchist in the Czech art world. He worked often in print or wood and these two wood sculptures, the devout relief sculpture *Prayer* and the pagan totem *Figure*, reflect his often-contrary artistic vision of faith and heresy. Influenced by African art and cubism, he was fascinated by spiritualism and the occult and for a short period, Catholicism, and all inform his art.

František Bílek (1872—1941)
Prayer above the Altarpiece, 1900
This chalk drawing shares Bílek's characteristic symbolism, sense of drama, and extreme, pathos-filled mysticism. Bílek, who was most known for his sculpted work, was a highly individual artist interested in the psychological and spiritual possibilities of art, and often called his works "prayers." Filled with sweeping movement, this image is

meant to personify the motion of the prayer upward from earthly darkness and suffering to the celestial world above, almost like an ethereal wave. The wave was also a common theme in symbolist painting.

Otakar Nejedlý (1883—1957)

In the Cove, 1911

Nejedlý was a Bohemian landscape painter who travelled to India and Ceylon in 1909–1911, and was inspired by Gauguin and by his own romantic nature and passion for southern color. His stylized pictures explore ideas of paradise lost and classicism and display a decorative depiction of nature's wildness, as in this picture where natives in a small boat illuminated by yellow light are enveloped by lush tropical foliage.

Jaroslav Horejc (1886—1983)

The Sun, 1916

Horejc was inspired by antiquity and by the heroes of Greek mythology and the Old Testament. He created distinctive, stylized figures influenced by art nouveau and Greek and Etruscan art. "As a sculptor," he wrote, "I sought beauty via this 'archaism.' I aimed somewhere high, toward beauty, poetry, imagination and fairy tale. Perhaps this is why Ancient Greece was so familiar to me." This wood sculpture of a highly stylized head with golden hair and mahogany skin is meant to be a personification of the sea.

Jan Zrzavý (1890—1977)

San Salvatore, 1928

Influenced by the Italian primitives and neo-classicism, Zrzavý's singular paintings depict a highly stylized, poetic reality of geometric shapes and unrealistic color. This image was inspired by a trip to Venice in 1928. The architecture of the church of San Salvatore is depicted as a dreamy vision of stereometric shapes of precise contours and muted colors—pale greens, greys, and pinks—creating an almost surreal, intangible landscape.

Toyen (Marie Čermínová) (1902—1980)
Paddy Fields, 1927

In 1927, Toyen, along with her creative partner, Jindřich Štyrský, published *Artificialism,* an artistic manifesto that sought to fuse the ideas of painter and poet. Exhibited in Paris in 1927 and in Prague in 1928, *Paddy Fields* is a characteristic example of High Artificialism. The movement, reacting to a perceived tension between the contemporary art movements of abstraction and surrealism, believed that the painting genre should be freed of deception, literary character, and decorativeness. Only then could it approach poetry, considered the supreme art form. The painter's goal should be to bring shape and color to an emotional idea in order to awake poetic feeling. According to their manifesto, "...[T]he interference of recollections without using memory and experience gives the painting a conception whose extract and concentration eliminate any form of mirror effect and shift the recollections into imaginary space."

Josef Šíma (1891—1971)
Theseus's Return, 1933

Originally part of Thesean triptych, now lost, Šíma reduced the narrative motifs of ancient Greeks to a minimum. There is a silhouette of a shadowy ship as it slips into dark clouds, which look more like ominous boulders—a reminder of the tragedy to come. Theseus told his father, Aegeus, that if he were successful in killing the Minotaur he would tell him by changing his sails from black to white. Theseus neglected his duty and his father, believing his son to have been killed, threw himself into the sea. In the foreground, Athena rises up, spreading the news that the Minotaur is dead, and three female figures rejoice. This near surrealist treatment of a classical theme was done in a period when Šíma was moving from a lyrical vision of the world's creation to a darker expression of the tragedy in existence.

SECOND FLOOR: IN THE MIRROR, BEHIND THE MIRROR

This section explores the relationship between modern art and reality and the way the world is mirrored—however altered or distorted—through the artist's subjectivity.

Emil Filla (1882–1953)

Still-life on a Table, 1927

Filla was a printmaker, sculptor, and art critic whose earliest work is influenced by realism and expressionism but by 1911 he had been fully drawn into the cubist movement, which marked his work for the rest of his life. Despite the influence of Picasso and Braque, his pictures are very much infused with his own personality. This still life is considered one of his best works and combines contorted reality with ornament.

Karel Nepraš (1932–2002)

Bust, 1968

A grotesque portrait of a man with bulbous features made of plastic, mesh, and wire all painted Nepraš's characteristic red. The figure is a skeleton of imaginary tissue and muscle created with spare parts and treated with an ironic humor, and is meant as a parody of the official busts of communist party leaders. Nepraš's work underlines the tragicomic and the often absurd existence of man who is "seemingly the greatest burden to himself." Franz Kafka was an inspiration for Nepraš and other artists working under communism.

Vladimír Boudník (1924–1968)

Variations on a Rorschach Test, 1967 (several versions)

The Czech lands have produced many unique artists and no more so than Vladimír Boudník. A factory worker for much of his life (first under Nazi forced labor and later under communism), he paradoxically thrived in this context, finding ways to express himself and believed that anyone could be an artist by simply releasing his or her own creativity from social constraints and finding art inherent in the environment. This was the basis for his *Explosionalism Manifesto* (1949). He regarded

the surface of the material (any material used for art production) as a place to express "one's inner nature." Around 1954 he began to explore "active graphics," where he used the machines he operated in the Prague factory and other objects, to disfigure and break metal sheets. This he considered "writing" his works into the material. He began to make prints from these plates and explored different methods of affecting the metal surface. The works found in the collections all demonstrate the intense results of his explorations.

Eva Kmentová (1928–1980)
Hands, 1968
Kmentová's sculpted works repeatedly explore ideas of touch and she often used her own body as part of her expression. This simple but effective image of molded hands on a wall, riddled with bullet holes, is an eloquent reaction to the August 1968 Soviet invasion of Czechoslovakia.

Note that the gallery's collection also has some of Antonín Slavíček's (1870–1910) best works (*View of Prague from Ládví,* 1908, shown here and *St. Vitus Cathedral,* 1909) which were not on display at the time of writing.

THIRD FLOOR: UTOPIA, VISION, ORDER
Here the broad overall theme is the search for a way to order or present the world or a vision of it; a personal concept of a possible or ideal state of being.

Karel Teige (1900–1951)
Greetings from Abroad, 1923
Departure for Cythera, 1923–1924
These two collages date from after Teige's break with the artist group Devětsil and his movement to poetism. He called these types of images "picture poems" and works like *Greetings from Abroad* and *Departure for Cythera* were more specifically "touristic poems," offering a "reflection of travel lyricism." On *Greetings from Abroad,* Teige stated that the collage included images of a trip: " ...[S]everal typical photogenic features: a ship's flag, a

Antonín Slaviček, View of Prague from Ladvi, *1908 (oil on canvas), Prague City Gallery (Interfoto)*

picture postcard, a photograph of a starry night, a travel map... namely allusions which are to evoke impressions whose vividness is expressed in words."

Jiří Kolář (1914–2002)
Collage, 1960s

This image is a woman's profile, based on Renaissance Italian types, created by a collage of ripped magazine photos with a background composed of torn phonebook pages. In Kolář's work all meaning is permeable. Playing with the concept of "rollage," he combines two or more images into one, thus creating a third image, as well as a tension between something both familiar and new, a state with infinite possibilities. Kolář began as a poet but by the 1960s had uncovered the possibilities of visual poems, in the form of collage. A bit dada, a bit surreal, his structures recall *Alice in Wonderland,* but with a very Czech mix of black humor and ironic playfulness.

Magdalena Jetelová (1946–)
Table 1978

Jetelová often creates remarkable renderings of single,

isolated objects found in ordinary surroundings in a quest to express the "magic of things." Carved from pearwood, the sculpture's contoured and voluptuous surface forms a tabletop and tablecloth, and atop a split fruit, which seems to ooze off the edge of the table. Presented outside of their usual, consumer-oriented context, her sculpted objects allow the viewer to re-evaluate what they see and appreciate the form anew.

As you leave the museum, the eastern choir of the towering **Týn Church** confronts you. Note the sturdy buttresses (not at all the light flying buttresses of near contemporary St. Vitus Cathedral) and the sadly neglected north portal. The tympanum is a copy of an exceptional sculpture by the workshop of Peter Parler (the original, c. 1380, is found in the Lapadarium Museum). The relief represents three scenes of the Passion: the Crucifixion at the center, the Flagellation to the left, and the Crown of Thorns to the right. Above is an abbreviated scene of the Last Judgment. Remaining in the jamb corbels are a few original sculptural details (such as a man's head swallowing a snake), which were part of the portal's medieval iconography, presenting images that prefigured Christ's suffering.

Follow narrow Týnská street along the north flank of the church. The street is lined with stalls selling tourist paraphernalia, which, however tacky, is in many ways historically accurate, as hawkers selling souvenirs and other goods to churchgoers usually surrounded (and sometimes even entered) medieval churches, which were, among other things, commercial venues. Among the items sold were pilgrims' badges, often in the form of a saint or holy symbol, which acted as a memento or proof of a person's visit to a shrine. Examples of these small badges can be seen in the treasury section of the Museum of Decorative Arts.

OLD TOWN SQUARE

At the heart of Prague is the Old Town Square (Staroměstské náměstí), one of the most splendid public spaces in Europe. Surrounded by historic buildings and today a pedestrian

zone dotted with restaurants and cafés, Old Town Square is usually bustling with locals and crowds of tourists oohing and aahing over its architectural beauties.

The square is no stranger to crowds. A busy marketplace since the 11th century, it was also part of the royal procession route of Bohemia's kings and the site of chivalric tournaments. After the building of the Town Hall in the mid-14th century, the square had the double-edged distinction of being the principal center of civic and political ceremony. George of Poděbrady was elected king here in 1458 but only a year earlier it was the site of the execution of dozens of Hussites. After the defeat of the Protestant Estates at the Battle of White Mountain in 1621, 27 aristocratic rebels met a similarly gory end on the square. In 1650, a column in honor of the Virgin Mary Victorious was erected here as thanks for the end of a siege by the Swedes. By 1918, however, the column was seen as a symbol of Habsburg oppression and was torn down by mobs upon the declaration of Czechoslovak independence in 1918 (the surviving pieces of the column are now displayed at the Lapadarium). In 1945 large crowds cheered as liberating Soviet troops entered the square, where three years later Klement Gottwald proclaimed the new communist state (a scene brilliantly described in the opening pages of Milan Kundera's *The Book of Laughter and Forgetting*). Fast-forward 30 years to the suppression of the Prague Spring and Soviet troops once again entered the square, this time met with jeers and Molotov cocktails.

Testament to its organic evolution, the "square" is an irregular rectangle shape. Many of the surrounding houses retain 11th or 12th-century cellars that originally were the main floors of Romanesque buildings. They became basements when 13th-century flood-protection measures forced owners to build higher. Until the turn of the 20th-century, when Pařížská Street was created, only narrow medieval streets led into the square. The square was further opened with the destruction of the east end of the Town Hall during the fighting of May 1945. This made the Church of St. Nicholas, which was formerly tucked away on a narrow street, part of the square.

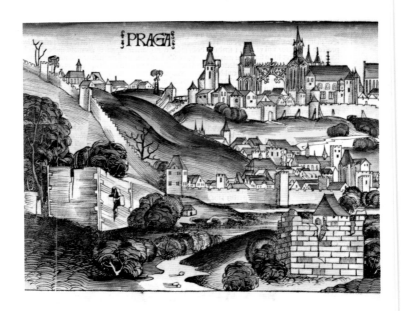

German school, executions of Protestant rebels in Old Town Square, Prague, 1621 (engraving), private collection

Presiding over the square is a powerful example of Czech Secession sculpture and a consummate monument to Czech history: the **Jan Hus Monument**. Rising magnificently like a ship's prow from a sea of pastel façades, Hus stands as a symbol of eternal strength in the face of crushing odds, a powerful reminder of the dark days of Czech history and of the Czech's stubborn perseverance.

Jan Hus (1370–1418) was a charismatic reformer who was among the first to speak out against church corruption. To bring the common people closer to God, he preached in Czech (as opposed to Latin) and offered all full communion (traditionally only priests could drink the "blood of Christ," the consecrated wine served in a chalice, which became the symbol of the Hussite movement). For his revolutionary efforts, the Inquisition—which had

promised him safe passage—burned him alive after a show trial in Constance, Switzerland.

Created by the idiosyncratic sculptor, Ladislav Šaloun, after seventeen years of planning, the statue was first unveiled in 1915 on the 500th anniversary of Hus' death, but without ceremony because of Austrian anxiety over rising Czech nationalism. The Nazis, who immediately draped the statue in swastikas upon occupying the city in 1939, also recognized its potent symbolism. The base bears Hus' words "Pravda vítězí" ("The truth will prevail") and Hus rises from a mass of huddled followers: exiled Czechs and a mother and child, symbolizing the Czech National Revival. The style is painterly, influenced by art nouveau as well as the sculpture of Auguste Rodin whose work Šaloun admired.

The following descriptions proceed clockwise around the square beginning with the Týn Church.

Týn Church or Church of Our Lady Before Týn (Kostel paní Marie pred Týnem)

Location: Old Town Square. Enter the church via a vaulted passageway found in the arcades of the gabled Týn School (no. 604/14), now an Italian café.

Opening hours: Mon–Fri 9 AM–12 noon, 1 PM–2 PM, and for services

The piercing spires of the Týn Church rise (262 ft/80 m) above Old Town Square yet the church's façade is hidden behind arcaded houses of medieval origin. It was rare to leave space around a church in medieval town layouts. Usually with only limited space within fortified walls, structures were built around and sometimes even into the walls of a church. The Týn has retained this compact position and its entrance is through a vaulted passageway via the Týn School (no. 604/14), which was a school for over 500 years and is distinguished by its 16th-century Venetian step-gables. A tiny courtyard before the church offers a tunnel-like vision up to the church's exposed masonry façade.

Begun around 1360 to replace an earlier church serving the

nearby Týn Court, by the 1380s the north portal (with the participation of Peter Parler's workshop; the side aisles, the walls of the nave and much of the east end were completed. The plan—a lofty, three-aisled basilica with three shallow, parallel choirs—is one of the grandest in Prague.

The spiritual center of the Old Town, it was associated with Reformist thought almost from its inception and by the early 15th century was the main church of the Hussites in Prague. The nave was vaulted in 1457 and a year later the newly elected King George of Poděbrady began work to complete the western towers (the present neo-Gothic spires date from the 19th century). On the façade's gable he placed the symbol of the Hussite movement, a golden chalice, along with his own statue. Both were melted down in 1623 by triumphant Catholic forces and made into that most Catholic of symbols— the halo for the Virgin Mary which still adorns the façade.

Inside, the church has been recently restored after many years of neglect. Though the decorative hand of the baroque Reformation added voluted capitals and frescoes of Habsburg crests, still a sense of the Hussite simplicity remains in the soaring whitewashed walls of the nave. The vaults in fact date from after 1679, when lightning destroyed the roof. In restorations, the ceiling was lowered and the formerly Gothic pointed clerestory windows and vaulting were replaced with more baroque-like barrel curves. The aisles have retained their Gothic arches.

Styles mix throughout the church. In the north aisle stands a 1493 stone canopy, carved with foliated tracery, finials, and the high-Gothic pointed arches that once adorned the tomb of the Hussite Bishop Mirandola by Mathias Rejsek. The choir chapel in the northern aisle has baroque altarpieces holding medieval art works: a 15th-century *Crucifixion* and a typical Bohemian *Madonna and Child* (c. 1400) with the Virgin's body and head gently inclined and a long-limbed Christ Child grasping his mother's belt. Karel Štréka's *Ascension of the Virgin* (1649) is found in the choir's main altarpiece, with a huge black and gold frame covered with gilded Bohemian saints and angels (note the winged Hermes-like angel on top). The red granite tombstone of Tycho Brahe stands upright on

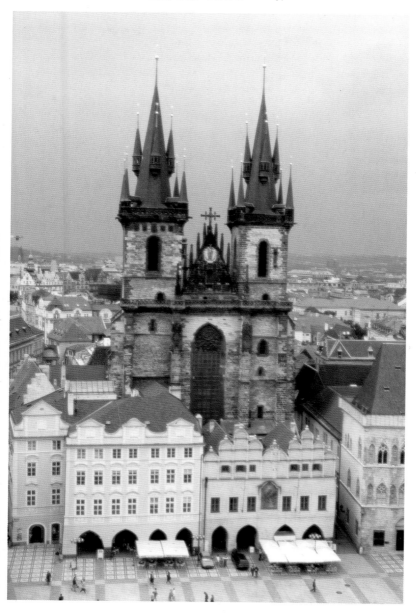

View of the Týn Church, begun c. 1360, Old Town Square

a pillar to the front of the south aisle and portrays Rudolf II's famed astronomer with a globe and his artificial nose, the real one having been cut off in a duel. In the south choir chapel are sedilia in the form of two crowned heads said to be Václav IV and his queen. In the south aisle is a remarkable sculpted wooden *Altarpiece of the Baptism of Christ* (1520). Contained within a classical architectural frame is a central scene of Christ's baptism by John the Baptist with angels and God watching from above. The wings contain scenes from the lives of Christ and John the Baptist. To the north (left) are the Annunciation and the Adoration of the Magi and to the south (right) are the Visitation (of the pregnant Virgin to her also pregnant cousin Elizabeth, the mother of John the Baptist) and the beheading of John the Baptist upon the request of Salomé. The base is decorated with the Nativity and the top has scenes of Christ healing a beggar and the Crucifixion. The background of most scenes is composed of precise architectural and natural detail with a good use of Renaissance perspective.

Returning to Old Town Square, to the south is a line of historic burgher houses. The **Štorch building** (no. 16/552) is a neo-Renaissance style 19th-century structure with frescoes, including an equestrian St. Wenceslas by Mikoláš Aleš. The exceptional Renaissance portal of At the Stone Lamb (U kamenného beránka, no. 17/551) is by the royal architect Benedict Ried's workshop. At the Golden Unicorn (U zlatého jednorožce, no. 20/548), once a music school founded by Smetana, has a Romanesque basement and late Gothic vaulting by Mathias Rejsek. The Old Town Hall is the next building of note.

Old Town Hall (Staroměstská radnice)

Location: Old Town Square 1
Opening hours: Town Hall: April–October, Mon 11 AM–6 PM, Tues–Sun 9 AM–6 PM; November–March, closes 5 PM.
Prague City Gallery (2nd floor): Tues to Sun 9 AM–6 PM

The Old Town Hall is an important medieval monument consisting of an agglomeration of several heavily restored

historic buildings. The Old Town received its charter in 1230 but not until 1338 did King John of Luxemburg give the burghers permission to build a Town Hall. With limited funds, they acquired an existing corner house, belonging to one Wolflin of Kámen. As the town prospered, additions were made, such as the tower in 1364 and a chapel with an east-facing oriel window in 1381. To the north of this building, a large block was built in the late 15th century and later rebuilt, only to be burned down by the Nazis in 1945. Only a fragment of its late-Gothic façade survives.

The Astronomical Clock, framed with late medieval sculptural detail, was added in 1410 although it only worked properly after adjustments in 1552–1560. The upper clock has three hands that indicate the passage of time as well as the position of the sun, moon, and planets according to medieval cosmology. To either side are allegorical figures reflecting the anxieties of the medieval mind: Death with his hourglass, Vanity with her mirror, Greed with a bag of money, and an Ottoman Turk, representing the empire that threatened central Europe at the time. Above, as the hour strikes and flocks of tourists gather below, an elaborate show of carved figures of the Apostles and Christ parade by (the original 17th-century figures were destroyed 1945 and replaced by copies). Other allegorical figures—Astronomy, History, Philosophy, and Religion—stand to the sides of the lower clock, which is a monthly calendar by Josef Mánes from 1865 (the original is now in the City of Prague Museum).

To the west of the clock is the Town Hall's main entrance, a beautifully ornate portal (1470–1480) by Mathias Rejsek. Further west is the former Kříž House, added to the Town Hall in 1360, with its elegant Renaissance window (1520) and Latin inscription *Praga caput regni* (Prague, capital of the kingdom). The adjoining property was acquired in 1458 and was remodeled in a neo-Renaissance style in 1878. The next building, with its Empire façade (1830) concealing a Romanesque structure, was added in 1835, and finally, in 1896, the Town Hall bought the adjoining house, At the Minute (Dům U Minuty). Yet another former residence of the Kafka family, it stands out for its lunette

which recalls Sant'Agnese in Rome, by that great papal architect, Borromini. Here, though, the proportions were elongated to fit the cramped space and the interior gives a vaguely uneasy impression of being squished. Centrally planned under a vaulted dome with a cupola on a tall, eight-sided tambour, the ceiling has fine frescoes of the lives of St. Nicholas and St. Benedict and stucco-work by Bernard Spinetti.

Along the north side of the square is a row of 19th-century neo-baroque buildings that were part of the 1895–1915 rebuilding of the Jewish Quarter (see page 77). In the northeast corner at the junction of Dlouhá Street is the former **Pauline Monastery** (Klášter paulánů, no. 7/930), a 1684 baroque structure by Giovanni Domenico Canevale. Next to it sits one of the city's finest rococo buildings, the **Goltz-Kinský Palace**, which is part of the Prague National Gallery's chain of museums and houses a permanent exhibit on landscape in Czech art.

Goltz-Kinský Palace (Palác Kinských)
Prague National Gallery (Národní galerie v Praze)

Location: Old Town Square 12
Contact details: www.ngprague.cz
Opening hours: Daily 10 AM–6 PM, closed Mondays

To build his palace, Count Johann Ernest Goltz hired the most important architect in late baroque Prague, Anselmo Lurago, who may or may not have used a design by his predecessor, the prolific K.I. Dientzenhofer. Built on the foundations of three earlier medieval buildings, the palace was constructed from 1755–1765. Count Goltz didn't have much time to enjoy his palace. Upon his death in 1768, Habsburg Prince Rudolf Kinský, whose family retained the house until 1949, purchased it.

The pleasant façade imparts a lively yet controlled effect. Elements of the high baroque (the rhythmic façade, mansard roof, and the roof parapet sculpted with allegorical figures of the elements and ancient gods by Ignác František Platzer) are mixed with a classicism (the triangular pediments and balcony-supporting columns) and rococo motifs (the stucco

cornice, volute gable and the beautiful sgraffito decorations of mythological and biblical scenes. Executed around 1611, the sgraffito images were restored in 1919 by artist Josef Čapek, brother of writer Karel.

The interior of the Town Hall can be visited on a guided tour, which includes the late Gothic Council Chamber, the 19th-century Assembly Room (with Václav Brožík's paintings, *Master Jan Hus before the Council at Constance* and *The Election of George of Poděbrady*), some of the post-1945 restored chambers and a trip up the tower for views over the city. The Prague City Gallery also presents exhibits on modern art on the second floor.

St. Nicholas Church (Kostel sv. Mikuláše)

Location: Old Town Square 24

Opening hours: Mon noon–4 PM, Tues to Sat 10 AM–4 PM, Sun for services.

From its prominent position on the Old Town Square today, it is hard to imagine the challenge of St. Nicholas' architect, K.I. Dientzenhofer, to construct a great church in a tiny space wedged between narrow streets off the square. Exposed by the destructive battles of 1945, St. Nicholas's white, twin-towered façade now adds an exuberant baroque element to northwestern end of the Old Town Square.

The first St. Nicholas was founded by German merchants in the late 13th century. It later became an Utraquist church until the Hussite defeat at White Mountain. In 1635 it was given to the Benedictine Order who, between 1732 and 1735, had it demolished and rebuilt by Dientzenhofer (who also built its sister church in Malá Strana, see page 115). The monastery was abolished in 1787 and since that time, St. Nicholas has been a concert hall, a Russian Orthodox Church (which explains its Russian crown-shaped chandelier given in 1860 by Czar Nicholas II), and finally, in 1920, it was given to the newly founded Czechoslovak (now Czech) Hussite Church.

As with most religious structures built after 1620, it was designed to be a potent affirmation of the Catholic faith. Sculptures of holy figures by Mathias Braun adorn the façade,

relief by court artist Carlo Giuseppe Bussi). Pink foliated tendrils fall from each pediment and window and stucco figures—from predatory satyrs to the Madonna and Child—dot the façade.

Built boldly jutting into the square, the designer nonetheless considered the overall unity of square and divided the façade with applied pilasters and twin pediments to better blend the palace's broad baroque face with the narrower, neighboring, multi-gabled structures.

Since 2004, the interior has been used by the National Gallery for an exhibit called "Landscape in Czech Art," which presents the development of the landscape genre in painting and graphic arts from the 17th to the 20th century in Bohemia. While the exhibit could do with a more coherent organization and labeling (it is in Czech and English), it nevertheless does shed light on a facet of Czech art and many artists who are little known outside of Czech circles, many undeservedly so. Look for works by several noteworthy painters such as Karel Škréta, the Hartmann family, Antonín Slavíček, Jakub Schikaneder, Jan Preisler, Josef Šíma, and Eva Kmentová. Next door is the House at the Stone Bell.

House at the Stone Bell (U kamenného zvonu)

Location: Old Town Square 13
Contact details: www.citygalleryprague.cz
Opening hours: Tues–Sun 10 AM–6 PM

Sandwiched between the Goltz-Kinský Palace and the Týn Church is the sole surviving component of the 14th-century royal palace of King John of Luxemburg and his queen, Elizabeth Přemyslid. Hidden under a baroque façade until the 1960s, after much scholarly debate, it was restored (completed in 1987) to roughly its state before the late 17th-century changes, which had removed sculptural decoration that was then used to block up the original windows. Some of these sculptures are displayed in the interior, which also retains some original polychrome and architectural detail. The building is now an exhibition space for the Prague City

Gallery, which presents temporary shows on modern art.

The Royal Route continues from Old Town Square west toward Charles Bridge along historic Karlova (Charles Street). Off the southwestern corner of Old Town Square is **Malé náměstí** (Small Square), which is centered on a fountain with a very rare wrought-iron grille dating to 1560. Originally painted in bright colors, this exceptional six-sided grille was commissioned by an unnamed city investor; probably, considering its quality, from a court artisan. The square dates back to the days of the Přemyslid kings and most of its houses have Romanesque foundations, including the 1890 neo-Renaissance **Rott Building** (no. 3/142) which was built as a hardware store for V.J. Rott and decorated with designs by Mikoláš Aleš. At the eastern side of the square, no. 10 dates from around 1600 and displays a few fragments of original sgraffito decoration. In the Middle Ages the square had at least two apothecaries, one of them at no. 11/459. A 19th-century neo-baroque pharmacy is preserved in the 18th-century **At the Golden Crown** (U zlaté koruny, no. 13).

Follow the crowds westward toward the pedestrian-only Karlova Street, a narrow winding street lined with picturesquely askew houses. Somewhat marred by its own popularity, this cobblestone lane is often crowded and the tourist shops stuffed into its medieval houses have become gaudier, louder, and harder to ignore. Nevertheless, this impressive, architecturally significant route is worth the effort. At the junction of Karlova and Husova is the **Czech Museum of Fine Arts** (České muzeum výtvarných umění, open Tuesday to Sunday from 10 AM to 6 PM). It presents excellent temporary exhibits on Czech and international 20th-century and contemporary art in three historic houses dating to the Romanesque period. The exhibits are often drawn from the museum's extensive collections (begun in 1963), which include painting, sculpture, and graphic works from the beginnings of Czech modernism, the surrealist period, the Czech Art Informel and geometric abstraction. Recent acquisitions have focused on post-1960 art. Part of the museum is housed behind the elegant 18th-century façade on Karlova but the principal entrance is found in the step-

gabled, Renaissance façade on Husova Street, which leads into an airy, modern exhibition space. Galleries downstairs offer a rare opportunity to visit an original Romanesque cellar as well as to see the unusual sight of contemporary art displayed beneath 12th-century limestone vaulting.

Just to the north of the Czech Museum of Fine Arts is the **Clam-Gallas Palace** (Clam-Gallasovský palác, Husova Street 20/158). The great Viennese architect Bernhard Fischer von Erlach built one of the grandest residences in the Old Town, the Clam-Gallas Palace, for Johann Wenzel, Count Gallas, between 1713 and 1719. The site had formerly held the Gothic residence of Charles IV's brother and was later rebuilt by the Kinskýs in the 16th century. After Wilhelm Kinský was murdered along with the treasonous General Wallenstein (see pages 116–117) in 1634, the emperor gave the palace to the Gallas family. Count Gallas was an important imperial diplomat and his choice of architect reflected the Gallas family's strong ties to the Vienna-based Habsburg emperors and a clear desire to advertise this status.

Von Erlach himself thought so highly of the palace he created for Gallas that he included it in his compendium of the world's great architecture. The main façade, now hemmed in on narrow Husova, is highly classical with a large central pediment and simple windows and walls. It is the decorative sculpture by Mathias Braun, Prague's leading sculptor, which animates the façade and gives it its baroque dynamism, particularly evident in two pairs of Herculean figures sinking under the weight of twin porticos. The interior, one of the city's finest, was completed in the 1720s and includes graceful frescoes by Carlo Carlone, stuccowork by Santin Bossi, and vases and lampposts by Braun. For generations the palace was one of the city's most glamorous venues and one can easily imagine perfumed ladies and elegant gentlemen gathering with Beethoven (who performed here) playing in the background.

Since 1945 the palace has been part of the **City Gallery of Prague**, which holds interesting temporary exhibitions on history and art in galleries on the first floor at the top of the palace's magnificent main staircase.

Those with an interest in early 20th-century Czech art and architecture can make a brief detour to Marian Square (Mariánské náměstí) by following north along Husova. Here stands the hulking art nouveau **New Town Hall** (Novoměstská radnice) built in 1908–1911 by Osvald Polívka (who also worked on the Municipal House). The statuary around the portal is by Stanislav Sucharda and Josef Mařatka, however the most striking sculptures are those found in the corner niches by Ladislav Šaloun; to the left is the *Iron Man*; and to the right *Rabbi Löw* (1910), the great 16th-century Talmudic scholar who, legend says, created the Golem. An elderly Löw is portrayed as he meets Death in the form of a rose-offering maiden. The neighboring **Municipal Library** (Městská knihovna), a sober example of interwar neo-classicism with art-deco interiors, was built by František Roth in 1926–1930. The massive Clementinum complex (see below) takes up the west side of the square. Follow the walls of the complex along Seminářská Street back to Karlova.

At the junction of these streets sits the **House at the Golden Well** (U zlaté studně, Karlova 3/175). This former burgher's home has Romanesque cellars and a mostly late Renaissance structure but it is its superb baroque sculpture and stucco reliefs that catch the eye. In the center is the Virgin and Child being crowned by two cherubs in a baroque starburst flanked by the Bohemian patron saints, Wenceslas and John of Nepomuk. Other figures are saints evoked against the plague: below is a partially nude St. Sebastian and St. Roch as a pilgrim showing his leg marked by the plague; above is St. Ignatius of Loyola and St. Charles Borromeo, Counter Reformation figures known for caring for the sick. In a fine example of middle-class art patronage, Burgher Johann Wersser commissioned the saintly ensemble in 1701 from sculptor Ulrich Mayer, as pious thanks for saving the city from the plague.

The northern side of Karlova is taken up by the largest building complex in Prague after the castle, the former Jesuit College of the Clementinum.

Clementinum (Klementinum)

Location: The block bordered by Karlova, Křížovnická, Platnéřská, and Seminářská Streets.

Opening hours: Churches open for services. Guided tour of interior offered daily on the hour from 2 PM–7 PM. Czech National Library (Národní knihovna), open Mon–Fri 8 AM–10 PM; Sat 8 AM–7 PM

Covering two hectares, the Clementinum's walled enclosure holds two churches, three chapels, an observatory, courtyards and a collection of residential and service buildings, several of which are today part of Charles University and the Czech National Library (Národní knihovna).

The story of the Clementinum began with an invitation in 1556 from Emperor Ferdinand I to the Jesuit Order to come to Prague to re-Catholicize the rebellious, predominantly Protestant population. The Jesuits took over the former Dominican monastery of St. Clement, which they rebuilt and expanded in stages. At first met with disdain, even abuse, they came into their own after the crushing Protestant defeat at the Battle of White Mountain in 1620. This military victory was followed by an intellectual conquest when in 1622 the Jesuits were put in charge of the Utraquist-inclined Charles University (Carolinium). Soon after, the Jesuits, now in control of all noble education in Prague, began a massive building campaign employing the best architects and artists of the day and involving the demolition of over 30 houses. The Clementinum evolved into a large, fortress-like complex, symbolically reflecting its role as a Counter Reformation bastion. The Jesuit's heyday was not long, though, and in 1773 Emperor Joseph II, as part of his religious reforms, expelled the Jesuits from Habsburg territory. The Clementinum continued as an academic institute and developed into an important library, today holding numerous precious medieval manuscripts, including the Vyšehrad Codex of 1085.

Several of the Clementinum's religious structures are accessible, albeit usually only for services. The entrance to the church of **St. Clement** (Sv. Kliment) and the adjacent **Italian Chapel** (Vlašská kaple), is along Karlova, where the street curves along the rounded exterior of the Italian Chapel.

One of the first baroque structures in Prague and the earliest example of an elliptical plan in central Europe, the domed Italian Chapel was begun in 1590 by Ottaviano Mascharino (the interior was remodeled in 1714). As its name suggests, it served Prague's sizeable Italian community of merchants and nobles serving the royal court.

The Italian Chapel is found at the western end of the Church of St. Clement, which dates back to the 13th century and was rebuilt in 1711–1715 by Francesco Lurago according to plans by František Kaňka and Christoph Dientzenhofer. With classic baroque extravagance, the interior is ornately decorated with scenes of the life of St. Clement and a fantastic trompe-l'oeil altarpiece, both by Johann Hiebel. Lively, emotive statues of holy figures by Mathias Braun and his workshop adorn the church's piers.

Continue west along Karlova past the high baroque Colloredo-Mansfeld Palace (no. 2/189), begun in 1700 by Giovanni Battista Allprandi. At the end of Karlova facing the Knights of the Cross Square (Křížovnické náměstí) and Charles' Bridge is the Clementinum's **Church of the Holy Savior** (Sv. Salvator). Begun in 1578 but not completed until 1714, several eminent architects contributed to church's design including Carlo Lurago, Francesco Caratti, and František Kaňka. The façade was inspired by the Jesuit's mother church, Il Gesù (1568–1575) in Rome but with the additions of a tripartite portico (1653–1659) by Caratti, and statuary (1659) by Johann Georg Bendl. Facing Charles Bridge and the castle, the façade, filled with Catholic imagery, formed a symbolic entrance into the former Protestant stronghold of the Old Town. More statues by Bendl and a ceiling painting, the *Four Continents* (1748) embellish the ornate interior.

Contiguous with the church along busy Křížovnická Street is the Clementinum complex's grandest façade, designed by Carlo Lurago in 1653. Lined with colossal pilasters and stucco medallions of Roman emperors, it was criticized by the head of the Jesuit Order for its extravagance.

The Clementinum courtyards can be entered through portals on Karlova, Mariánské náměstí or Křížovnická. The only way

to see the buildings' interiors—other than as an authorized library user—is on a guided tour. This takes in the 18th-century **Observatory Tower** (Astronomická Věž) and the sumptuous baroque **Library Hall** (Barokní Sál, 1727) by František Kaňka. The 1725 **Chapel of Mirrors** (Zrcadlová kaple) designed by K.I. Dientzenhofer is only accessible for concerts.

Back on Křížovnické náměstí, to the north of Charles Bridge sits the Church of St. Francis (Sv. František) and the adjacent former monastery of the Knights of the Cross with the Red Star.

Church of St. Francis (Kostel sv. František)

Location: Křížovnické náměstí (Knights of the Cross Square)
Opening hours: Open for services and concerts

The monastery was named for the hospice brotherhood, founded by Agnes of Bohemia, which was entrusted with the protection of Judith Bridge, the predecessor of Charles Bridge. In 1252 they founded a church and monastery beside the Bridge and these same foundations still support the present buildings, which were rebuilt between 1675 and 1685. The baroque renovations were carried out under the auspices of the Archbishop of Prague—who also happened to be the Grand Master of the Knights of the Cross—for which he employed his court architect, Frenchman Jean-Baptiste Mathey, to redesign the church of St. Francis.

The church's cut-stone façade is articulated with classically inspired applied pilasters and a pediment, while baroque movement is felt in the concave indented wings and the cupola that was the first of many that would dot the city skyline. Mathey created a centralized plan in the form of a Greek Cross with a long oval dome, which is based, as much in Counter Reformation Prague, on Roman models. The building is remarkable for the fact that it is the first church in Prague to display a full understanding of the baroque sense of space and mass. The warm coffee-colored interior, which has an unusual north–south orientation due to the constraints of the space, is perfectly balanced. The astonishing dome fresco

of the Last Judgment (1722–1723) by V.V. Reiner is a swirling mass of angles, saints, and sinners and the central space is ringed with dark marble altars adorned with gilded starbursts and cherubims. Note the glass reliquary coffin in the west chapel with slumping skeletal figures crowned and clothed in crumbling 18th-century finery, a concept brought to Prague through the Spanish branch of the Habsburg rulers.

Just outside the church, picturesquely framed against the panorama of the Vltava and Prague Castle, is a **Memorial to Charles IV** erected in 1848 on the 500th anniversary of the foundation of Charles University. To continue on the Royal Route across Charles Bridge see Trail 2: The Little Quarter, Malá Strana (page 106).

SOUTHERN OLD TOWN

This section of the Old Town attracts fewer tourists than the Royal Route and offers a chance to wander along relatively quiet streets layered, as so much of Prague is, with architectural history. Urban history—if lucky enough to escape the ravages of the 20th century—is often found in architectural styles and building techniques that reflect centuries of political and social change. Many often lesser-known buildings along this route tell of Bohemia's past, offering glimpses in stone of varied epochs: from prosperous imperial capital to radical Hussite state to communist nation.

From the Knights of the Cross Square (Křížovnické náměstí), head south along the Smetana Embankment (Smetanovo nábřeží)—taking a moment to let your jaw drop at the breath-taking panorama of the city and the castle—and turn left onto the second small street, Na Zábradlí, leading to Anenské náměstí.

To the right on the square at no. 4 is the rococo palace (c. 1765) of music patron Count Hubert Karel Pachta, whose guests included Mozart. Directly ahead is the plain 17th-century façade of the former **Convent of St. Anne** (Klášter sv. Anny), which today houses the rehearsal rooms for the National Theater. The monastery originally belonged to the Order of Knights

Templar, who were forcibly disbanded on October 13, 1307 by Pope Clement V. Six years later the buildings were taken over by an order of Dominican nuns under the auspices of King John of Luxemburg, whose royal insignia, the Bohemian lion, still graces a boss in the convent's church vaulting. The high, narrow single-nave church, found inside the convent walls (at the time of writing the church was closed for restoration, but the exterior can be seen from Liliová Street), was built by the nuns in the mid-14th-century on the site of a Romanesque rotunda. Its form was unique in the era and greatly influenced the architecture of other women's religious orders. The same church was later filled with the music of Christoph Willibald Gluck, who played the organ here in the early 18th century. The convent was abolished in 1782, after which the monastic buildings served various functions, such as a warehouse and a lithographic studio.

Continue along Anenská, crossing Liliová Street onto Řetězová to view a remarkable example of Romanesque domestic architecture.

House of the Lords of Kunštát and Poděbrady (Dům pánů z Kunštátu a Poděbrad)

Location: Řetězová 3/222
Opening hours: Daily 9 AM–11 PM (closed in winter)

Romanesque stone houses were built by prosperous merchants along several streets of the Old Town—Celetná, Karlova, Husova, Jilská, and around Old Town Square. Their ground floors were often partly below ground (and used for crafts or trade while the family lived above) and have often survived as the cellars of Gothic houses, which were built higher as part of later 13th-century flood-protection measures. Such is the case here. The ground floor, which in summer houses a gallery, was originally the first floor of a late-12th-century noble house complex rebuilt in the Gothic period. Downstairs, the Romanesque ground floor has survived with groin vaults supported by huge pillars, little changed since about 1200. In fact the entire two-story oblong structure dates from the same period, although later

reconstructions have altered its appearance. A famous occupant was Hussite leader George of Poděbrady who owned the house in the 15th century. Interestingly, Romanesque survivals such as this house were not discovered until the late 19th-century rebuilding in the Old Town and have only been excavated since the 1960s, revealing about 70 extant Romanesque structures.

Return to Liliová Street and turn left toward Bethlehem Square (Betlémské náměstí). Entering the square, before you is the **Náprstek Museum of Asian, African and American Cultures** (open Tuesday to Sunday 9 AM to 5:30 PM). This rambling museum displays the eclectic ethnographic collections of Vojta Náprstek (1826–1894). An industrialist and leading figure of Prague's intelligentsia, he was also an anthropology enthusiast and active collector of exotic objects from around the world. The museum also has interesting temporary exhibits on everything from ancient Egypt to Mexican coinage to Inuit art.

Turn right after the museum along Betlémské Street to Karolíny Světlé, a street that marks the line of the now disappeared medieval walls. Turn left to the tiny **Holy Cross Rotunda**.

Holy Cross Rotunda (Rotunda sv. Kříže)

Location: Corner of Karolíny Světlé and Konviktská

Opening hours: For services only: Sun 5 PM; Tues 6 PM; first Monday of month 7 PM

One of Prague's oldest buildings, the Rotunda was built as the private church of a noble court in the early 12th-century. Its cylindrical nave, built of clay slate blocks, is topped by a lantern and has a shallow apse. Ceramic vessels were discovered hidden in the walls, which was a common Romanesque technique to improve acoustics. Altered through the centuries, from 1863–1876 the Rotunda was stripped of its exterior plaster and baroque additions and extensively restored to what was considered at the time its "pure" medieval Czech condition (i.e. to its condition pre-Habsburg and Catholic control). Josef Mánes designed a neo-Romanesque ironwork fence to encircle the refurbished structure and also recorded the Rotunda's dilapidated appearance before restoration. The simple interior,

which was once again restored in the 1970s, has fragments of 14th-century frescoes, including a scene of the coronation of the Virgin.

Return to Betlémské náměstí via Konviktská. (K.I. Dientzenhofer fans may want to detour one street over to Bartolomějská to visit his recently restored, 1726–1731 Jesuit **Church of St. Bartholomew**, which is only open for services).

Bethlehem Chapel (Betlémská kaple)

Location: Betlémské náměstí
Opening hours: Tues–Sun 10 AM–6:30 PM

The twin gables of the Bethlehem Chapel, reconstructed in 1950–1952, dominate the north side of the square. A relatively soulless reconstruction, the chapel's interest lies in its fascinating political history. The original Bethlehem Chapel was built in 1394 by followers of reformist preacher Jan Milíč of Kroměříž as a place where mass would be given in Czech. University master and priest Jan Hus began to preach here in 1402. Hus, a farmer's son who had risen to such heights as to be the personal confessor to King Wenceslas IV's queen, was a charismatic speaker and had a large following among the Czech-speaking citizens of Prague. (The German speakers, many of whom did not agree with his reforms and had suffered as a result of Hus's pro-Czech changes at Charles University, were less enthusiastic.) His growing criticism of church corruption—inspired by the English reformer John Wycliffe—drew large crowds to the chapel and led to his exile from Prague in 1413. Before his departure, Hus had his assertions written (with illustrations) on the chapel walls, physically linking the chapel with his reforms. Hus was called to Constance in 1415 to answer accusations of heresy and was burned at the stake, but the chapel remained a political and spiritual center of the Hussite Utraquist movement for the next two centuries.

In the inevitable ironic turns of history, the bitterest foes of the Reformation, the Jesuits, took over the chapel after the Battle of White Mountain. After their expulsion from Prague in 1773, the chapel was destroyed and replaced with

a private residence. In the 19th century, the growing sense of Czech nationalism led to a desire to rebuild the chapel. A reconstruction plan, however, only took form in 1949 under the new communist government. The government wanted to create a monument to the Hussites, who, according to Klement Gottwald, had been "fighting for communism" 500 years ago. Popular dissident opinion during the communist period considered the chapel a bit of a sham; novelist Josef Škvorecký (1924–) in his novel *The Miracle Game* (1972) suggests that it was "reconstructed—mainly to attract tourists... "

The present building reflects the original irregular Gothic plan from its tent-like roof (copied from a 1606 Sadeler drawing) to its spacious, hall church interior. It is one big trapezoidal space, reflecting the egalitarian Utraquist view of the preacher as among, rather than apart from, the people. Topped by a wooden roof, three of the walls (with the help of reinforced concrete piers) support the remnants of Gothic walls that were discovered to have been used in the 18th-century residence. The façade facing the square is new. The east side has an attached building that would have been the sacristy (now a ticket office) and upstairs lodgings for a preacher (now a small exhibit on Hus and his followers).

Turn left out of the chapel's gate and look up. Hanging above Husova Street is, yes, the father of communism, Lenin, nonchalantly clinging to a metal beam. Entitled *Hanging Out* (1996), this witty artwork is by "situationist artist" **David Černý** (1967–), whose cleverly subversive installations dot the city. Now exhibited internationally, Černý first achieved notoriety in 1991 when he painted the Soviet Memorial Tank (which formerly stood in náměstí Kinských in Smíchov) a babe-in-arms pink, humanizing a controversial symbol. The Soviet embassy didn't see it that way, however, and Černý was arrested. Protests followed; the tank was repainted (by politicians using their political immunity), and Černý was released to create again.

His works around Prague include: *Quo Vadis?*, a gilded Trabant car on four legs now in the German Embassy compound (see Malá Strana page 133); an upside down version of the St. Wenceslas statue from the eponymous square (now hanging in

the Lucerna Palace, see page 200); and ten giant babies clinging to the Žižkov TV tower. His sometimes outrageous projects (one recent concept was a giant gilded nude entitled *Do it Yourself* (2003), which was to sit atop the National Theater and sporadically emit a stream from its... um, nozzle) still create controversy. See www.davidcerny.cz for his latest projects.

Turn left on Husova Street and right on tiny Zlatá Street past the towering 14th-century **Church of St. Giles** (sv. Jiljí), its soaring towers typical of the period, when height was a matter of competition between churches. Remodeled in 1733, the interior has ceiling paintings by V.V. Reiner. From Zlatá, turn right on Jilská, then left on Vejvodova. On the corner is U Vejvodů (no. 4/353), a middle-class Renaissance house, dating from 1403. Turn right on Michalská and continue through Uhelný trh (the former coal market) until you arrive at St. Martin's in the Wall.

St. Martin's in the Wall (sv. Martina ve zdi)

Location: Martinská Street

Opening hours: For services and concerts only

The patchwork appearance of this small church reflects its equally mish-mash history. Founded around 1180 in the southern outskirts of Prague, it began as a single-aisle church with a semi-circular apse and a western tower. In the 1230s, its west wall was incorporated into the (then new) Old Town walls (hence the descriptive "in the wall"). Around the mid-14th century a more spacious square presbytery replaced the apse and a south side tower was built. Aisles were added only in the 15th century. From 1414 it was a principal Hussite church until it was forcibly returned to the Catholic faith in 1621. Deconsecrated in 1784, it was converted into residential housing. Astonishingly, much of the original structure survived and in 1905–1906 it was converted back into a church. Rarely used during the communist period, it was restored again post-1989 and is now part of the Evangelical Church of Czech Brotherhood (Českobratrská církev evangelická).

As you walk around the exterior there are a number of features to note: walls of medieval rubble masonry with deep tracery windows; the north entrance with a baroque image of St. Martin as he divides his cloak; and the art nouveau metal door and gate at the west entrance. There are also stone figures clinging to the choir buttresses: a wild man covered in fur, making a face at onlookers, and a cawing bird. These playful, grotesque figures are often found on medieval churches and may be characters from Christian fables, moral tales, or simply intended to amuse—their original purpose continues to be debated. The charmingly crooked interior is simple with whitewashed walls exposing fragments of Romanesque ashlar walls and Gothic stone rib vaults.

Return to Uhelný trh and turn right on Havelská, an open-air market lined with historic structures such as **U Bruncvícka** (no. 5/510) which dates back to the 14th-century and has a Gothic archway with ribbing and bosses. Further along is the former Carmelite **Church of St. Gall** (sv. Havla), dating to the 14th century but later engulfed in baroque refurbishments. In 1671 Giovanni Domenico Orsi added the façade towers and neighboring monastic buildings, but it was in 1704 that a radical reconstruction was undertaken by Pavel Ignác Bayer (who was buried in the church), including its dynamic façade with undulating movement. The interior has woodcarving by F.M. Brokoff and the main altar is by J.K. Liška.

Northeast of St. Gall on the former Fruit Market (Ovocný trh) is the **Estates Theater** (Stavovské divadlo). Art patron Count František Antonín Nostitz commissioned court architect Antonín Haffenecker to construct a permanent theater here in 1781–1783. Haffenecker based the elegant neo-classical structure on the Berlin Opera and, quite appropriately, the theater held the first performance of Mozart's *Don Giovanni*, conducted by the composer himself, in 1787 and was later used as a setting for Miloš Forman's film *Amadeus*. Originally called the Nostitz Theater, it is now known by the name it received in 1799 when taken over by the Czech Estates.

Next door stands the **Carolinum** (Železná 9), part of the original buildings of Charles University, the oldest university in central Europe (1348). The building today is a composite of several rebuildings, including an extensive baroque re-do by František Kaňka in 1718 of the then Jesuit-run university. However, the medieval structure can still be seen in some architectural detail on the ground floors and in the superb oriel window (facing Ovocný trh).

Continue northwest on Železná and turn left onto tiny Kožná Street. Follow the serpentine lane to **At the Two Bears** (U dvou medvědů), no. 1/475, found at the intersection with Melantrichova Street. A Renaissance burgher's house built by wealthy printer Jan Kosořský of Kosoř after 1564, it has a wonderfully carved portal, after which the house is named.

There are also several remarkable structures along Melantrichova. Considered one of the most beautiful mannerist buildings in central Europe, the **House at the Five Crowns** (no. 11/465) has a monumental gable and its original wooden door carved with the date of the building, 1615. Close by, the narrow baroque façade of no. 13/464 was once home to Bohemian composer Josef Mysliveček (1737–1781). Lastly, step into the enclosure of no. 15/463 to view an archetypal arcaded courtyard of a Renaissance burgher house.

Return along Melantrichova to the Old Town Square to begin the tour of the Jewish Quarter and St. Agnes Convent.

JOSEFOV

To the north of Old Town Square lies Josefov, the historic Jewish Quarter. The area dates back to the Romanesque period but its present appearance is the result of late 19th/early 20th-century rebuilding.

Built, along with the entire quarter, between 1895 and 1915, this elegant Haussman-like street was part of an urban renewal plan that demolished the picturesque but decaying medieval Jewish Quarter. From 1781 (the date of the Edict

of Toleration issued by Joseph II, after whom the quarter is named), Jews were not required to live in the Jewish Ghetto and over time many residents moved to other parts of the city and growing suburbs. The area deteriorated and by the mid-19th century was a densely populated, disease-ridden slum with the highest death rate in the city. Talk began in the 1870s about rebuilding the area. A design competition was held in 1886 and clearance began in 1893. Six hundred and two houses were demolished and the only things left standing were eight churches, five synagogues, the Jewish Town Hall, and the Old Jewish Cemetery, all of which were accommodated in the new layout. Pařížská was one of the principal boulevards created, cutting a straight line through the former winding lanes of the quarter.

The rebuilding was subsequently called "garish" and "characterless" and condemned for its destruction of a historic area, criticisms that were also made about Paris, Berlin, and other cities that destroyed even larger historic areas in the 19th century. Today the patina of a century has begun to mellow the tall, ornate apartment buildings lining the streets and decorated in a variety of neo-historic (Gothic, Renaissance, baroque, Romantic) and art nouveau-inspired styles. And, perhaps in comparison to some of the soul-numbing architecture of the latter 20th century, Josefov's sometimes overdone, bourgeois prettiness doesn't seem so bad anymore.

Looking north along Pařížská, one sees in the distance atop a hill across the Vltava a giant red metronome (1991) by neo-Constructivist artist Vratislav Karel Novák (1942–). The surreal tick-tocking needle stands on the spot where a massive social-realist statue of Stalin once briefly lorded over the city. Czech sculptor Otakar Švec won a 1953 design competition to have the dubious honor of designing the 98 ft/30 m colossus, which took six hundred men 500 days to erect. To avoid the impropriety of having spectators looking up at Stalin's backside, the artist added a line of Czech and Soviet workers behind the chairman (giving the statue its loaded nickname, "the meat queue"). The statue was barely upright and the artist

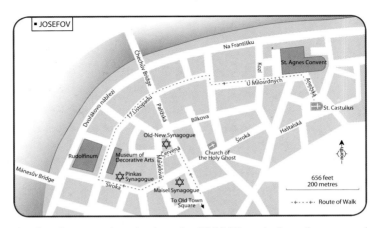

dead at his own hand when in 1956 Khrushchev denounced Stalin. The embarrassed Czech communists covered the statue in scaffolding while trying to figure out how to demolish the disgraced leader. It was finally blown up by a series of small detonations in 1962, but the absurdity of the story still echoes in Czech literature and art.

Off of Pařížská are several of the historic Jewish buildings saved from destruction, the most architecturally and historically significant being the intriguingly named Old-New Synagogue.

Old-New Synagogue (Staronová synagoga)

Location: Corner of Pařížská and Červená

Opening hours: Sun–Thur 9:30 AM–6 PM; Fri. 9:30 AM–5 PM

Once blending inconspicuously into crowded medieval streets, the brick gables of the Old-New Synagogue now stand out distinctly on Pařížská. Besides being one of Prague's most outstanding early medieval buildings, it is also the oldest functioning synagogue in Europe, dating back to the 13th century, and was originally called the "New Synagogue" until a newer synagogue was built nearby. It was a sanctuary and a school as well as a place where public affairs were discussed until the Jewish Town Hall was built in the 16th century.

The entrance is through a narrow vestibule that, before the building of the main hall (after 1270), functioned as a diminutive meeting hall (it later became the women's gallery). A portal with an exquisitely carved tympanum of a grapevine with twelve bunches, symbolizing the twelve tribes of Israel, leads into the present main hall. (In early 2004 this wonderful tympanum simply crumbled overnight, most likely because of latent dampness from the 2002 floods. It has since been restored.)

The main hall is one of central Europe's outstanding examples of Cistercian Gothic architecture. The vaulted double-nave hall is similar to contemporary double hall churches (often found in contemporary convents) and was probably constructed by Christian builders. Today lit by a brass chandelier and sconces, its lovely clean lines and minimal décor—mostly non-figural sculpture and frescoes, of which traces are still visible on the walls—reflect the simplicity of Cistercian style and its religious function as a synagogue. The most sacred place of the building is the niche in the middle of the east wall, which holds the Torah and is decorated with delicate 13th-century carving. Such important scholars as Rabbi Löw once spoke from the pulpit, or bema, which stands in the middle of the hall surround by a beautiful Gothic grille. Above hangs a banner given to the Jewish community by Ferdinand I in thanks for helping fight off the Swedish siege of 1648. As with so many of Prague's Gothic treasures, the synagogue was restored by Josef Mocker in 1880–1885.

Also of architectural interest is the **Pinkas Synagogue** (Pinkasova Synagoga, Široká 3/23), a short walk away. It was founded in 1479 and remodeled between 1607–1625 by one Juda Coref de Herzis, who is also believed to have built the nearby Maisel Synagogue (c. 1590, redone between 1893 and 1905). The Pinkas was originally a medieval private prayer room in the house of the influential Horovice family that was expanded into a synagogue during the time of the religiously tolerant Emperor Rudolf II, a golden time for Prague's Jewish community. The style reflects the mannerist fashion popular at the royal court, which can be seen in the synagogue's

many double stone windows, whose arches penetrate the entablature, playfully breaking the rules of classical order.

Just around the corner from the Pinkas Synagogue sits one of Prague's often overlooked gems, the Museum of Decorative Arts.

Museum of Decorative Arts
(Uměleckoprůmyslové muzeum)

Location: 17 Listopadu 2
Contact details: www.upm.cz
Opening hours: Tues–Sun 10 AM–6 PM

Whether your interest lies in art nouveau furniture, baroque jewelry, or medieval textiles, this museum has something for you. It offers a fascinating collection of exceptional items from everyday life (which is, after all, what decorative arts are) from the Middle Ages to the 20th century, focusing on Bohemia and Moravia. Decorative arts, long overlooked by art history in preference to paintings or sculpture, are often small masterpieces that not only impress with their craftsmanship and artistry but reveal much about the time in which they were made. The museum has 250,000 objects, but the exhibition (labeled in Czech and English) is an approachable size: just five rooms, each filled with fascinating tidbits of life over a thousand years.

The idea for a museum displaying objects of fine craftsmanship, applied arts, and design arose in the 1880s as part of a more global reaction to the industrial revolution and the move from handicraft to often lower-quality machine-made goods. The museum building was custom built between 1897–1900 in a neo-Renaissance design by Josef Schulz. Because he only had a narrow strip of land before the Jewish Cemetery to work with, Schulz created a wide but shallow building with lofty interiors that are lavishly ornamented in a neo-Venetian Renaissance style designed to convince the visitor of the important link between art and craft. On the façade, reliefs by Bohuslav Schnirch and Antonín Popp represent different branches of decorative arts

in Bohemia and the coats of arms of towns most renowned for these arts.

Excellent temporary exhibits are presented on the first floor. The permanent exhibit, found on the second floor, is called rather matter-of-factly the "Stories of Materials," while the names of individual halls or galleries are meant to reflect the nature of the objects exhibited.

Votive Hall

The décor of this prettily painted entrance hall (1898) is devoted to the history and founders of the museum. In the central display case is the remarkable Karlštejn Treasure. Two 19th-century builders discovered 387 pieces of precious costume ornaments, clasps, and buttons, most probably from the Luxemburg court (14th century), in the walls of Karlštejn Castle. The men sold all for profit, and only after many years and many owners was the treasure given to the museum. The treasure contains an interesting array of objects, from a lavish jewel-encrusted brooch to more utilitarian pieces such as gilded buttons or buckles. Surrounding cabinets display the ceramic collection of Hugo Vavrečka (1880–1952), a prominent cultural figure in the first half of the 20th century and grandfather of Václav Havel. It includes exceptional examples of central European glass and faience from the 16th to 19th centuries. Along with examples by prominent manufactures of faience such as Habaner (1590–1730) and Holtich (1743–1827), there are eye-catching examples of folk pottery.

The Story of Fiber

If you've ever wanted to see 17th-century Bohemian bed linens, medieval velvet, or a 1920s flapper's dress, this is the room. Devoted to textiles and costume, the hall—hung with tapestries dating from the 16th century—presents a fascinating collection of women's fashion from the 18th century to the later 20th century and multiple-drawered cabinets that pull out to reveal textiles dating back to the 5th century. There are also some wonderful antiques, such as a 1465 Italian wedding chest with portrait medallions, most likely of the bride and groom.

Born into Fire

This long hall presents an eclectic collection of ceramics and glass, mostly everyday objects that give a glimpse into the daily life of their users. The large central case shows the metamorphosis of styles from Roman times to 2000, with amazing pieces, from a 1st-century glass bowl to an 18th-century asparagus-shaped butter dish. On display are some rare examples of Bohemian 16th- and 17th-century glass, many painted with delicate scenes of drinking, dancing, and riding, as well as chinoiserie decorations reflecting the 18th-century fashion for all things oriental. Look out for intriguing objects such as: a tankard depicting an allegory of Africa (c. 1760) with a peculiar-looking African riding a horse-like elephant, suggesting the Bohemian-maker had never seen either; a 16th-century Italian majolica birthing bowl with childbirth scenes; and striking examples of cubist ceramics.

Print and Image

This hall is a treasure trove of graphic arts and photography. There is a display of early Czech photography, including work by Josef Sudek (1896–1976), and a wonderful collection of advertising posters from about 1900 onward; look for the dramatic art nouveau poster for a 1902 Rodin Show. In between examples of design furniture, such as a cubist desk by Gočár, are cabinets filled with astounding examples of graphic design by artists such as Alfons Mucha, Jan Preisler, Josef Váchal, Karel Teige, and Toyen, as well as examples of early books and prints dating from the 13th century. You just never know what you'll find opening the long, thin drawers: anything from Teige's surrealist collages to a 13th-century illuminated manuscript. Keep an eye out for a 1598 print of Prague hanging above the 16th-century book cabinet, and note the former appearance of Prague Castle with baroque spires and a much-reduced St. Vitus.

Treasury

The Treasury, very appropriately, houses objects fashioned from precious and common metals and other materials, such

as ivory: look for an amusing ivory carving of old woman with the mask of pretty young girl (1770–1780). There are tons of silver and gold church items, as well as interesting revolving display cases of pewter and bronze from the 16th to the 20th century. However, the most fascinating display has to be the jewelry from the 15th to the 20th century. There are Renaissance rings and Napoleonic portrait pendants, as well as an interesting collection of medieval French pilgrimage badges, the souvenirs collected by Christian pilgrims at holy shrines that were then worn on clothes as evidence of the bearer's travels.

A new gallery entitled Time Machines—a collection of clocks—is presently in the works.

Directly across from the museum is the **Rudolfinum**. Josef Schulz and Josef Zítek built the neo-Renaissance structure between 1874–1885 as an art gallery and concert hall, although from 1918 to 1939 it served as the Czechoslovak parliament. Today it has returned to its original purpose as a music venue and the well-respected art gallery **Galerie Rudolfinum** (www.galerierudolfinum.cz, open Tuesday–Sunday between 10 AM and 6 PM), which is known for its first-rate exhibits of modern and contemporary Czech and international artists.

Make your way east to one of the best museums in the city, the National Gallery's medieval art collection in the historic Convent of St. Agnes.

Convent of St. Agnes (Klášter sv. Anežky České) and the National Gallery's Museum of Medieval Art

Location: U Milosrdných 17. Entrance near the intersection with Anežská
Contact details: www.ngprague.cz
Opening hours: National Gallery open daily 10 AM–6 PM, except Mondays. Convent churches closed at time of writing for restoration.

One of the finest and first examples of Gothic architecture in Bohemia, the St. Agnes Convent was founded in 1233 by Princess Agnes (Anežka, 1211–1292) and her brother King

Wenceslas I, as the first convent of the Order of Poor Clares (the female version of the Franciscans) north of the Alps.

Daughter of Otakar I, Agnes of Bohemia was born in 1211 and, like most royal daughters, was immediately entered into the dynastic marriage market. However, a succession of suitors, including Emperor Frederick II, were unsuccessful and at 23 she devoted herself to religious life, becoming Abbess of the Convent of Poor Clares. Although Agnes herself was noted for her deep commitment to the Franciscan ideal of poverty and abstemious lifestyle—she is said to have eaten only raw onions and fruit—she was nonetheless deeply involved in international affairs, keeping up a polemic correspondence with the pope for 20 years about the future of the church. She was also immersed in her family's dynastic politics and oriented her convent to the glory of the Přemyslids. She launched an ambitious building campaign to create a convent worthy of the coronation and burial of kings, and indeed, Agnes's brother Wenceslas I was crowned (1249) and buried (1253) here. The country's most precious relics were kept here and Agnes herself was venerated in her lifetime. However, it wasn't until 1989, four days before the Velvet Revolution, that she was canonized.

The grandly conceived convent was constructed between 1233 and the 1280s, first in stone, then in brick, and was highly influenced by contemporary Burgundian Cistercian architecture. The earliest work began with a hall Church of St. Francis and nuns' quarters, which extended north toward the newly built Old Town walls along the Vltava. The second stage of construction began after 1238, when the Cistercian plan was altered in relation to Agnes's royal status. A long, elegant, two-bay and polygonal apse choir was added to the Church of St. Francis. Running parallel to the north of the choir, a two-story palace was built for Agnes but was later transformed to a Chapel of the Virgin Mary (also called the Lady Chapel) where Agnes planned to be entombed. To the north of this, Agnes also built herself a private oratory, a common addition for royal churches, from which she could attend mass unobserved. In the early 1260s, to the east of the Lady Chapel, Agnes and her nephew Otakar II founded the sanctuary of the Holy Savior as

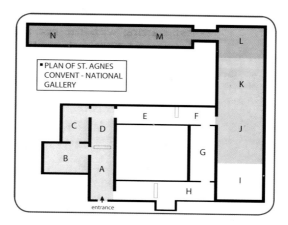

the family mausoleum. With a layout similar to but grander than that of St. Francis, the sanctuary's design suggests the builder was familiar with the architecture of the Ile-de-France. Its courtly décor includes capitals carved with portraits of kings and queens, and in the apse, the carved head of a nun is believed to be a portrait of Agnes herself.

The convent flourished until the Hussite period, when in 1420 the nuns were expelled by the Hussites, who turned the convent into an arsenal. In 1556 the Dominicans took over the convent, but used it as, among other things, a brewery, timber yard, and lodging for the indigent. The Poor Clares returned after 1620, but the convent never regained its prestige and was dissolved in 1782 by Josef II. The dilapidated convent was slated for destruction during the late-19th-century clearance of the Jewish Quarter, but was luckily saved by the Association for the Renewal of the Convent of the Blessed Agnes and was slowly restored. In 1963 the National Gallery renovated the cloister as a museum. Badly damaged in the 2002 floods, the Church of St. Francis and the Sanctuary of St. Savior were still closed indefinitely for restoration at the time of writing.

The National Gallery's collection of medieval art is located in the former convent buildings and cloister, the exterior of the latter retaining something of its medieval appearance, apart from the upper level of the eastern side, which has a Renaissance arcade built by the Dominicans.

The exhibit—with extensive descriptions in both Czech and English—is chronological, starting with the first appearance of Gothic art in Bohemia around 1200 and concluding with the advent of the Renaissance in the early 16th century. The exhibit follows through four main historic eras: 1200–1378 (Rooms A to D), 1378–1437 (Rooms E to I), 1437–1490 (Rooms J and K), and 1490–1526 (Rooms L to N).

1200–1378 (Rooms A to D)

The era of the last Přemyslid and Luxemburg dynasties saw a flowering of Gothic art. Under the French-educated, enlightened art patron Emperor Charles IV (1346–1378), Bohemian art reached a golden age, with Prague developing into an international artistic center rivaling other European capitals. (Note that, for much of early medieval art, the individual artist is rarely known but is sometimes referred to as "Master of...," a title assigned usually on the basis of stylistic analysis.)

ROOM A

The exhibit begins with several examples of one of the most popular images from the Middle Ages: the Virgin Mary (Madonna). In the 12th and 13th centuries a popular cult of the Virgin developed partially in response to the church's traditional hostility toward women, an attitude exemplified by the vilification of the figure of Eve. Due to the religious ardor at the time of the Crusades, the great Gothic cathedrals were often dedicated to "Our Lady" and images of the Virgin, whether alone or with the Christ Child, were found in most religious structures throughout Europe.

Madonna Enthroned, Moravia, c. 1180–1200

Although quite damaged, this Romanesque statue is one of the oldest woodcut objects of its kind in Bohemia. Comprised of several pieces of wood held together with pegs, some original color is still visible. In medieval theology, Mary was seen as Regina Coeli, or Queen of Heaven, and her lap was considered Christ's throne, i.e., the throne of heaven. This frontal composition of the enthroned Madonna holding the Christ Child is typical of the era.

Madonna of Strakonice, Bohemia, c. 1300–1320

This standing life-size statue of the Virgin and Child is one of the National Gallery's most remarkable pieces. The Madonna stands in a typical pose of Gothic art: with one knee bent, giving her body a slight S-curve. The Christ Child gazes at his mother and with one hand awkwardly reaches for her face; with the other he holds an apple, referring to original sin and Christ's role as redeemer. The statue's rigid gestures and block-like form reflect its early date, but there is also a monumentality and harmonious composition that suggest that the artist was aware of the sculptural style of the great western European cathedrals, such as Strassburg and Reims.

There are several examples of a type of Bohemian Madonna painting called the "Graceful Madonnas," whose gentle imagery reflects the popularity of the Marian cult in Bohemia.

Madonna of Most, before 1350

This is one of the oldest types of Graceful Madonnas that developed in the latter 14th-century: a half-length figure of the Virgin holding the Christ Child. The Madonna's facial features, black hair, halo, and royal purple robe, along with Christ's long dress and halo, all painted in an overall stiff, iconic style, suggests an artist very familiar with Byzantine-Italian icons. The image was also probably used, much like an icon, in liturgical processions. Christ holds a goldfinch, an ancient motif that was a pagan symbol of the soul later adopted by Christianity. A legend grew that the goldfinch acquired its red spot when it flew down to remove a thorn from Christ's crown on the way to Calvary, and so it was seen as symbolizing Christ's role as savior and martyr and became a popular attribute in Italian art. The panel is displayed so that its reverse side is visible, which is painted with a window frame, symbolizing that through devotion to the Virgin, the faithful would see into the Kingdom of Heaven.

Workshop of the Master of Vyšší Brod
Madonna of Veveří, c. 1350

This is the next step in the development of the Graceful Madonnas, moving away from the style of icons and blending Italian and Bohemian styles. The prime characteristic of this type of Madonna is her graceful expression, in terms of both physical and spiritual beauty. Her hair is now blonde (as are most Bohemian Madonnas), her movements less rigid, and she now wears a crown, denoting her role as Queen of Heaven. Still holding a goldfinch, the Christ Child is now draped with transparent cloth and reaches for Mary. As in many such images, Christ gazes adoringly at his mother while the Virgin looks out at the viewer, stressing that this image's worshipful focus is the Virgin herself.

Madonna of Zbraslav, 1350–1360

This image is seen as the culmination of all that comes before. The Madonna sits enthroned and crowned as Queen of Heaven with golden hair and a deep blue dress. The color blue was associated with the Virgin from the 12th century and represented her exalted status as Queen of Heaven. Blue was the color symbolic of heaven, but it was also one of the most expensive dyes in Europe, available only to the very rich. Blue dye was made from the stone lapis lazuli, which was imported from the east and was considered as valuable as gold. Mary wears a ring, which symbolizes the mystical union of Mary and Christ; as such, it symbolizes the Christian church as well. This panel painting was clearly considered exceptional in its own time: it originally hung in the Cistercian monastery of Zbraslav (see Trail 6: Zbraslav), the traditional burial place of Bohemia's kings.

St. Andrew, St. John the Evangelist, and St. Peter, Prague, c. 1340
The oldest preserved panel painting in Bohemia, this work was probably commissioned by the influential Prague Bishop Jan IV of Dražice (d. 1343), most likely for a religious institute in Roudnice nad Labem, the country seat of the

bishop. The rectangular panel portrays the three saints in Gothic niches, each with his symbol: Andrew with a cross; John with an eagle; and Peter with a key. It may have been part of a chest-like reliquary holding the relics of the Apostles; there are traces of hinges on the back of the panel. The contents must have been important because the painting is of high quality and reflects contemporary French styles—unsurprising, since the bishop spent from 1318 to 1329 in Avignon at the exiled Papal court and brought French artists back with him to Bohemia.

Room B

Filling the next room are sumptuous gilded paintings depicting the life of Christ, dramatically displayed on a smoky blue wall. A series of nine panel paintings, the group is considered one of central Europe's greatest medieval cycles. The cycle was probably made for the Cistercian Abbey of Vyšší Brod in southern Bohemia and its iconography reflects the teachings of the Cistercian's founder, Bernard of Clairvaux. Peter I of Rosenberg (d.1347), who funded much of the building work at the Vyšší Brod monastery and is portrayed as a patron in the image of the nativity scene, probably commissioned the paintings. The cycle's exact function is uncertain, but it may have originally hung as a single square retable or as a partition in a church's ambulatory. The artist is unnamed, but the style suggests a familiarity with both the linear style of western Europe and the color and richness of Italy.

The cycle follows the life of Christ from the Annunciation to the Pentecost. The first three images and perhaps the Resurrection are believed to be by the Master and the others by the workshop.

The Master of Vyšší Brod and workshop

The Life of Christ Cycle, c. 1350
Annunciation

This iconographically rich image draws its symbolism from the teachings of Bernard of Clairvaux, and refers to the moment of Christ's conception. The crowned Virgin Queen of Heaven is seated on a rather architectonic

throne (most liking referring to the creation of the church) topped with peacocks (symbols of immortality), a lily (a sign of purity as well as a reference to the spring date of the incarnation, March 25) growing at its base, and below, an open treasure chest (a rather worldly example of the rewards awaiting the faithful in heaven). From a highly decorative cloud manna falls, announcing the coming of Christ. God himself is pictured in the cloud and in the golden ring surrounding him is written very faintly, "I will send victory from the sky like rain..." (Isaiah 45:8) He sends the Holy Spirit in the form of a dove to the Virgin and the archangel Gabriel tells her she will be the savior's mother (the banner reads "Ave gratia plena"—"Greetings most favored one"). Gabriel's courtly gesture and his blue cloak decorated with fleur-de-lys have led to speculation that this image could be a reference to Charles IV's French-influenced court or to Charles's first wife, Blanche de Valois. The background nature, as in most art of the period, is highly decorative and stylized with trees like verdant lollipops and oddly craggy ground.

Nativity

The recumbent Virgin and Child wrapped in a loving embrace lie beneath a simple shelter while in the foreground Joseph and the midwife prepare the newborn's bath (a popular medieval legend). In the background are animals and a shepherd, clearly aware of the Messiah's presence. The kneeling donor holding a model church is Petr I of Rosenberg (d. 1347), the head of a powerful southern Bohemian family. The family's coat-of-arms, a five-petal flower, sits beside him.

Adoration of the Magi

Three regal magi come to worship the infant Christ, who sits enthroned upon the Virgin's lap. The Virgin, with her blond hair and gentle features, is very much a "Graceful Madonna" type. The angel above symbolizes the star the Magi followed.

Christ on the Mount of Olives

A blonde angel peers out of a stylized cloud, bringing strength to a serene Jesus, who had come to the Mount of Olives for a night of prayer before the Crucifixion. Accompanying him were three apostles, Peter, James, and John, who have fallen asleep instead of praying, a scene that was often played for comedy in the Middle Ages. The fantastic decorative landscape includes decorative birds in trees; the latter are considered symbols of the Crucifixion as well as of the soul.

Crucifixion

This is a common portrayal of the Crucifixion, with mourners and soldiers gathered under the dying Christ. The gestures of grief—such as the figure of Mary Magdalene clinging to the cross and the anguished angel with his hands to his mouth—are motifs that developed in the early 14th century and are derived from the work of Giotto.

Lamentation

Although this scene of Jesus' followers lamenting over his dead body is not found in the gospels, it became popular in western art in the 13th century. Christ's body is supported by John the Evangelist at his head, the tearful Virgin (who kisses his face in a gesture also influenced by Giotto), Mary Magdalene (with her ointment jar) and Joseph of Arimathaea. Holy women and angels complete the scene.

Resurrection

This scene depicts two separate events, neither specifically discussed in the gospels but nonetheless popular in the Middle Ages. First, Christ is emerging from a bathtub-like sarcophagus holding a banner of the Lamb of God, as slumbering soldiers are awakened. Secondly, the three Mary's are arriving at the tomb and being told by an angel that Christ is risen.

Ascension

An expressive group of apostles and a pretty Virgin watch as Christ ascends to heaven; only his feet are visible as he shoots up like a rocket to heaven.

Pentecost

Also called the "Descent of the Holy Ghost," this scene represents the symbolic beginning of the Christian church. The apostles and the Virgin gather for the Jewish feast of Pentecost after Christ's ascension and suddenly, the Holy Spirit (as a dove) comes to them, causing them to speak in different tongues and filling them with Christian fervor to spread Christ's word.

ROOM C

This room holds works by Bohemia's most celebrated medieval painter, **Master Theodoric**. As court painter to Charles IV, he is one of the first identified individual artists in Bohemia, and his distinctive "soft" style has survived in numerous splendid paintings. Theodoric's style is a synthesis of the descriptive style of French and Flemish painters, with the color of northern Italy. The result is a singular, luminous style of molded, monumental forms. His figures have large, expressive faces and voluminous costumes, which, to a modern eye, look a bit like the art of the popular Columbian painter Fernando Botero!

Displayed are six reliquary panel paintings from Karlštejn Castle's magnificent Chapel of the Holy Cross (where today these six are replaced by copies; also see Trail 7: Karlštejn). A total of 130 panels were produced for the Chapel of the Holy Cross, 30 of which were completed by Master Theodoric and his workshop between 1360 and 1364 (the others were done by three or four other Prague workshops). Charles IV was a great collector of holy relics: each of the paintings for the Holy Cross Chapel was intended as a reliquary and small holes can be seen in many frames, where the relic was stored. The six paintings depict, from left to right:

St. Luke: One of the four evangelists and the patron saint of painters, he is pictured with his symbol, the cow.

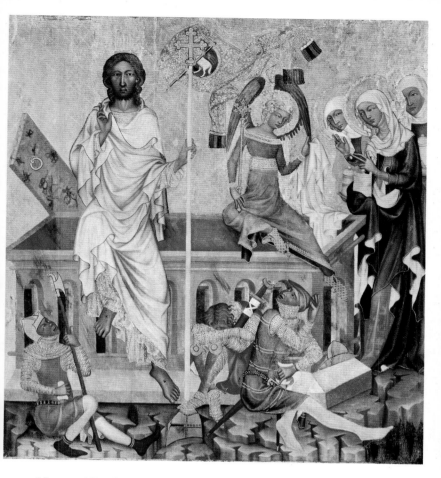

Master of Vyšší Brod, Resurrection of Christ, c. 1350 (tempera on panel), National Gallery, Prague (Giraudon)

St. Charlemagne: King of the Franks and the first Holy Roman Emperor (crowned in 800), Charlemagne was Charles' IV's patron saint. This painting was most likely completed by Theodoric himself.

St. Catherine: An early Christian virgin martyr, Catherine became one of Charles IV's favorite saints after he won a battle in Italy on her saint's day. She is portrayed with her characteristic wheel, upon which she was martyred.

St. Matthew: Another evangelist and the author of the first gospel, he is portrayed with his symbol, an angel, whispering divine inspiration in his ear.

St. Ambrose: This 4th-century Milanese bishop was one of the four church fathers and is depicted in a bishop's costume with writing implements in the background, in reference to his theological and hymn writing. The gilded, patterned background is well preserved, giving an idea of the original brilliance of all panels.

St. Gregory the Great: Also a prolific church father, Gregory is depicted writing at his lectern. The writing instruments are portrayed in minute detail, unsurprising for a painter who worked with similar tools.

Room D

Votive Panel of the Archbishop Jan Očko of Vlašim, Prague, before 1371

Intended for private use in the archbishop's chapel in Roudice nad Labem, this exceptional image reflects the high culture of the Luxemburg court circles. The panel is comprised of two scenes, reflecting both a celestial and terrestrial hierarchy. In the top scene Emperor Charles IV (wearing the crown of the Holy Roman Empire with the crest of the imperial eagle) is presented by St. Sigismund to the Virgin and Child. Opposite, his son, the future Wenceslas IV (wearing the Bohemian crown with the lion crest of Bohemia), is presented by his patron saint, St. Wenceslas. Below Jan Očko kneels before St. Adalbert, patron saint of the Prague Bishopric. Behind Adalbert stands the tonsured St. Procopius in monk's garb. To the right side stands St. Vitus, holding a martyr's palm and with one hand on Očko's shoulder, and St. Ludmila, holding the cord with which she was strangled. The six saints portrayed are Bohemia's most important patron saints.

The anonymous painter attempts a degree of individuality in his portraits, such as in Jan Očko's less than ideal profile, making this one of the earliest examples of Bohemian portraiture. The style, with its patterned decorative background and soft matte faces, is influenced by Master Theodoric. The image melds secular and religious powers in one image, placing holy figures and powerful men on the same plane. Charles IV used similar techniques to promote his own prestige and divine right to power.

1378–1437 (Rooms E to I)

A period of strife followed the death of Charles IV (1378) leading to the Hussite Wars (1419–1437). This epoch saw fewer monumental works of arts, reflecting unstable conditions as well as an international movement toward private devotion, necessitating more personal artwork. Toward 1400 the influence of the International Gothic style—a sophisticated courtly style begun in France and spread throughout Europe—was felt in Bohemia, where it was called the "Beautiful" style. During the Hussite Wars artistic creation continued through the patronage of great families in southern Bohemia, which was less affected by the war. From the 1420s the influence of Netherlandish realism, a style best exemplified in the work of Jan van Eyck, can be seen in much central European artwork.

ROOM E

The most remarkable work of the late 14th century is by an anonymous artist known as the **Master of the Třeboň Altarpiece**, who more than likely was a court artist active in Prague in the 1370s and 1380s. The three double-sided panels on display are the surviving pieces of a larger altarpiece that was made for the Church of St. Giles in the Augustinian monastery at Třeboň in southern Bohemia c. 1380–1385. The powerful Rosenburg family, who founded the monastery, could have been the patrons for this exceptional work of art. All the panels have scenes on both sides and many have been part of the closeable wings of the altarpiece. The three panels depict:

Christ on the Mount of Olives
Compare this depiction of the scene with the more stylized version by the Master of Vyšši Brod (see Room B), dating from 30 years earlier. The Třeboň artist uses similar decorative elements, such as the trees and birds, but attempts a more realistic depiction and uses the chiaroscuro technique to add depth. The scene is divided into three diagonal planes: the sleeping apostles; the meditative Christ; and the soldiers who are coming to arrest him. Note the curious official peering through the trees, one of several individualized faces in the cycle. On the reverse side, under a tripartite niche, are three pretty blonde saints with their attributes, all standing with a gentle S-curve: St. Catherine with a wheel, Mary Magdalene with an ointment jar, and St. Margaret with a dragon.

The Entombment
Presented, like the first image, on a diagonal line, the scene depicts the placement of Christ's body in his tomb by his followers. On the reverse side, under a white marble niche, are: St. Giles pierced by an arrow and with a stag at his feet, St. Augustine in a bishop's mitre, and St. Jerome in a red cape with a lion at his feet.

Resurrection
In the most ethereal of the images, a sedate Christ in a dramatic red cape hovers above his coffin-like tomb and the startled soldiers, giving the painting an almost surreal, mystical quality. Note the adoring upturned face of one of the soldiers. On the reverse side, the saints all hold the objects with which they were martyred: St. James the Lesser holds a staff, St. Bartholomew a knife, and St. Phillip a double cross.

Room G

Madonna of Jindřichův Hradec, c. 1410
This lovely bijoux image of the Madonna and Child is in the "Beautiful" style, with bold colors and stylized drapery. Its diminutive size and subject indicate it was designed for use in private devotion.

Madonna of St. Vitus, Prague, before 1400

Done in the International Gothic style, this Madonna and Child is still in its extraordinary original frame with twelve framed relief portraits set into it. An exceptional example of Bohemian wood carving, it is one of the first attempts to give the illusion of space and depth. In the corners are angels holding inscription rolls with the text to a Marian hymn. On the upper frame is St. John the Evangelist with a lamb and St. John the Baptist with a chalice; on the left side are St. Wenceslas and St. Sigismund; on the right are St. Vitus and St. Adalbert; on the lower frame is St. Procopius and the kneeling donor, believed to be Prague Bishop Jan of Jenštejn, who awkwardly gazes up at the Virgin.

The Capuchin Cycle, Prague, c. 1410

These individual portraits of Jesus, Mary, John the Baptist, and the twelve apostles are believed to have formed part of a predella or choir partition. The original location is unknown, but by the 17th century the images are recorded at the Capuchin Monastery in Hradčany. Each face is individualized with different hairstyles and expressions, almost like a series of holy passport photos.

ROOM H

Master of the Votive Panel from St. Lambrecht (active 1420s–1440s)

Epitaph of the Goldsmith Sigismund Waloch, Vienna, 1434

This artist was probably working in Vienna when he was commissioned by goldsmith Waloch from Weiner Neustadt to create a painting to commemorate Waloch's deceased wife. Much of early medieval art was commissioned by royalty or the church and only in the later Middle Ages did a growing class of middle-class patrons, such as this wealthy artisan, develop. Waloch and his wife are portrayed kneeling before the enthroned Madonna and child. The couple is presented by their patron saints, St. Barbara and St. Judas Thaddeus; Waloch holds a banner

with the 51st Psalm, and his wife's banner is a plea to the Virgin. In keeping with tradition, the donors are tiny figures compared to the monumental holy figures. The two donors are dressed in contemporary fashion—he in a fur-lined tunic and she in a white wimple (head covering).

Portable altarpiece from Boletice, southern Bohemia, before 1450

An unusual rustic example of a portable altarpiece; which would have been used as a prop by travelling clergy for their itinerant preaching. It is composed of a slate slab surrounded by a wooden frame and looks like a 19th-century school slate. Simple images of saints Barbara and Agnes decorate the frame and a small opening at the bottom would have held a holy relic.

1437–1490 (Rooms J and K)

Rooms I, J, K, and L are actually one long, partitioned room. We go straight through Room I to Room J. The era shown in these rooms saw continued Hussite conflict and the rule of the Hussite King George of Poděbrady (1458–1471), who had no time or money for art patronage. In these unstable times, art in Bohemia was more and more influenced by the art of the surrounding German-speaking cities (such as Nuremburg and Vienna). The entrance of the Polish Jagiellon dynasty as Bohemia's rulers in 1471 saw the first introduction of Renaissance forms but conflict kept patronage to a minimum.

ROOM J

Hans Pleydenwurff (c. 1420–1472)

Beheading of St. Barbara, Nuremberg, c. 1470,

Pleydenwurff was a prominent Nuremberg painter of the generation before Dürer who was influenced by the art of the Netherlands. In this image he tells the story of St. Barbara (taken from the *Golden Legend*: a 13th-century compilation of the lives of the saints), focusing on her beheading but with numerous tiny background scenes telling the events of her martyrdom. Barbara's

father, a Roman pagan nobleman, had her shut up in a tower to discourage suitors. He became enraged when he discovered she had become a Christian, but Barbara escaped him and hid in a rock cleft. Shepherds betrayed her and her father dragged her out by the hair, then turned her over to the Roman authorities who tortured her. She was finally beheaded by her father's sword, a scene depicted in the foreground. These harrowing events had their reward, however, and a tiny Barbara, crowned by angels, is pictured flying to heaven. The scene is also an interesting and detailed picture of contemporary fashion and textile; note the cruel father's rich damask robes and the executioner's fine boots.

Hans Pleydenwurff (c. 1420–1472)

Epitaph with the Assumption and Donors, Nuremberg, c. 1470

The central image is of a rather fatigued Virgin Mary floating in a golden background upon a half crescent (a symbol of chastity, and, in the case of the Virgin, of the immaculate conception), but what is really intriguing is the large donor family kneeling below. Although the family is unnamed, this is an interesting example of bourgeois patronage. The entire family is included: the father and three sons on one side and the wife and four daughters (one of whom was already married, as indicated by her adult wimple) on the other. Both parents' coats of arms are included. The image would have hung in a church or chapel, perhaps for private worship, but more likely in a public space where both the family's piety and wealth would have been well displayed.

Room K

Master of the Altarpiece of the Knights of the Cross with the Red Star (active 1480s)

Altarpiece of Nicholas Puchner, or *The Puchner Ark*, Prague (?), 1482

Displayed are the surviving fragments of an altarpiece

made for the St. Francis Church of the Monastery of the Knights of the Cross with the Red Star in the Old Town (on Křížovnické náměstí). The patron was one Nicholas Puchner, the Grand Master of the Order, who is pictured in the robes of his order on one of the wings of the altarpiece. Presented by St. Barbara, he kneels gazing up to where an image of the Assumption of the Virgin would have formed the center of the altarpiece (now lost). Today the opposite wing depicting St. Catherine is displayed beside him. Other pieces displayed are: the stigmata of St. Francis; the Death of the Virgin; St. Agnes of Bohemia nursing a patient; and the saints Ludmila and Ursula. Each is a story or legend popular with the order, which was founded by St. Agnes of Bohemia in 1237. The images all have a high level of realism, perspective, and color, reflecting the strong influence of Dutch painting, particularly that of Rogier van der Weyden, on the talented but unnamed artist.

1490–1526 (Rooms L to N)

When the dynasty moved their court from Prague to Buda in 1490, Prague became a secondary city. In 1495 the pope's embargo on heretical Bohemia was finally lifted, leading to a stronger foreign influence in the arts. This external stimulus was augmented in 1526 when the Habsburg dynasty—whose empire spread from Spain to the Netherlands to Prague—came to the throne, drawing to an end the Gothic era in Bohemia.

Room L

Lucas Cranach the Elder (1472—1553)

Portrait of a Lady in Hat, 1538

Cranach was court painter to the Electors of Saxony, the protectors of Martin Luther, and was practically the official painter of the Lutheran Reformation. This did not mean, however, that his paintings were only religious in nature; in fact he made a specialty

of oddly sensual, rather menacing-looking blondes, whether in mythological, religious, or, as here, portrait paintings. This anonymous woman, perhaps a burgher's wife or daughter, is typically Cranach: a rather feline-looking blonde wearing a decorative costume with a fashionably shaved forehead. His singular style with its sophisticated use of pattern, flattened light, and solid bourgeois-looking subjects was wildly popular in his time and dozens of his works survive (see the National Gallery's Sternberg Palace).

Master of the Litoměřice Altarpiece (active c. 1500–1525)

Altarpiece of the Holy Trinity, after 1510

This master was one of the best painters of the Jagiellon court and also completed murals in the St. Wenceslas Chapel in St. Vitus (1506–1509). This mystical image reflects a popular contemporary religious movement called "Devotio Moderna," which focused on inner spiritual life and was most likely used as an aid for intense personal devotion and meditation on Christ's suffering. The central panel depicts the "Throne of Grace": Christ on the cross rests on the lap of God, symbolizing God's grace to mankind. The Holy Spirit hovers above and all are enveloped in a psychedelic yellow and orange light. A tiny donor kneels in a corner. The Virgin and St. Barbara are portrayed on the wings, and on the external panels are St. Wenceslas and St. Sigismund.

Room M

Soon after Gutenberg developed printing in the later 15th century, exceptional works of graphic arts—easily reproducible and widely disseminated—began to be produced in central Europe by the most important artists of the day. This room contains several masterful examples. As graphic works are damaged by long exposure to light, most museums rotate images to protect them. However, for some reason, the gallery has chosen to instead display only copies of these delicate

works. Nevertheless, make note of some of the greatest works of the era by the likes of Albrecht Dürer (*Apocalypse*, 1511), Lucas Cranach (*The Passion Cycle*, c. 1509) and Hans Burgkmair (*Weisskunig*, 1515).

ROOM N

Monogramist I.P. (active c. 1520–1540)
Visitation, after 1520

This room holds several spectacular works by this anonymous sculpture of the Danube School known only by his initials, I.P. He is believed to have worked in Bohemia around 1520–1525 for noble and royal patrons. His minutely carved images recall the art of engraved prints and combine elements of the late Gothic and the Renaissance using exceptional detail and perspective. This tiny image displays the painstaking detail of his art and depicts the visit of the pregnant Virgin Mary to her cousin Elizabeth, who herself was pregnant with John the Baptist. It shows a strong influence by Dürer who made a very similar engraving, and was most likely part of a diptych or altarpiece used for private devotion. The initials I.P. are found near the center of the lower panel, just beneath a foot.

Lucas Cranach the Elder (1472–1553)
The Law and the Gospel, 1529

In this action-filled and cryptic (at least to modern viewers) painting, Cranach gives us a lesson on the beliefs of the Lutheran Reformation. An educational work for a largely illiterate population, it represents the history of the redemption of mankind with the Old Testament on the left and the New on the right. In the upper left corner, Moses receives the Ten Commandments (coming out of a cloud held by two bodiless hands). In the opposite corner, is the incarnation of Christ beside the Virgin Mary (who sits on a hill surrounded by strange angelic cloud as a cross-bearing angel zooms toward her.) Note the shepherds being alerted by a shining angel. Back on the left, Adam and

Eve represent original sin and death (emphasized by the open grave) and opposite, Christ's resurrection represents triumph over death. To the left is an Old Testament scene of the Israelites camp punished by snakes against which Moses raises a serpent on a cross, prefiguring Christ's crucifixion. On the right, a celestial city glitteringly awaits the righteous. The central scene is of John the Baptist and the prophet Isaiah, who show the way to mankind, represented by an indecisive, naked man.

Church of St. Castulus (Sv. Haštala)

Location: Haštalské náměstí
Opening hours: Services only

Standing near the St. Agnes Convent, St. Castulus has a single tower, a lopsided façade with a classically inspired portal, and deep Gothic windows that stand out against its newly plastered and painted walls. Built around 1375 on the site of an earlier Romanesque church dedicated to Castulus (a 3rd-century Christian martyr who was chamberlain to Emperor Diocletian), the interior of the four-aisled basilica was redone in a baroque style between 1689–1695, after it had been damaged in a fire. However, the double northern aisles retain their Gothic vaulting, with round, slender piers that flow into elegantly carved rib vaulting. Corbels on the outer wall are decorated with "wild man" and foliage images, similar in style to those made by Peter Parler's workshop at St. Vitus (although the originals were replaced by copies after 1885 repairs). The high level of craftsmanship suggests a patron and architect (both unknown) connected with the later 14th-century royal court, perhaps in relation to the neighboring St. Agnes cloister. At the time of writing the interior was undergoing major restoration.

MALÁ STRANA AND HRADČANY

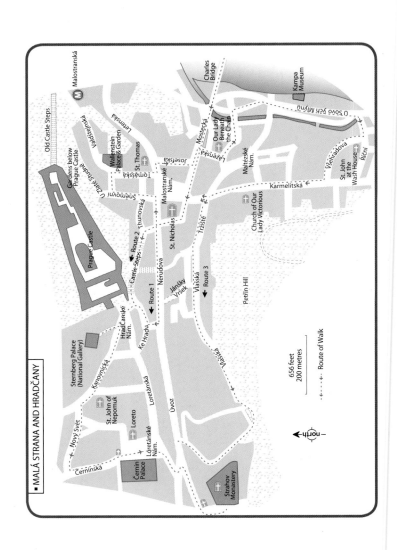

- Malostranská Ⓜ
- Old Castle Steps
- Valdštejnská
- Letenská
- Wallenstein Palace & Garden
- St. Thomas
- Gardens below Prague Castle
- Sněmovní
- Zámecká
- Prague Castle
- Tomášská
- Route 2
- Castle Steps
- Thunovská
- Josefská
- Malostranské Nám.
- St. Nicholas
- Route 1
- Nerudova
- Jánský Vršek
- Vlašská
- Route 3
- Tržiště
- Mostecká
- Lázeňská
- Our Lady Beneath the Chain
- Charles Bridge
- Kampa Museum
- U Sovo ých Mlýnů
- Maltézské Nám.
- Karmelitská
- Church of Our Lady Victorious
- St. John at the Wash House
- Všehradova
- Říční
- Hradčanské Nám.
- Ke Hradu
- Sternberg Palace (National Gallery)
- Kanovnická
- Loretánská
- Úvoz
- Vlašská
- Petřín Hill
- Nový Svět
- St. John of Nepomuk
- Loreto
- Černínská
- Loretánské Nám.
- Černín Palace
- Strahov Monastery

656 feet
200 metres

- - - ◆ - - - Route of Walk

← north

Trail 2:

The Little Quarter

In a city filled with atmosphere, Malá Strana (Little Quarter) is perhaps the most evocative of all quarters. Framed by the mighty Vltava, the majestic castle, and verdant Petřín Hill, the quarter has the best-preserved streets in the city. These narrow streets are lined with noble palaces, baroque gardens, and panoramic lookouts. Inhabited since the 9th century, it was only in 1257 that King Otakar II decided to consolidate the hitherto uncoordinated settlement, officially founding the "New Town below Prague Castle" (as Malá Strana was called until the early 14th century), creating a marketplace (Malostranské náměstí) with a parish church (St. Nicholas) and inviting skilled settlers from northern Germany. Charles IV expanded the quarter, creating new fortifications to include Petřín Hill. Located in the shadow of the castle, from the beginning the quarter was associated with the royal court and by the 16th century, aristocrats as well as clergy and artists (many from Italy) who worked for the court made their homes in Malá Strana. The 18th and 19th centuries saw a decline as nobles focused on their country estates and on the Habsburg capital in Vienna. Many palaces were subdivided for apartments or became embassies in the 20th century, but mostly the quarter remained a picturesquely crumbling shadow of past glory.

Restoration began in 1989. Largely focused on the tourist market, restaurants, shops, and hotels are popping up in many a former palace. Some areas, such as the heavily touristed Royal Route (Mostecká, Nerudova), have suffered from over-

commercialization and some gaudy paint jobs, but generally Malá Strana has retained its historic beauty, making it one of the most desirable addresses in the city. A relatively small area, it can be walked in half a day. However, allow more time to visit sites such as Museum Kampa, one of the city's best modern art venues, and simply to linger in riverside parks and gardens, basking in splendid, centuries-old vistas. The last part of the Trail gives three potential routes to Prague Castle (Trail 3), and could be incorporated into your visit to the castle.

Charles Bridge and North of Mostecká

One of Prague's most iconic sites, Charles Bridge is a 14th-century stone gateway to Malá Strana from the Old Town. The first bridge to span this sight was a wooden construction destroyed by a flood in 1157. Vladislav I built a 21-arch stone bridge called the Judith Bridge (named after his queen) in 1158–1160, but this too collapsed after a flood in 1342. It was the great architectural patron Charles IV who commissioned the equally exceptional architect Peter Parler to build a new bridge, known as the Stone or Prague Bridge until 1870 when it received the moniker Charles Bridge. The 16-arch, 1,692-ft/516-m bridge spans not just the Vltava but also the north of Kampa Island and the Čertovka, or Devil's Brook. Parler used the bridgeheads of the Judith Bridge, but constructed new piers just to the south of the old ones, creating a slight curve against the current. Although damaged several times by war and floods (the latest in 2002) it has never collapsed. (Like most of the Royal Route, it is often clogged with tourist traffic, so try to come early in the morning or later in the evening for a more serene experience.)

Above the first pier stands the **Old Town Bridge Tower** (Staroměstská mostecká věž). The tower was built between the 1360s and 1390s and still maintains its basic medieval form, although it has been altered over the centuries—the sculptural decoration of the west façade was destroyed in the Swedish seige of 1648 and Josef Mocker got his neo-Gothic hands on the tower in 1874–1880. A part of Parler's bridge

View under Charles Bridge along Čertovka (the Devil's Brook)

design, the tower's fine decorative work was probably done by Parler himself along with stonemasons and sculptors from the workshop of St. Vitus Cathedral.

The tower was to function on several levels, which speaks to the relationship between the king and his Old Town subjects. With a compact design and surface-only decoration, it was primarily a defensive tower that could be used in times of invasion or, more likely, local rebellion. There was a prison in the cellar and a guardroom on the first floor. It also acted as a ceremonial arch, almost a triumphal gate, through which coronation processions would pass. The design of the Old

Town-facing façade was significant because it was a symbolic portal leading to St. Vitus; in fact, the relief sculpture on the façade echoes the architecture of the cathedral. Its iconography is designed, like the cathedral's, in a tripartite hierarchy: at the ground, or earthly, level are the coats of arms of the Czech lands under ribbed arches springing from corbels sculpted with amusing scenes, such as a girl being groped by a lecherous knight, which were meant to warn against immoral behavior. On the higher, or celestial, level are enthroned statutes of Charles IV and his son Wenceslas IV to either side of the bridge's chief patron, St. Vitus. Royal coats of arms are dotted around them. Above them are the Bohemian saints Sigismund and Adalbert, who are buried in the cathedral. The scene was clearly a reminder to the oft-rebellious citizens of the king's divinely given authority.

A bridge was more than a transport route in the Middle Ages. It was a place of commerce, where tournaments were held, custom duties collected, criminals executed, and delinquents punished by being dipped into the Vltava in a wicker basket. The most famous event to take place on the bridge was the murder of John of Nepomuk (Jan Nepomucký), who in 1393 was flung from the bridge to his death and eventual sainthood; the event is commemorated by one of the bridge's 30 statues that are placed on opposite pedestals along the length of the bridge.

Although many of these statues are masterpieces in their own right, it is as a whole procession, seen against the ever-changing city backdrop, that they make the greatest impression. French artist Antoine Bourdelle once described Charles Bridge as a centaur: baroque above and Gothic below. The reality is a bit more complicated: twenty statues date from 1707–1714 but others range from the 1650s to 1938. Many were originally part of Counter Reformatory propaganda, promoting the Catholic faith in Bohemia, although later historians have seen Protestant subtexts included by the Bohemian artists who carried out the commissions. The list gives information on the most noteworthy pieces, beginning with the first statue to the left, then the first to the right, the second to the left, and so on. Note that several of the statues are copies of originals that can be seen in the Lapadarium (see pages 243–244).

Madonna with St. Bernard, 1709
This statue is by Matyáš Jäckel, a sculptor of middling talent who first introduced Bernini's exuberant style to Bohemia; it was commissioned by the Cistercian abbot of Osek.

St. Ivo, 1711
This exceptional work by Mathias Braun is of the patron saint of lawyers with a lovely blindfolded allegory of Justice commissioned by the Charles University law school.

Madonna with the saints Dominic and Thomas Aquinas, 1708 (copy)
Commissioned by the Dominicans of St. Giles in the Old Town from Matyáš Jäckel, this statue shows the Madonna passing prayer beads to St. Dominic on the left, while Thomas Aquinas holds up a book inscribed "Bene scripsisti" ("you have written well"), the Virgin's praise of Thomas' theological writings.

The saints Barbara, Margaret, and Elizabeth, 1707
Although the inscription states IOANN BROKOFF FECIT (Jan Brokoff made this), the style suggests it was not Jan but his son, Ferdinand Maxmilián Brokoff, one of the best sculptors of his generation, who made this statue (this is the also case with several other statues).

The Crucifixion, 1650s
The first crucifix was placed here in 1362. It was later destroyed by Hussites, replaced, and then destroyed again by a Swedish cannonball in 1648.

Pietà, 1859
As with most of the 19th-century statues, this replaces a destroyed earlier statue of the same theme.

St. Anne, 1707
St. Joseph, 1854

The saints Cyril and Methodius, 1938
These statues of the two Byzantine saints who first brought Christianity to the Czech Lands were commissioned

during the brief period of Czechoslovak independence.

St. Francis Xavier, 1711

Commissioned by the (Jesuit-run) theological faculty of Charles University, the statue celebrates the Jesuit missionary's successes in India and Japan. It is a classic piece of colonial propaganda, with Francis depicted with some of his foreign converts. Sculptor F.M. Brokoff includes himself as a young man handing Francis a book.

St. John the Baptist, 1857

Between this statue and the next are five stars marking the spot where legend says Jan of Nepomuk was tossed into the river.

St. Christopher, 1857
The saints Norbert, Wenceslas, and Sigismund, 1853

St. Francis Borgia, 1710

F.M. Brokoff was commissioned by a Habsburg Imperial official to make this statue of the recently canonized (1671) Jesuit, who himself had been a Habsburg imperial official.

St. John of Nepomuk, 1683

This bronze cast, based on a sculpture by Jan Brokoff, has the most fascinating story on the bridge. Erected before the subject was made a saint (in 1729), the statue was part of the campaign for his sainthood (which also included exhuming his body in 1719 and discovering his miraculously preserved tongue). The Jesuits needed a local Catholic martyr to counter the memory of Jan Hus, so they altered the facts of one Jan of Pomuk's life—the vicar of the Archbishop of Prague who got caught in the power struggles between the king and archbishop and was murdered by the king's henchmen and tossed in the Vltava in 1393. The story was changed (a fact acknowledged by the Vatican in 1963) as follows: Nepomuk refused to divulge the queen's confessions, so was tortured and thrown into the river, where five stars appeared as he drowned. The statue presents the soon-to-be-saint in a pose copied in countless statues throughout Bohemia—as a bearded

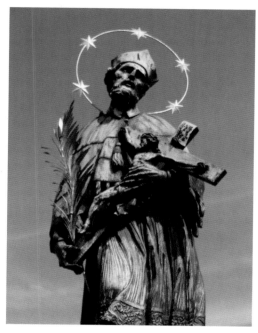

St. John of Nepomuk, Charles Bridge

capitulary with an S-curved body, a large cross, martyr's palm, and a halo of five stars. At the base are scenes from his invented story. There have also been suggestions that the sculptor, a Lutheran who converted to Catholicism (some suggest for professional reasons) in 1682, gave Nepomuk a more somber Protestant sensibilty, as opposed to the more exuberant Catholic visions.

St. Ludmila, 1710
Attributed to Mathias Braun, the statue depicts Ludmila teaching her grandchild, St. Wenceslas.

St. Anthony of Padua, 1707
St. Francis of Assisi, 1855
St. Jude, 1708

The saints Vincent Ferrer and Procopius, 1712
This work of outstanding skill and expression (although questionable subject) by F.M. Brokoff was commissioned by Count Thun. The two saints tower above devils they have triumphed over and heathen souls they have saved. Note the expressive rabbi, aghast at the saints' success.

St. Augustine, 1708
St. Nicholas of Tolentino, 1708
St. Cajetan, 1709, by F.M. Brokoff

St. Lutgard, 1710
An intense (and somewhat creepy) example of baroque emotional intensity, this statue by M. Braun, commissioned by the Cistercian abbot of Plasy, depicts the blind Cistercian nun who in a vision kissed the wounds of Christ.

St. Phillip Benizi, 1714
St. Adalbert, 1709, by Michel and F.M. Brokoff
St. Vitus, 1714, by F.M. Brokoff

The saints John of Matha, Felix of Valois, and Ivan, 1714
By F.M. Brokoff, the statue presents the two founders of the Trinitarian Order (as well as the Slavic St. Ivan, included for an unknown reason) who collected money to free Christians captured by the "Infidel." The base has three captives in a cave praying for salvation with a supremely indifferent Turkish guard. St. Felix reaches down to help free the captives and St. John appears with a deer, the vision of which was the impetus for founding the order.

Christ with the saints Cosmas and Damian, 1709
St. Wenceslas, 1858

The bridge ends with the double chisel roofs of the **Malá Strana Bridge Towers** (Malostranské mostecké věže). The smaller tower is older, built c. 1130 as part of the Malá Strana defenses, later adapted to guard the approach to the Judith Bridge. Its Romanesque masonry was altered in the 16th century by adding a Renaissance gable and detailing.

A crenellated gateway connects it to the taller tower, built around 1464 and clearly inspired by the Old Town Bridge Tower, although its planned statuary never materialized.

Before leaving the bridge, note the 1585 **House of Three Ostriches** (Dům U tří pštrosů) on your right. Now a hotel, in 1597 it was the property of Jan Fuchs, royal supplier of ostrich feathers, then a rare and exotic commodity, who commissioned the ostrich frescoes on its façade. Its twin gables were added in 1657 and in 1714 an Armenian businessman, Deodat Damajan, established Mala Strana's first coffeehouse here. Continue on to Mostecká Street. Mostecká is lined with numerous Renaissance and baroque buildings, one of the loveliest being the **Kounic Palace** (Kounicův palác, no. 15/277), built for the Czech counts of Kounic and now an embassy (the fate of many Malá Strana palaces). Built in 1773–1775, the classically influenced baroque façade has stucco and sculptures by I.F. Platzer.

Mostecká leads to the Little Quarter Square (Malostranské náměstí), the site of the medieval market and still today the heart of Malá Strana. The square is divided into an upper and lower half by a cluster of buildings that include the rococo Grömling Palace (no. 28/5), as well as the grand Church of St. Nicholas and its adjoining former Jesuit monastery.

Church of St. Nicholas (Chrám sv. Mikuláse)

Location: Malostranské náměstí; entrance from west side.
Opening hours: 9 AM–5 PM daily

The greenish copper cupola and spire of St. Nicholas rise above the gables and tile roofs of Malá Strana like a Jesuit beacon, recalling the Jesuits' glory days in Prague. It occupies the site of the medieval church of the same name, which was taken over by the Jesuits after 1620 and to which they added an adjoining school between 1674 and 1691. Christoph Dientzenhofer completed the west façade and nave in 1703–1711 but financial problems meant that the east end would only be finished after 1737 under Christoph's son, K.I. Dientzenhofer, who built the chancel and 243 ft/74 m dome. K.I.'s son-in-law,

Anselmo Lurago, added the tower in 1755. When completed, it was among the largest and most lavish Jesuit churches in Europe. It also was the first example of a new type of baroque building in Bohemia, drawing on contemporary Italian trends and the work of Francesco Borromini and Guarino Guarini.

The vigorous façade undulates with concave and convex surfaces, broken pediments, and oblique decorative columns. The tripartite elevation has strong horizontal divisions with a rolling balustrade and cornice creating surface tension and energy. The statues by Johann Fredrich Kohl form a complex scheme of Jesuit saints with St. Nicholas in the gable above a Habsburg eagle with the acronym "JHS"—standing for "Jesus Habemus Socium" (Jesus is our ally).

The Jesuits loved sensational spectacle, which was intended to stimulate faith and inspire awe. They embraced the sense of emotional urgency, even ecstasy, that was created by the high baroque/rococo's use of irrational and dramatic form and ornament. Upon entering St. Nicholas one is almost overwhelmed by the eruption of ornament: an abundance of gilded altarpieces; vigorous, swirling frescoes; massive agitated statuary, and undulating architectural form. To experience the lightness of the Dientzenhofers' underlying architectural hand, walk to the choir and turn around. From here their dynamic use of space and illusion can be appreciated. The nave has an extraordinary sense of movement composed of interlocking transversal ovals with curved balconies and projecting cornices, all leading to the great domed crossing.

Surfaces are awash with decoration. The nave vaulting is covered with Johan Lukas Kracker's trompe l'oeil *The Apotheosis of St. Nicholas* (1760–1761) and the dome by *The Celebration of the Holy Trinity* (1752–1753) by Franz Palko. Enormous gesticulating saintly figures dot the church, the most remarkable being the rococo *Church Fathers* (1760s) at the four corners of the crossing by local sculptor I.F. Platzer. Note the ebullient St. Cyril taking out a devil with his crozier. Upstairs in the ambulatory is an exhibit of blackened paintings by the early baroque artist, Karel Škréta. All in all, St. Nicholas is a rococo confectionery of Jesuit triumphalism;

but it was all too little (or perhaps too much) too late: less than twenty years after its completion, the Jesuits were exiled from Prague.

Around Malostranské náměstí are several notable structures. The area was largely reconstructed after a great fire in 1541 and saw a building boom during the reign of Rudolf II (1576–1611), whose court was in Prague. Built by Karl von Liechtenstein, the converted Catholic who presided over the executions of Protestant rebels in 1621, the now neo-classical **Liechtenstein Palace** (remodeled in 1791, and today a music school), once dominated the square from its western position before the Jesuits' extensive additions. On the south side of the square are several narrow, arcaded houses of Renaissance and medieval origin, although the **House of the Golden Lion** (no. 10/2620) is the only one to retain its Renaissance appearance. A controversial cubist building was added close to Karmelitská when the street was widened for the tramline.

Along the lower east side sits the **Kaiserstein Palace** (no. 23/37), built in 1700–1708 by Christoph Dientzenhofer based on a design by G.B. Alliprandi. Its decorated façade is an example of Viennese palace architecture, with an attic half-story and prominent balustrade with sculptures of the four seasons by Ottavio Mosto. Nearby is the **Lesser Town Hall** (no. 21/35), which was remodeled during the early 17th century and given a façade with gables and towers in a classic example of late Renaissance civic architecture. Altered in the 19th century, the façade nevertheless retains some of its Renaissance character with its classically inspired fenestration and applied pilasters.

The contiguous façades of two palaces dominate the north side of the square. The lofty, four-storied **Smiřický Palace** (no. 18/6) was built on the site of several medieval houses in the early 17th century and many original features remain: double windows, two polygonal towers, traces of sgraffito on the façade, and carvings found in the marvelous Renaissance courtyard. It was here in 1618 that Protestant nobles, including royal candidate Jan Albrecht Smiřický, plotted the

Second Defenestration. Adjoining is the **Sternberg Palace** (no. 19) which was created by linking several older structures beginning around 1684. It once held the artistic and scientific collections of the noble Sternberg family that became the foundation for the National Gallery. Both palaces were given a late baroque facelift in 1763–1769, perhaps by Giovanni Battista Alliprandi.

Just to the west of the Smiřický Palace is Sněmovní Street. Follow this narrow cobblestone street, passing palaces now used by the Czech Parliament, to a lovely little square whose upper end leads to an ancient (dead-end) lane **At the Golden Well** (U zlaté studně). Painted on a house just to the left as you enter the square is a reminder of Prague's multilingual past: a 19th-century Czech-German street sign (Fünfkirchenplatz/Pětikostelní náměstí, literally translated as Five Church Square, though the name comes from a former resident, Jan Fünfkirchen). Note as well the charmingly unreconstructed 1589 Renaissance **House at the Golden Swan** (Dům U zlaté labutě, no.6) with a classical doorframe and stepped gables. Follow Sněmovní to the Wallenstein Palace on Valdštejnské náměstí.

Wallenstein Palace and Gardens (Valdštejnský palác a zahrada)

Location: Entrances to garden and palace on Valdštejnské náměstí. Second entrance to gardens on Letenská.

Opening hours: Palace: open Sat and Sun 10 AM–4 PM. Gardens: daily 10 AM–6 PM, April 1–October 31.

The escapades of Albrecht of Wallenstein (1583–1634), one of Czech history's most colorful characters, could have made Macchiavelli blush. Expelled from his Lutheran school for killing a servant, he fled to Italy, where he married a rich Catholic widow who soon died, leaving him a fortune. His Catholicism helped him cultivate a place at the Habsburg court of Ferdinand II and he become an imperial general, by which he gained enormous wealth during one of Bohemia's darkest periods; he amassed over 50 confiscated Protestant

properties after the Battle of White Mountain. Wallenstein grew in power and ambition, to the point of wanting to make himself king, until rumors of a coup reached Ferdinand's ears. The king subsequently had his former favorite killed—run through by an English assassin's halberd—in 1634. Though he was a ruthless megalomaniac, history (and romantic authors such as Schiller) would later turn him into a romantic Czech hero for his rebellion against the Habsburgs.

Always one-upping the rest, Wallenstein built Prague's first monumental baroque complex, demolishing twenty-six houses, six gardens, and two brickworks to do it. Built between 1624 and 1630, it soon became the backdrop for lavish, self-promotional receptions. The design of the palace's main wing, which faces Valdštejnská náměstí, mixes late Italian Renaissance (dormer windows) and northern Mannerism (ornate portals). Designed around a series of courtyards, the interior was mostly decorated in a similar style by Italian artists (much of which was unfortunately remodeled in the 19th century). The grandest room is the Main Hall (Hlavní sál), with its stucco ceiling with a fresco (1630) by Baccio del Bianco depicting a majestic Wallenstein as Mars in his chariot. Now housing the Czech Senate, the palace remained in the Wallenstein family until 1950.

Wallenstein's most impressive legacy, however, is his magnificent formal garden, designed by Andrea Spezza, Nicolo Sebregondi, and Giovanni Pieroni in the early 17th century (last restored in 2000–2001). Modeled on early baroque Italian types, the garden was a place to encounter not only nature, but also fantastic artifice, illusions, and places of mystery; all no doubt of appeal to Wallenstein, a fervid believer in the occult. There is a massive "wall grotto"— a wall made to resemble a cave interior, complete with scary animals and faces. Elements of sound and nature are added with an aviary, wandering peacocks, and a gigantic carp pond add elements of nature.

Visitors were active participants in the theater of the garden. They would act as both spectator and audience to this stage-like space and wander through the geometric parterres and mazes ornamented by fountains and classical

statuary, marveling at Wallenstein's resplendence. Bronze statues by Rudolf II's court sculptor, Adriaen de Vries (copies, as the originals now grace the Swedish Royal Palace since being taken as war plunder in 1648), preside over the path leading to the magnificent *sala terrena* (garden room). This huge, tripartite loggia resembles a triumphal arch leading to Prague Castle, which rises behind it; an obvious architectural expression of Wallenstein's ambitions, for only kings and conquerors created such structures.

Behind the garden's Hercules pond is the 1630 **Wallenstein Riding School** (Valdštejnská jízdárna)**,** now used for temporary exhibitions of the National Gallery (Open Tuesday–Sunday, 10 AM–6 PM).

Gardens below Prague Castle
(Zahrady pod Pražským hradem)

Location: Entrance at Valdštejnská Square 3
Opening hours: daily 10 AM–4 PM, April 1–October 31

Malá Strana contains several historic gardens. In the early 16th century wealthy patricians and burghers bought up the gardens and vineyards on the hill leading up Prague Castle. The new owners transformed the area into Renaissance Italian-styled gardens, which, after the sacking of the city by the Swedes in 1648, were rebuilt in a baroque style with gazebos, terraced gardens, monumental stairways, and fountains. These gardens were for show, where society would gather to admire the affluence of the owners and participate in the theater of the space. Several were linked together, each named for the palace to which it is attached: Ledebour, Small Palffy, Great Palffy, Kolowrat, and small Fürstenberk Gardens. Shoddily restored for use by the communist elite in the 1950s, the *sala terrena*, with murals by V.V. Reiner (18th century), was covered by a socialist realist painting of the 1945 Soviet liberation that in turn has been covered by less controversial climbing plants. The freshly restored gardens are now a pleasant place to relax under a pear tree and admire the serene city views. The Ledebour Palace holds temporary art and history exhibits.

Turn back toward Malostranské náměstí along Tomášská Street. On route note the **House of the Golden Stag** (U zlatého jelena, no. 4), a lovely example of secular architecture in Malá Strana. It was designed by K.I. Dientzenhofer for a wealthy burgher. The façade sculpture of St. Hubert and the Stag is by F.M. Brokoff.

Turn left on Letenská. Immediately to the left tucked into a short lane is the remarkable Church of St. Thomas.

Church of St. Thomas (Sv. Tomáše)

Location: Letenská 12

Opening hours: Services only, although its doors are sporadically open for visitors.

Even in this restricted space, the façade of huge scrolls and broken pediments (dating from 1617) is a particularly well done example of K.I. Dientzenhofer's Borromini-inspired drama.

The monastic complex dates back to the 13th century but was burned down by the Hussites in 1420. Partially rebuilt in the 16th and 17th centuries, it became fashionable with court circles and many artists and aristocrats were buried here, including sculptor Adriaen de Vries and the defenestrated Catholic councillor Jaroslav Bořita of Martinic. K.I. Dientzenhofer undertook a complete remodeling in 1723–1731, but underneath its baroque flourishes, the church maintains its medieval core.

Inside, there seems to be two churches. One, the lower part of the church, is filled with somber baroque altarpieces, some with glass coffins holding the costumed and masked skeletal bodies of holy figures. The other part soars overhead, with weightless Gothic vaults overlaid with applied baroque decoration: pilasters with Corinthian capitals, delicate stuccowork, and dramatic jutting cornices. A distinct contrast, yet as a whole the interior retains an elegance reflecting its courtly history, and the gracefully sculptured space, particularly in the clerestory and vaults, fully demonstrates Dientzenhofer's ability to evoke movement in architecture.

Paintings by some of the best baroque artists fill the well-crafted space. V.V. Reiner's vivid scenes from the lives of saints Thomas and Augustine decorate the nave ceiling, and his *Four Continents* grace the central dome. There are several works by Karel Škréta: an altarpiece to St. Thomas (1671) in the first bay of the south aisle and paintings of the Assumption and the Holy Trinity (both 1644) in the choir. Dientzenhofer designed the main altarpiece, which holds Peter Paul Rubens' masterful *St. Augustine* and the *Martyrdom of St. Thomas* (the original is now in the Sternberg Palace. See page 185).

For an idea of the church's original form, and to appreciate Dientzenhofer's total architectural transformation, step into the preserved Gothic chamber to the north of the choir, which retains its high, pointed rib vaults and some remarkably distinct Gothic frescoes.

Less commanding but still noteworthy is **St. Joseph's** (Sv. Josefa), which sits close by on Josefská Street. Its simple oval interior is fronted by a Flemish-styled baroque façade and was built for a Carmelite order from Louvain (Belgium) between 1631 and 1691.

SOUTH OF MOSTECKÁ

Return to Mostecká and turn right onto Lázeňská, a street where many sculptors' workshops, including that of Adriaen de Vries, were situated during the reign of Rudolf II. The stagecoach terminus from Vienna was originally nearby and thus the area had several hotels such as the **House at the Baths** (Dům U lázní, no. 6), which accommodated visitors as illustrious as Czar Peter the Great in 1698 and Chateaubriand in 1833.

Maltese Square (Maltézské náměstí) marks the area given in 1169 by Vladislav II to the Order of the Knights of Malta, who were to guard the bridge and oversee river activity. The order's primary task, however, was to care for pilgrims and the sick, and so they created a walled hospice dedicated to the Virgin Mary, which included a church that has come down to us as the **Our Lady Beneath the Chain** (Panny Marie pod řetězem). The fortress-like façade dates from a 14th-

century rebuilding, but the open courtyard behind it is part of the original three-aisled Romanesque basilica and leads into a baroque church (1640–1660) by Carlo Lurago. In the interior (open for services), Karel Škréta's high altar depicts the Virgin and John the Baptist coming to the rescue of the Knights of Malta during the Battle of Lepanto in 1571. Parts of the 13th-century fortifications are preserved by the Devil's Brook and on the south side of Saská Street.

Opposite the church's west façade on Maltézské náměstí is a 1715 plague memorial by F.M. Brokoff featuring St. John the Baptist. Around it are numerous 17th-century and 18th-century palaces. On the west side is the 1767 rococo **Turba Palace** (Turbovský palác, no. 477/6, now the Japanese Embassy) and to the south is the **Nostitz Palace** (Nostický palác, no. 471/1, now the Czech Ministry of Culture). Created by Francesco Caratti and Carlo Lurago in 1662–1675, the early baroque façade contrasts nicely with the 1762 rococo portal, highlighting the evolution of the baroque. It was built for the Counts Nostitz, the Supreme Chamberlains of Bohemia, and major patrons of art whose collections are now part of the National Gallery.

Return back toward the Knights of Malta Church and turn right toward Velkopřevorské náměstí (Grand Prior's Square). Immediately to the left at no. 485/4 is the **Palace of Grand Prior** (the leader of the Knights of Malta), which dates to the 13th century and was redesigned several times until it finally took its baroque form in 1725–1726 under architect Bartolomeo Scotti. Along the southern wall is the famous **John Lennon Wall**, a dissident symbol spontaneously created in 1980 following Lennon's death and added to many times since. Opposite is the 1736–1748 **Buquoy Palace** (no. 486/2) now the French Embassy. Go west across a small bridge next to the **Grand Prior's Mill** (Velkopřevorský mlýn), a Renaissance building with a medieval waterwheel, one of several mills that formerly dotted Kampa Island. Walk south through the Kampa Island park to one of the city's most exciting new museums, **Museum Kampa**.

Museum Kampa

Location: U Sovových mlýnů 2, Kampa
Contact details: www.museumkampa.cz
Opening hours: Open 10 AM–6 PM daily

Perhaps the most beautifully situated art museum in Prague (a very stiff competition), the Museum Kampa is a redesigned mill dating to the 14th century, set on the Vltava and near Charles Bridge. The interior is a wonderful, light-filled space, ideal for viewing the modern central European collections of the Czech-American couple Jan and Meda Mladek.

Described as a "baby Guggenheim," the museum is essentially divided into two parts: a section of works by two of the most important Czech artists from the early 20th century, František Kupka and Otto Gutfreund; and a section of works dating from the 1960s by Czech and other former eastern European artists. The Mladeks purchased the latter over decades in an attempt to help artists suppressed by the communist regime by buying pieces and exhibiting them abroad. Since 1989, Meda Mladek has continued to build her collection and worked to create the museum, which was to open in 2002, only to be nearly washed away in that year's floods. It finally opened to much acclaim in 2003.

The museum's main building has two wings. The northern wing holds the works of Kupka and Gutfreund. The other wing that runs parallel to the Vltava, along with a second, one-story building connected by a glass bridge, contains the collected works of modern central European artists. A separate building in the courtyard holds temporary exhibitions of contemporary art.

Modern Central European Art

The entrance leads into the ground floor exhibition halls where the section on Modern Central European Art begins. Many of the artworks created before 1989 reflect the alienation, solitude, and dehumanization of life and art under totalitarianism. They are echoes of a constricted age when artists created in private and exhibited secretly, telling truths that could not be said in public. The following expands on a few of the many exceptional works.

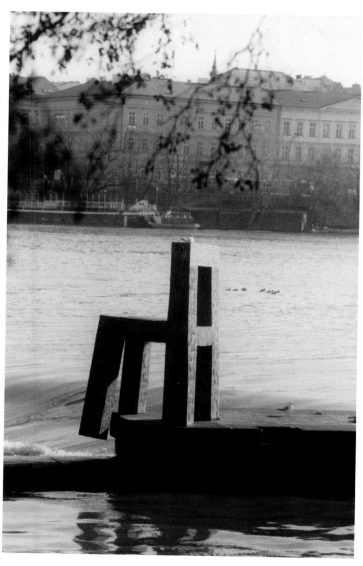

Magdalena Jetelova, Chair, 1980s, Museum Kampa, Prague

Karel Nepraš (1932–2002)
Family (Rodina), 1967–1969

One of Nepraš's most monumental works, this industrial sculpture of a "family" of seven red figures is somewhere between human and machine, inside and out. Nepraš was part of the "Unofficial" art scene (as opposed to the "Official" art produced for the state) from the late 1950s. His work often has an element of the grotesque and/or absurd, which provokes a kind of relieving humor and reflection. Highly influenced by the Capek's idea of the robot, he explores the automated, often amoral responses provoked by totalitarianism. "I did not look at the human tragedy directly," said Nepraš in 1995, "but again through that fracture of some absurd situation."

Aleš Veselý (1935–)
Chair, 1974–1978

An artist of the "Unofficial" generation, Veselý, who also does illustrations and drawings, is best known for his abstract sculptures of non-traditional materials (metal, wire, textile, etc.) or "debris," with which he creates an "authentic reality." This piece is a terrifying half-human/half-machine vision, the chair comprised of menacingly jagged metal pieces, resembling a nightmarish torture device. Veselý is still active in the art scene in Prague and internationally; see www.ales-vesely.cz.

Magdalena Jetelová (1946–)
Chair, 1980s

Set outside on a breakwater in the Vltava River, Jetelová's enormous wooden *Chair* is visible from the windows. It seems to be walking away, as if tired of waiting for some unseen giant to come take a seat. Both amusing and unsettling, it displays Jetelová's characteristic preoccupation with the "magic of things." Her voluminous everyday objects—doors that don't close and stairs that can't be walked up—are like living objects and prompt a revaluation of perception and reality. The *Chair* gained unexpected notoriety in the 2002 floods when it was

washed 35 kilometers downstream. The first floor galleries present another Alice-in-Wonderland-like *Chair*, this time a functionally sized, but quixotically angled wooden armchair. (See www.jetelova.de for her latest.)

The next exhibit room is reached by walking across an enclosed clear glass bridge, disconcertingly placed above a shimmering, manmade rivulet.

Magdalena Abakanowicz (1930–)
Figures, 1985

Considered Poland's greatest living artist, Abakanowicz is famed for her ability to transform natural and found materials into sculpted work of great expression and monumentality. In the 1970s she began to create figures made of burlap, sisal, glue, and resin over plaster casts. *Figures* is a cluster of such figures—faceless, backless, and hollow life-sized individuals—expressing the zombie-like anonymity of the collective. Each of her figures is unique, imprinted with the artist's fingerprints, their surface natural like tree bark or skin. There is a dignity to the figures but also a feeling of loss, of the submersion of the self in the crowd. The meaning is ambiguous, meant to be the personal experience of the viewer. (For more, see www.abakanowicz.art.pl).

Jiří Kolář (1914–2002)
Double Portrait (1969)

Kolář created several types of intriguing collages from printed matter—books, newspapers, maps, reproductions of art. One type, of which *Double Portrait* is an example, is called "chiasmage." Torn fragments of typeset words are arranged at random or in a pattern (here a spiral) and applied to either a flat surface, object, or, as here, a relief image. The disintegrated text, randomly reassembled, gains a new and more complex meaning. Kolář, a founding member of the avant-garde Group 42 (Skupina 42), created experimental poetry and surrealist-inspired collages and was briefly imprisoned for subversion in

1953. The Mladek's collection has 240 pieces by Kolář from the 1940s to the '70s, which it hopes to display more fully in the future.

Adriena Šimotová (1924—)

Drooping II, 1984
Submersion, 1984
Fear, 1984

Born to a Czech-French Swiss family in Prague, Šimotová studied art and became part of Prague's unofficial art scene in the 1960s. She began as a painter but later altered her use of the canvas; she used canvas, glass, mesh, and often paper as not simply a material vehicle of the visual message but as an expression unto itself. Cutting, tearing, layering, imprinting, etc., she used her material in a quest to represent the transparency of human existence. She saw her works not as having definitive meaning but rather as a conversation and herself as a mediator who "paves the way" to understanding. Her work has no precedent and is original, authentic, and very personal. These three figures jaggedly drawn on, and torn into, layers of paper, hang side by side, almost as a triptych, their fragmented forms and layers suggesting the title words.

Walk up the modern, open stairwell—which is also hung with art—to the first floor, a light, airy space overlooking the Vltava. The rooms display several conceptual and minimalist pieces. One of the most intriguing and cleverly placed is:

Radek Kratina (1926—1999)

Threaded Discs (Disky se závitem), 1976

This is a deceptively simple creation: a glass sphere with three magnifications. Yet look through it and experience a distortion of reality, a questioning of one's own senses. Placed before a window overlooking the river and city it becomes a monumental trompe l'oeil, turning the city into a collage of itself. Adding an extra surrealist touch, sitting just outside on the Vltava is Magdalena Jetelová's *Chair*. There are other earlier works by Kratina in white

wood mobile-like structures, such as *White Sticks in Six Fields* (1966–1967).

Wander outside to appreciate the view from the terrace and then continue up to the next floor.

Kupka and Gutfreund

Return to the floor below and enter the galleries devoted to František Kupka (1871–1957) and Otto Gutfreund (1889–1927). Although stylistically divergent, each was an important pioneer of Czech modern art. Kupka was a leading figure of the avant-garde and a pioneer of abstract art, credited with exhibiting the world's first abstract painting. The Kampa Museum's extensive collection of his work (over 200 pieces) ranges from Kupka's student days to his late minimalist abstract work, showing his extraordinary artistic breadth. A brilliant draftsman and colorist, he evolved through several styles, from art nouveau to symbolism to abstract expressionism, all the while developing his belief that color and line were all that was needed for expression.

Gutfreund was an avant-garde sculptor who explored the poetic aspect of everyday life in three-dimensional form, most famed for his cubist work before World War I. The collection focuses on his bronze cast cubist works (1911–1914) as well as a few examples of his post-war, lyrically realist sculpture (1923–1927).

The exhibits begin with Kupka's early drawings and studies for graphic works that show him to be a natural draftsman and colorist. By the first decade of the 20th century, his work begins to move toward abstraction.

Gigolette: Io, the Cow (Io: La Vache), 1910

This colorful outline of a haughty dancing girl reflects Kupka's growing conviction that expression required only line and color, a concept he explores through the Gigolette series. This is particularly evident in the loosely drawn and vibrant *Study for a Dancing Gigolette*, c. 1909.

The same room also holds Gutfreund's sculpture from his cubist period (1911–1914) and post-cubist (1923–1927). In *Concert*

(1912–1913), he reduces the players and their instruments to molded cubist forms—all angles and protrusions—in order to capture the spirit and motion of the music. Whether in cubism or his later work in the "Social Civil" style (a sort of folksy realism popular in the optimistic years following Czechoslovakian independence in 1918), Gutfreund always sought to express the essence of things, such as in *Girl Looking Up* (1924), a bust depicting just that.

In the next room are a number of Kupka's early works such as a very Mucha-esque design for an advertising poster (*Demandez Partout Celluloid*, 1906) and the eye-catching *Study for Prometheus* (1908–1909), which is all orange and purple fire, nearly reduced to pure color. The following rooms explore Kupka's early abstract work.

The Fair, 1912–1913
Kupka drew inspiration from many sources. In this striking image of color and vertical line, it is the human body and its movements that inspire him. The image is almost a kaleidoscope, bristling with movement, line, and color. One can sense, rather than see, the bustle of human bodies at a fair.

Nearby, Gutfreund's full-length figure of *Hamlet* (1912–1913) is positioned as if to gaze upon and contemplate this vibrant scene. Another literary figure, *Don Quixote* (1911–1912), is found nearby. Gutfreund presents the comic hero with humor and empathy in an almost deflating cubist bust.

Warm Chromatics, 1911–1912
Kupka had three paintings selected for the 1912 Paris Salon de la Section d'Or, which also featured works by Picabia, Duchamp, Brancusi, Delaunay, and Picasso. Two, *Warm Chromatics* and *Fugue* (which today is in the Trade Fair Palace) were the first ever exhibited examples of abstract expressionism. In attempting to create analogies of music in painting, Kupka's imagery evolved into abstract compositions of imaginary music, architecture, and cosmic visions of creation and

origins. Acknowledged at the Salon as a revolutionary development, avant-garde poet Guillaume Apollinaire stood before Kupka's paintings and introduced his concept of orphism which he described as "the art of using elements which have not been borrowed from visual reality, but have been entirely created by the artist, and which have been endowed by him with a powerful reality."

Going up the spiral staircase, you will find many examples of Kupka's later abstract work, one of the most arresting being *The Cathedral* (1912–1913). Inspired by music, the painting presents a magnificent breakdown of stained glass and soaring stone walls reduced to an angular essence, using a distinct color palette of red, blue, black, and brown. Also look out for Gutfreund's chilling and aptly entitled *Anxiety* (1911–1912) and the *Cellist* (1912–1913), another exploration of the movement of music, fusing instrument and musician in cubist fragment. End your visit by climbing to the glass-cube balcony at the top of the stairwell for more splendid views.

Leaving the island from the southern side, turn right on Říční Street, where at the corner of Všehrdova sits the tiny **Church of St. John the Baptist at the Wash-House** (sv. Jana Křtitele na Prádle), named in reference to the generations who washed their laundry here on the banks of the Vltava. A simple 13th-century church with fragmented 14th-century frescoes within, it is enclosed in a courtyard complex built as a hospice in 1662. Walk along Všehrdova past the **Michna Palace** (Muchnův palác, no. 40), the 16th-century summer palace of the Kinský family. After the Battle of White Mountain it was acquired by the Catholic-supporting Michna family, who had it remodeled by Francesco Caratti (1640–1650). It now belongs to the Sokol Physical Education Association.

Turn right on Újezd, which becomes Karmelitská, to the **Carmelite Church of Our Lady Victorious** (Klášter Prazského jezulátka). Built for German Lutherans in 1611–1613, it was handed over to the Carmelite order in 1624, who rebuilt the church in pale emulation of Il Gesu in Rome

as a thanksgiving for the Habsburg victory at White Mountain. Architecturally unremarkable, it nevertheless attracts tourist crowds to see a 16th-century wax figure from Spain of the infant Christ, oddly called the Bambino di Praga. Presented to the church in 1628 by Polyxena of Lobkowicz, it has gained a miraculous reputation as well as an absurd wardrobe; it is dressed in various costumes, much like a Barbie, for special occasions. Artistically of interest are several altarpieces by Petr Brandl.

Further along, tucked in behind the **Vrtba Palace** (Vrtbovský palác, no. 25) is a wonderfully hidden terraced garden (Vrtbovská zahrada) dating from 1631 and redesigned by F.M. Kaňka in 1720. The entrance courtyard has a statue of Atlas by Mathias Braun and inside, the *sala terrena* is painted by V.V. Reiner and from the top terrace there are lovely views. A plaque on the entrance notes that the Czech painter Mikolaš Aleš lived here between 1886 and 1889.

UP TO THE CASTLE

There are three principal routes to the Prague Castle. All involve a steep walk up picturesque streets. Though the distances are not long and could be walked in less than half an hour, allow more time to enjoy the dazzling views.

Route One: The Royal Route

One of the most visually pleasing of streets in a scenic city, Nerudova runs up from the upper west end of Malostranské náměstí. Formerly called Spur Street, for the brakes used by coachmen on the precipitous road, it was renamed in 1895 for the Czech poet and journalist Jan Neruda who spent his youth here. The street is lined with 16th- to 18th-century palaces and burgher's houses rich in period details: house signs, ornate portals, and sculpture.

In 1713–1714, Jan Blažej Santini-Aichel combined five Renaissance buildings behind a baroque façade to create the **Morzin Palace** (Morzinský palác, no. 5), the present-day Romanian Embassy. Taking the slanting site into account, Santini-Aichel cleverly articulated the façade with pilasters

and bays in several individual sections, following the lines of the original buildings. Representing day and night, a pair of portals (one blind) by F.M. Brokoff balances the composition, as does a pediment that draws the viewer's eye up. Brokoff also provided the feather-costumed moors (the patron's heraldic symbol), that support the balcony.

Santini-Aichel also designed the **Thun-Hohenstein Palace** (no. 20/213) built in 1716–1721. Note the architect's characteristic jutting pediments, unique shape combinations and the portal with the exceptional sculptures of contorted eagles by Mathias Braun. Santini-Aichel also worked from 1706–1717 on the adjoining **Church of Our Lady of Unceasing Succor and St. Cajetan** (Panny Marie ustavičné pomoci u Kajetánů, no. 24), which was built between 1691 and 1703 by Jean-Baptiste Mathey.

The names of many middle-class buildings reflect their baroque house signs: the **House at the Red Eagle** (U červeného orla, no. 6); the **House at the Three Fiddles** (U tří housliček, no. 12), home to the Prague violinmakers, the Edlingers; the **House at the Golden Goblet** (U zlaté číše, no. 16), a 17th-century goldsmiths; the **House at the St. John of Nepomuk** (U sv. Jana Nepomuckého, no. 18); the **House at the Golden Key** (U zlatého klíče, no. 27); the **House at the Golden Horseshoe** (U zlaté podkovy, no. 34) presenting a horse-riding St. Wenceslas with a real horseshoe; and the **House at the Two Suns** (U dvou sluncǔ, no. 47), home of Jan Neruda from 1845 to 1857.

Just before turning sharp right up to the castle, photography enthusiasts may wish to take a short detour up Úvoz to the tiny **Josef Sudek Gallery** (no. 24, open Wednesday to Sunday, 11 AM to 7 PM May to September, 11 AM to 5 PM for the rest of the year). Set in the 1709 building where celebrated Czech photographer Sudek lived from 1959 to 1976, the gallery is an offshoot of the Museum of Decorative Arts and holds temporary exhibitions on Czech photography.

Route Two: Castle Steps

The shortest and steepest route is via the Castle Steps (Zámecké schody), which were first built in the 15th century along a 13th-century path. Buildings sprang up along it in the 16th century, and merchants would ply their wares from the wide stone ledges of the windows. From the northwest of Malostranské náměstí turn right on Zámecká Street to Thunovská and then left up the stairs. En route is the lovely gabled **Palace of the Lords of Hradec** (Palác pánů Hradce, Thunovská 25), connected to the stairs by a Renaissance door. Built by a powerful southern Bohemian family as their Prague residence in the late 16th century, its prized location reflects the Hradec's courtly prominence. Aristocratic families vied for prime real estate close to the king, resulting in a high concentration of grand architecture within the castle's orbit. Don't forget to take a breather and turn to admire the rooftop views.

Route Three: South of Nerudova

The third route up is via Tržiště and Vlašská streets, skirting the edge of Petřín Hill. Calm compared to busy Nerudova, these cobblestone streets are no less atmospheric, with surprisingly pastoral views over Petřín Park. Tržiště begins at Karmelitská just south of Malostranské náměstí. Conspicuous for its heavy security is the elegant **Schönborn Palace** (Schönbornský palác), now the American Embassy (no. 15). Built in 1656 on the site of five earlier houses by the Counts Colloredo-Walsee, the military commanders of Prague during the Thirty Years' War, the palace was remodeled in 1712 based on plans by the ingenious Santini-Aichel. The 17th-century gardens are closed to the public.

You now have three choices. Tržiště veers off to the right eventually leading back to Nerudova. Alternatively, walk up narrow Břetislavova, which was lined with brothels for many generations, and turn right up twisting Jánský vršek Street to join Nerudova. Or continue slightly to the left along Vlašská to the stately **Lobkowicz Palace** (Lobkovický palác, no. 19), built in 1702–1704 for the evidently prosperous Master of the

Bohemian Mint. It is now the German Embassy. The design by G.B. Alliprandi was inspired by Bernini's unrealized plan for the Louvre in Paris, with a dynamic façade of convex–concave curves and dynamic wings. Sadly closed to the public, the embassy's panoramic gardens feature David Černý's *Quo Vadis?* (1990)—a Trabant (an East German-manufactured car) on legs in homage to the East Germans who flooded west in the heady days of 1989.

From here Vlašská opens up on to Petřín Hill, with paths leading up to Strahov Monastery (see page 194) or into **Petřín Park**. Petřín was first enveloped into Malá Strana by Charles IV, who in 1360–1362 erected the Hunger Wall (Hladová zed)—so named because its construction provided work for famine-stricken peasants— as the district's southeastern boundary. The hill was cultivated with vines until the 18th century, although in troubled times following the Thirty Years' War it became a treacherous spot filled with robbers. In the 19th century Petřín was transformed into as a public park and today remains a wonderful place for a bucolic urban stroll. The oldest structure on the hill is the Romanesque **Church of St. Lawrence** (Sv. Vavřinec) near its peak, which was remodeled in the 18th century. Standing incongruously nearby is a miniature Eiffel Tower, added along with the funicular for the Jubilee Exhibition of 1891.

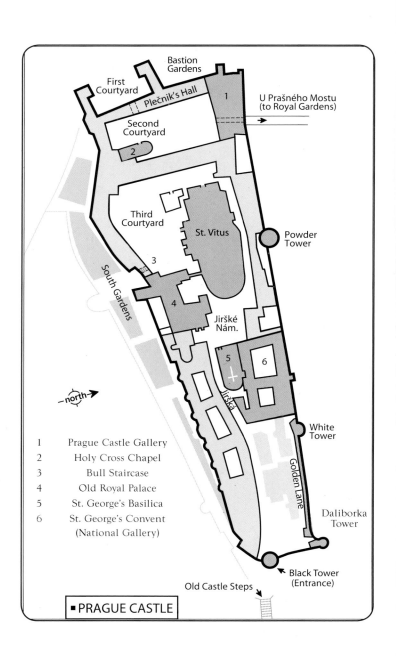

Bastion
Gardens

First
Courtyard

Plečnik's Hall

1

U Prašného Mostu
(to Royal Gardens)

Second
Courtyard

2

Third
Courtyard

St. Vitus

Powder
Tower

South Gardens

3

4

Jirˇské
Nám.

5

6

Jiřska

—north→

White
Tower

Golden Lane

1 Prague Castle Gallery
2 Holy Cross Chapel
3 Bull Staircase
4 Old Royal Palace
5 St. George's Basilica
6 St. George's Convent
 (National Gallery)

Daliborka
Tower

Black Tower
(Entrance)

Old Castle Steps

■ PRAGUE CASTLE

Trail 3:
Prague Castle

A spell hangs in the air of this citadel and I was under its thrall long before I could pronounce its name.

—Patrick Leigh Fermor, *A Time of Gifts* (1977)

Most visitors' first glimpse of "the Castle" ("hrad" in Czech) is often as a hazy silhouette of bastions and Gothic spires rising above the red rooftops of Malá Strana. Depending on your frame of mind, it can seem like a fairytale palace or a sinister specter, and indeed it has been both. Home at various times to medieval kings, eccentric emperors, Nazi invaders, and playwright presidents, the castle has reflected the fortunes of the city. Today, it holds some of the city's most impressive art and architectural treasures, such as the remains of Rudolf II's collections, Bohemian baroque art (displayed in the Romanesque St. George's Convent), a fascinating exhibition of the story of Prague Castle (the palace complex itself features the work of many great architects), and the iconic Cathedral of St. Vitus. Plan at least half a day to explore the castle and its gardens, but more if you wish to visit the museums. For walking directions to the castle, see the last section of Trail 2.

HISTORY OF THE CASTLE

The first ruler to fortify this hill above the Vltava was Přemyslid Prince Bořivoj I, who in the late 9th century moved his stronghold here from Levý Hradec a few miles downstream. He built a modest timber residence and the stone Church of

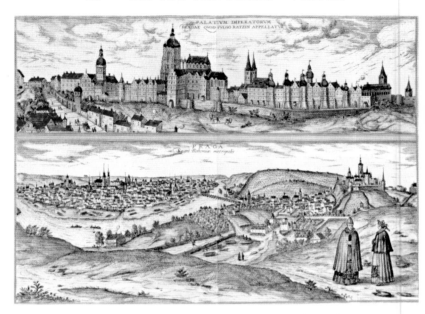

Czech school, view of Prague showing (above) Prague Castle (Hradčany) and (below) the Vlatva River, 17th century (engraving), private collection

the Virgin Mary, the second Christian structure in Bohemia, whose foundations are still visible today in the passageway to the Bastion Garden. In the early 10th century, St. George's Basilica and the Rotunda of St. Vitus were constructed, and in 973, after Prague became a bishopric, a convent was added to St. George's. Stone fortifications and gates replaced earthen ramparts around 1141. From 1067–1139 the princely capital moved to Vyšehrad, but on its return, Soběslav I rebuilt the fortifications (whose lines are roughly those of the citadel today) and added a limestone palace.

Otakar II would make improvements, but it wasn't until Charles IV and his architect Peter Parler that the castle was transformed into an imperial residence and the seat of the new archbishopric, beginning the Gothic St. Vitus Cathedral. The castle remained the seat of government even after Wenceslas IV moved his residence to the Royal Court in the Old Town (on

the spot of today's Municipal House). Jagiellon King Vladislav II returned the royal residence to Hradčany in 1484, bringing in Benedict Ried as castle architect to rebuild and expand the palace and the fortifications; both much needed, practically and symbolically, considering Prague's rebellious past. Ried gave the palace its first Renaissance elements and created Vladislav's Hall. Vladislav later moved his capital to Buda, but the Habsburg rulers returned to Hradčany in 1526, turning it into an impressive Renaissance complex, adding royal gardens to the north of the Stag Moat with an Italianate Summer Palace (Belvedere) and ball-game court that was completed under architect Bonifác Wohlmut. The castle's most colorful period was as Rudolf II's imperial capital. Rudolf expanded the castle to the west to house his growing art collections, and his successor Mathias added the triumphal arch-shaped Mathias Gate in 1614. But only four years later two Catholic ministers would be thrown from a palace window, launching the Thirty Years' War and the decline of Prague Castle to a secondary residence. The castle would be occupied several times over the following decades and only after the Prussian siege of 1757 would Empress Maria Theresa initiate a rebuilding campaign, led by her court architect Niccolo Pacassi. He removed the post-medieval silhouette of towers and turrets and replaced it with a rather austere framework influenced by Viennese late baroque and French neo-classicism, a style the palace retains today.

The last Bohemian king, Ferdinand V, was crowned here in 1836, but the castle was generally disregarded until the Czech National Revival spurred a desire to complete St. Vitus Cathedral and to make the castle the seat of the Czechoslovak president. The first president, T.G. Masaryk, employed Josip Plečnik in the 1920s to remodel the exteriors and interiors of the palace to fit its modern, democratic function. Franz Kafka's vision of a faceless bureaucratic tyranny described in *The Castle* (1926) was sadly prophetic of the long Nazi and communist years when the castle became a symbol of the totalitarian state. But after 1989, under President Václav Havel, the castle gained a human face, becoming a center of cultural life and a proud symbol of Bohemia's long history.

First Courtyard

Begin your tour of the castle from Hradčanské náměstí (Castle District Square). Once defended by moats and a ravine, the castle entrance is now purely ceremonial. The gate leading into the First Courtyard is a rococo grille with the initials of Maria Theresa and Joseph II flanked by two huge sculptures, *Battling Giants* (copies of the 1771 originals) by Ignác Platzer. The Roman-style triumphal arch of the **Mathias Gate** (Matyášova brána) is directly ahead. Based on designs by mannerist architect Vincenzo Scamozzi, it was originally built in 1614 as a standing structure but was incorporated into the palace's new west façade, built to the late baroque designs of Pacassi in 1763–1771. The 82 ft/25 m tapered flagpoles of Moravian fir were part of the additions of Plečnik, who also placed two doors to either side of the Mathias Gate, reducing that Habsburg symbol's importance by laying two paths of dark paving stones leading to the smaller doors. Inside the gate to the right, an 18th-century ceremonial staircase leads up to state reception rooms, and to the left a glass portal affords a view of Plečnik's remarkable **Hall of Columns** (Sloupová síň), built in 1927–1931 with a copper-paneled ceiling and walls lined with three levels of Ionic columns.

Plečnik also laid out the formal modernist **Bastion Garden** (Zahrada na Baště) found just to the north of the First Courtyard. Set on two levels linked by a circular staircase, the gardens can be reached directly from the northwest corner of Hradčany Square or via a passageway (which has a glassed wall revealing the foundations of the 9th-century Church of the Virgin) from the Second Courtyard.

Second Courtyard

Dating to the 16th century, the Second Courtyard's present appearance reflects Pacassi's elegant, if perhaps somewhat monotonous, design, which included the 1756–1763 Chapel of the Holy Cross (Kaple svatého kříže), constructed

by Anselmo Lurago and today housing an information office and bookstore. At the courtyard's center is a baroque fountain with statues of Hercules and other mythological figures (1686). The southeast area of the courtyard houses the presidential and administrative offices, with rooms dating to 1534 behind the 18th-century façade. On the east side, which runs along the line of the earthen rampart that separated the early Přemyslid stronghold from its outer bailey, is a doorway that looks as if it might be out of Star Trek (1995–1997), by Czech architect Bořek Šípek (b. 1949), who has completed several post-1989 renovations. It features a golden statue, the *Flying Panther* by Michal Gabriel, and leads to the president's offices. The Spanish Hall (Španělský sál) and the Rudolf Gallery (Rudolfova galerie), closed to the public, are found on the upper stories of the north side; both date to the 16th century but were redesigned in a neo-baroque style in the 1860s for the coronation of Emperor Franz Josef I, who never showed up. Below these are the former Imperial Stables, which house the Prague Castle Gallery displaying paintings associated with Rudolf II's collections.

Josip Plečnik (1872–1957)

This idiosyncratic figure of modernist architecture was one of Otto Wagner's best pupils, who, after a successful career in Vienna, came to Prague in 1911 to teach at the Prague College of Applied Arts. In 1920 President Masaryk gave Plečnik the task of turning "a monarchical castle into a democratic" one. Instead of using the popular Czech "national style," or making any reference to folk art or art deco, he took inspiration from "timeless architecture," e.g., from ancient Greece, Roman, Egypt. Although Masaryk liked his work, his opponents didn't: it was too unorthodox and Plečnik wasn't even Czech (he was from Slovenia). Taste, however, is rarely constant through time, and today Plečnik's renovations are considered an ingenious proto-postmodern synthesis.

Prague Castle Gallery (Obrazárna Pražského hradu)

Location: Northwest side of the Second Courtyard of Prague Castle
Contact details: (420–2) 2437 3368, www.hrad.cz
Opening hours: Daily 10 AM–6 PM, closed Mondays

The emperor's chamberlains, Hans von Aachen and Bartolomeus Spranger, both truly outstanding in the art of painting, led me to three castle rooms, and showed me there the most splendid paintings, old and new, and the rarest that one will ever see these days anywhere in Europe.

 —A visitor to Rudolf II's court (1597)

Rudolf II was one of the greatest of the Habsburg art collectors, amassing over 3,000 of some of the best and rarest art in Europe. Inheriting a love of great painting at the court of his uncle, the Spanish King Philip II, Rudolf later inherited court artists and Viennese collections from his father, Emperor Maximilian II. But Rudolf had a passion for collecting that went beyond the Habsburg traditions of patronage as a method of promoting family prestige and power. Rudolf sent agents throughout Europe purchasing and providing him with information on interesting art. For example, his court painter and chamberlain, Hans von Aachen, was sent to the courts of Italy to buy artwork and report on what others were collecting. Rudolf commissioned works directly from the likes of Tintoretto and Veronese, and when he decided he must own Dürer's *Feast of the Rose Garlands* (a 1505 masterpiece that hung in the German merchant's church in Venice; today it hangs in the Sternberg Palace) he entered into complex negotiations to buy it and have it carried across the Alps. Those seeking his favor, from diplomats to his own family, would know to send him gifts of art. Other agents recruited painters such as Giuseppe Arcimboldo and Bartholomeus Spranger for his court. The artists were set up in studios, sometimes in the castle, where Rudolf visited them regularly, offering opinions on their latest works.

However, after his death in 1611, the collections were dispersed: some went to the court in Vienna; some were stolen by courtiers; while others were plundered by invaders, notably by the Swedes in 1648, who took 600 priceless paintings, often slicing them from their frames. They left behind some works—

such as Dürer's *Rose Garlands*—which were of little interest to their Queen Christina, who preferred Italian works.

Ferdinand III built up the collection again, in part with 200 or so works bought at an 1648–1649 Antwerp auction of the collections of the infamous Duke of Buckingham. The collection again grew, with masterpieces by Titian, Rubens, Holbein, Bruegel, and others. However, in 1721, Charles VI began to take the better artwork to Vienna, and in 1782 Josef II held an auction to sell off others. Artwork continued to leave Prague, and by 1918, new President T.G. Masaryk needed to create a fund to acquire art to decorate the castle walls. When the communists took power, they ended the fund and removed objectionable artwork such as "elitist" avant-garde works (e.g., cubism) and religious works (e.g., Veronese). However, in 1965, in the more open days of the early Prague Spring, the Prague Castle Gallery opened, albeit with a less stellar collection than in Rudolf's time.

Today's collection is housed in the gracefully vaulted Imperial Stables built by Rudolf II in 1586, just below the two "New Halls"—today the Rudolf Gallery (1597–1598) and Spanish Hall (1602–1606)—Rudolf built to house his art collections. In the 1920s Plečnik redesigned the stables, although it was his assistant, Otto Rothmayer (1862–1966), who completed the work between 1947 and 1952. Inadequate renovations in the 1960s necessitated remodeling in 1995–1997, this time by Bořek Šípek, who incorporated the surviving work of Plečnik and Rothmayer into his own postmodern designs.

The gallery is divided into five rooms and the following expands on some of the most noteworthy pieces.

Room 1

Peter Paul Rubens (1577–1640)
Assembly of the Gods at Olympus, c.1602
A celebrated artist, diplomat, and intellectual, Rubens was the most important Flemish painter of his time. He began and ended his career in Antwerp, but from 1600–1608 he worked in Italy as court painter to the Dukes of Mantua. Dating from this early period, this

painting depicts the dispute between Juno and Venus before the Olympian gods, although the subject is clearly an excuse to depict an assortment of fleshy Rubenesque beauties and theatrically posed gods. The young Rubens's energetic baroque style blends northern realism with Italian grandeur, warm color and light. This picture is recorded in Prague before the Swedish siege of 1648, and probably survived by being part of a ceiling painting.

Bartholomeus Spranger (1546–1611)
Allegory of Triumph of Fidelity over Fate—Allegory of Life of Hans Mont, 1607

Spranger painted this late mannerist allegory of the life of his friend, sculptor Hans Mont, while Rudolf II's court painter. Born in Antwerp, Spranger studied in Italy, where he met Netherlander Mont and together, on the recommendation of Giambologna, the two artists were invited first to Vienna in 1576 by Maximilian II and later to Prague by Rudolf. There Mont's eye was injured in a game of tennis, leaving him unable to work. He left the court in the 1580s and all traces of him vanish. For some unknown reason, in 1607 Spranger choose to commemorate his friend with this image based on one of Mont's sculptural designs. The painting became part of Rudolf's collections and is characteristic of Spranger's late work with expressive color and an unusual, moralizing theme.

Hans von Aachen (1551/2–1615)
Portrait of Emperor Mathias as King of Bohemia, c. 1611 and *Head of Girl,* 1611

Painted in the same period, these two very different portraits show von Aachen's versatility as a portraitist. First trained by a Flemish painter in his native Cologne and later in Italy, in 1592 von Aachen came to Prague as court painter to Rudolf II, who loved his elegant mannerist style. After Rudolf's death, he became Emperor Mathias's official portraitist and here depicts

Mathias in his favorite Hungarian robes (he had been king of Hungary since 1608), right arm akimbo and left hand possessively on the crown of Bohemia, which he received in 1611. The other image is an intimate portrait of the artist's daughter, Marie Maximiliana, who looks out at the viewer with startling directness, capturing more than a mere physical resemblance. This painting is listed as part of the castle collection from 1685.

ROOM 2 (TO THE LEFT OF ROOM 1)

Peter Paul Rubens (1577–1640)
The Annunciation, c. 1610–1612
This charming painting shows a Rubenesque Virgin Mary bathed in golden light as the angel Gabriel tells her she will bear the Son of God. Rubens returned to Antwerp in 1608 where his successful workshop produced everything from altarpieces to mythological works to designs for tapestries for the ruling elite of Europe. This was a small study for a larger work (today in the Prince's Gate Collection, London) and would have been used as a guideline for Rubens and his assistants. But its quality is clear from the fact that it is recorded as hanging in the emperor's study at Prague Castle in 1685.

Lucas Cranach the Elder (1472–1553)
Saints Catherine and Barbara (plus partial saints Dorothy and Margaret), 1520–1522
Although emperor of a Catholic empire, Rudolf II liked and collected Old German masters and owned several works by Cranach (such as *Lady with an Apple,* 1526, in this room), who was court painter to the electors of Saxony and a good friend of Martin Luther. This painting, however, was probably commissioned by King Vladislav II or by provost Arnošt of Šlejnice. It is a fragment of Cranach's *Prague Altarpiece* depicting the Virgin and Child enthroned with female saints, which was made for the Chapel of St. Sigismund in St. Vitus Cathedral, and ripped apart by iconoclastic

Calvinists in 1619. The remaining fragments (another is in the Sternberg Palace) were placed in the Rudolfine Gallery in 1619 and luckily left untouched by invading Italophile Swedes in 1648. The two saints are elegantly dressed blondes (very typical of Cranach) kneeling at what would have been the Virgin's feet.

ROOM 3

This antechamber, designed by Plečnik and Rothmayer, leads to the original Imperial Stables (Rooms 4 and 5).

ROOM 4

Jacopo Robusti, called Tintoretto (c. 1519–1594)
The Flagellation of Christ, 1570s

Nicknamed "the Little Dyer" (Tintoretto) for his father's humble profession, Tintoretto became one of the most prolific painters in his native Venice, gaining a reputation for his dramatic, colorful mannerist style and quickly executed, painterly works (although some criticized him for lack of finish). Legend claims that he apprenticed with Titian, who jealously expelled his talented student after ten days. He painted mostly religious subjects, often with surprising viewpoints, striking perspective, and elements of everyday life. This freely painted scene, depicting Pilate's soldiers whipping and mocking Christ after his arrest, is from Tintoretto's later career, and uses dramatic light to highlight the scene's pathos. It came to Prague Castle as part of the Buckingham collection.

Paolo Caliari, called Veronese (1528–1588)
Portrait of Jakob König, c. 1575

Veronese was one of 16th-century Venice's most important painters (along with Tintoretto and Titian). An artist in every sense, he was once brought before the Inquisition for including "buffoons, drunkards, dwarfs, Germans and similar vulgarities" in a painting of the Last Supper, and defended himself by citing an artist's right to creative freedom. Known for his altarpieces and

decorative cycles in chapels and palaces, he also did portraits, such as this of his friend, a German art dealer and goldsmith living in Italy. Veronese depicts him as a vigorous man whose presence fills the canvas, but with a rather introspective look upon his face. König was a buyer for Rudolf II and visited Prague in 1586, where his family later settled. König's son, Hans, either gave or sold this portrait to Rudolf, along with his father's collection of self-portraits by famous artists.

Tiziano Vecellio, called Titian (c. 1480—1576)

Young Woman at her Toilet, 1512–1515

One of the greatest artists of his day, Titian was a court painter to both Charles V and Phillip II of Spain. Rudolf II came to know his work in Phillip's court and collected many of Titian's paintings. This image of a young woman dressing with her servant, however, is first noted in the castle inventory in 1781. From Titian's early career in Venice, this painting's solid, graceful forms and expressive light, hues, and textures show the influence of his teachers, Gentile and Giovanni Bellini and of Giorgione, with whom he worked in 1508.

ROOM 5

Guido Reni (1575—1642)

The Centaur Nessus Abducting Deianira, before 1630

Pious and eccentric, Reni studied with Ludovico Carracci in Bologna to learn his classicizing style, which would become his hallmark, along with refined color, delicate flesh tones, soft modeling, and gentle emotion (inspired by Raphael). He worked mostly for the ruling Italian elite, but we know this image entered the Prague Castle collections sometime before 1688, when a visitor writes of admiring it. The subject is from Ovid's *Metamorphoses* and presents the moment when the Centaur Nessus, as he attempts to ravish Deianira, is struck by an arrow shot by her husband, Hercules. Writhing in pain, he tries to pull the arrow out, but is doomed to die.

Jan Kupecký 1667—1740
Portrait of Frau Schreyvogel, 1716

Because of his Protestant faith, Bohemian-born Kupecký spent most of his life abroad in Vienna and Italy, where he became a renowned portraitist to court circles. That he also painted the bourgeoisie is demonstrated by this picture of a wealthy burgher's wife, painted during one of Kupecký's rare visits to Prague. She is dressed as a shepherdess with quite a daring décolletage, reflecting a fashion for pastoral costumes begun at the French court. It was purchased by the Masaryk Fund in 1931, as part of the fund's aims to collect works by Bohemian artists.

THIRD COURTYARD

To visit the many interiors of the castle (the choir of St. Vitus, the Old Royal Palace, the Story of Prague Castle Exhibition, St. George's Basilica, the Powder Tower, the Golden Lane and Daliborka Tower), purchase tickets at the **Prague Castle Information Center**. (Tickets for the National Gallery at St. George's Convent, also in this courtyard, are sold separately.)

Location: Third Courtyard of Prague Castle, opposite of the western façade of St. Vitus

Contact details: Prague Castle Information center, (420–2) 224 373 368, www.hrad.cz

Opening hours: For all of the above venues, daily 9 AM–5 PM

As you emerge from the shadowy passageway into the third and principal courtyard, it is somewhat startling to find before you suddenly the towering façade of one of the greatest cathedrals in central Europe, St. Vitus.

St. Vitus Cathedral (Chrám sv. Víta)

Although its foundation stone was laid in 1344, St. Vitus was not completed until 1929 and its décor, like Prague itself, has elements from every age.

The ultimate manifestation of Charles IV's empire was to be his

cathedral, begun on Prague's elevation to an archbishopric in 1344. Constructed on the site of a 10th-century rotunda dedicated to St. Vitus built by St. Wenceslas, which had later been expanded into a three-aisled Romanesque basilica in 1060, the new Gothic cathedral was to embody the ideals of French Gothic, reflecting Charles's French upbringing. Like Reims Cathedral, it would be the coronation and burial place of kings. For the task, Charles chose French architect Matthew of Arras, who had been working in Avignon for Charles's former childhood tutor, Pope Clement VI. Matthew completed the ground floor of the choir and eight of the eleven planned ambulatory chapels to the triforium level before his death in 1352.

His replacement was the ingenious Peter Parler, a 23-year-old architect from a respected Cologne family of master masons. The choice signaled a shift in Charles's political outlook: crowned Holy Roman Emperor in 1355, he chose an architect from an imperial city to draw up new plans for an imperial structure. Parler reoriented the cathedral to make the south portal, which faced Charles's palace, the main entrance. Just off this portal, he designed an elaborate chapel to St. Wenceslas, patron saint of Bohemia and Charles's ancestor, and a massive south tower, an imperial symbol that would be visible for miles. It was also to be a international pilgrimage site, filled with the relics of holy saints (several related to the emperor) that Charles had collected throughout Europe. These changes reinterpreted the cathedral in relation to Charles; almost as a lavish chapel for his palace and an architectural symbol of his temporal and ecclesiastical power.

Before his death in 1399, Parler constructed the south portal, began the tower and its open-air staircase and completed Mathew of Arras's choir, giving it soaring vaults of elaborate ribbing. A "temporary wall" (which would last until the 1880s) was erected at the west end so the choir could be used until the nave was completed. Work continued on the tower and the nave under Parler's sons; the Hussite Wars unfortunately stopped work. It resumed

only in the 1480s under Vladislav II, who redecorated the pillaged interior and had his architects Hans Spiess and the talented Benedict Ried add a royal oratory. However, Vladislav moved his capital to Buda in 1490 and, although attempts were made, later Habsburg rulers never seemed to have sufficient funds or interest to complete the cathedral.

Court architect Bonifác Wohlmut added a Renaissance organ loft in the west wall and completed the south tower in the 1560s, and in the 1570s a small mannerist chapel to St. Adalbert designed by castle master mason Ulrico Aostalli was added on the outside of the provisional west wall. But for centuries St. Vitus remained an ornate choir with an adjacent south tower and portal surmounted by an open Gothic arch. In the 1670s talk of completing the nave in a baroque style came to nothing and it was only in the 1860s that Czech nationalism spurred the creation of the Society for the Completion of the Cathedral. Architect **Josef Kranner**, known for his scrupulous adherence to Parler's original medieval plans, began the work around 1861, making repairs and removing all decorative baroque additions, but the principal construction began in the 1870s under **Josef Mocker**, who created a new building plan based on his own interpretation of Parler's design. Mocker completed the nave, transept, and twin west towers by his death in 1899, after which architect Kamil Hilbert oversaw the finishing touches, including decorative elements, such as tracery and stained-glass windows. St. Vitus was finally completed in 1929, on the 1,000th anniversary of St. Wenceslas's martyrdom.

The Exterior

The two-towered west entrance gives a convincing impression of a Gothic façade, but closer inspection reveals modern detail, such as the rose window (1928) by František Kysela, carved tympanums from 1948–1952, and a uniformity of masonry that reveals a neo-Gothic work. Walk clockwise around the cathedral—passing by the former deanery (Vikářská no. 2) remodeled by Jan Santini-Aichel after 1705—to see some original Gothic stonework. From St. George's Square (Jiřské náměstí), Parler's choir can be appreciated (it is magical when

lit up at night). Delicate twin buttressing, tracery, and finials rise above the wreath of ambulatory chapels, creating a web-like scheme to support the vaulting and light the interior. Like a forest of stone, it is both beautiful and technically complex, and would have awed any medieval pilgrim.

Continue clockwise under the **covered passageway**, first built in the 14th century and rebuilt by Hans Speiss between 1490 and 1493. This passage allowed the ruler to pass from the palace to his royal oratory in the choir. Just beyond is the **south portal**, known as the *Porta aurea* (Golden Gate), designed by Parler as the ceremonial entrance to the cathedral. The tripartite Gothic arches of the portal jut up into the pictorial space of a mosaic of the Last Judgment (1370–1371). According to a contemporary chronicler, Charles IV had "made in glass in the Greek manner, a magnificent and very costly glass picture," the only one of its type in central Europe. Poorly restored in the 19th century, it was again restored in the 1990s by the Getty Conservation Institute.

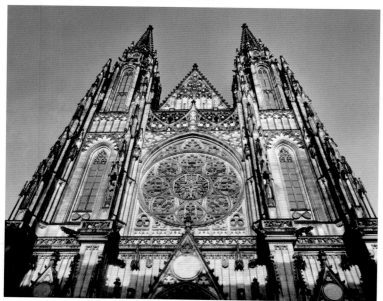

Kamil Hilbert & Josef Mocker, Façade of St. Vitus Cathedral, completed 1929 (Lauros/Giraudon)

The central scene presents Christ as Judge carried by angels and below are the patron saints of Bohemia (Procopius, Sigismund, Vitus, Wenceslas, Ludmila, and Adalbert) and Charles IV and his queen kneeling to either side of the central portal arch. To either side are the Virgin and John the Baptist with the apostles, and below the naked souls of the saved are taken from their tombs by angels, while the damned are dragged into hell by blue devils. Above the mosaic is a royal presentation balcony accessed by an above-ground passageway that links the Royal Palace and the Royal Oratory in the choir and continues around the length of the choir's triforium. This highly symbolic placement of the ruler above the masses was common in central European royal churches and part of royal/religious ceremonies. As the emperor presented himself on the balcony he would stand above Christ himself, making a clear statement of his authority as Holy Roman Emperor.

Inside the tripartite portal (which leads to a double doorway and then a single portal), Parler added inventive vaulting of freestanding skeletal ribs, spread out like a fan. His virtuosity is further demonstrated by a complex, openwork staircase found to the right above the portal; a daring technical feat. To the left of the portal soars the 316 ft/96.5 m **tower**; designed by Parler and executed by his sons to the gallery level, which was added by Bonifác Wohlmut in the mid-16th century, and finally topped by a spire in 1770 by Pacassi.

Continue back to the western entrance, past the sheltered excavated foundations of the Romanesque St. Vitus and the old provost's residence, built in 1662 but incorporating the ashlar masonry of an earlier Romanesque bishop's residence (dating from 1142) into its east wall.

The Interior

For all the criticism levied against neo-Gothic rebuildings, the first impression upon stepping into the softly lit interior is of beauty, especially on bright days when the stained-glass windows give everything a multicolored, luminous glow. It is easy to imagine the awe with which a medieval pilgrim would have entered such a building. Filled with a mysterious twilight, lit only by candles and natural light, under miraculously

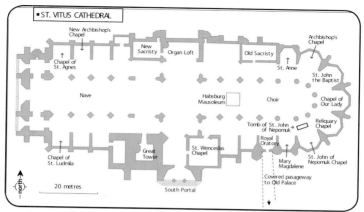

soaring vaults often painted with twinkling stars to resemble a night sky, it was a glimpse of heaven, designed to dazzle the viewer with the glory of God—and that of his earthly representatives: the church and the monarchy.

The 19th-century **nave** has been critiqued for its rather academic coldness; this, however, is warmed by eclectic modern stained glass. The window for the Chapel of St. Ludmila (first on right) was designed by Max Švabinský (who also designed the south transept window) and the window for the Chapel of St. Agnes (first on left) by František Kysela. The new archbishop's chapel (third on left) has a magnificent blue-green hued window by Alfons Mucha, designed long after the heyday of art nouveau in 1931, depicting the lives of saints Cyril and Methodius. Nearby, before the new sacristy, is František Bílek's powerful wooden sculpted altarpiece of the Crucifixion (1899–1927).

The **north transept** is today filled with Bonifác Wohlmut's organ loft, which originally closed off the western end of the choir. It was once slated for destruction, but Hilbert decided to move the organ loft to its present position in 1924. Reflecting the mix of styles at work in late 16th-century Prague, Wohlmut creatively built a classical Renaissance front (lifted straight from the architectural treatise of Serlio) with Gothic vaults inside.

To enter the choir, a ticket is required (see above), but before entering admire Parler's vaulting from the nave. Parler topped

Arras' narrow Gothic arcades with a triforium, clerestory, and soaring vaults with parallel diagonal ribs that spring from applied pillars forming intersecting diamonds. Characteristic of Parler's innovative work, these forms have a dynamism and rhythm, seeming to sculpt space out of architecture, unifying the space rather than dividing it into bays. Around the triforium pathway (unfortunately not open to the public), Parler added sculpted portraits of people involved in the cathedral's construction, such as Charles IV and his family, the archbishop, and Parler himself. As medieval architects rarely left their monogram, let along a self-portrait, on their work, the portrait suggests that Parler saw himself as much more than a hired builder.

Entering the **choir**, the unfortunately inaccessible old sacristy (second chapel on north side) displays more Parlerian genius: the vaults spring from a carved boss suspended in space. The center of the choir is enclosed in a grille containing the mausoleum of Ferdinand I and Anne Jagiello (1566) by Netherlander Alexander Colin. Commissioned by their son, Maximilian II, who lies with his parents atop the pale marble tomb, the side panels depict previous rulers, including Charles IV, thus linking the Habsburg rulers to the earlier Luxemburg kings. Attached to the choir arcades are a series of wood relief panels (1622–1623) by Casper Bechteler depicting the flight of the "Winter King" Frederick of Palatinate and his Queen Elizabeth Stuart after the Battle of White Mountain in 1620. The panels show interesting views of 17th-century Prague.

The apse chapels completed by Matthew of Arras still contain a number of royal and saintly remains, reflecting the original function of the space: housing precious relics. On feast days, pilgrims would be allowed into the normally restricted area to see these relics, which were often attributed with miraculous powers.

Continuing clockwise from the old sacristy, there are a number of chapels. In **St. Anne's Chapel**, a 1266 reliquary sits on the altar surrounded by 19th-century frescoes. The **Archbishop's Chapel** holds the 16th-century tomb of High Chancellor Vratislav of Pernštejn, commissioned by his Spanish wife, Maria Manrique de Lara. Opposite kneels Josef

Master Theodoric, Charles IV Kneeling beside the Virgin and Christ on the Cross, *from the St. Wenceslas Chapel, c. 1372 (tempera & gold on panel), by Cathedral of St. Vitus (Lauros/Giraudon)*

Myslbek's 1895 statue of Cardinal Bedřich Schwarzenberg. The **St. John the Baptist Chapel** was built at the expense of Prague's first archbishop, Arnošt of Pardubice (d. 1364). The chapel contains tombs of Přemyslid Princes Břetislav II and Bořivoj II by the Parler workshop; note also the 12th-century Rhenish candelabrum. The **Chapel of Our Lady** was the first chapel to be begun in 1344 and holds tombs of Princes Břetislav I and Spytihněv II, also by the Parler workshop. Opposite is a 19th-century statute of St. Vitus marking his tomb. The **Reliquary (or Saxon) Chapel** is decorated with medieval wall paintings of the Adoration of the Magi, and contains tombs of Kings Otakar I, wearing royal robes with a lion (a symbol of strength and eternal life) at his feet, and Otakar II in full armor, both by the Parler workshop.

The **St. John of Nepomuk Chapel** contains the tomb of

Bishop Jan Očko of Vlašim (d. 1380) with a dog (symbolizing fidelity) at his feet. Medieval wall paintings also picture Jan Očko kneeling before the baptism of St. Ottilie. These relatively simple items however, pale in comparison to the outrageous solid silver baroque tomb of that ubiquitous semi-saint, St. John of Nepomuk. Completed to plans by Fischer von Erlach in 1736, it takes baroque theater to a new level, with four silver angels holding a theatrical canopy aloft (a gift of Empress Maria Theresa). Von Erlach must have been happy that the Calvinist iconoclasts who destroyed the cathedral's décor in 1619 (who are depicted in a nearby wooden relief panel, which also shows the cathedral's 17th-century exterior) didn't get their hands on this wildly opulent tomb.

Beside it, the **Mary Magdalene Chapel** contains fragments of medieval paintings of the Virgin and Christ with saints and the tombs of architects Parler and Arras. Just to the west of the gilded Nepomuk are contrastingly realistic statues of two miners (referring to the Kutná Hora silver mines that gave Bohemia its wealth and paid for much of the original cathedral) in kneepads and mine lamps set before the extraordinary **Royal Oratory**. An ingeniously vaulted balcony with daring hanging bosses and faux branches taking the place of tracery, this late Gothic fantasy was made in 1490–1493 for King Vladislav II, most likely designed by Benedict Ried (perhaps with the help of Hans Spiess). A shield with the king's monogram "W" (Polish Władisław) hangs under the balcony's extended bay.

In the south transept is the sumptuous **Chapel of St. Wenceslas**, sadly only visible from its doorways. Commissioned by Charles IV around 1365 to celebrate his ancestor, Wenceslas, it is like a giant bejeweled reliquary, with the chapel covered in gems and gold and crowned with a stellar vault by its creator, Peter Parler. The lower painting cycle dates from around 1372 and depicts Christ's Passion framed by gilding and roughly cut precious stones, with Charles IV and his fourth wife, Elizabeth of Pomerania, kneeling on opposite sides of the Crucifixion. A Master Oswald is believed to be the artist. Above are scenes from the life of St. Wenceslas, featuring portraits of the cycle's patron, Vladislav II, and his wife, dating from around 1504 and

attributed to the Master of the Litoměřice Altarpiece. The north door has a famous 14th-century bronze lion-headed knocker that later pilgrims touched believing it was grabbed by the 10th-century Wenceslas as his brother Boleslav murdered him.

From here you can visit the Royal Crypt where 10th- and 11th-century foundations can be seen, as well as the tombs of Bohemia's greatest rulers (Charles IV, Rudolf II, etc.), since the 1930s encased in strangely modern, monolithic sarcophagi; or climb up the cathedral's **Great Tower** to get a bird's eye view of St. Vitus and the city.

Back in the Third Courtyard, note the statue of an armor-clad St. George killing a scaly dragon. A lost inscription tells us that "in 1373 this statue of St. George was cast by Martin and George of Cluj" (in Transylvania) but no information exists on how it came to Prague Castle, where it is first recorded in 1541. The original is now, like much of Prague's historic sculpture, in the Lapidarium of the National Museum (see page 243.) The 18th-century palace frames the courtyard, but its layout is by Plečnik, who in the 1920s repaved the space, sheltered the excavated remains of the Romanesque St. Vitus basilica (on north side), and added the war memorial obelisk and the marvelous **Bull Staircase** (Býčí schodiště), whose Cretan-inspired canopy leads to the South Gardens (see below). To the east end of the courtyard is the Old Royal Palace and perhaps the most astonishing structure in the castle complex: Benedict Ried's Vladislav's Hall.

Old Royal Palace (Starý královský palác) and Vladislav's Hall (Vladislavský sál)

From the 12th century to the 16th century this was the palace of the kings of Bohemia. The foundations of Soběslav I's 1135 structure still lie beneath that created by Peter Parler in the 14th century and that built by Benedict Ried from 1485–1510. Habsburg kings later moved their headquarters to the newer west wing and the Old Palace became government offices until the 18th century, after which it was little used until it was renovated in the 20th century and opened to the public. Today it is also occasionally used for

presidential ceremonies. Pacassi remade its west façade in the 18th century, but inside its historic layers remain, dominated by Ried's splendid renovations, carried out for Vladislav II Jagiellon, including the superb **Vladislav's Hall**.

The largest vaulted secular space in Europe (204 ft/62 m long, 43 ft/13 m high), the hall was a throne room and used for royal assemblies, feasts, and even jousting tournaments. It was a hub of political and cultural activity; a famous 1607 print by Aegidius Sadeler depicts the hall bustling with crowds and merchants selling their wares. The hall is a sophisticated and daring combination of late Gothic virtuosity and Renaissance architectural principals. Like a celestial sky, the vaults float weightlessly, bordered by Renaissance windows and portals. Patterned with five six-pointed rosettes, which spring from jambs that disappear into the wall surface, the ribs are treated as malleable, organic material (a naturalism comparable to the faux branches he used in the Royal Oratory) to be formed into fantastic patterns, sculpting space much as his predecessor, Peter Parler, did, but also anticipating the baroque. The northern exterior is a mix of Renaissance window frames and Gothic pinnacles and buttresses, which help support the lofty interior. The whole is a symbolic space of royal authority, with south windows overlooking the city and the northern, St. Vitus.

A door in the southwest corner leads to the **Ludwig (or Louis) Wing**, which was added by Ried from 1503–1510. Although the exterior (which can be seen from the South Gardens) is wholly Renaissance, the interior has Ried's late Gothic vaulting, another demonstration of Ried's mastery of both styles. It became the headquarters of the Bohemian chancellery, where in 1618 two Catholic government ministers were infamously thrown from the window, an event known as the Second Defenestration. At the east end of Vladislav's Hall is a staircase leading to a balcony overlooking the interior of the Church of All Saints (Všech svatých), originally made by Peter Parler in the 14th century and rebuilt unremarkably after a fire in 1541; its northern chapel holds the tomb of St. Procopius.

At the hall's northeast corner are two remarkable sets of doors by Ried. The eastern single door has a rounded pediment supported by fluted, twirling pilasters; an audacious

twist of architectural form. It leads into the **Diet Hall**, today laid out as for a meeting of the Diet members (monarch, nobility, clergy, and town representatives) and enclosed by another outstanding vault, originally built by Ried in 1500 and reconstructed by Bonifác Wohlmut after the 1541 fire. The Renaissance double doors lead to the **Rider's Staircase**, which horses once climbed to joust in the hall. Look up at perhaps Ried's most intricate vaulting, a riotous web of intersecting and truncating ribs controlled by a precise geometric discipline. Gothic styles in the 16th century have traditionally been considered retrograde, supposedly reflecting the designer's lack of Renaissance knowledge. This was not, however, the case for Ried, whose vaulting could be considered post-Gothic (in the same sense as postmodern), a daring and original concept, often under-appreciated in later eras.

The Story of Prague Castle Exhibition

Located in the lower levels of the Old Royal Palace, this informative permanent exhibition opened in 2004 and is entered from either the Third Courtyard or St. George's Square (Jiřské náměstí). Featuring period artifacts and instructive panels (in English and Czech), the exhibit is divided into two sections. The main route outlines the development of the castle from prehistory to the present. Off this main route are thematic rooms with explorations of subjects such as patronage, burials, and the history of scholarship on the castle. Anyone with an interest in Bohemian history and archaeology will enjoy the exhibit, particularly because it is located in some formerly inaccessible historic rooms with early foundations and original vaulting. Throughout, signs and interactive computer terminals provide information on each room's original function, layout, and context.

The exhibition offers the chance to see up-close some truly remarkable artifacts, including the silk and damask burial robes of Rudolf II, the original tomb of Otakar II by Peter Parler and the original Romanesque tympanum of St. George's Basilica. The latter, commissioned by Abbess/Princess Agnes before 1228, is a fascinating reflection of the medieval Marian cult, of royal patronage and gender roles. The central figure of the

enthroned Madonna is flanked by patrons: two small figures, Abbesses Mlada and Berta of St. George's Convent, kneel at her feet, and to the sides are the larger figures of Agnes and her father, King Přemysl Otakar I. On the surrounding archivolt is the Latin inscription "the wisdom of the father remains in the lap of the mother" (IN GREMIO MATRIS RESIDET SAPIENTIA PATRIS). Contemporary theological interpretations viewed the Virgin's lap as the throne of God, with the infant Jesus as the embodiment of the true word; an appropriate theme to be chosen by an Abbess promoting a female cult and her own relatively powerful position in the Přemyslid court. Placed on the façade of the court's church, the tympanum represented Agnes as more favored than even her kingly father, as she practically stands (Otakar kneels) to the Virgin's right, with Jesus extending his blessing directly to her.

Back in St. George's Square (Jiřské náměstí), to the north is the neo-Gothic **New Provost's House** (1878–1880) built by Josef Mocker, who lived there while working on St. Vitus; and to the southeast is the **Church of All Saints** (whose interior is visible from Vladislav's Hall). This church was attached by Niccolo Pacassi to the **Convent for Noblewomen** (the former Rožmberk Palace) whose circular portico states that "this holy dwelling" was built by Empress Maria Theresa in 1755 "to strengthen the faith and offer noble consolation." The east side is dominated by St. George's Basilica and Convent.

St. George's Basilica (Basilika sv. Jiří)

Despite its baroque façade, St. George's Basilica is often referred to as Bohemia's best-preserved Romanesque church. But is it? Numerous, controversial 19th-century/20th-century "restorations" have given its interior the impression of being Romanesque but its history is far too complicated for a definitive answer. In 925 Vratislav I founded St. George's on high ground within the castle grounds. It became the repository of the remains of Přemyslid St. Ludmila and in the 970s was transformed into a three-aisled structure with an adjacent convent, whose first abbess was Princess Mlada, sister of Boleslav II. After an 1142 siege, Přemyslid Abbess Berta had

a stonemason, Verner, rebuild the church and convent, and it is this era that is commemorated in the modern restorations.

St. George's close royal ties (e.g., its abbesses had the right to crown the Queen of Bohemia until the 18th century) meant that over the centuries numerous rulers made additions and repairs to the convent. However at the monastery's dissolution in 1782, it fell into disrepair and it was only in 1876, in the heyday of the Czech National Revival, that controversial discussions began about how to restore St. George's. Czech patriots wished to return it to its "original" Romanesque form, even though it was unclear how much was to be found beneath centuries of Gothic, Renaissance, and baroque additions. Renovations from 1888 to 1907 saw several questionable decisions made. For instance, in 1892 the vault of the nave was demolished and eventually replaced by a wooden ceiling, even though the vault probably dated from the Renaissance and included late Romanesque elements. The Chapel of Ludmila was so greatly altered that today historians are doubtful as to the authenticity of the reconstruction. Further questionable restorations were carried out from 1959–1963. Today the church displays varied historic and reconstructed styles, offering a fascinating study in the use of architecture in the reconstruction of history.

It was Leopold I who funded renovations in the 1670s that included the baroque, burgundy colored west façade designed by Francesco Caratti, which features founding Abbess Mlada and Vratislav atop the main pilasters and St. George in the top pediment. (The façade's original Romanesque tympanum is now in the Story of Prague Castle exhibit; a copy is found in the church's crypt.) Attached to the southeast corner is the Jesuit-inspired Chapel of St. John of Nepomuk, which was added in 1717–1722. Rising behind the façade are two Romanesque towers first built in 1142 and reconstructed (along with the eastern exterior) at the turn of the 20th century when their baroque plaster and metal cupolas were removed and replaced by stone spires. The south portal was reconstructed by royal architect Benedict Ried's workshop around 1520 in a classical Renaissance style, with a tympanum (the original is in the Story of Prague Castle exhibition) of St. George slaying the dragon.

The atmospherically lit interior makes the most of the nave's original thick Romanesque walls pierced by round arched windows and supported by sturdy round pillars, recalling the architecture of the neighboring Ottoman Empire. Several Přemyslid kings are buried in the east end, approached by a curving baroque double staircase, between which stairs lead to the Romanesque crypt. Fragments of original frescoes are found throughout, including a c. 1200 "Heavenly Jerusalem" on the choir's semi-circular apse. To the south of the choir the Chapel of St. Ludmila contains her 14th-century tomb by the Parler workshop and 16th-century frescoes, including an image of the saint with a knotted rope around her neck (with which she was murdered). Pictures of the modern renovations can be seen in the south aisle.

National Gallery at St. George's Convent (Kláster sv. Jiří): Mannerist and Baroque Art in Bohemia

Location: Jiřské náměstí 33; the northeastern corner of St. George's Square

Contact details: 222 321 459, www.ngprague.cz

Opening hours: Daily 10 AM–6 PM, closed Mondays

Next to the basilica is the St. George's Convent, since 1963 a part of the National Gallery. Today the first floor of the convent displays the National Gallery's collection of Bohemian art from the 16th century to the late 18th century. Laid out chronologically, the exhibit begins with the mannerist works of the illustrious court of Emperor Rudolf II (e.g., Bartholomeus Spranger, Hans von Aachen, and Roelandt Savery). Bohemian's political evolution after the Protestant defeat at White Mountain in 1620 and the subsequent domination of the Catholic Counter Reformation is a significant factor in the baroque art of the 17th century and 18th century. Key figures of this period are the early baroque painter Karel Škréta, high-baroque painters Petr Brandl and Jan Kupecký, and sculptors Mathias Braun and M.F. Brokoff. The drama of the late baroque, exemplified by V.V. Reiner, by the late 18th century gave way to the playful rococo of artists such as Norbert Grund.

Enter the gallery through the medieval cloisters, which were redone in the baroque period, and climb to the first floor.

Bartolomeus Spranger (1546 – 1611)

Epitaph of Prague Goldsmith Nicholas Müller, 1592–1593

Most of Spranger's work was for Rudolf II's court. However, this image was made for the tomb of his father-in-law, Nicholas Müller, in the St. Matthew Chapel of St. John's Church in Malá Strana. Müller appears with his wife and children (the eldest daughter being Spranger's wife, Christine) at the bottom of the picture, all looking directly at the viewer. The dour piety of the family stands in contrast to the mannerist glamor of the risen Christ who, enrobed in glowing light, stands atop his sarcophagus surrounded by angels. Karl van Mander wrote that Spranger considered this to be his best picture in terms of color, which is indeed both vibrant and subtle.

Hans Von Aachen (1551 – 1615)

The Annunciation, 1613

Born in Cologne and trained in Italy, von Aachen moved to Prague in 1597, serving as painter, art dealer, and diplomat to Rudolf II. Better known for his sensual images of smoothly modeled, elongated figures—often of nude women—in elegant poses that were a favorite of his royal patron, this painting depicts a demure Virgin and the Angel of the Annunciation. His idealized style combines Roman and Florentine Mannerism with rich Venetian color and Dutch realism. Painted late in his career for a former secretary of Rudolf II, it hung in the Clementinum's Church of the Holy Savior in the Old Town and was a great influence on baroque painter Karel Škréta.

Roelandt Savery (1576 – 1639)

Landscape with Orpheus and Animals, c.1625

This crowded pastoral scene includes romantic architectural ruins and numerous exotic animals, e.g. bison, parrots, lions. Dutch-born Savery spent ten

Bartholomeus Spranger, Epitaph of Prague Goldsmith Nicolas Müller, or Resurrection, *c. 1592 (oil on canvas), National Gallery, Prague (Lauros/Giraudon)*

formative years (1603–1613) at the Prague court, and this image encapsulates the relations between court painting and natural science under Rudolf II. The animals were based on observations Savery made in Rudolf's menagerie in the Royal Gardens behind Prague Castle and the landscape on natural studies he made while travelling in Bohemia. Following Rudolf in his attempts to connect the natural and artificial, Savery often painted these paradise-like scenes where nature and man live in harmony, here with the added classical allusion to Orpheus, the mythic Thracian singer who brought harmony to nature with his music.

Karel Škréta (1610–1674)

Portrait of Gem Cutter Dionysius Miseroni and his Family, c. 1653

Škréta made this portrait for the 50th birthday of Dionysius Miseroni, who is pictured at a table with his wife and many children. From a family of celebrated gem cutters first invited to Prague by Rudolf II (referred to by the busy workshop in the background and the two boys playing with a large uncut gem), Dionysius was also keeper of the art collections at Prague Castle. To this image of a prosperous, upwardly mobile merchant/craftsman, Škréta adds a touch of intimacy with the child laying her head in her father's hand as she looks at the viewer, bringing us into this happy family scene.

St. Charles Borromeo Visits the Victims of the Plague in Milan, 1647

Škréta, from a Protestant family who fled in 1618, later trained in Italy, converted to Catholicism and returned to a successful career in Prague in 1638, where he became known for his darkly Italianate altarpieces. This complex and perfectly balanced scene was made for the high altar of the Italian hospice in Malá Strana and it depicts the popular Counter Reformatory figure Charles Borromeo dressed in bishop's robes blessing the sick. In the background the picture's donor, Max Antonius

Karel Škréta (1610–1674), St. Charles Borromeo Visits the Victims of the Plague in Milan, 1647 (oil on canvas), National Gallery, Prague (Lauros/Giraudon)

Cassinis, unabashedly points to his name written on the altar. Standing behind Borromeo, with a curling moustache and looking at the viewer with a cheeky smile, is none other than the convert Škréta himself.

Ferdinand Maxmilián Brokoff (1688–1731)
Two Moors, 1718–1719

Brokoff was known for his expressive, monumental sculpture, exemplified by these muscular Africans dressed in feathers and holding decorative shields. Made for the gates of a mansion in Kounice (outside of Prague), they are portrayed in a manner typical of the period, which depicted any non-European as an exotic figure, in costumes often copied from erroneous costume books. The base of the statues are signed by Ferdinand's less

talented father, Jan, reflecting the workshop ethos that gave creative credit to the workshop master.

Mathias Braun (1684–1738)

St. Judas Thaddeus, 1712
Bust of a Young Goddess, 1714–1716

This Tyrolean sculptor was trained in Italy and worked in Prague from 1710, where he became known for his technical virtuosity and painterly, emotional style, inspired by Bernini. These two very different subjects show his range. The vivacious grin of the young goddess, a fragment from the décor of the Clam-Gallas Palace in the Old Town, contrasts distinctly with the agitated drama of the persecuted saint who looks heavenward, his clothes and hair whipped by a wild wind. The latter decorated the Church of our Lady Na Louži in the Old Town.

Petr Brandl (1668–1735)

Self-Portraits, 1697 and 1722–1725

Brandl was one of the most prolific and successful painters in Prague in the early 18th century, known for his passionate realism and drama in religious works and portraits. Here he turned his artist's gaze upon himself, creating remarkably honest portraits; one as a confident young man and the latter, which he completed in a similar pose, as an aged, world-weary man in his 50s.

Jan Kupecký (1667–1740)

Portrait of Miniaturist Karl Bruni, 1709

This striking picture was painted in Vienna where Prague-born, Protestant Kupecký had a highly successful workshop specializing in portraits. The man's identity is uncertain, and it has been suggested that the sitter may not be Bruni, a professional artist, but rather an aristocrat who painted in his leisure time. An air of sophistication pervades the scene, with the richly dressed sitter holding a small brush and oval canvas with pieces of classical architecture—an obelisk and an ancient temple—in the background, suggesting an interest in antiquity and/or travel. His pose and demeanor

suggest the casual elegance of the aristocracy—or, perhaps, of a socially ambitious artist?

Self-Portrait of Artist at Work and the Likeness of his Wife, 1711
Noted for the perceptive realism and humanism of his portraits, Kupecký here portrays himself and his wife: he, as painter and she, as his subject. On the table in the foreground are the painter's paraphernalia: brushes, flasks of oil, and containers for mixing pigments. Supposedly painted as part of a reconciliation with his unfaithful wife, she appears as a penitent, although her hair is still fashionably powdered, while he looks out of the canvas with a sad, world-weary expression.

Norbert Grund (1717—1767)
Gallant Scenes, c. 1760
These rococo "gallant scenes" were a specialty of Grund and a popular collector's item. They present images of the aristocracy at play, pastoral landscapes with shepherds, romantic Italianate landscapes with classical ruins and mythological scenes. The images often have a traveller's sensibility, as if trying to capture the romance of visiting an exotic or romantic locale. The 18th century saw a rise in cultural travel, epitomized by the Grand Tour, an education voyage around Europe undertaken by many aristocratic young men and, occasionally, women. Grund's style shows the transition from baroque sensuality to a more classical sensibility.

Downstairs is another permanent exhibition entitled "The Artist and his Workshop in Baroque Bohemia." While a bit haphazard, the exhibit is nonetheless a fascinating primer on the business of the baroque-period art world, using artwork and preparatory drawings and models to explore the life of a Bohemian artist.

EASTERN CITADEL AND CASTLE GARDENS

The sense of Hradčany as a town is best felt in the eastern end of the citadel. Follow Jiřská (George) Street leading to the highly

Norbert Grund, Gallant Scene in a Park, c. 1760 (oil on canvas), National Gallery, Prague (Lauros/Giraudon)

touristed Golden Lane, which is lined with tiny houses dating from the 16th century (a less crowded and just as charming street is Nový Svět; see Trail 4, Castle District). Further along is the **Leica Gallery** (with temporary photography exhibits) in the Burgrave's courtyard, the baroque **Lobkowicz Palace** by Carlo Lurago, as well as the **White**, **Daliborka**, and **Black Towers**; part of Benedict Ried's 15th-century/16th-century fortifications. When exiting through the Black Tower Gate, instead of descending by the Old Castle Steps to Malá Strana, turn to the right to enter the South Gardens.

South Gardens

Location: Along south façade of Prague Castle. There are three entrances: one at top of the Old Castle Steps at the east end of the citadel; at the top

of the castle steps leading to Hradčany Square at the west end; or from the castle's Third Courtyard via the Bull Staircase. It is also possible to enter via the "Gardens below the Castle" in Malá Strana.

Opening hours: April 1 to September 31, daily 10 AM–6 PM

Running the length of the castle's southern front, the gardens offer glorious city views and a chance to see the castle's exterior up close. Josip Plečnik's first task when redesigning the gardens in the 1920s was to lower the 1849 rampart walls, visually reconnecting the castle and city. He then set about linking the eastern Rampart Gardens (Zahrady na valech) and the western Paradise Gardens (Rajská zahrada; first laid out in 1562 as the private garden of Archduke Ferdinand) as well as creating the distinctive Bull Staircase linking the gardens to the Third Courtyard. He left all the original trees, building around them if they didn't fit his plan. He unified the length of the garden with several postmodern, classically inspired architectural elements of pronounced clarity, such as gazebos, colonnades, observation points, a small pyramid and a massive granite bowl, designed as the "female" counterpart to the "male" obelisk in the Third Courtyard. Continuous with the "Gardens below Prague Castle" (see page 118), the South Gardens create a surprisingly verdant area within the castle complex.

Royal Gardens (Královská zahrada)

Location: North of Prague Castle. Entrances on U Prašného mostu Street (found north of the Castle's Second Courtyard) or near the Summer Palace (Belvedere) on Mariánské hradby Street.

Opening hours: April 1 to October 31, daily 10 AM to 6 PM

From the Second Courtyard cross the Stag's Moat (Jelení příkop), coming to the elegant **Jízdárna**, or **Royal Riding Hall** (U Prašného mostu 1/53) built by Jean-Baptiste Mathey in 1694, and restored by Pavel Jának in 1948–1654. This hall now holds temporary art exhibitions. Opposite is the entrance to the Royal Gardens, first created in 1534 by Ferdinand I and prized by Rudolf II. Here southern fruits and rare flowers were cultivated (including the first tulip imported from Constantinople) and

a menagerie (located at today's Lion Court, near the western entrance) was filled with exotic animals, such as parrots, orangutans, and lions, all for the amusement of the royal court. Today the Gardens are a lovely park dotted with historic structures and fabulous views to the castle, giving a sense of its formidable bastions.

Intended as a place for courtiers to indulge in "vigorous bodily movement," the **Ball-Games Court** (Míčovna) is found on the southern edge of the gardens and was originally designed by royal architect Bonifác Wohlmut in 1567–1569 and much restored after a 1945 fire. The long classical façade is composed of large arcades with a colossal column order covered in decorative sgraffito. The arcade spandrels contain a cycle of the liberal arts (astrology, geometry, music, arithmetic, rhetoric, logic, grammar) presented as female allegories based on engravings by Netherlander Frans Floris (1516–1570). The four elements (earth, fire, water, air) and seven cardinal and theological virtues (prudence, temperance, courage, justice, faith, hope, charity) connect them. Also look for a Soviet hammer and sickle added by a mischievous communist-era restorer.

Just to the east is the new **Orangery**, a greenhouse built in the 1990s, incorporating the walls of the original 16th-century structure. Continuing to the east is a pretty Renaissance formal garden centered on the 1568 **Singing Fountain** (so called for the tinkle of the water falling into the basin), which sits before the elegant **Summer Royal Palace** (Belvedere), the first Italian Renaissance building in Bohemia. Commissioned by Ferdinand I for his Queen, Anne Jagiellon, it was designed by Paolo della Stella who oversaw the project from 1537 to his death in 1552, by which time he had completed the first level. Bonifác Wohlmut then took over, adding the upper floor and the unusual copper roof in the shape of a ship's upturned hull.

The graceful arcade gallery of the lower level is adorned with relief sculptures executed by Stella of 74 secular themes taken from Ovid, Livy, and other classical sources, as well as scenes of bacchanalia, hunts, and historic battles. The labors of Hercules adorn the corners of the buildings, which have an iconographic connection to its patron, the Habsburgs, whose own spurious

lineage supposedly included such figures as Julius Caesar and Hercules. Called the Lusthaus in contemporary records, the palace was used for court fests and dances, to house Rudolf II's collections, and by Tycho Brahe for astronomical observations. In the 18th century it was an artillery storage and in the 19th century it was used as a picture gallery, a function it occasionally fulfills today.

There are pleasant walking trails from here leading south into the Stag's Moat and east into Letná Park (see Trail 6). Also a short walk away is the unique **Bílek Villa** (Mickiewiczova 1, Prague 6; open Tuesday to Sunday from 10 AM to 6 PM May 15 to October 15; during the rest of the year on Saturdays and Sundays only from 10 AM to 5 PM). It was designed by art nouveau symbolist sculptor and graphic artist, František Bílek (1872–1941) as his home and studio and now houses a museum of his art.

Trail 4:
The Castle District

Spreading west and north around Prague Castle, Hradčany is the smallest of Prague's four historical quarters. In the Middle Ages, the area around the castle was forested, crossed only by a road leading from the castle to Strahov Monastery. Settlement first began around present-day Castle District Square (Hradčanské náměstí) and in 1321 it was officially made a township. After a devastating fire in 1541 the palaces of court dignitaries slowly replaced the original humble settlement. Hradčany was raised to the status of a royal town in 1598 and remained so until the creation of a unified Prague in 1784. However, with the removal of the royal court to Vienna the Castle District went into a deep slumber and seems to have only just been awakened, probably by a noisy tour group. Spared from urban expansion, it is little changed since the 18th century and is a marvelous place to pass a few hours exploring streets brimming with wonderful architecture. Hradčany also holds several important monuments, such as the medieval Strahov Monastery, the baroque Loreto, and the superlative pre-modern international art collection of the National Gallery's Sternberg Palace, which can occupy several hours in itself. See page 106 for the map of this area.

Hradčanské náměstí lies before Prague Castle's western gate. Standing to the southside before the city skyline is the distinguished **Schwarzenberg Palace** (Schwarzenberský palác, no. 2/185). The powerful Lobkowicz family acquired this prime piece of real estate, formerly occupied by several medieval buildings, in the early 16th century. Italian architect Agostino Galli completed the Renaissance palace

with a courtyard opening on to the square around 1560. Its three stories are topped by a curved Italianate cornice with lunettes and distinctive step volute gables, all enveloped with marvelous black-and-white sgraffito of elaborate friezes and faux rustication. It is presently closed for renovation and due to open in 2007 as the National Gallery's new home for its Old Masters collection. Also included in the renovations is the adjacent empire-style **Salm Palace** (1840).

Opposite is the equally prestigious **Archbishop's Palace** (Arcibiskupský palác, no. 16/56). It was Emperor Ferdinand who first gave the Renaissance residence that stood here to the archbishopric in 1562, but it wasn't until 1675–1684 that Jean-Baptiste Mathey constructed a new palace on the site. However, only Mathey's basic framework and main portal remain, as it was completely renovated in a rococo style in the 18th century by Johann Josef Wirch, who added a rooftop extension. Richly ornamented inside and out, the palace is still the archbishop's residence and closed to the public.

To the left of the lavish Archbishop's Palace is a simple cobblestone alleyway leading to the National Galley's Sternberg Palace.

Sternberg Palace (Šternberský palác)

Location: Hradčanské náměstí 15
Contact details: 222 321 459, www.ngprague.cz
Opening hours: Daily 10 AM–6 PM, closed Mondays

The Sternberg Palace was built for one of the wealthiest men in Prague, Václav Vojtěch Šternberg, who also build Troja Chateau (see page 247) between 1698 and 1708, probably based on designs by G.B. Alliprandi. Never fully completed (thus its unusual entrance), the structure is arranged around an inner courtyard. Its most distinctive features include a large vestibule (today by the ticket office) and a grand pavilion topped by an oval dome that faces a garden overlooking the old moat (today accessible by a door near the library entrance). The interiors have recently been restored, exposing more of the original decoration, including some lovely ceiling paintings (see below).

The Sternbergs sold their palace in 1811 to the Society of Patriotic Friends of Art, who remodeled it as a picture gallery in order to, in their words, "raise the debased artistic taste of the public." They were also trying to slow the flow of masterpieces out of the country to more influential cities like Vienna or Dresden. The gallery was moved in 1871 and the collection of European (i.e., non-Czech) paintings was only returned to the Sternberg Palace in 1947. Since 1989 the gallery has had some shake-ups, with several confiscated paintings that entered the collection during the communist period being returned to their original owners (for examples, see Nelahozeves Castle, Trail 7) and in 1995, the modern European collection was moved to the new Museum of Modern and Contemporary Art at the Trade Fair Palace (see page 230).

Nevertheless, the collection remains an excellent survey of Old Masters, with particular strengths in German Renaissance and 17th-century painting from the Low Countries. Some paintings originated in aristocratic or royal collections, including that of Rudolf II, while others were purchased since the 19th century by the Society of Patriotic Friends of Art, which controlled the collection until the 1930s when it became the state-run National Gallery. The following walks through the museum highlight some of the most outstanding works.

FIRST FLOOR

Italian Art 14th Century–16th Century (Rooms A2–3/A8)

A2: Bernardo Daddi (active in Florence 1312–1347)
Betrothal of St. Catherine
This early Renaissance triptych depicts a tale from the life of St. Catherine of Alexandria, taken from the Golden Legend and popular in 14th-century Italy. In it, Catherine prays with increasing devotion to an image of the Virgin and Child until she receives a ring from Christ (depicted in the central panel), a metaphor for spiritual betrothal to God. Daddi's workshop specialized in these

types of small panels designed for private worship within the home. Daddi, the leading Florentine figure of his generation, was a pupil of Giotto, who introduced a naturalistic approach to painting as opposed to the more static Byzantine traditions. Compare Daddi's emotive faces and gestures and clear spatial organization to those of the Byzantine icons found in room A4.

A2: Pietro Lorenzetti (active in Siena 1306–1345)
A Holy Martyr/St. Anthony the Hermit
These two fragments are from the Loeser Altarpiece, whose pieces are spread around the world (the central panel is in Palazzo Vecchio, Florence; a side panel is at the New York Metropolitan). They represent the founder of monasticism, St. Anthony, who passed many years as a desert hermit, and an unnamed youthful saint. Known for his harmony, refined detail and dramatic emotion, Lorenzetti studied with Duccio but was also influenced by Giotto's naturalism. Along with his brother Ambrogio, he was one of the leading painters of Siena, a fact attested to by his inclusion in Vasari's *Lives*.

14th- and 15th-century painting in Northern Italy and the Veneto (A6–7)

A7: Antonio (c. 1415–1484) and Bartholomeo (c. 1432–1495) Vivarini da Murano
St. Paul/St. Peter, 1451
The Vivarini brothers descend from glassworkers from the small island of Murano (near Venice) and the elder, Antonio, is considered the founder of the Murano School of painting. The richly colored saints (a characteristic of both Venetian and the Vivarini's art) have incised haloes and stand on pedestals like statues, boldly defined by gold backgrounds. They were originally part of a large retable in the Church of St. Francis in Padua. A complete retable (with its original frame, c. 1447) for the same church by Antonio and his German brother-in-law, Giovanni d'Alemagna, is also displayed. All three works were later part of the collection of the Archduke

Ferdinand d'Este (assassinated in 1914) at Konopiště Castle, a source of many of the 14th-century to 16th-century Italian works.

Art of the High Renaissance and Mannerism (A8–9)

The first room (A8) has some wonderful, recently restored 18th-century ceiling frescoes of the four (then known) continents, represented in each corner by a female allegory with an animal (for instance, Europa on a bull, Africa on an elephant, etc.) and partially unrolled map. The subjects of the portrait medallions are uncertain but one may be Christopher Columbus. Also note the hook-nosed bust of Lorenzo de' Medici by Antonio del Pollaiuolo (1431–1498)

A9: Agnolo di Cosimo Bronzino (1503–72)
Eleanor of Toledo, c. 1540–1543

Eleanor, daughter of the Spanish viceroy of Naples, with her stunning colors, gilded frame, and sulky expression, is one of the most striking paintings in the gallery. Her decidedly less colorful husband, Cosimo I de' Medici, grand duke of Tuscany, whom she married in 1539, hangs nearby. Bronzino was de' Medici's court painter. He had studied with the mannerist Pontormo, but soon developed his own distinct style, particularly evident in his portraits. For Bronzino, a portrait was a mask, used to convey his subject's social standing, elegance, and restraint, not their character. With cool detachment, Bronzino recorded precise detail of the material world, such as clothing (note the delicate threads around Eleanor's neck), jewelry, and hair, giving his portraits a remote decorativeness. Eleanor's hand on her stomach may indicate a pregnancy (she had eight children, four between 1540 and 1543).

15th–16th-century Art in the Low Countries (A10–13)

A10: Geertgen tot Sint Jans (c.1460/5–1470/95)
Triptych with Adoration of the Magi, c. 1460

Although cutdown from its original size, this masterful panel has the gentle grace and quiet lyricism characteristic of the late work of Sint Jans, who studied and worked in

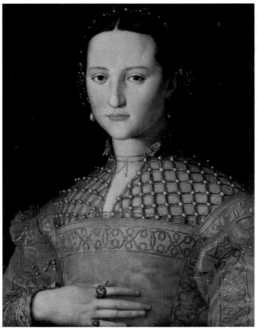

Agnolo di Cosimo Bronzino, Eleonora of Toledo, *c. 1540–1543 (oil on panel), National Gallery, Prague (Giraudon)*

Flanders. The central panel portrays a dainty Virgin and Child with three awestruck, exotic Magi. The background presents the Magi's cortège, complete with camel, in a scene of contemporary village life, and further back is a fantastic celestial city. Typical of Netherlandish painting, the image combines the biblical and the everyday. There are elements of comic realism, such as the gentle one-tooth smile of a man standing behind the third Magi. The side panels present the two unnamed donors (probably middle-class burghers) and their patron saints. The woman kneels before an enclosed garden with peacock—both symbols of the Virgin's purity and meant to reflect the piety of the donor. A near-perfectly executed image, there is even a reflection of the central scene in St. Adrian's armor.

A10: Master of the Well of Life (active in early 16th century in Utrecht)

The Well of Life, 1511

This iconographically fascinating late Gothic panel was made as the epitaph of Father Jan Clemenssoen, pictured in the foreground with a chalice of Christ's blood. The image is an allegory of Christ as the source of all mercy, symbolized by the Eucharist. The 16th-century imagination brought the well to literal life, with Christ himself as part of a Gothic fountain with his wounds pouring blood to fill the font. Pilgrims from all classes, segregated according to contemporary social hierarchy (the clergy as celestial authority, royalty as terrestrial authority, and the poor) line up to receive his blood/salvation. The original frame is dotted with portraits and the instruments of the crucifixion.

A10: Jan Gossaert, called "Mabuse" (1478–1533/6)

St. Luke Drawing the Virgin (c. 1513)

This marvelous painting is of St. Luke, patron saint of painters, who according to legend made the first image of the Virgin. It was originally commissioned for the painter's chapel in the church of St. Rombaud in Mechelen, then a center of the Habsburg Empire (today in Belgium). After Mechelen was sacked in 1580, the highly regarded altarpiece was taken to the Habsburg Empire's then-capital, Prague. After 1619, it was placed in St. Vitus, where it stayed until it was incorporated into the gallery collections in 1870. Gossaert was court painter to the Habsburg Princess and Regent of the Netherlands Margaret of Austria (1480–1530), and was skilled in both northern Gothic (then called "modern") and new Italian Renaissance (then called "antique") styles, first introduced in the north at the Mechelen court. The backdrop is a magnificent architectural display with a draftman's mastery and an excellent use of Renaissance proportion and perspective (note the tiny scene of the Virgin standing beside Luke as he writes his

gospel). As was common in northern art, the detail is minute, from Luke's drawing to the crisp folds of cloth. There is also a note of Netherlandish homeliness with St. Luke taking off his slipper.

A13: Jan Hermessen (1500—1563)

The Tearful Bride, 1540

From the next generation of Antwerp mannerists, Hemessen is considered one of the founders of genre painting (images that depict everyday life). He made many satirical, moralizing images, such as this mocking image of an aged wedding. The leering youth, an unflattering contrast with the older couple, holds a chamber pot that will go under the marriage bed, an understood symbol in Netherlandish painting for the consummation of the marriage. These types of didactic images—part lesson, part pitiless joke—were popular subjects in both engraving and painting. The muscular figures, densely packed foreground, and intense gestures and expressions are typical of Hemessen's late mannerist style.

SECOND FLOOR

Italian, Spanish & French Art 16th–18th Century (B1–6)

B1: Jacopo da Ponte, called Bassano (c. 1515—1592)

Annunciation of the Shepherds, c. 1575

This Veneto artist was a pioneer of Italian genre painting and often experimented with light in night scenes. Here a glowing angel awakens shepherds asleep among their cattle. Come to announce Christ's birth, the angel has a light that illuminates the partially obscured figures, literally and figuratively, adding a mystical element to a peasant scene. Bassano, although influenced by the rich drama and color of Tintoretto and Titian, preferred humble subjects, which he imbued with an earthy realism.

B3: Simon Vouet (1590—1649)

Suicide of Lucretia, 1625–1626

Rising semi-nude from her luxuriant bed, the Roman

noblewoman Lucretia is about to commit suicide to preserve her honor after being raped by the son of King Tarquin. The story is taken from Livy and was a popular moralizing tale (as well as a respectable excuse to paint an alluring female nude). Painted during Vouet's time in Italy (1613–1627), it demonstrates his classical, restrained yet sensuous baroque style. Louis XIII would call Vouet back to France in 1628, where he would initiate the French baroque and dominate the Paris art world until his death.

B4: El Greco 1541–1614
Praying Christ, 1595–1597

Acclaimed for his penetrating portraits, El Greco, "the Greek," worked in Italy and Spain. This image of Christ reflects his trademark style: an elongated figure, free brushwork, expressive lighting, acid color, and an air of religious ecstasy. An inimitable artist, he was his own best promoter and is reported to have said, "as surely as the rate of payment is inferior to the value of my sublime work, so will my name go down to posterity as one of the greatest geniuses of Spanish painting."

B5: Francisco José Goya y Lucientes (1746–1828)
Portrait of Don Miguel de Lardizabal, 1815

By the 1780s Goya was Spain's leading painter, specializing in religious pictures and portraits. He acknowledged three masters: Diego Velázquez, his predecessor as court painter to the Spanish royal family; the truthful, penetrating Rembrandt van Rijn; and, above all, nature. This late portrait is of a Mexican-born court official who spent the Napoleonic years in exile, was once condemned to death (alluded to in the papers he holds), and was finally made minister of the Indies (America) in 1814. The dark background, delicately modeled face, and soulful eyes are typical Goya.

The same room also holds works by Francesco Guardi, Nicolas Poussin, Francois Boucher (1703–1770) and a wonderfully haughty *Portrait of a Young Man* (1654) by Pierre Mignard.

B6: Roelandt Savery (1576—1639)
Paradise, 1618
The years Savery spent at Rudolf II's court (1604–1612) were his most formative. Travelling in Bohemia and the Tyrol, he made drawings of rural scenery that would provide source material for the rest of his career, even after returning to his native Holland in 1619. He also studied the exotic animals in Rudolf II's menagerie, many of which were brought to the imperial court from the Habsburg colonies in the Americas. Rudolf had a deer park around Prague Castle, an aviary with birds of paradise and a dodo, and his *Kunstkammer* (cabinet of curiosities), which included living and dead examples of fantastic creatures, from crocodiles to iguanas. This image, which includes Adam naming the animals in the background, acts more like a pictorial list of European and foreign animals all preening before a romantic landscape, reflecting contemporary interest in nature and exotica peaked by New World exploration.

17th–18th-Century Art in the Low Countries (B7–B20)
Room B7 has several works by the Flemish Bruegel family, although the famous *Haymaking* (1565) by Pieter Bruegel I (c. 1525–1569) has been returned to the Lobkowicz family and can now be seen at Nelahozeves Castle (see Trail 7).

B7: Pieter Bruegel II (1564—1638)
Adoration of the Magi, date unknown
Pieter II continued in his father's footsteps, producing genre pictures, often with a secondary religious or moralizing theme, for a noble and middle-class market. This winter scene in a Dutch village includes the Magi bowing before the Virgin and Child who are just out of the picture frame. However the majority of the image is taken up with daily life: drawing water from a frozen canal, a child playing, gathering kindling, etc. Winter landscapes were popular (there are over 30 paintings extant today based on this model alone) and reflect the mini ice age that gripped much of Europe from roughly 1300–1800 (Dutch canals rarely freeze today).

B7: Jan Bruegel I (1568–1625)

Landscape with Diane and Acteon, 1606–1609

Jan I was renowned for his richly textured still-lifes and landscapes (thus his nickname "Velvet"). He worked for the imperial court at Brussels (1606–1609) where he often collaborated with painter Hendrick de Clerck, who added these graceful mannerist figures. Taken from Ovid, the painting depicts the moment when unfortunate Acteon, out hunting, happens upon the goddess Diana and her nymphs bathing. Furious, Diana turns him into a stag and his own hounds devour him.

The c. 1708 Chinese cabinet (room B8) was part of the Sternberg Palace's original décor and served as an intimate room off of the reception halls of the elegant piano nobile. It is charmingly ornamented with a mish-mash of baroque and Far Eastern motifs, mostly from China and Japan. Asian designs, first called "Indian," and later "Chinoiserie" in Europe, were popular in domestic décor from the late 17th century. They arrived in central Europe via England and the Low Countries with motifs often copied from porcelains or prints. The walls of the cabinet were decorated with a lacquer technique by Jan Kratochvíl and the ceiling is by Swiss painter Johann Rudolf Byss, who managed to work in the Sternberg's symbol: the eight-pronged star.

B13: Rembrandt van Rijn (1606–1669)

The Scholar in his Study, 1634

One of the era's greatest artists, Rembrandt painted this image in the year of his marriage to Saskia van Uylenborch—a happy time for Rembrandt, when both his career and social standing were on the rise. The subject has not been identified, despite the detail of the scholar's costume and the books and globe of his study; it could be a costumed portrait of a contemporary or a historic figure. But his gentle, somewhat absent expression, as if he were still absorbed in his thoughts, is filled with Rembrandt's characteristic profound compassion for humanity and the canvas is a symphony

of texture, soft light, and quiet gesture. Throughout his oeuvre, Rembrandt strove to represent not only the corporeal, but also the soul.

The same room also holds interesting works by Rembrandt's students, such as Gerbrandt van den Eeckhout's *Bathsheba Pleads with David for Solomon's Succession*, 1646 (which is well described in the exhibit).

B14 : Peter Paul Rubens (1577–1640)

General Ambrogio Spinola, 1627

Besides being the most gifted and original artist of his era, Peter Paul Rubens was also a diplomat, businessman, intellectual, devout Catholic, and fluent in six languages. He studied in Antwerp and Italy and became the painter of Europe's rulers. The subject of this portrait is Genoese Marquis Ambrogio Spinola (1569–1630), who was in the service of the Archduke Albert and the Infanta Isabella. At the Brussels court Spinola met Rubens, the court's official painter and diplomat. The two became friends and Rubens painted Spinola several times. Standing in a typical soldierly pose in ceremonial armor, the image combines Rubens's northern European sense of realism with the grandeur and monumentality he had learned from Italian art. The sumptuous precision of the color frames the general's face, which exudes character and a world-weary fatigue.

B14: Peter Paul Rubens (1577–1640)

The Martyrdom of St. Thomas and *St. Augustine*, 1636–1638

These two canvases were painted for the Church of St. Thomas in Malá Strana (see page 119) in the last years of Rubens's life. The *St. Thomas* was originally part of the main altarpiece but the *St. Augustine* was only incorporated into the altarpiece in 1730. Its original location is unrecorded. The St. Thomas image depicts his martyrdom in India. Rubens builds the dramatic scene with two converging diagonals, with fierce gestures and wild expressions below and graceful apotheosis above. In contrast, the St. Augustine image captures a quiet

atmosphere of meditation. A legend tells that Augustine met a child trying to fill a hole with a shell as he was walking on the seashore mediating on the Holy Trinity. When Augustine remarked on the futility of the task, the child (representing Christ) replied that it was no more so than for man to try to fathom the mystery of God.

B15: Frans Hals (1581—1666)
Jasper Schade van Westrum, 1645

Hals did what no painter had done before: captured people in the spontaneous act of living. Traditionally, portraits had been posed and were prized for restraint, but Hals conveyed a sense of capturing his subjects in a fleeting moment. He didn't use preliminary drawings and most likely worked directly on the canvas using the paint's viscosity and brushstrokes to create texture and describe surfaces. His style is said to anticipate Impressionism (note the sitter's sleeve) and his work was admired by 19th-century artists such as Gustave Courbet and Édouard Manet. This image is of a 22-year-old young man from a well-to-do Utrecht family with a brilliant career ahead of him. With insight into human nature, Hals depicts his confident, superior attitude, a slightly bored expression, and hint of an ironic smile.

Room B16 is a long hall with several small idyllic genre scenes of refined brushwork; the characteristics of the "Leiden School," which includes Gerrit Dou, Frans van Mieris, Gabriel Metsu, and Jan Steen.

B16: Jan Steen (1626—1679)
Physician and Woman Patient, c. 1665

Steen made a specialty of humorous scenes of the lives of the Dutch middle class. Contemporary viewers would have understood several allusions in this scene of a doctor's visit: the maid with a urinal (for diagnosing pregnancy); the feminine-shaped lute that plays romantic music; the open bed curtains; the picture of the sea and ships above the entrance as a metaphor for the lovers'

relationship. The diagnosis: the patient is lovesick and probably pregnant. With great skill in rendering light and texture, and a good-humored approach to human foibles, Steen created scenes of the theater of ordinary life, usually with clearly understood references to a moral lesson. Today the Dutch still call a lively, untidy home a "Jan Steen household."

B18: Gerard ter Bosch (1617—1681)
Portrait of Willem Marienburg Jr. and Geertruide Marienburg, after 1661

Ter Borsch was one of the most respected and accomplished painters of 17th-century Holland. In the 1640s he adopted a new pictorial type, the full-length portrait, and began to simplify interiors. Ter Borsch characteristically depicts this patrician couple from Deventer with subtle psychological interplay and great refinement in the handling of color, light, and texture. His fabrics are startlingly realistic. Following standards of Protestant decorum they are soberly attired, yet their wealth is clearly displayed with jewels, expensive lace, and black cloth (black was the most expensive of all dyes), and when Willem later became mayor, their costumes were repainted to reflect the latest fashions.

B19: Bartholomeus van der Helst (1613—1670)
Self-portrait and *Portrait of Anne de Pire* 1660

Van der Helst portrayed his wife as the Persian Princess Granida and himself as the shepherd Daiphilus, characters from a popular Dutch play (*Granida*). The erotic playfulness of the scene—her with exposed breast and holding a suggestive open shell while he holds a staff and gazes admiringly—suggests that the pictures were intended for private chambers. Van der Helst was a fashionable portraitist in Amsterdam, where his elegant portraits, full of swagger, bright color, and sumptuous detail, soon surpassed those of his contemporary Rembrandt in popularity among the upper classes.

GROUND FLOOR

15th–18th-Century German and Austrian Art (C4–5)

The ground floor galleries contain some of the most important pictures in the collection. Undergoing renovations at the time of writing, rooms C1–3 were closed and all of the below pictures were found in room C5, a condition that will no doubt change when renovations finish.

Albrecht Dürer (1471–1528)

The Feast of the Rose Garlands (or Rosary), 1506

"I have silenced all those painters who say I am a good engraver but a poor hand with the brush," was Dürer's proud claim after completing this painting for San Bartolomeo, the church of the German community in Venice. Painted on Dürer's second trip to Italy in 1505–1506, it would win him great prestige, and marks a turning point not only in his career but also the art in northern Europe. In 1606 it was bought by the ultimate art connoisseur, Rudolf II, and has been one of the greatest works of art in Prague ever since.

The subject is linked to the cult of the rosary associated with the Dominican Order, and thus St. Dominic (who stands next to the Virgin) and cherubic angels distribute crowns of roses among the faithful. Assembled is a virtual who's who of 1506; to either side of the Virgin kneel Emperor Maximilian I and Pope Julian II. The image's imperial aspect (Dürer also worked for Maximilian) is reinforced by the Habsburg-like crown received by the Virgin, who in turn crowns her two earthly representatives with heavenly crowns (their terrestrial ones sit at their feet). Other figures are done with the precision of portraits, although not all are identifiable. One certain inclusion, however, is Dürer himself. With the self-assurance of a true Renaissance artist, he pictured himself handsomely dressed and golden-haired, staring directly at the viewer and holding a leaf with his signature, details of his origin, the date of the painting and how long it took him to paint it (five months).

The picture demonstrates Dürer's mastery of Venetian painting technique with the grand spatial composition, suppleness of line and a feeling for light, plasticity of shape and marvelous color. Dürer was clearly influenced by Giovanni Bellini, who himself admired this painting. This is the earliest northern European painting in which Italian Renaissance ideas prevail. However, a sense of the northern delight of detail remains: note for example the grass and the ribbons on a soldier's armor, which have the precision of an engraving.

Lucas Cranach the Elder (1472–1553)
St. Christine, 1520–1522

Cranach, as court painter of the elector of Saxony (from 1505 until his death) and a good friend of reformer Martin Luther, was considered the leading painter of the German Reformation. Nevertheless, his prosperous workshop produced portraits as well as religious and secular works in painting and prints for both Protestant and Catholic patrons. His idiosyncratic style has a rather awkward, courtly mannerism characterized by bold design, intense color, and gracefully outlined costumes. Almost all of Cranach's women are pale, blonde, and somewhat feline. This angelic St. Christine is a fragment of a large Marian Altarpiece commissioned by King Louis Jagiello for St. Vitus Cathedral, which was later ripped to bits by iconoclastic Calvinists in 1619. Several fragments survive in various collections.

Lucas Cranach the Elder (1472–1553)
The Old Fool, 1530

Cranach made several version of this popular moralizing image warning of the dangers (and milking the comic value) of an unequal match. In this version, a toothless but rich old man lecherously kisses a minx-like blonde who pickpockets his money.

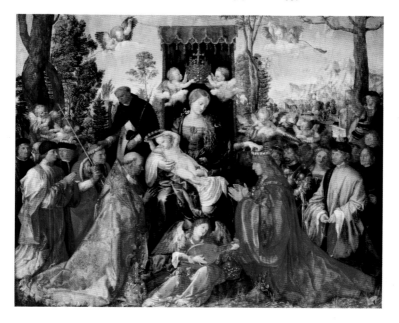

Albrecht Dürer, The Feast of the Rose Garlands, *1506 (oil on panel), National Gallery, Prague (Giraudon)*

Lucas Cranach the Elder (1472–1553)
Adam and Eve, 1538

Cranach often depicted sin as a beautiful, crafty-looking young woman. Here, a nude Eve, seductively posed against the tree of knowledge, literally places the apple in Adam's mouth. An artfully placed branch adds a trace of decorum to what otherwise is a titillating nude in the guise of religious instruction.

Hans Holbein the Elder (1465–1524)
Wings of the Hohenburg Altarpiece, 1509

These two double-sided panels were the wings of an altarpiece for the St. Odile Monastery in Hohenburg (Alsace), where the Augsburg-born Holbein stayed in 1509. Painted in an eye-catching, sculptural, gray and blue grisaille technique, it is a primarily late Gothic

image with some Renaissance detail in the architectural framework. The right wing depicts, on the front side, St. Ambrose and St. Margaret (with her dragon). On the other side, in the upper register, are St. Barbara, St. Apollonia (holding the pincher that removed her teeth), and St. Roch, and, in the lower part, a scene from the life of St. Odile as she prays to have her father's soul (represented by a crowned nude man) released from purgatory. The left wing depicts St. Thomas and St. Augustus (with Holbein's signature "Hans" on Augustus's lower robe) and the other side has images of St. Sebastian, St. Lucy, and St. Catherine and, below, the death of the Virgin, which takes place in a contemporary German interior.

Georg Flegel (1566–1638)
Breakfast with Egg, 1630

Following in the tradition of the nature studies of artists like Dürer, Moravian-born Flegel, who worked in Vienna and Frankfurt, aimed for scrupulous naturalism to the point of illusion. He was one of the very first in central Europe to specialize in still-life paintings, which were prized for their decorative verisimilitude. In this small image he depicts everyday breakfast items: butter in a porcelain plate, a glass of beer or wine (in an age before clean drinking water, commonly drunk at all meals), an egg in a holder with bread for dipping and expensive cut flowers in a delicate vase. Still-lifes are often filled with exotic, luxury items, but in this picture the bread, butter and egg might have been just pulled out of the artist's larder that morning. Perhaps they were his lunch. The fly on the egg makes the metaphorical point of the fleeting nature of life as well as providing a comment on 17th-century hygiene.

On leaving the gallery, turn right (north) on to Hradčanské náměstí toward Kanovnická Street. In the open square, note the 1726 plague column by F.M. Brokoff, and Aleš Linsbauer's 1867 cast-iron public lighting column supported by classical caryatids, a rare survivor of the decorative gaslight system

that lit 19th-century Prague. The western end is dominated by the **Tuscan Palace** (Toskánský palác, no. 5/182), designed by Jean-Baptiste Mathey for Count Michael Thun-Hohenstein and built from 1685–1694. Its symmetrical façade, graced by statues by Johann Brokoff, is now the Ministry of Foreign Affairs. To the northwest corner, leading to Kanovnická Street, is the delightful sgraffito-covered **Martinic Palace** (Martinický palác, no. 8/67), built between 1570–1600 by the Martinic family, whose crest is displayed above the rusticated portal. The façade is a late Renaissance design, but shows some early baroque influence, such as the volutes on the graceful gable. The sgraffito depicts biblical moral tales, which were also no doubt for amusement, such the image on the façade of Potiphar's wife trying to lure Joseph to her bed. By 1800, the interior was divided into apartments, but recent restorations have uncovered original frescoes and painted ceilings (unfortunately not open to the public).

Follow along winding Kanovnická street past the **Church of St. John of Nepomuk** (sv. Jana Nepomuckého). Built in 1720–1729 as part of an Ursuline convent, it is the first known church by K.I. Dientzenhofer. Turn left onto the charming old-world Nový Svět (New World) Street, which follows the line of the old baroque fortifications and has numerous tiny houses that were first developed in the 16th century as modest housing for castle servants. In the 19th century the dilapidated area began to attract artists and writers inspired by its romantic decay. Turn left, following the line of the old walls up Černínská Street, pass **Gambra, Surrealistická galerie** (Černínská 5, open 12 PM to 6 PM from March–October on Wednesdays to Sundays, but from November to February only on Saturdays and Sundays). This surrealist art gallery and bookshop is owned by renowned animated filmmaker and visual artist, Jan Švankmajer (1934–) and his wife, artist Eva Švankmajerová. Note the wonderful folk-art sculpture of Jan of Nepomuk just after the gallery.

Entering Loretánské náměstí (Loreto Square), you'll pass on your left the walls of a Capuchin monastery founded in 1602 (closed to the public), then arrive before the vivacious façade of the Loreto, which dominates the eastern side of the square.

Detail of sgraffito on façade of Martinic Palace, showing Potiphar's wife trying to lure Joseph to her bed (photo by Troy McEachren)

Sanctuary of Our Lady of Loreto (Loreta)

Location: Loretánské náměstí 7
Opening hours: Tues–Sun 9 AM–12:15 PM, 1 PM–4:30 PM

In 1626, Countess Benigna Kateřina of Lobkowicz commissioned Giovanni Battista Orsi to build a replica of the Santa Casa, the Virgin Mary's house. According to legend, the house was in the Italian town of Loreto, where it had been miraculously transported from the Holy Land. A popular Marian cult developed around the house, and later the shrine around it, built by Bramante, inspired copies all over Catholic Europe. Prague's was the most popular and became a major pilgrimage site. The adjoining Capuchin monastery was placed in charge of the shrine but the Lobkowicz family remained its principal patrons. In the mid-17th century an arcaded courtyard was added around the shrine and then, in the early 18th century, the Dientzenhofer family added an upper story to the courtyard, the Church of the Nativity, and the splendid western façade.

The festive tripartite façade was completed by K.I. Dientzenhofer in 1721–1724 and has been compared to an altarpiece. In keeping with the Marian theme, atop the

gables are statues of the Virgin (left) and the Angel of the Annunciation (right). The interior is not for those who have developed an aversion to the pathos of baroque religious theater. Every corner is richly decorated with sprightly angels and martyred saints (look out for the crucified bearded lady saint). The Santa Casa itself is a rather odd re-creation of another re-created building. In 1664 it was covered with stucco reliefs of the life of the Virgin, but it was otherwise designed to imitate the imagined humble circumstances of the Holy Family and even has a false crack imitating the lightning that once struck the original in Italy. Several members of the Lobkowicz family are buried inside the almost folk art-like shrine, upon which is written "EN LOBKOVIZIANOS TV PIA VIRGO REGE" (Behold the Lobkowiczes whom the Blessed Virgin rules).

The Church of the Nativity (1718–1737) is little altered since its creation, giving the full effect of the flamboyant theater of the baroque. Note the oratories, which resemble theater boxes. Gilded niches to either side of the apse present the masked corpses of St. Marcia and St. Felicissimus, posed like action figures. There are so many cherubs it is more like an infestation than a decoration (note a particularly sinister pair north of the pulpit with a pair of pliers and a newly pulled tooth!) The treasury in the upper courtyard holds the gilded and bejeweled paraphernalia of the sanctuary.

As you leave the Loreto, before you rises the monumental façade of the **Černín Palace** (Černín Palác), designed by Francesco Caratti in 1669 for the ambitious Jan Černín of Chudenice, the imperial ambassador to Venice. Designed to impress, it was one of the most luxurious palaces in the city, but by the 19th century it was boarded up and crumbling. Former cubist architect Pavel Janák remodeled it from 1928–1934 for the Ministry of Foreign Affairs, but retained Caratti's long façade lined with Corinthian columns, which had been the first fully baroque façade in the city. It was here that in 1948 Jan Masaryk, son of the first Czechoslovak president and the last non-communist member of parliament, mysteriously died by that peculiarly Czech form of death falling out a window.

Turn right (west) along Loretánská to Pohořelec, a square dating to the 14th century and lined with mostly baroque buildings. Climb the narrow passageway through the house at no. 8 to Strahov Monastery. Alternatively, continue west and enter through the main baroque gate (1742).

Strahov Monastery (Strahovský klášter) and Strahov Gallery (Strahovská obrazárna)

Location: Strahovské nádvoří (courtyard)
Opening hours: The library halls, daily 9 AM–12 noon, 1 PM–5 PM; the Strahov Gallery, Tues–Sun 9 AM–5 PM.

This splendidly located hilltop monastery was founded in 1140 by Vladislav II, and by the 1180s a great Premonstratensian Romanesque abbey rose above the city. First called Mount Zion, it later became known as Strahov (from "stráž" meaning guard) for its strategic position on the western approach to Prague; this proved a mixed blessing because the monastery was sacked and burned many times. From its inception it was an international center of learning and it was this scholarly reputation that kept the abbey open after Joseph II's monastic closures in the 18th century. It did not, however, save it from the communists, who in 1950 turned Strahov into a museum of Czech literature. Today the Premonstratensians are once more in charge and have turned the monastic complex into a booming business, exploiting Strahov's tourist potential to its fullest.

There are two churches within the leafy convent precinct. The **Chapel of St. Roch** (sv. Rocha) stands next to the main entrance gate, and its whitewashed interior is now a contemporary art gallery. Commissioned by Rudolf II in thanks for saving Prague from the plague, it dates from 1603–1612 and is an interesting melange of Gothic and Rudolfine mannerism. While Gothic in its basic architectural vocabulary (multi-sided chapels, tracery windows, buttresses, etc.), in expression it is purely mannerist, such as in the elongated octagonal layout, the buttresses with voluted consoles, and the mannerist classicism of the interior and portal. The

Church of the Assumption of Our Lady (Nanebevzetí Panny Marie) is part of the main complex. Above its portal a wind-swept Virgin upon a half-crescent (a symbol of chastity) in mid-assumption is flanked by two angels, all by Johann Anton Quitainer. The church's original Romanesque basilica shape is fully submerged beneath the mid-18th-century high-baroque reconstruction of Anselmo Lurago. The festooned interior is only visible through a grille, from which one can glimpse the paintings of the life of the Virgin and St. Norbert (the founder of the Premonstratensian Order, whose remains are held in the church), all framed in elegant creamy stuccowork by Ignác Palliardi.

But it is the lusciously decorated library halls for which Strahov is most known. Dating from 1782–1784, the **Philosophical Hall** (Filozofický sál) was the work of Palliardi, who gave it a neo-classical façade with a medallion of Joseph II, to whom the library owed its existence. The grand interior was designed to fit the huge carved walnut bookcases brought from the dissolved monastery of Louka. The swirling ceiling painting was the last work of Viennese Franz Anton Maulbertsch (1724–1796). Its theme is mankind's search for true wisdom, and no doubt library-goers were inspired by the triumphal images of biblical and Bohemian figures, such as St. Wenceslas, and of heretical Enlightenment thinkers, such as Voltaire and Diderot, being cast into hell.

If the rectilinear design of the Philosophical Hall reflects the rational style of the Enlightenment (if not all its principles) then the 1671–1679 **Theological Hall** (Teologický sál) evokes the baroque's enthusiasm for the miraculous and mystical. Designed by Giovanni Domenico Orsini, its broad barrel vaults rest upon the bookshelves and are decorated with late 17th-century stuccowork and paintings celebrating human knowledge.

The small **Strahov Gallery** (Strahovská obrazárna) is found on the upper floor of the cloisters, which are entered through the courtyard behind the Church of the Assumption. The monastery's art collection was confiscated by the communist regime but many have now been restituted, including some

from the National Gallery. The display comprises only about one-tenth of the collection, but includes some of Bohemian Gothic and Rudolfine masterpieces.

Follower of the Master of Vyšší Brod
Strahov Madonna, 1340–1350

This panel is an excellent example of a type of Bohemian votive image called a "Graceful Madonna" (see St. Agnes Convent page 87), which were made in abundance in 14th-century Bohemia, reflecting the popularity of the cult of the Virgin. It blends the motifs of Italian-Byzantine icons (such as the active Christ Child in a transparent draping, the bottom view of his foot, the more static quality of the drapery and movement) and Bohemian traditions (such as the crown, the blonde hair, the tenderness between mother and child). Both the Virgin and Child look out of the picture space making a connection with the worshipper/viewer.

Lucas Cranach the Elder (1472—1553)
Judith, c. 1530

Judith's story is found in the Old Testament. When the Israelites were under siege, Judith, a beautiful widow, devised a plan to save her people. She entered the enemy camp, seduced their general, and when he fell into a drunken sleep, chopped his head off. In the Middle Ages she was seen as an allegory of virtue overcoming vice, but by the Renaissance she was regarded as a symbol of man's misfortune at the hands of scheming women. In typical Cranach style (for more, see the Sternberg Palace, page 186), he portrays her with a sly grin, suggesting a sexually voracious killer rather than an Old Testament heroine.

Bartholomeus Spranger (1546 Antwerp—1611 Prague)
Resurrection of Christ, c. 1576

After studying landscape painting in his native Antwerp, Spranger passed several years in Italy, absorbing Roman-

Florentine mannerism. In 1576 he was invited by Emperor Maximilian II to Vienna where he made this image for the imperial hospice of a long-limbed Christ rising gloriously from his tomb as sleeping soldiers begin to stir. Spranger poured everything he learned in Italy into the painting: dynamic composition, exciting movement (note the fluttering cloaks), subtly vibrant color and masterly execution. Rudolf II knew talent when he saw it and later invited him to his court in Prague, where Spranger executed some of his best works.

Hans von Aachen (1551–1615)
Portrait of Rudolf II, 1604–1612
Von Aachen first trained with a Flemish painter in his native Cologne, studied in Italy and in 1592 became court painter to Rudolf II. The emperor liked von Aachen's mannerist style, genre paintings, and his portraits, in which he captured more than simply the sitter's resemblance. Here he turns his portraitist's eye to his imperial patron, clearly recognizable by his distinctive Habsburg lip and his chain with the symbol of the Order of the Golden Fleece, a noble fraternity inherited from his Burgundian forebears.

Dirk de Quade van Ravesteyn (1565–1625)
Allegory of the Reign of Rudolf II, 1603
And quite a reign it must have been! In this picture designed to extol the virtues of Rudolf as the empire's protector from Turkish peril (the Ottoman Empire threatened the Habsburgs' borders for much of the 17th century), the artist creates a playful, erotic allegory of bare-breasted, bejeweled beauties and a lusty soldier. The maidens, suggestively posed for the titillation of the viewer, appear to represent prosperity (with a cornucopia), victory (with a sword) and peace (with a dove and olive branch). A fourth maiden keeps out an aroused soldier, who seems to have been distracted from his duty defending against the turbaned Turk. A chain attached to Victory is being flown aloft by an imperial

eagle toward a celestial vision of a scepter and crowning laurels, referring to the emperor whose rule makes this merry scene possible. Little is known about the artist other than he studied in the Netherlands and came to Prague in 1589, where he was influenced by the Italian mannerism of Spranger and von Aachen, although never quite achieving their level of mastery.

This ends Trail 4, but for excursions further west, see Western Prague, Trail 6.

Trail 5:
The New Town

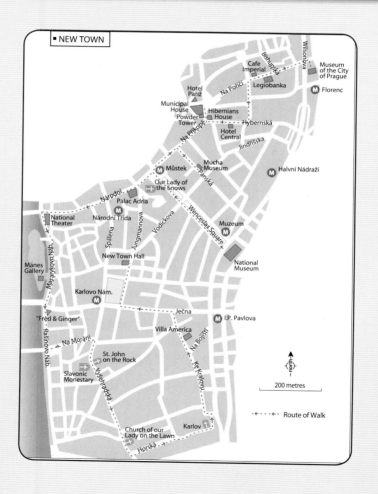

■ NEW TOWN

Wilsonova

Cafe Imperial
Biskupská
Na Poříčí
Legiobanka
Museum of the City of Prague
Ⓜ Florenc

Hotel Paříž
Municipal House
Hibernians House
Powder Tower
Na Příkopě
Hybernská
Hotel Central
Jindřišska

Ⓜ Můstek
Mucha Museum
Panská
Ⓜ Halvní Nádraží

Our Lady of the Snows
Národní
Palac Adria
Ⓜ Národní Trída
Špálena
Jungmannova
Vodičkova
Wenceslas Square
Ⓜ Muzeum

National Theater
Mánes Gallery
Masarykovo Náb.
New Town Hall
National Museum

Karlovo Nám. Ⓜ

Rašinovo Náb.
"Fred & Ginger"
Ječna
Ⓜ I.P. Pavlova
Na Moráni
Villa America
Na Bojišti
Vyšehradská
St. John on the Rock
Ke Karlovu
Slavonic Monestary

Church of our Lady on the Lawn
Karlov
Horská

↑ north

200 metres

-+----+- Route of Walk

When Charles IV decided to transform Prague into his imperial capital, one of his first tasks was to found the New Town in 1348, located to the south and east of the Old Town and bordered by new fortifications that stretched from the foot of Vyšehrad hill north to the Vltava. The government offered incentives designed to attract new citizens, the poor, and less desirable trades (e.g., slaughterhouses, tanning) out of the more ceremonial Old Town, including tax breaks for those who constructed houses within eighteen months and promises of "honor, freedom, well-being, joy and protection against violent conflict." Within a decade the New Town was thriving and the town's layout, based around three principal markets—the Cattle (today Karlovo náměstí), Horse (Václavské náměstí) and Hay (Senovážné náměstí) Markets—was so successful that today it still forms the basis of the area's urban organization.

In the later 19th century, as the New Town became Prague's social and commercial center, its medieval walls and much of its older housing were demolished to make way for contemporary apartment blocks and civic buildings. Thus the New Town, quite appropriately, has a newer feel than Prague's other historic townships (Old Town, Malá Strana, and Hradčany). There are, of course, remarkable medieval churches and baroque palaces; however, the excitement of the New Town is in its reflection of the optimism, experimentation, and modernity of the late 19th and the early 20th century, embodied in such styles as art nouveau/Secession, cubism, and functionalism. With only a few smaller museums (e.g., Mucha Museum), this trail can be covered in a pleasant afternoon's walk past some of the city's most eclectic architecture, including Canadian-born architect Frank Gehry's "Dancing Building," the Secessionist Municipal House, the baroque Villa America, and the great medieval monastery of Emmaus.

WENCESLAS SQUARE (VÁCLAVSKÉ NÁMESTÍ)

One of Prague's most recognizable spaces, Wenceslas Square has been the modern city's gathering point during various times of crisis and celebration: the creation of Czechoslovakia

in 1918; the invasion of the Nazis in 1939; communist-era May Day celebrations; the Soviet invasion of 1968; and the Velvet Revolution of 1989. Known as the Horse Market (Koňský trh) until 1848, Wenceslas Square is really more of a long, broad boulevard. Its present form was developed from 1880–1920, when it became the city's focus of commercial and social activity, and avant-garde architects lined the square with art nouveau, modernist, and functionalist buildings—progressive, modern architecture for a young, optimistic nation.

The present-day character of the square is somewhat less inspiring, having gained a degree of seediness since 1989, with sleazy nightclubs attracting less desirable characters, including pickpockets. However, the level of street crime in Prague is still low compared to most Western cites; just watch your wallet when walking here at night.

Dominating the square is the vast, neo-Renaissance **National Museum**, which occupies the site of the Old Horse Gate (demolished in the 1880s) that for centuries led directly to the countryside. Today it is divided from the rest of the square by a double highway added in the 1950s. Built by architect Josef Schulz in 1880s, it was designed as a potent symbol of Czech nationalism. Its interior pantheon of Czech art and work is adorned with statuary portraits of historic Czech figures and allegorical paintings by members of the National Theater Generation such as Václav Brožík and Josef Myslbek. The museum itself, devoted to prehistory, coins, geology, and zoology, is of limited interest but offers a good view from its steps.

Before the museum rises the noble equestrian **St. Wenceslas** (sv. Václav), a statue immortalized in the photographs of the Velvet Revolution. Conceived by Josef Myslbek in 1887, the statue, which combines a noble historicism with art nouveau sensibilities, was only completed in the early 1920s when flanking figures of Bohemia's other patron saints—Ludmila, Agnes, Procopius, and Adalbert—were added. The plinth on which they stand is engraved with the humble entreaty, "may we and our descendants not perish." Nearby a small memorial commemorates the tragic self-immolation of student Jan Palach in protest of the Soviet invasion in 1968.

The sloping square is a showplace of early 20th-century architecture. On the east side, at no. 45, the rather severe **Hotel Jalta** is a example of Soviet social realism from the 1950s, while just few buildings further down is the elegant Secessionist **Grand Hotel Europa** (no. 25) built in 1903–1905 by Bedřich Bendelmayer and Alois Dryák. The façade is awash with art nouveau balustrades and mosaics, and inside, the café's period décor evokes the fin-de-siècle atmosphere of pre-World War I Prague. Across the square is the famous **Melantrich Building** (also known as the Hvězda Palác, no. 36) built in a late Secessionist style in 1912–1914 by Bedřich Bendelmayer. It was there, on November 24, 1989, to the astonishment and pure joy of thousands of protestors, that Alexander Dubček, hero of the Prague Spring, and Václav Havel, leader of the dissident political group Civic Forum, appeared on the balcony declaring the success of the Velvet Revolution. Reflecting the enormous changes since that fateful year, it is now a Marks and Spencer. Next door is the neo-Renaissance façade of the 1895–1896 **Wiehl Building** (no. 34) built by architect Antonín Wiehl and covered in sgraffito decorations by Mikoláš Aleš.

Take a short detour left (west) along Vodičkova Street. At no. 36 is the façade of the **Lucerna Palác** designed by Osvald Polívka, the leading architect of the Prague Secession, and constructed by Václav Havel, grandfather to the playwright president, between 1907 and 1920. When built, the Lucerna Palace was the ultimate in modern commercial venues: a practically self-contained world of pasáže (passages)— labyrinths of internal corridors lined with elegant shops, restaurants, and theaters that were popular around the turn of the 20th century. It is now more tacky than trendy; nevertheless it is worth having a look into the pasáže. It still has some wonderful modernist décor, which makes a great backdrop for contemporary artist David Černý's amusingly absurd *St. Wenceslas*, who sits astride the belly of his noble, but upside-down, steed. (For more on Černý, see page 73.) Further along at no. 30 is the former Novak department store (sadly now a casino), **U Nováků**, a wonderful example of

Secessionist architecture by Polívka, with a façade mosaic of allegories of trade and industry by symbolist artist Jan Preisler and whimsical stuccowork, including a crowned frog entwined in a red sash below a windowsill.

Back on Wenceslas Square, the 1929 functionalist **Alfa Building** (west side, no. 28) by Ludvík Kysela has a sleek pasáž leading into a delightfully unexpected park that was once the medieval garden of the adjoining 14th-century Franciscan monastery (see below). Next door is the last of the square's baroque hotels, the **Hotel Adria** (no. 26), while a few doors down is the 1925–1933 **Julius Building** (no. 22, now "Sports Town"), a functionalist work by former cubist architect Pavel Janák. Jan Kotěra, the founder of Czech modern architecture, created the 1899 early Secessionist **Peterka House** (no. 12), remarkable for its complete lack of historicism and lyrical yet restrained ornament. Before its construction, the 14th-century **Church of our Lady of the Snows** (see below), which stands behind Kotěra's building, dominated this end of the square. The late Secessionist **Adam Pharmacy** (Adamova lékárna, no. 8) from 1913 shows the influence of cubism, while the 1927–1929 **Baťa Building** (no. 6), whose façade was designed by Ludvík Kysela and Josef Gočár, was the original functionalist model for all of Tomáš Baťa's shoe stores. Reflecting the forward-thinking atmosphere of the inter-war city, around 1935 pioneer kinetic artist **Zdeněk Pešánek** designed a surreal, luminous commercial sign for the Baťa façade involving baroque clouds and fragmented male and female torsos projecting from the building. An image of the project, which was never completed, can be seen in the Trade Fair Palace. Adjacent is one of the city's first functionalist stores, the 1925 **Lindt Building** (no. 4) also by Kysela.

Opposite, on the east side, are the pre-World War I art deco hotels **Ambassador** (no. 5) and **Zlatá husa** (Golden Goose, no. 7) and at the junction with Na příkopé is the 1910–1914 **Koruna palác** (no. 1), whose style marks the transition from the more naturalistic art nouveau to art deco, with more stylized, geometric forms, such as its futuristic crowned tower. The T-junction at the base of Wenceslas Square marks

the line of the medieval Old Town walls, which divided the
Old and New Towns. The metro station Můstek (Little Bridge)
is named for a medieval bridge that crossed the moat at this
point, the remains of which can be seen in the station. The
bridge is also recalled in the name of the street leading north
to Old Town Square, Na můstku (At the Little Bridge). Turn
right on to Na příkopé to explore northeast of Wenceslas
Square (see below for southwest of the square).

Northeast of Wenceslas Square

Called Valejích or An Graben (meaning "in the ditch") until
1939, Na příkopé (Moat street) follows the line of the moat of
the Old Town wall. Filled in and made into a leafy boulevard
in the 1760s, in the 19th century it was lined with prestigious
offices and cafés and was the favorite haunt of Prague's German
population. Today it is a pedestrian shopping street lined
with several historic buildings. Prague's oldest department
store (1870) is the neo-Italian Renaissance **Haas Building**
(no. 4, now a Benetton), while the street's oldest building
is the elegant **Sylva-Taroucca Palace** (no. 10), designed for
Prince Ottavio Piccolomini by K.I. Dientzenhofer in 1743–
1745, today housing a seedy casino. Built by Georg Fischer
in 1824, the simple neo-classical **Church of the Holy Cross**
(sv. Kříže) stands on the corner of Panská Street. Turn up
Panská, upon which is found the Mucha Museum.

Mucha Museum

Location: Kaunický Palace, 7 Panská Street
Contact details: tel: 221 451 333, www.mucha.cz
Opening hours: Daily 10 AM–6 PM

This small museum offers an introduction to the life and work
of art nouveau innovator, Alfons Mucha (1860–1939). Because
his designs are now so often reproduced on everything from
greeting cards to fridge magnets, it's difficult to imagine the
startling originality of Mucha's images when they first appeared.

Avoid the overstocked gift shop and check out the real thing.

A biographical film begins the visit. After failing to enter Prague's Academy of Fine Arts, Mucha took varied creative jobs (e.g., stage designer, house painter) until a noble patron sent him to study in Munich (1885–1887) and Paris (1888), where he became an illustrator. His big break came in 1894 with a last-minute commission for posters for a performance by Sarah Bernhardt. The 34-year-old illustrator suddenly found himself the toast of the town and "le style Mucha," i.e., art nouveau, was born. Mucha's flowery, decorative style was characterized by sinuous, asymmetrical lines based on organic forms, and showed varied influences, including the pre-Raphaelites, the Arts and Crafts Movement, and Byzantine art. His work united beauty and utility, art and everyday objects. He worked for Bernhardt and others designing advertisements, theater decorations, books, jewelry, furniture, and interiors, gaining worldwide renown. Inspired by Slav nationalism, he returned to Bohemia in 1910, where he dedicated much of his time to an epic series of twenty paintings depicting the history of the Slav people. He also created designs for the newly created Czechoslovakia, e.g., banknotes and stamps, and contributed to the nation's emblematic buildings, such as St. Vitus and the Municipal House. An ardent Czech nationalist, he died in 1939, at close to 80 years old, after being interrogated by the invading Nazis.

The exhibit is divided into seven sections: Parisian posters; decorative panels; *Documents Décoratifs,* Czech posters; oil paintings; drawings and pastels; photographs and personal memorabilia of the artist. The exhibit begins with the Parisian lithographs that made Mucha famous.

Gismonda, 1894–1895

A last-minute commission for an advertising poster for Sarah Bernhardt's performance of *Gismonda,* a play by Victor Sardou, shot Mucha to fame overnight. One of the first examples of the melding of art and advertising, the posters caused a sensation and became instant collector's items, with people even cutting them out of their frames at night. The image has an unexpected stateliness and

understated dignity, with Sarah Bernhardt portrayed in costume: a long, lean figure of subtle colors and art nouveau folds and curves. Bernhardt herself was so pleased with the effect that she offered Mucha a six-year contract.

Hamlet, 1899
This was the last of the many posters Mucha made for Bernhardt. He portrays Bernhardt's Hamlet with dramatic, bold lines and colors rather that than more subtle approach he used in the early *Gismonda*. Behind the lanky image of Bernhardt's Hamlet lurks the ghost of Hamlet's slain father haunting the halls of Elsinor; at his/her feet lies drowned Ophelia, wreathed in flowers. Celtic designs are woven into the decorative frame.

His Czech posters, made after his return in 1910, are equally interesting. Note the *Moravian Teacher's Choir* (*Pěvecké sdružení učitelů moravských*, 1911), filled with beautiful decorative detail and a girl in folk costume holding her hand to her ear to hear some faraway music, and the elegant, lounging lethargy of *Princess Hyacinta* (1911). Throughout the exhibit there are interesting photos from Mucha's years in Paris and Bohemia, with friends (including Gauguin), family, and some pictures of the costumed models that Mucha often used. Mucha's designs were so in demand he expanded into household items, furniture, and commercial products and developed an all-encompassing approach to design, especially after his work for the 1900 World Exhibition. In 1902, he published his *Documents Décoratifs*, 72 plates of stylistic patterns (several of which are displayed), with designs for jewelry, furniture, and everything else.

Although known as a graphic designer, Mucha painted all his life and devoted the last 30 years of his life to a massive painting cycle of the history of the Slavic people, the *Slav Epic*. Unfortunately, it is now found in Moravský Krumlov, a small town in Moravia. (Ask at the ticket desk for information on the exhibit). Disappointingly, only one of Mucha's major paintings is here in the museum.

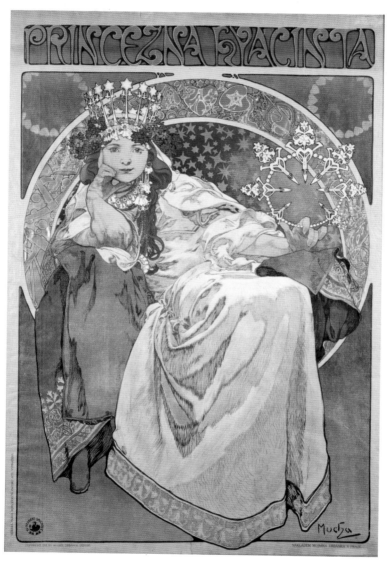

Alfons Mucha (1880–1939), Princess Hyacinta, 1911 (color litho),
(Mucha Trust)

Star (Hvězda), 1923

The image is of a kneeling Russian peasant surrounded by a deep blue winter night, calmly accepting her coming death, either by cold or the wolves gathering nearby. In keeping with the *Slav Epic*, it is meant to embody the fortitude and silent suffering of the Slavs. The style is a combination of realism, symbolism, Romanticism, and fierce nationalism (as well as a good dash of melodrama) and the rich color and patterning shows the artist's decorative inclinations. Although Mucha himself had visited Russia and done several studies and drawings *in situ*, he actually used his wife as the model. A photograph of her dressed and posed as the Russian woman hangs beside the painting.

Leaving the museum, return to Na příkopé, and continue to the right. The 1895 **Živnostenská Banka** (Investment Bank, no. 20) is perhaps the most decorative bank in Bohemia. Wanting to merge architecture and applied arts in the design, architect Osvald Polívka cooperated with artists such as Mikoláš Aleš, Stanislav Sucharda, and Max Švabinský on the lavish décor, which embodies the enthusiasm of Czech nationalism with allegorical images of Bohemia's virtues, including façade lunettes of Thrift, Industry, Welfare, and the harmony between Capital and Labor, suggesting the worthiness of both the bank and nation. Fifteen years later, Polívka created the neighboring structure (no. 18), in which he mixed historicism and art nouveau, and mosaics by symbolist Jan Preisler, linking the two buildings together with a covered passageway.

After the 17th-century baroque Vernier Palace (no. 22), which was remodeled in a neo-classical style in the late 18th century, Na příkopé leads past several imposing interwar banks and the medieval Powder Tower (see Old Town) to the magnificent Secessionist Municipal House.

Municipal House (Obecní dům)

Location: Náměstí Republiky 5

Contact details: tel: 222 002 101, www.obecnidum.cz.

Opening hours: The café, bar, and restaurants are open to the public, but to see the ceremonial halls one must take a guided tour. The information center is open daily, 10 AM–6 PM, and has information about daily guided tours and performances in the Smetana Hall. The café is open from 7:30 AM–11 PM and the restaurants are open for lunch and dinner.

It is often forgotten that Bohemia's greatest piece of art nouveau architecture was already out-of-date upon its completion in 1912. Gočár's nearby cubist House of the Black Madonna was completed the same year and other daring modernist styles were prevalent. Nevertheless, the Municipal House's glorious décor, the combined effort of some of the country's best architects and artists, perfectly suited its primary purpose as a vibrant symbol of the emerging Czech nation.

Design by Alfons Mucha (1860–1939), Mayor's Hall, Municipal House, Prague, 1910 (photo), (Mucha Trust)

The Municipal House stands on the site of the Royal Palace built by Václav IV in the 14th century. After the kings returned to Hradčany, the palace became a seminary, then a barracks, and finally fell into disrepair and was demolished in 1902. It was the Czech Patriotic Society that first envisioned a social and cultural center for the Czech community as a counterweight to a similar German institution on Na příkopě. Architects Osvald Polívka and Antonín Balšánek were chosen for the task and, in conjunction with numerous leading artists, such as Alfons Mucha and Max Švabinský, completed the structure from 1903–1912. Although met with stylistic criticism upon its completion (Jan Kotěra called it ostentatious and over-decorated) the Municipal House became the meeting place for Czech affairs, and on October 28, 1918, the new Czechoslovak state was declared from its Smetana Hall (a fact commemorated in a plaque by Secessionist sculptor Ladislav Šaloun on the corner of the building). The Municipal House's connection with Czech nationalism may be why the Nazis used it as their headquarters from 1939–1945. Today its concert hall is home to the Prague Symphony Orchestra and each year the Prague Spring music festival is kicked off here with a performance of Smetana's "*Má vlast*" ("My *Country*").

Restored in the 1990s, the Municipal House has once more drawn criticism, this time for being "over-restored," even "garish." Its new image is definitely aimed at the tourist market: the building sparkles with burnished gilding and restored colors; whether this bright, shiny newness is true to the original structure is debatable. It is, at least, a step forward after decades of neglect.

Exterior
Balšánek and Polívka found themselves with an awkwardly shaped site, a fact that resulted in the Municipal House's irregular diamond-shaped plan, with an above-ground passageway adjoining the Powder Tower. The structure, with a monumental façade of two angled wings that meet at an ornate portal, topped by a grand copper dome, suggests the influence of the age's great neo-baroque monuments, such as Garnier's Paris Opera House; however, its decoration is pure

Prague Secession. Surfaces are adorned with sinuous foliage and allegorical faces and the entrance's ironwork balcony is all organically patterned stained glass and supple gilded-green metal. Above, the allegorical figures of the mosaic *Apotheosis of Prague* by Karel Špillar are encircled by the words, "Hail to thee, Prague! Stand steadfast against Time and Malice as you have withstood the storms of the ages." Flanking the lunette are Šaloun's allegorical sculptures, *Humiliation of the Nation* and *Its Revival* (the latter with a copper eagle).

Interior

The marvelous interiors are wholly devoted to art nouveau, down to the concert program notice boards, elevators, and even the cloakroom. A café and restaurants, open to the public, fill the ground floor and basement. The foyer is decorated with reliefs of flora and fauna by Bohumil Kafka. To the right is the elegant **Francouzská** (French) **Restaurant** whose gilded chandeliers and dark wood wainscoting glow in the afternoon sun. It is embellished with allegorical paintings, such as Josef Wenig's *Prague Welcoming her Guests*, an appropriate theme for a popular tourist eatery. To the left is the equally opulent **Kavárna** (café) **Obecní dům**, with a fountain presided over by a white marble nymph. The stairwell leading to the basement is lined with glossy tiles of scenes of old Prague and leads to the **American Bar** with its Secession chandelier and reproductions of rustic scenes by Mikoláš Aleš. Next-door is the **Plzeňská** (Pilsen) **Restaurant**, a vaulted beer hall colorfully decorated with sapphire ceramic tiles and harvest scenes by Josef Obrovský.

Stairs lead up to the celebrated **Smetana Hall** (Smetanova síň), a 1,300-seat concert space, accessible for concerts or on a guided tour. The creamy stucco-covered space is lit by a central stained-glass dome and is decorated with Karel Špillar's murals: *Poetry* and *Drama* (to the left) and *Music* and *Dance* (to the right). To either side of the stage are sculptures by Šaloun of scenes from Dvořák's *Slavonic Dances* (left) and Smetana's opera *Vyšehrad* (right).

Other ceremonial rooms are only accessible on the guided tour. Each room was sumptuously designed to glorify the nation

as well as to fulfill a practical purpose: for instance, the **Grégr Hall**, decorated with allegorical paintings by František Ženíšek, was meant for debating; the **Sladovský Hall** for lectures; and the exotic **Oriental Room** for games. The **Palacký Hall**, with a statue of its namesake by Josef Myslbek, and the **Rieger Hall**, adorned by Max Švabinský's portraits of famed Czech writers, artists, and musicians, such as Jan Neruda and Dvořák, were designed to honor the greats of Czech history.

The illustrious Alfons Mucha, just returned from years in Paris, had wanted to decorate the entire Municipal House but had to content himself with artistic control of the circular **Mayor's Hall**, the ceremonial heart of the structure. Mucha designed every inch, from the curtains to the allegorical paintings, which display his strong Slav nationalism as well as an inventiveness and intensity that transcended his already passé style. Solemn, mystical wall paintings are paired with dramatic statements, including "With Strength toward Freedom, with Love toward Concord." The ceiling fresco is a vision of "Slavic Concord," with an eagle encircled by joyous Slavs, which is supported by pendentives depicting characters from Czech history as allegories of the virtues; e.g., *Independence* is George of Poděbrady, *Justice* is Jan Hus, and *Militancy* is Jan Žižka.

To view another Secession masterpiece, leave the Municipal House and turn left and left again on to the street U Obecního domu, where on the right you will see **Hotel Paříž**, regarded as a model example of art nouveau from the turn of the last century. Note its gabled, Gothic-inspired exterior and step inside to admire its ornate period décor. The hotel is memorably described in Czech author Bohumil Hrabal's comic novel, *I Served the King of England*: "The Hotel Pařiž was so beautiful it almost knocked me over. So many mirrors and brass balustrades and brass door handles and brass candelabras, all polished till the place shone like a palace of gold."

Back on náměstí Republiky, opposite the Municipal House stands the **Hibernians' House** (U Hybernů), which was formerly part of a monastery of the Hibernian Order (Irish

Detail of sculpture on façade of Legiobanka

Franciscans, who first introduced potatoes to Bohemia). The unremarkable monastic building (from 1637–1652, no. 3) now houses offices, but the adjoining former church is one of the finest examples of Empire style in Prague, having been transformed by George Fischer in 1810 into a Customs House. (The building was closed for restoration at time of writing.)

To the east of Municipal House are several buildings of note. Along Hybernská Street lies the beautiful copper, beige, and gold façade of the 1899–1902 Secession **Hotel Central** by Bedřich Bendelmayer and Alois Dryák. One of the first art nouveau buildings in the city, it has recently been restored as a boutique hotel.

At the corner of Na poříčí and Havlickova Streets, duck into the **Café Imperial**, a turn-of-the-last-century art nouveau gem filled with character and ceramic-tiles of Egyptian friezes and medieval scenes. Further along at Na poříčí 24 is Josef Gočár's rondocubist masterpiece, the **Bank of the Czechoslovak Legions** (also called the Legiobanka, now the ČSOB) from 1922–1925. The rondocubist (sometimes called National) style is a highly sculptural concept based on segmented cylindrical forms and folkloric decoration. The façade sculpture is by Jan Štursa and Otto Gutfreund, both working in the objective realism (or civilism) style that focused on depicting the everyday, and which, like rondocubism, was part of the new Czechoslovakia's search for a national style. Štursa's four panels of earnest, emotional soldiers in the trenches support Gutfreund's frieze of families welcoming the soldiers home. A landmark of Czech 20th-century sculpture, the combination is both powerful and sympathetic. Inside, the 1920s décor is intact down to the floor tiles and the chandeliers.

To the left along Biskupská Street is a late Gothic tower belonging to neighboring **St. Peter's Na poříčí**. The former parish church of the German Poříčí district, it dates back to the mid-12th century with later rebuilding, including an efficient 19th-century remodeling of Josef Mocker. Although it is open only for services, you can nonetheless glimpse the surviving triple Romanesque arches with some original frescoes from the west façade doors. As you return toward Na poříčí, turn to the

left along Biskupský dvůr to visit one of the most interesting contemporary galleries in Prague, **Jiří Švestka Gallery**, which holds temporary shows of international and Czech artists (Biskupský dvůr 6, open from Tuesday to Friday from 12 PM to 6 PM, and on Saturdays from 11 AM to 6 PM, www.jirisvestka.com).

Those with an interest in Prague's history and urban planning should continue along Na poříčí, under an overpass, to the Museum of the City of Prague.

Museum of the City of Prague (Muzeum hlavního města Prahy)

Location: Na poříčí 52, Prague 8, metro: Florenc.

Contact details: www.muzeumprahy.cz

Opening hours: Tues to Sun 9 AM–6 PM

This informative museum traces the development of the city from a primitive settlement to the 20th century through educational panels (in Czech and English), historic photographs, and a fascinating array of archaeological and historical artifacts, including the astounding 1826–1837 model of Prague created by a (clearly bored) lithographer in his spare time, which presents a meticulous image of the pre-industrial city. The building itself was custom built as a city history museum in the heyday of Czech nationalism in the 1890s. Its exterior façade has a tympanum by Ladislav Šaloun featuring a female personification of Prague (damaged in World War II and restored) depicting how, according to the motto, "History with art, science, and craft create the glory of our past."

Nearby are two train stations representing the great age of railways: **Masaryk Station** (Masarykovo nádraží on Hybernská Street), first opened in 1845, and the **Central Train Station** (Hlavní nádraží on Wilsonova Street), one of the city's great Secessionist buildings, by Josef Fanta. Built in 1901–1909, the Central Station was detrimentally altered in the 1970s when a highway was built in front of it, leaving it accessible only through a horrible modern vestibule beneath the original building. Its monumental façade can still be seen from busy Wilsonova Street. Today both stations are very

rundown and it is best to avoid them at night. Return to Můstek to continue.

SOUTHWEST OF WENCESLAS SQUARE

The following walk covers quite a bit of territory but can be shortened at various points by hopping on a tram or metro. From Můstek, head west to Jungmann Square (Jungmannovo náměstí), which runs parallel to the pedestrian street 28 října (28 October, referring to the date of 1918 Czechoslovak independence). This eclectic space features the backside of the functionalist Baťa store, a Gothic doorway, and a distinctive 1913 cubist lamppost designed by Emil Králíček. Further along is a baroque door leading into the courtyard before the soaring Carmelite **Church of our Lady of the Snows** (Panny Marie Sněžné). A rare but potent reminder of the area's medieval roots, it was begun by Charles IV in 1347 as the principal church of the lower New Town.

The Hussite Wars prevented its completion except for its 99 ft/30 m choir, where the radical Hussite Jan Želivský preached and was entombed. The Franciscans took over in 1603 and added the baroque décor the church still holds. South of the church is found the **Franciscan Garden** (Františkánská zahrada), first laid out as an enclosed monastic garden in the 14th century and in Franciscan hands until 1950. Restored in 1992, the peaceful space often abounds with city-dwellers seeking respite from the busy city. (It is also accessible via the Alfa Passage.)

At the corner of Jungmannova and Národní is the unusual rondocubist **Palác Adria**, best described as an Italian medieval fortress meets Lego set. Built for an Italian insurance company by Pavel Janák and Josef Zacshe in 1923–1925, it has sculptural decoration by Jan Štursa, Otto Gutfreund, and Karel Dvořák. Close by is the **Urbánek Publishing House** (Jungmannova 30) the first truly modernist building in Prague. It was built by Jan Kotěra in 1913, with caryatids by Jan Štursa. Consistent with its avant-garde design, architects including Le Corbusier, Adolf Loos, and Walter Gropius lectured here in the 1920s.

Follow Národní třída (National Avenue), which runs along the line of the moat of the Old Town walls to the Vltava. Today Prague's most important thoroughfare, it is lined with stores and civic buildings and is a major junction for the city's tramlines. The baroque former **Portheim Palace** (no. 37/38, south side) was once the home of the baroque sculpting family, the Brokoffs. Next door at no. 36 is the functionalist former **Czechoslovak Crafts Union**, built in 1934–1938 by Oldřich Starý with a sleek interior arcade and multistoried atrium. The **Platýz House** (no. 416, north side) contains elements dating to the 14th century (including remains of the medieval Old Town Walls in its basement) but was refurbished from 1817–1825 as the city's first apartment building, where Liszt once played. The respected contemporary art galley **Václav Špály** is found behind the shiny functionalist façade of no. 30. The warehouse-like **Tesco** (no. 26) was plopped on to the street in the 1970s when it was the Máj (May, referring to communist May Day) department store.

In the arcade of a small baroque palace (no. 16) probably by F.M. Kaňka, is a pair of sculpted hands, a simple memorial on the spot where peaceful protesters were brutally attacked by riot police on November 17, 1989, sparking off events leading to the Velvet Revolution. Just across Voršilská is the former convent of **St. Ursula** (sv. Voršily) built in 1698–1704 by Marco Antonio Canevale, which contains a painting of the saint by K. Liška and an *Assumption* by P. Brandl. Facing this are two wonderful art nouveau office buildings by Osvald Polívka: the 1910 former **Topič Publishing Company** (Topičův dům 9) and the 1903–1906 **Praha Assurance building** (pojišťovna Praha 7). Both are richly decorated with stucco, ceramic, metal, and glass, all the work of Polívka and Ladislav Šaloun.

Across from the legendary literary Café Slavia (no. 1), housed in an 1860s apartment building, is the jewel of the Czech National Revival, the **National Theater** (Národní Divadlo). Today home to the Czech National Opera (www.

Vojtěch Hynais (1854–1925), poster advertising an "Exhibition of Czechoslovakian Ethnography," 1894 (color litho), private collection (The Stapleton Collection)

nationaltheater.cz), from its inception this huge neo-Renaissance structure overlooking the Vltava was seen as a gift of "the nation for itself" (Národ sobě), reflecting the fact that the building was paid for by a subscription to which Czechs countrywide contributed. It was seen as a symbol of burgeoning Czech culture. Its foundation stone was taken from the mountain Říp, where Čech, the legendary father of the Czech nation, had first gazed out over the promised land of Bohemia. The laying of the stone in 1868, by Czech historian František Palacký and Bedřich Smetana, was accompanied by three days of proto-national celebrations. Created by architect Josef Zítek, it opened on July 11, 1881, with a stirring performance of Smetana's *Libuše*, but only nine

days later was gutted by fire. Undaunted, Josef Schulz took over the rebuilding, adding north Italian Renaissance effects and giving the roof its distinctive silhouette, which may have been inspired by Hradčany's Summer Palace (Belvedere). The theater reopened in 1883 to acclaim, with special "theater trains" arranged so Czechs from across the land could see the great edifice that they had helped finance—twice.

The theater's opulent decoration was the joint effort of almost every major Czech artist; this group became known as the National Theater Generation. The north entrance façade features attic-level sculptures of *Apollo* and the *Muses* flanked by racing, victorious chariots by Bohuslav Schnirch. The west portal has lounging figures of *Opera* and *Drama* by Josef Myslbek. The ornate foyer (open 45 minutes before performances), decorated with a "homeland" theme, has another statue by Myslbek, the allegory of *Music*, as well as ceiling paintings by František Ženíšek, lunette paintings by Mikoláš Aleš based on Smetana's *Má vlast* (*My Country*) and a gallery of portrait busts of figures from Czech theater. Almost every surface throughout the theater has been adorned with rousing allegories of national awakening; Ženíšek added allegorical figures to the auditorium's elaborate ceiling, and Vojtěch Hynais painted the stage's backcloth depicting *The Origin of the National Theater*, as well as contributing to the décor of the presidential box along with Václav Brožík and Julius Mařák.

The National Theater was expanded east with the Nová scéna (New Theater) in 1977–1983, an unusual troika of glass buildings by Karel Prager.

Turn left along Masarykovo nábřeží (Masaryk embankment). Connecting the embankment and Slovanský Island is another of Prague's great modern art spaces, the **Mánes Gallery** (Výstavní síň Mánes). Headquarters of the Mánes Society of Artists (founded in 1887 as a society for contemporary art), it was built from 1927–1930 according to designs by Otakar Novotný, who, rather romantically, built his rectilinear functionalist gallery and meeting space spanning the river channel, much as the original medieval mills that formerly

stood here would have. Novotný also incorporated the surviving water tower, which dated from the 12th century, was rebuilt around 1495, and later was topped by a baroque onion dome, creating an unusual juxtaposition of styles. Today Mánes continues to present interesting modern and contemporary art exhibitions (see www.galeriemanes.cz).

Václav Havel, who formerly lived at nearby no. 78 Rašínovo nábřeží, counts the Mánes Gallery as one of his favorite buildings, despite (or perhaps because of) the fact that communist secret agents used to spy on him there from the Mánes water tower. Havel's former apartment building now adjoins the most controversial new edifice in Prague, American architect Frank Gehry's **Dancing House** (Tančíci dům), popularly known as "Fred and Ginger." Built from 1993–1994, this postmodern, deconstructive structure has a façade of undulating windows, from which spring two cylindrical forms, abstractions of a dancing couple: "Ginger," all glass and curves, and "Fred," a stalwart ballast topped by a tangled copper dome. Loved by some, hated by others (one critic said it resembled a "crushed can of Coke"), it is still among the most noteworthy of Prague's post-1989 architectural endeavors.

Continue along Rašínovo nábřeží to Palackého náměstí (Palacký Square), which holds the wonderfully poetic **František Palacký Monument**, a Secessionist masterpiece by Stanislav Sucharda. Initiated in 1898 but only completed in 1912, it depicts ethereal bronze figures—embodying the world of imagination—emerging from the solid plinth of reality at whose center sits the noted historian, who looks out toward his namesake, the 1876 **Palacký Bridge** (Palackého most). Until World War II, sculptures of mythological Bohemian figures by Josef Myslbek adorned the bridge's four corners; they are now found at Vyšehrad (see Trail 6, in Southern Prague).

Turn up Na Moráni Street and turn right on Vyšehradská. On the east side of the street rises the 1730–1738 **St. John** (of Nepomuk) **of the Rock** (sv. Jana na skalce), one of the most important buildings built by K.I. Dientzenhofer. Its twin-towered façade is full of dramatic movement, as is the interior (open for services), an octagon with concave sides

topped by ceiling frescoes of the life of St. John of Nepomuk (1745) by Karel Kovář.

Slavonic Monastery (Klášter Na Slovanech), also called Emmaus

Location: Vyšehradská Street, across from the baroque Church of St. John on the Rock.

Opening Hours: 9 AM–6 PM daily

The exterior of the Slavonic, or Emmaus, Monastery could easily be mistaken for a construction site or a university parking lot, but inside, this medieval monastic complex has some of the most marvelous medieval paintings in Bohemia. Because it's off the main tourist beat, visitors can often enjoy these atmospheric cloisters in the same spirit of quiet meditation for which they were built.

The monastery was founded by Emperor Charles IV in 1347. The Slavonic monastery was the most prestigious of several religious foundations Charles created in his New Town. Contemporaries called it "a wonderful work" and it became a center of learning and a scriptorium whose illuminated manuscripts were found throughout Europe. It had special papal permission to use the Slavonic liturgy, i.e., to spread the faith in a Slavic language (a fact that later saved the monastery from Hussite destruction), and was populated by Croatian Benedictines. This monastery was part of Charles's ongoing efforts to further his imperial connections to southern Slav countries and to the eastern church. The church, dedicated to, among others, the Virgin, St. Jerome, St. Methodius, and St. Procopius, was finished in Charles' lifetime and consecrated in 1372 in a service that gave the complex its secondary name, Emmaus, for the gospel read on that day.

Built on a rocky plateau above the Vltava, the large three-aisle church had a high roof and turret, a distinctive silhouette on the medieval horizon. Attached on the south side was a vaulted cloister covered with 85 fresco scenes from the Old and New Testament (about two-thirds of which still exist) by the best painters of the day. The centuries saw many

changes. The Hussites turned it into a unique Utraquist monastery; Counter Reformatory Spanish Benedictines gave it a baroque veneer and 19th-century restorers re-Gothicized it. The most devastating alteration, however, was the result of a stray Allied bomb in 1945 that caused great damage and gutted the church. After being renovated over several years in the 1960s it became the Czechoslovak Academy of Science and acquired its unique and controversial modern spires: distinctive, interlacing sail-like forms of reinforced concrete. In 1990 it was returned to the Benedictines, who are restoring the complex yet again.

After so much history it is amazing anything has survived, yet the serene enclosed cloister retains the pale remnants of medieval frescoes (1370–1375, heavily restored after 1960) on its walls and high groin vaults, attributed to the royal painters Master Theodoric, Nikolaus Wurmser, and the Master of the Emmaus cycle. Despite their fragmented state, the frescoes still rank among Bohemia's most remarkable examples of Gothic painting. The cloisters open into the monastery church, which, although a reconstruction, is a lovely, light space with an open hall church plan and simple Gothic pillars and vaulting. The choir has recently been repainted with 19th-century-style frescoes.

Continue along Vyšehradská, passing on your left the little **Church of Our Lady on the Lawn** (Panna Maria na Slupi), another of Charles IV's foundations, begun in 1360. Restored in the 19th century, the church retains its original slender tower, south portal, and inside (open for services). The tiny nave's vaults spring from a single pillar, a symbol for the Virgin as the supporting pillar of the church.

From here it is possible to continue south to Vyšehrad; see Trail 6, in Southern Prague. Otherwise, turn left up Horská Street, which turns into a footpath as it climbs past the remainders of the New Town's medieval fortifications and emerges at the **Church of Our Lady and Charles the Great** (or Charlemagne c. 742–814), most commonly known as Karlov (open Sunday between 2 PM and 5 PM). Built by Charles IV from 1352–1377 at the highest point of the New

Town, this convent was designed to emulate Charlemagne's octagonal burial chapel in Aachen, linking Charles with the first Holy Roman Emperor. This royal edifice was damaged by the Hussites, then reconsecrated by the Jagiellons in 1498, and in 1575 royal architect Bonifác Wohlmut added a striking star-shaped vault. Later baroque restorations destroyed the Gothic interiors, replacing them with over-the-top decoration, including theatrical balconies filled with strange life-sized holy figures and the Scala Santa stairs (sometimes attributed to Santini-Aichel) leading to the Holy Chapel, which pilgrims would have climbed on their knees.

Head north along Ke Karlovu Street, passing on your left two other churches founded by Charles IV: **St. Apollinaris** (on Apolinářská Street), redone in the 19th century by Josef Mocker, and **St. Catherine** (on Ke Karlovu), rebuilt in 1737–1741 by K.I. Dientzenhofer. Across from St. Catherine's is one of Dientzenhofer's early gems, the lovely **Villa America** (1715–1720), today the Dvořák Museum (Ke Karlovu 20). Tucked in between multi-story 19th-century apartment blocks, this delicate rococo-influenced house has a small garden with mythological sculpture by Mathias Braun. Built as a suburban retreat for nobility, it resembles a nostalgic baroque oasis, straight out of Miloš Forman's film *Amadeus*.

From here head west along Ječná Street to Karlovo náměstí (Charles Square), the original Cattle Market laid out in the 14th century by Charles IV and reworked as a wooded public park in 1848. To the north are the square's most noteworthy structures, the **New Town Hall** (Novoměstská radnice, at no. 23). Found in 1367, it was expanded around a courtyard in 1411–1412 and given its tower a few years later. The triple-gabled façade, pierced with Renaissance windows and a portal, is in fact a 1905–1906 restoration based on research into the Town Hall's 1520–1526 appearance.

Karlovo náměstí has both a metro station and tram stops to take you on to your next destination.

National Gallery at Zbraslav, designed by Jan Santini-Aichel, 1700–1730

Trail 6:
Out of the Center

S ome of Prague's best attractions are found outside of the center, including two of the National Gallery's newest and most impressive collections: the world-class Asian art collection at Zbraslav and the Modern European art collection at the Trade Fair Palace (Veletržní palác) in Holešovice. The outskirts also hold masterpieces of modernist architecture (such as Loos' luxurious functionalist Müller Villa and Chochol's cubist apartment houses), baroque palaces (Troja), Renaissance hunting lodges (Hvězda), and historical gardens (Stromovka, Letná). As most sites are quite spread out, the following is less of a trail and more of a collection of highlights grouped in geographic areas, which can be reached by a lengthy walk, or by tram, metro, or bus rides from the center.

SOUTHERN PRAGUE
Vyšehrad

Location: The most direct way to Vyšehrad citadel is either from the Vyšehrad metro stop via Na Bučance Street to the Tabor Gate, or from the Výtoň tram stop on Rašínovo nábřeží via Vratislavova Street to the North (or Cihelná) Gate.

Opening hours: Church of Saints Peter and Paul and Vyšehrad Cemetery are open Mon–Thur and Sat 1 AM–12 noon, 1 PM–5 PM; Sun 10:30 AM–12 noon, 1 PM–5 PM. Closed Fri. The grounds are open year-round.

Perched on a cliff high above the Vltava at the southern end of the New Town, Vyšehrad has been successively a

Slavic settlement, a Gothic castle, a baroque citadel, and a 19th-century national pantheon for famous Czechs. Greatly rebuilt in the late 19th century, it still retains fragments of its illustrious past, offers spectacular views, and remains a potent symbol of Czech history, ancient and modern.

History

According to legend it was here that Libuše, the mythical founder of the Přemyslid dynasty, made her home and foresaw the founding of Prague, "a city whose splendor shall reach unto the stars." Archaeological evidence, however, suggests that it was first built up in the 10th century under Boleslav II, who established a mint and a small church (the foundations of which lie beneath the Romanesque Church of St. Lawrence). The site was further enhanced from 1070–1135 when Vyšehrad became the Přemyslids' principal residence. Several structures were built, including a palace on the southern citadel, the three-aisled Church of Saints Peter and Paul, and the Rotunda of St. Martin. Abandoned in the mid-13th century for the better-located Hradčany, in the 14th century Vyšehrad was revived by Charles IV as a glorious symbol of his Přemyslid roots. He transformed it into a lavish royal castle with a grand palace, servants' quarters, a school, churches, and fortifications. As it was attached to the southern end of his New Town, Charles incorporated a pilgrimage to Vyšehrad as part of the royal coronation ceremonies.

Charles' glory did not last long, as the Hussites destroyed most of Vyšehrad in 1420. At the end of the Thirty Years' War the site was transformed into a baroque fortress with new walls built in 1663–1672 by Carlo Lurago. In the later 19th century, as Czech nationalism grew, Vyšehrad's mythical and real history, as well as its romantic location and decaying state, made it a great source of inspiration artists, writers, and musicians (think Smetana's *Libuše*). In the 1880s this led to a scheme to turn its parish cemetery into a national cemetery for celebrated Czechs and to restore the few extant buildings, such as the Church of Saints Peter and Paul. Finally, in 1927, the citadel was laid out as a public park, as it remains today.

The Site

Entering via the Tabor Gate, the first item of architectural note is the 1678 **Leopold Gate**, part of the baroque fortifications, and whose gable is adorned with an eagle and two wryly-grinning lions. Further along is the late 11th-century **Rotunda of St. Martin** (Rotunda sv. Martina). Topped by a lantern, this small cylindrical nave with a tiny apse is the only extant structure dating from the Romanesque period, although it was greatly restored in 1878–1880. Take your first left along K rotundě past the late 18th-century former Deanery, which was built on the site of the Romanesque church of St. Lawrence, which was destroyed by the Hussites (its foundations can be seen at the back of the building).

Further along is the massive neo-Gothic **Church of Saints Peter and Paul** (sv. Petra a Pavla), that dates back to the 11th century. First built as a three-aisled Romanesque basilica, it was rebuilt and expanded by Charles IV in the 14th century, only to be gutted by the Hussites in 1420. From 1723–1729, the church was completely redone and given an undulating baroque façade by the creative Jan Santini-Aichel. The neo-Gothic enthusiast Josef Mocker conducted a massive renovation of the church from 1885–1903, remodeling the layout, removing most post-Gothic additions, and covering the nave with rich decorative paintings in a muted palette of green, yellow, blue, and ochre. Though Mocker himself had respected Santini-Aichel's façade, upon his death in 1903 his successor replaced it with the characterless twin-towered façade it has today.

Surrounding the church is the **Vyšehrad Cemetery**, laid out in 1868–1871 as the final resting place of great Czech artists, writers, intellectuals, and scientists, such as Mikoláš Aleš, Josef Gočár, Bedřich Smetana, and Karel Čapek. Part of the cemetery is taken up by the pantheon, or **Slavín**, an arcaded colonnade inspired by the Italian concept of the Campo Santo, added from 1874 to the early 20th century. Throughout is a fantastic array of funerary sculpture in varied styles. Some are surprisingly simple—avant-garde artist Karel Teige is found in an unadorned family plot in the Slavín, with not a collage or floating body part in sight. Dvořák,

on the other hand, has a fabulous art nouveau monument peppered with a golden mosaic (listen and you may hear the church chimes ringing the *New World Symphony*).

In a park found to the south of the church are four gargantuan sculptures by Josef Myslbek, one of the most influential Czech sculptors of the late 19th-century Czech National Revival. Each mythological figure has a central European Valkyrie-sensibility, with a hint of an Arts and Crafts influence in the details—the hair here, a shield there. Originally placed at the four corners of the Palacký Bridge and transferred here in 1945, the figures are: Libuše and Přemysl, founders of Bohemia's ruling dynasty; Lumír and Píseň, the Czech Orpheus and his muse (figures reflecting the importance of music in the Czech revival); Šárka and Ctirad (Šárka was a female warrior under Libuše who tricked Ctirad to his death, but fell in love with him and killed herself by jumping off a cliff into the valley northwest of Prague, which now bears her name); and two male warriors, Záboj and Slavoj, who were invented in the 19th century.

After enjoying the splendid views, leave Vyšehrad by the North or Cihelná Gate and descend to the corner of Přemyslová and Neklanova Streets to see several landmark works of cubist architecture. The 1911–1913 **Hodek apartment building** (Neklanova 30) is the earliest cubist work by Josef Chochol (1880–1956), the leading exponent of cubist architecture. Chochol eschewed flat surfaces in favor of abstract, prismatic forms with a slender corner pillar supporting a sharply angled cornice, creating a sense of undulation not unlike the Bohemian baroque. At Neklanova 2 is another cubist building by Chochol's less radical contemporary, Antonín Belada. Continue on to 3 Libušina Street, to the 1912–1913 **Villa Kovařovič**. Among the best examples of the style, the dynamically broken, almost sculptural planes of the façade of this single family home present an interesting counterpart to its neighbors, a modernist brick house by Otakar Novotný and a neo-classical villa by Emil Králíček. The three houses reflect concurrent trends in Czech architecture. A third building by Chochol is the tripartite house at Rašínovo nábřeží 6–8, centered on a raised central polygonal gable.

Much further south, but well worth the trip, is the Asian Art Collection of the National Gallery, which is one of the best collections in Europe and housed in the handsome baroque monastery of Zbraslav.

National Gallery (Národní galerie) at Zbraslav— Asian Art Collections (Sbírka asijského umění)

Location: Found about 7.5 miles/12 km (20 minutes by bus) to the south of central Prague. From Smíchov train station take a bus (there are several: no. 129, 241, 243, 255, 314, 338, 360, etc.) to the stop Zbraslavské náměstí (Zbraslav Square), which is within city limits. In summer, it is sometimes possible to make the trip by boat along the Vltava.

Contact details: Tel: 257 921 638; www.ngprague.cz

Opening hours: Daily 10 AM–6 PM, closed Mondays

The Monastery

The Cistercian monastery "Aula regia" ('Royal Hall') was founded at the confluence of the Vltava and Berounka River in 1292 by Václav II to be the royal burial church of the Přemyslid dynasty. As the most lavish monastic complex in Bohemia with strong royal ties, it was among the first to be destroyed by the Hussites, who left it in ruins. It was only from 1700–1732 that the monastery was rebuilt according to designs by innovative architect Jan Santini-Aichel who oversaw construction until 1724, when František Kaňka took over. Though never completed to the original plans due to lack of funds (the church was never even begun), the three wings of the main building—where the Asian art collection is kept today—display Santini-Aichel's idiosyncratic style with his unique baroque-Gothic detail, articulated windows and portals, a multi-planed roof (which has an almost Asian air), and wonderfully sculpted interior spaces. When all Bohemian monasteries were dissolved in 1785, Zbraslav was turned into a sugar refinery. Restored in the early 20th century, it has been associated with the National Gallery since 1939.

Today the monastery is surrounded by a lovely leafy park scattered with 19th-century and 20th-century Czech sculpture (leftovers from Zbraslav's former life as the National

Gallery's modern-sculpture exhibit space) and inside is one of the finest Asian art collections in Europe.

The Gallery of Asian Art

Collected by explorers, travellers, and researchers in the 19th and early 20th centuries, this outstanding collection of Asian art was kept in storage by Communist authorities for over 40 years. It finally went back on display here in 1998. The focus of the collection is Japan and China, but there are also items from Southeast Asia, India, Tibet, and the Islamic world.

The cleanly restored Santini-Aichel's interiors—with high arched ceilings, unadorned baroque curves, and pure lines—are an unexpectedly perfect backdrop for Buddhist gods and Chinese silks. The exhibition's design makes the most of this space, adding theatrical lighting and wood constructions that suggest bridges, temples, and other objects that convey an Oriental context and atmosphere. The display is organized to be both educational and aesthetically pleasing and rooms are well-documented in Czech and English, with clear and informative panels helping to place the objects' contexts and often pointing out connections with Western art.

FIRST FLOOR: JAPANESE ART

This floor explores various aspects of Japanese art: lacquer-work, Buddhist art, sword-fittings, enamels, screens, ceramics, paintings, and graphic art. One of the many highlights is the ethereally lit room devoted to Japanese Buddhist art, which displays sculpture and scroll paintings, most dating from Edo period (17th–19th-century). Note the delightfully sour-looking *Emma Daió, King of Hell* by an anonymous master of the Muromachi Period (15th–16th century) who sits below an exquisite Edo-period statue, *Buddha Amita Standing on a Lotus.* Further along is beautiful late 19th-century enamel work, some of which shows a decidedly art nouveau sensibility. Like a palette cleanser, in the middle of the exhibition is a large empty room with a baroque frescoed ceiling by V.V. Reiner (1720s), after which there is an excellent display of graphic art. As with all paper art in the museum, the display is changed regularly to protect the

delicate material; nonetheless, this section usually contains outstanding works by Hiroshige, Hokusai, and other masters.

SECOND FLOOR: CHINESE AND SOUTHEAST ASIAN ART

This impressively comprehensive section follows the development of Chinese art from the Bronze Age to the 20th centuries, with portions devoted to funerary art, ceramics, decorative arts, Buddhist art, painting, and calligraphy. There are fascinating examples of tomb sculpture and ceramics from a graceful standing lady (Han dynasty, 2nd century BCE) to an astoundingly animated Tang dynasty horse (7th century–8th century). Decorative arts range from the vivid turquoise and gold dragon-rider roof-tiles (Ming dynasty, 16th century–17th century) to a tiny figure of a recumbent lamb (Qing dynasty, 18th century) that could fit in a small hand. In the superb Buddhist art section, the polychrome *Goddess Guanyin Seated in a Royal Position* (Song dynasty, 12th–13th century) is perhaps the most regally elegant lady in all Prague.

While not as comprehensive as the Japanese and Chinese sections, this section has exceptional artwork from numerous countries: Myanmar (Burma), Cambodia, Thailand, Laos, Indonesia, India, and Tibet as well as a section devoted to Islamic art. In the Southeast Asian art section, note the varying appearance of the Buddha: a 3rd-century Buddha from Gandhara, Pakistan has a classical Greco-Roman look, while a 13th-century Cambodian Buddha has the calm wide face and long ears of Khmer art. Tibetan *thangka* paintings, used as Buddhist meditation aids, are displayed in atmospheric room suggesting a temple interior.

At the end of the permanent exhibit are rooms for temporary shows, often drawn from the gallery's extensive collections.

NORTHERN PRAGUE

Letná Park

To the northeast of Malá Strana, rising over a bend in the Vltava, is Letná Park, first laid out in 1858. Accessible via a little bridge over Chotkova Street from the Hradčany Royal Gardens

(see Trail 3) or via stairways from Edvarda Beneše nábřeží (Edward Beneš Embankment), the park offers wonderful city views and has several noteworthy structures. To the west side of the park, overlooking the Vltava is the **Hanavský Pavilion**, an eccentric neo-baroque/art nouveau structure by Otto Prieser, originally built for the 1891 Jubilee Exhibition. Admired by contemporaries and later by Le Corbusier for its innovative use of cast iron (easily dismantled, it was reassembled in Letná Park in 1898), it was commissioned, unsurprisingly, by the owner of an ironworks, the Count of Hanava. Further east is the giant red **Metronome** (1991) by contemporary artist Vratislav Karel Novák on the former site of the notorious statue of Josef Stalin (See Trail 1, page 77 for the whole story). To the eastern end of the park is the 19th-century **Letná Chateau** (Letenský zámeček) built as part of the 19th-century park (today a restaurant and pub), and the outstanding aluminum and glass **Expo '58 building**, which was the Grand-Prix-winning Czechoslovak pavilion at the 1958 Brussels World Exhibit (today it is an office). It had great influence on the resulting neo-modern "Brussels" style.

To the east and north of Letná Park is the residential district of Holešovice, which, since 1997, has been home to the National Gallery's fascinating and extensive collections of international and Czech modern art housed in a landmark of functionalist architecture, the Trade Fair Palace.

Trade Fair Palace (Veletržní palác)—Museum of Modern and Contemporary Art (Muzeum moderního a soucasného umění)

Location: Dukelských hrdinů 47, Prague 7, Holešovice. Trams 5, 12, and 17 from downtown or a five–minute walk from Letná Park

Contact details: Tel: 224 301 111; www.ngprague.cz

Opening hours: Daily 10 am–6 PM, closed Mondays

Known better (at least to foreigner visitors) for its exceptional collection of iconic European artists such as Picasso, van Gogh, Cézanne, and more, the Trade Fair Palace (TFP) is also

home to an encyclopedic gathering of works by modern Czech artists. For those wanting to understand the evolution of modern Czech art, there is no better starting point than the gallery's vast collections housed in the equally mammoth and intriguing TFP.

Architects Oldřich Tyl and Josef Fuchs won the 1925 competition to build Prague's first trade fair center. Built between 1926–1928, it was designed to cater to 10,000 visitors and 4,000 exhibitors and included offices, a 600-seat cinema, a great hall (even bigger than the atrium), and more. Among its first visitors was Le Corbusier who, despite some criticisms, said that the Trade Fair Palace had shown him "how to make large buildings." The first exhibit to take place in this ultra-modern building was, paradoxically, the decidedly backward-looking *Slav Epic* by Alfons Mucha (today in Moravia, see Trail 5, Mucha Museum, page 202), a mythic art nouveau cycle of twenty giant paintings celebrating the Slav people. In the 1950s the building became the storehouse for closely regulated western goods, a function it retained until a 1974 fire. Years of discussion finally led to its refurbishment and in 1997 it was opened as the home of the National Gallery's modern and contemporary art collections.

Not much to look at from the outside, the TFP's interior best displays the vitality and originality of early functionalism before it became a synonym for drab and impersonal. Consider the ornate character of most late 19th- and early 20th-century architecture and you can begin to appreciate the appeal of these cool, clean lines. The most impressive part is the sky-lit atrium surrounded by balconied galleries that slope inward on one side, resembling the railings of a sleek ocean liner from a 1920s art deco poster. It is a fantastically pure, if cold, space. Of a gargantuan size, the atrium recalls London's Tate Modern and gives a visitor the strange sensation of being very, very small in a very big space.

This huge museum is really more like five museums in one. The permanent collection is spread over four floors and divided into five main sections: 19th-century Czech Art (fourth floor); Czech Art 1900–1930 (third floor, part 1);

French Art 19th century and 20th century (third floor, part 2); Czech Art 1930–Present (second floor); 20th-century European Art (first floor). There are also temporary exhibitions on the ground and fifth floors, as well as smaller separate exhibitions devoted to applied arts, architecture, industrial design, photography, and more. The size and breadth of the collection can be overwhelming and the organization is often confusing; so the best approach is to choose a floor or two (each floor is a separate ticket anyway) and take your time, as opposed to trying to do the whole museum in one visit (which can lead to serious museum overload!). Everything, however, is well labeled in Czech and English and biographies of most

Pablo Picasso (1881–1973), Self Portrait, 1907 (oil on canvas), National Gallery, Prague

artists are posted near their works. An excellent bookstore at the entrance also has monographs and biographies for more in-depth research.

The following starts on the uppermost exhibition and goes down in order to follow the Czech art sections in chronological order.

Don't miss:

Paul Gauguin, Bonjour M. Gauguin, *1889 (3rd floor)*
Gustav Klimt, Virgin, *1913 (1st floor)*
Oskar Kokoschka, Charles Bridge in Prague, *1934 (1st floor)*
Jiří Kolář, Tribute to František Kupka, *1974 (2nd floor)*
František Kupka, Fugue in Two Colors, *1912 (3rd floor)*
Zdeněk Pešánek, Male and Female Torsos, *1936 (2nd floor)*

FOURTH FLOOR—19TH-CENTURY CZECH ART

The fourth floor offers an interesting overview of art in 19th-century Bohemia. Even though many of the works are rather mediocre, the subjects and formats reflect the concerns of the burgeoning Czech nation and a few luminaries, like **Jan Preisler** and **Antonín Slavíček**, are pleasant discoveries for those new to Czech art.

Sculptural works by the leading exponent of the late 19th century, **Josef Myslbek** (1848–1922) open the section; otherwise, the presentation follows chronically from the early 19th-century Romantics, featuring **Josef Navrátil** (1798–1865) and **Antonín Mánes** (1784–1843), here represented by several evocative Bohemian landscapes (such as *Kokořín and Křivoklát in a Storm*, 1834). Mánes was the father of a family of painters, including his son, **Josef Mánes** (1820–1871), who dominated the later 19th century.

Beginning in the 1850s, many artists spent time in France, such as the remarkably versatile, Courbet-influenced **Karel Purkyně** (1834–1868) and **Viktor Barvitius** (1834–1878), who created atmospheric urban scenes, such as *Thursday in Stromovka Park* (1865). Paris-based **Jaroslav Čermák** (1830–1878), was the only Czech of his generation to gain an international reputation and his painting *Dalmatian Wedding* (1875–1877) shows the influence of French Orientalism and Delacroix.

The "National Theater Generation" (artists who contributed to the decoration of that edifice) dominated the later 19th century. Some of the most eye-catching are the works of history painters like **Mikoláš Aleš**'s (1852–1913) theatrical *Jiří of Poděbrady's Meeting with Mathias Corvinus* (1878) and **Václav Brožík**'s (1851–1901) costumed portrait of the actress *Julie Šamberkova as Messalina* (1876).

The turn of the 20th century and onset of modernity saw several interesting figures emerge, many influenced by symbolism. Moody paintings by idiosyncratic figure **Jakub Schikaneder** (1855–1924), such as *Contemplation* (1893), demonstrate his ethereal, poetic style. There are several passionate wood sculptures, such as *Interpretation of the Word Madonna* (1897) by mystic sculptor **František Bílek** (1872–1941). **Max Švabinský**'s (1873–1962) *Union of Souls*, (1896) was a key work of poetic realism, drawing on the work of the pre-Raphaelites and French symbolism, while the introspective and mysterious *Evening Silence* (1900) by **Antonín Hudeček** (1872–1941) is a haunting image that approaches landscape as a symbolic mirror of the soul. Taking this concept to include the psyche as well as the soul, **Jan Preisler**'s (1872–1918) dream-like *Black Lake* (1904) creates a near psychological landscape. No less insightful are the post-Impressionistic paintings of **Antonín Slavíček** (1870–1910), which include beautiful, intensely expressive images of Prague and its countryside, such as the windswept *Eliška Bridge* (1906) and still *Birchwood Atmosphere* (1897).

THIRD FLOOR, PART 1—CZECH ART 1900–1930

This section is principally concerned with the art of the Czech cubists, and one of the most outstanding figures of this period in both Czech and international art, **František Kupka** (1871–1957). A brilliant draftsman and colorist, Kupka evolved through several styles from symbolist art nouveau to orphism to geometric abstraction, all the while developing his belief that color and line were all that were needed for expression. The gallery displays works from throughout his versatile career.

A major work of his early symbolist period is *The Path of Silence* (1903), which plays with the allegory of a pilgrim travelling a road (in this case lined with Egyptian sphinxes) in search of the meaning of life. In the late 1910s Kupka began to experiment with fauvism and color (exemplified in the saucy *Gallien's Taste—Cabaret Actress*, 1909–1910) which, along with his studies of movement and music, began to push toward abstraction, such as in the fragmenting image of *Piano Keys* (1909), depicting vertical piano keys rising into a rippling lake. Just a few years later he arrived at full abstraction with *Two-Colored Fugue—Amorpha* (1912), which, when shown at the 1912 Paris Salon (along with Kupka's *Warm Chromatics*, today in the Kampa Museum, see page 124), created a sensation as the first exhibited example of pure abstraction. Kupka continued to explore abstraction, creating compositions of imaginary music, architecture, and cosmic visions of creation and origins, such as *Cosmic Spring* I (1913). By the later 1920s, he had moved from organic forms and colors to geometric, monochromatic forms such as in the minimalist *Abstract Painting* (1930).

Much of the remainder of this section is devoted to the painting, sculpture, and decorative arts of the Czech cubists. The National Gallery seems to have split its large cubist collections between the Trade Fair Palace and the Museum of Czech Cubism in Old Town (for background information on Czech cubism, see page 39). Here there are several early works by later cubist artists, showing their artistic evolution. Several were members of Osma ("the Eight"), an artistic group formed

in 1907, inspired by Edvard Munch's expressionism. Just four years later, many were inspired by the cubist works of Braque and Picasso (some of which were in Prague by 1911 thanks to the astute collecting of art historian Vincenc Kramář). Just compare **Bohumil Kubišta**'s (1884–1918) *Card-players* (1909) and his fragmented, arrow-pierced *St. Sebastian* (1912) to see the transformation. Another artistic evolution can be seen in the works of sculptor **Otto Gutfreund**; his cubist angles (see *Anxiety*, 1911–1912) later smooth out into the soft lines and folk art tendencies of Civilism (see *Self-Portrait*, 1919). Another cubist of note is **Josef Čapek** (1887–1945). *The Accordian Player* (1913) reflects his characteristic gentle humanism, with which he searched for the essence of even the most banal of subjects. He wrote:

> It was my task to penetrate this banality as profoundly as possible from an artistic point of view in order to achieve the kind of feeling we have when observing photographs or figures by Cézanne and Picasso: that people, even when it is possible to smell and touch them, are something of an apparition.

Prague sometimes seems to specialize in creating individuals with a unique artistic vision who just don't fit into a larger artistic group. One of these figures is **Jan Zrzavý** (1890–1977) whose highly stylized primitive paintings (several of which are displayed here) evoke otherworldly planes with simplified forms, magical lighting, and unrealistic colors. Another solitary figure is **Josef Váchal** (1884–1969), a graphic artist, sculptor, and painter who took inspiration from a myriad of styles—symbolism, medieval and baroque art, folk art, and so forth—and, who, rebelling against industrialization, often worked with "primitive" techniques such as woodcuts (see *Meditations on Life*, 1916).

THIRD FLOOR, PART 2—MID-19TH-CENTURY TO EARLY 20TH-CENTURY FRENCH ART

The Trade Fair Palace's excellent French art collection is the result of active collecting by the Czechoslovak state in the 1920s and 1930s under the influence of Czech intellectuals. The art historian and critic Vincenc Kramář, director of the

National Gallery in the 1920s, believed that French art had an essential role in stimulating Czech cultural development. And indeed it did; between the many Czech artists who studied or worked in France since the mid-19th century and the influence of the many exhibitions of French art organized in Prague by the Mánes Association of Artists, the artistic connection between Prague and Paris was well established. A large number of works in this section are from the personal collection of Vincenc Kramář; in the 1960s the Communist authorities "suggested" the elderly Kramář donate his entire collection to the National Gallery.

Henri Rousseau (1844–1910), **Self Portrait, from L'ile Saint-Louis, 1890** *(oil on canvas)*, **National Gallery, Prague**

Claude Monet (1840–1926), Ladies Among the Flowers, 1875 (oil on canvas)

Among the artists represented with superlative works are **Rodin**, **Delacroix**, **Renoir**, **Monet** (*Ladies Among the Flowers*, 1875), **Degas**, **Cézanne**, **Toulouse-Lautrec** (*At the Moulin Rouge*, 1892), **Gauguin** (including *Bonjour M. Gauguin* 1889), **van Gogh** (*Green Wheat*, 1889), **Rousseau**, **Chagall**, **Derain**, and **Matisse**, as well as numerous works by **Picasso** and **Braque**.

SECOND FLOOR—CZECH ART 1930–PRESENT
This jam-packed floor begins with the surrealists and continues through the art of the communist period (socialist realism, Art Informel) to the near present, with works by artists active in Prague

today. There is so much here it can be confusing, a condition not helped by the sections' rambling organization. Regardless, there are some fascinating works and artists to be discovered here.

Toyen (aka Marie Čermínová), 1902–1980
Fright, 1937

Taking a genderless name (in Czech, female surnames end in -ová) from her early career, Toyen rejected taking a female role and endorsed the anarchist movement. She and her creative partner, Jindřich Štyrský, went to Paris in the early 1920s and created their own alternative to abstraction and surrealism: artificialism, represented in *Fjords*, 1928, which hangs nearby. By the mid-1930s, her work turned to surrealism and, back in Prague, she became a founding member of the Czech surrealist group, maintaining a lifelong friendship with French surrealists André Breton and Paul Eluard. Here she plays with the disparity between real objects—the fingers clutching the wall—and the imaginary and indefinable. The absurd, almost comic, illogic of the image creates an uneasy tension for the viewer with its irrationality, a key theme for the surrealists.

Josef Šíma (1891–1971)
Landscape near Yèbles (1929), *Torso in Landscape* (1932), *Grey Landscape with Red Body* (1967)

A student of Jan Preisler and later a prominent member of the 1930s Czech surrealist group, these three paintings follow Šíma's evolution from poetic surrealism further and further into symbolic abstraction or "mental landscapes." The earliest shows his lyrical approach to landscape, in which he begins to reduce descriptive elements to mere signs or shapes—horizontal lines for land, green smudges for trees, irregular shapes for clouds, diagonal slashes for grass. In *Torso in Landscape* images move further into abstraction with a fragmented female torso floating in a symbolic landscape. Finally, in *Grey Landscape* his signs have dematerialized to more of a mental than physical landscape.

Zdeněk Pešánek (1886–1965)

Male and Female Torsos (from a fountain created for the 1937 Paris World Exhibition), 1936

A pioneer of kinetic sculpture and one of the most original figures of the interwar avant-garde, Pešánek was one of the first to use unconventional materials, such as synthetic resin, neon tubes, and polystyrene, which he used in these surviving fragments of the light-kinetic fountain he made for the 1937 Paris World Exhibition. Celebrated by the French press and public, the fountain incorporated light, color, movement, and sound and can be considered one of the first multimedia artworks. Forward-thinking Pešánek envisioned a burgeoning art world where artists would abandon traditional materials in favor of new technology, with art "floating in the room" or "projected on the sky" (a concept incorporated into his design for a luminous sign for the Baťa shoe store, displayed nearby). The fountain was supposed to be moved to a Prague square, but the Nazi invasion intervened.

During World War II, the surrealist and existentialist group Skupina 42 developed under the influence of theorist Jindřich Chalupecký, who is depicted in Kamil Lhoták's 1946 painting of the same name. From 1948 the only officially recognized art form was socialist realism: art that aided in the formation of a new socialist society. This had the effect of dividing art into "official" and "unofficial." A small section gives a few examples of the idealized, inspirational official style including designs for Tatras, the car used by senior apparatchiks, and plans for the Letná Park Stalin statue.

The flip side was "Art Informel" (also called structural abstraction), which emerged in Czechoslovakia during the late 1950s. Influenced by Western European artistic trends (such as Abstract Expressionism), unofficial art was initially displayed at private studios, its somber existential tones unpalatable to the Communist culture of obligatory optimism. The Prague Spring, a period of artistic and political openness, ended with the 1968 Soviet invasion, which lead to a twenty-year period of hardline state repression (officially called "normalization").

During this period, the unofficial art scene continued to hold events and exhibitions outside traditional centers of art, despite attempts by the authorities to suppress anything outside of the party line. Among the many key "unofficial" artists worth noting from this fateful period are neo-surrealist **Mikuláš Medek**, abstract expressionist **Jan Kotík** (*Deucalion*, 1960), **Aleš Veselý** and **Karel Nepraš** with their frightening, surreal assemblages, **Vladimír Boudník** (*Variation on a Plane of Lines*, 1966), **Karel Malich** (*Café—I sit and watch, I have turned my head slightly*, 1979–83), **Adriena Šimotová** with her ethereal fabrications, and **Jiří Kolář** (*Tribute to František Kupka*, 1974). The final section features numerous artists still active today including **Michael Rittstein**, **Jiří Načeradský**, **Ivan Kafka** (note his one-armed clocks in *Potent Impotency*, 1989–95), and **Magdalena Jetelová**.

FIRST FLOOR—20TH-CENTURY FOREIGN ART
This section teems with the art of well-known foreign figures such as **Paul Klee**, **Edvard Munch**, **Max Oppenheimer**, **Joan Miró**, **Henry Moore**, **Pablo Picasso**, and more. There are also several exceptional works by three of Austria's most important early 20th-century artists: **Gustav Klimt**, **Egon Schiele**, and **Oskar Kokoschka**.

Gustav Klimt (1862–1918)
The Virgin, 1913
This decorative jumble of ecstatically intertwined bodies and colorful patterns is typical of the work of this Austrian artist, leader of the Viennese Secession (or "Jugendstil," the Austrian term for art nouveau). His work combined brilliant drawing with stylized flat surfaces, merging bodies, rich color, and decorative elements for which he drew inspiration from numerous sources from the Austrian rococo to Byzantine, Persian, and Japanese art. Klimt's images revolve around ideas of beauty, evanescence, youth, and death, often with a disturbing portrayal of female sexuality. Despite early success, Klimt's later work was often criticized as indecent (it was sometimes displayed behind a screen to avoid corrupting the sensibilities of the young). His beautiful, sumptuous surfaces are, on close

examination, far from carefree. An underlying tension between ecstasy and terror and between life and death reflect the desires and anxieties of the fin-de-siècle.

Egon Schiele (1890–1918)

Pregnant Woman and Death, 1911

Schiele was regarded by many of his contemporaries as Klimt's successor. At the age of sixteen, he came to study in Vienna, where Klimt took him under his wing. While remaining true to the principles of the Secession, Schiele became one of the major figures of Austrian expressionism, despite his disturbing personal life. (Schiele had a persecution-mania and a lifelong predilection for young girls, of whom he made erotic pictures for the pornography market; he spent a short time in prison 1912 for indecency and at one point was driven out of the town of Český Krumlov—where today there is an art center devoted to his work—for similar issues.) A superb draftsman, his highly expressive style is full of unsettling psychological and sexual issues, often dealing with death, decay, and women. Here he uses dark hues, geometric forms, and lines to construct an enveloping, clinically abrupt image of a pregnant woman and death, the latter of which resembles Schiele with a tonsure.

Oskar Kokoschka (1886–1980)

The Red Egg, 1939

This dark political satire was Kokoschka's response to the debacle of the Munich Peace Accords that legitimized the Nazi invasion of Czechoslovakia. With obvious allusion, he depicts one red egg and four forks sitting on a table crawling with vermin and beneath, a grinning cat with a French tri-color hat. Above, a raging Hitler screams and to the other side a British lion sits upon the Accord next to a grotesque Mussolini. In the background is a silhouette of Prague in flames with a dead angel floating in the Vltava. Disturbed by the growing power of the Nazis, Kokoschka, a leading Austrian expressionist, had moved to Prague and taken Czechoslovak citizenship in 1935. In his short time in Prague he painted a portrait of his friend, President T.G. Masaryk, as well as several views of Prague (one

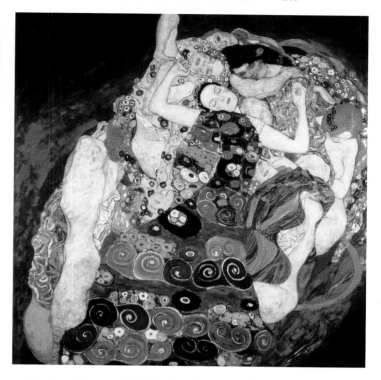

Gustav Klimt (1862-1918), The Virgin, 1913 (oil on canvas), National Gallery, Prague

hangs nearby). In 1937, the Nazis condemned his work as "degenerate art" and a year later, realizing that Prague was no longer safe, Kokoschka fled to England, where he made the *Red Egg*, a futile protest against a fateful act.

Leaving the Trade Fair Palace, the next stop on the Trail is just a short walk away.

Lapidarium of the National Museum

Location: To the right after entering the Prague Exhibition Grounds (Výstaviště) found at the junction of Dukelských hrdinů and U Výstaviště Streets in Holešovice. A two-minute walk from the Trade Fair Palace.

Contact details: Tel: 233 375 636; www.nm.cz; lapidarium@nm.cz

Opening hours: Tues–Fri 12 noon–6 PM; Sat and Sun 10 AM–6 PM

Housed in one of the neo-baroque pavilions built for the 1891 Jubilee Exhibition is the remarkable Lapidarium, the repository of Prague's original public statues and monuments dating from the 11th century to the 19th century. Most of Prague's historic exterior sculpture has been replaced by copies to protect the originals from the hazards of the modern environment, so this exhibit offers visitors the rare chance to see some of the city's best sculpture up close. Included in the many outstanding works displayed are: a 13th-century sculpted capital with a portrait of Agnes of Bohemia from her eponymous convent, Peter Parler's 14th-century sculptures for the Old Town Bridge, the 16th-century Krocín Fountain that stood in Old Town Square until 1862, and F.M. Brokoff's dramatic St. Ignatius of Loyola from Charles Bridge.

Behind the Prague Exhibition Grounds (Výstaviště) lies **Stromovka Park**, the former Royal Game Reserve first laid out by Charles IV. Beginning in the 17th century, it was connected to Prague Castle by a 1 mile/1.7 km long path lined with lindens and willows. Today it is a public park that offers a pleasant 30-minute walk to Troja Chateau, the next site on this Trail. As you wander in the park you may spy the **Governor's Summer Palace** high on a wooded hill. Ideally placed as a symbolic marker to the beginning of the Royal Reserve as well as for magnificent bucolic views over the forest for those within, the building would have greeted many a royal hunting party. Although first built for Rudolf II in 1578–1579 by Ulrico Aostalli, it retains none of its Rudolfine late Renaissance/mannerist detail, as it was rebuilt in the 19th century by Jiří Fischer in a neo-Gothic style.

Troja Chateau (Trojský zámek)

Location: Suburban district of Troja, just north of Holešovice-Bubeneč across the Vltava. It is a pleasant 20–30 minute walk through Stromovka Park or take bus no. 112 from Nádraží Holešovice metro station.
Contact details: Tel. 222 327 677; www.citygalleryprague.cz
Opening hours: Open April 1–October 31, Tues–Sun 10 AM–6. PM;
November 1 to March 31, Sat–Sun 10 AM–5 PM

Nestled between a vineyard-covered hill and the Vltava, Troja is a lovely baroque palace (because of its French style

and architect it is usually referred to as a "chateau") built for Count Václav Vojtěch Sternberg in the late 17th century. Despite aggressive restorations in the 1970s and 1980s and the devastating 2002 floods (which submerged most of the grounds), it has retained much of its charm and frescoed interiors, which today hold the Prague City Gallery's collection of 19th-century and 20th-century Czech art.

The Chateau

It was a bit of calculated self-promotion when Count Sternberg decided to build a chateau on the site of a farm he owned in Troja. The land was next to the royal park of Stromovka where the king often hunted. Sternberg correctly surmised that by creating a conveniently located, elegant country residence where the king could take a break from the hunt, he would improve his position at court. It would also be evidence of Sternberg's loyalty to his Habsburg rulers, whose relations with the Czech nobility had been tenuous since the Estates' Rebellion and the Battle of White Mountain.

Work began in 1679 based on the design of architect Jean-Baptiste Mathey, who drew on his own French background and Roman villas he had seen while in Italy. Considerable expense was taken to ensure the main façade and gardens looked south toward Prague Castle, in deference to the sovereign, and so that those arriving by boat could admire the chateau. To experience this effect, enter the grounds from the riverside gate, as 17th-century visitors would have. From here guests would walk through the formal French gardens, one of the first in Bohemia, up the chateau's monumental staircase, and into the Grand Hall (today's visitor must be content with the north entrance).

Based around concepts recently developed by Fontana and Bernini, the two-storied chateau is symmetrically designed around a grand central hall flanked by two lower wings with corner pavilions. Colossal applied pilasters, prominent in red, were added to emphasize the scale of the building. The south façade is dominated by a magnificent portal and a horseshoe-shaped staircase inspired by that at the Chateau of Fontainebleau outside Paris. The stairs are dotted with animated statues by

Dresden artists Johann Georg Heerman and his nephew Paul, both followers of Bernini. Portrayed are the gods of Olympus battling the Titans into hell, two of which have already fallen, writhing, into the grotto between the staircases.

The chateau's interior has one of the most extensive cycles of baroque paintings in the Czech Republic. The ground floor is mostly the work of northern Italian Francesco Marchetti and his son, Giovanni Francesco. Each room displays scenes of the glory and genius of the Sternberg family, who are portrayed in the company of Olympians, in allegorical scenes, proclaiming virtues, and conquering Vice. The Sternbergs' family symbol—an eight-pointed star—along with the emblem of Count Sternberg's wife's family, the Malzans—a coat of arms with a hare's head and cluster of grapes—are found throughout. This fawning display still could not hide the secondary quality of the Marchettis' work and so, for his Grand Hall, the Count hired Abraham and Isaac Godyn. These Flemish brothers who had trained in Bologna, the 17th-century center of fresco painting, created an amazing trompe-l'oeil hall (see below) much more to the count's liking.

The Gallery

The Prague City Gallery's modern art collection is displayed throughout the chateau and is well-documented in Czech and English, a helpful fact considering many of the artists are little known outside of the Czech Republic. Not all are of great interest, but there are some noteworthy 19th-century paintings by Jaroslav Čermák and Václav Břožík, some interesting 20th-century sculpture and, of course, the frescoes themselves.

On the ground floor are found works by **Jaroslav Čermák** (1830–1878), one of the few Bohemian painters to gain international renown. Primarily a history painter, Čermák trained under Belgian artist Louis Gallait, from whom he learned the compositional style of Rubens, the painterly approach of the French Romantics, and the Barbizon School's approach to color and light. He travelled widely and spent much time in the Slavic south.

Portrait of Hippolyte Gallait, 1863

Hippolyte Gallait (1825–1905) was the wife of Čermák's teacher Louis Gallait; Čermák had a 23–year on-and-off love affair with her. This full-length portrait of her in a long satin dress was painted during the two-year period she and her two young daughters lived with Čermák in Dalmatia. After Čermák's death, it was she who donated much if his work to the City Gallery of Prague.

Montenegrin Women in a Harem, 1877

Čermák travelled in Herzegovina and Bosnia where locals were fighting against Turkish rule. The artist became fascinated by events he saw there, in particular, the fate of local women captured by the Turks. Partially sympathetic, partly voyeuristic, his images fit the tradition of titillating harem scenes designed for a Western male gaze. The woman in a black shawl standing against a wall with an expression of utter humiliation and futile defiance is a motif Čermák used again and again (such as in *Captives,* 1870, at the Trade Fair Palace).

Climbing to the next floor, there are several works by **Václav Brožík** (1851–1901), a boilermaker's son who became one of the most successful Czech artists of the period. He studied in Prague, Germany, and finally Paris in 1876 where he went on to great success, becoming the only Czech elected to the French Academy. He is buried in Montmartre. Displayed are several of Brožík's landscape and genre works, giving an interesting, if somewhat romanticized, vision of French rural life. He is best known, though, for his dramatic history paintings.

Defenestration, 1889

This massive work was first displayed at the Paris Salon of 1889 and then in the Rudolfinum from 1889–1890. In both cases, brochures identifying characters and supplying historical detail were given to viewers. It depicts the dramatic moment of the 1618 Second Defenestration, an event that set off the Thirty Years' War. A Habsburg government minister is being thrown,

back first, out a window in Prague Castle, while another is restrained by rebellious members of the Czech Estates. Brožík draws on historical records for every detail, down to the room's décor, and his depiction of the characters is very much influenced by the portraits and costume of van Dyck.

The next room is the Grand Hall, fully covered—everything except the floor—with the Godyns' extraordinary trompe-l'oeil frescoes. An ambitious cartoon-like framework of fictive architecture and tapestries holds various scenes whose iconography revolves around a celebration of the Habsburg dynasty. There are legendary events from Habsburg history and celebrations of their contemporary victory, as part of an Austrian, Polish, and Venetian coalition, against the Turks, who were turned back at Vienna in 1683. The following is a brief explanation of the scene's complex iconography (which is fully detailed on handouts found in the hall).

Abraham Godyn (c.1663—1724) and his son, Isaac
Trompe-l'oeil Frescoes, 1691–1697

All scenes are presented in a mixture of contemporary and antique Roman style. The west wall has three levels. The top depicts the Roman Temple of Janus, god of war, which is being symbolically guarded by the representatives of the peace coalition of 1683. The Godyns use the scene to show off their impressive command of trompe-l'oeil techniques: The Archangel Michael and a turbaned Turk seem to plunge headlong into the room. The middle level is a faux tapestry with Emperor Leopold I (quite recognizable despite his Roman garb, with a 17th-century wig and his distinctive Habsburg protruding lower lip) riding a chariot in a triumphal procession. The banner beside him is a dedication from the Sternbergs. Below, a gloating Victory sits astride captured items and severed enemy heads with two captured Turks chained to either side of a fireplace.

On the opposite east wall the top level is a scene from Habsburg mythology explaining the source of their emblems. Below is another trompe-l'oeil tapestry

with the legend of Rudolf I, founder of the Habsburg dynasty, who gave his horse to a needy priest who later prophesized that Rudolf would become emperor. The bottom level shows the personification of Justice flanked by allegorical characters: Injustice (wearing, what else, a turban), Anger (with a smoldering mouth), Avarice (accompanied by a wolf) and Foolishness (a man with donkey ears).

The upper north wall depicts an actual historic event: the marriage of Philip I of Habsburg to Juana of Spain in 1497, which brought the Habsburgs a worldwide empire. The upper south wall shows Emperor Charles V abdicating in favor of his brother Ferdinand I—whom he crowns with laurel—and bestowing the Order of the Golden Fleece on his son, Phillip II. The ceiling is a complex scene of cherubs, kings, and saints as part of an allegory of the Habsburgs' terrestrial and celestial victories. And of course, the Sternbergs' stellar family symbol is found throughout the room's decorations, confirming their prestige and close ties to the ruling Habsburgs. All and all, it is an impressive feat of self-promotion and Habsburg propaganda.

To the east of the Grand Hall are a series of rooms covered in delicate scenes of Chinese landscapes (by an unknown artist). The rest of the exhibit is devoted to 20th-century sculpture. Of note are František Bílek's dramatic *A Tree Struck by Lightning Burned for Ages* (1901), Ladislav Šaloun's study for Hus's head for the Old Town Square Monument (1906–1910), Otto Gutfreund's first serious attempt at cubist sculpture, *During Toilet* (1911), and Jaroslav Horejc's archaic *Archer* (1918).

Eastern Prague
Vinohrady

The streets of the popular residential area of Vinohrady are lined with apartment blocks and offices from the late 19th century and early 20th century when the area was first developed. In between the popular shops and restaurants that dot the area

are a few spots of artistic and architectural interest.

Anyone intrigued by Josef Mocker, who was responsible for many of the 19th-century restorations of medieval buildings, may wish to visit Mocker's very own creation, the **Church of St. Ludmila** (Sv. Ludmily). Found on náměstí Míru, it was built between 1888 and 1893 and is a highly formal, rather lifeless example of French-influenced high neo-Gothic, of which Mocker was a great fan. Josef Myslbek executed the west tympanum of Christ and saints Wenceslas and Ludmila.

Much more impressive is the highly original **Church of the Sacred Heart** (Nejsvětějšího Srdce Páně), which lords over the nearby George of Poděbrady Square (Náměstí Jiřího z Poděbrad, open for services on Sunday at 7 AM, 9 AM, 11 AM and 6 PM, and Monday to Saturday at 8 AM and 6 PM). The greatest Prague work of Slovenian architect Josip Plečnik (who also worked on Prague Castle, see page 139), it was created from 1928–1932 and is an eccentric, postmodernist mix of Egyptian temple, early Christian basilica, and other sources. Inspired by the church's location in the area of the former royal vineyards, Plečnik included several royal motifs: the bricks protruding from the building surface evoke an ermine robe; the massive, flat clock tower is topped by a royal orb. Plečnik also took into account the view of the church's distinctive façade from Hradčany.

The interior is a large open space more like an ancient temple than a church, mingling different forms of spirituality. The walls are red brick with simple applied pilasters and dotted with small bronze cruciform crosses. A brief clerestory level is pierced by pale stained glass windows and topped by a flat, coffered wood ceiling. Dozens of hanging lamps are suspended from the ceiling like an immobile cosmos.

Žižkov

On a high rocky outcrop, towering over the working-class neighborhood of Žižkov, is the **National Monument** (Národní památník), devoted to the great military commander, Jan Žižka (1360–1424), who won a major Hussite battle here in 1420. The project was initially contemplated as a

World War I memorial, then expanded to include the 1918 independence. The huge granite slab of a structure was finally built from 1926–1930 and inside, mosaics were created by Max Švabinský and Jakub Obrovský and relief carvings by Karel Pokorný. A massive bronze equestrian statue of Žižka (30 ft/9 m) was begun in 1931 by Bohumil Kafka and only placed before the monument in 1950.

The monument gained a sinister connotation from the 1950s as Communist additions were made, turning it into the burial place for prominent Communist functionaries, including the first Communist president, Klement Gottwald, whose embalmed corpse for years was displayed Lenin-style in a glass coffin. Closed at the time of writing, new uses for the structure are now being debated.

Another noted Žižkov site is the great eyesore of the 709 ft/216 m Television Tower (Televizní vysílač), which has been given a surrealist edge by the addition of contemporary installation artist David Černý's *Babies*—giant, gravity-defying infants crawling up and down its pillars.

WESTERN PRAGUE

Galerie Anderle

Location: Pelléova 10, Prague 6; close to Hradčany metro

Contact details: Tel: 224 326 189; galerie@anderle.cz

Opening hours: Tues–Sun 10 AM–6 PM, closed Mondays

This gallery is devoted to the art of renowned artist Jiří Anderle (1936–). The exhibit presents Anderle's works in prints, drawings, and paintings from the 1950s to the present. Through his long career, Anderele has explored the idea of the individual in society, approaching the human body as a vision of the soul. Spending most of his life under a repressive regime, in his art he drew on centuries of art history, searching out a common cultural heritage in an imperfect world. His work speaks of a Kafkaesque world of apprehension, distrust, and absurdity, yet always looks for the human dimension, be it ugly or beautiful, good or evil. A unique dimension of the gallery is

the juxtaposition of Anderle's work with his major collection of African sculpture, a key source of his inspiration.

Müller Villa

Location: Nad hradním vodojemem 14, Prague 6, Střešovice. From the Hradčany metro take tram no. 1 or 18 to Ořechovka

Contact details: Tel: 224 312 012; www.mullerovavila.cz

Opening hours: Guided visits only, which must be booked in advance at the above telephone number. Open year-round, but closed on December 25, 26, and January 1.

Considered one of the great works of modern European architecture, the Müller Villa was the design of Moravian-born architect Adolf Loos (1870–1933). An early advocate of functionalism and a leading innovator of modern architecture, Loos worked mostly in Austria; yet this Prague villa, built for engineer František Müller, is considered one of his best. Located in Střešovice, a Prague suburb laid out in the 1920s and modeled on English garden suburbs, the luxurious villa is today a national cultural landmark, having remarkably survived the anti-bourgeois, anti-elitism of the Communist years. In 1948, Communist authorities declared the villa a "tenement" and the widowed Mrs. Müller was forced to live in her boudoir as others moved in; later, the Marxist-Leninist Institute and the Communist Party took over the space. Fortunately, much of the original décor has survived and in the 1990s was the villa restored to its c. 1930 state.

Perched overlooking the city, surrounded by a garden designed by Loos and the German landscape architect Karl Fürster, the villa has an unassuming exterior—a rather severe rectangular box pieced by crosshatched windows with canary-yellow frames, like Chinese lacquer—which belies the sumptuousness of the interiors. Only the finest materials—marble, mahogany, and opaxite—were used in the radically conceived layout based on Loos' idea of a "Raumplan," in which rooms are interconnected but at different levels. Loos' intentions can best be described in his own words:

I do not design floor plans, façades, cross-sections. I design spaces. For me, there is no ground floor, first floor and the like. For me, there are only continual connected spaces... floor levels overlap and all spaces lead to one another. Every space requires a different height: the dining room is surely higher than the pantry, thus the ceilings are set at different levels. To join these spaces in such a way that the rise and fall are not only unobservable but also practical, in this I see what is for others the great secret, although it is for me a great matter of course... it is just this spatial interaction and spatial austerity that thus far I have best been able to realize in Dr Müller's house. (1930)

Břevnov Monastery (Břevnovský klášter)

Location: Bělohorská ulice, Prague 6, Břevnov. From Malostranská metro station, take tram 22, or from Hrančanská metro take trams 15 or 25 to Břevnovský klášter. (No. 22 can also be caught from the stop at the west end of Pohořelec Square, Hradčany.)

Opening hours: The grounds are open to the public daily; the church and monastic buildings can be visited only on a guided tour, in Czech, led by a local priest, every Saturday and Sunday at 10 AM, 12 noon, and 4 PM.

Břevnov Monastery is the oldest in Bohemia, founded in 993 in a secluded wooded area west of Hradčany by Prince Boleslav II and Bishop Vojtěch (Adalbert, who later became a patron saint of Bohemia). Legend says the two men met by a spring after having the same dream. The monastery was built, becoming one of Bohemia's most important Christian centers, only to suffer the fate of most Bohemian religious institutions in the 15th-century: destruction by the Hussites. The monastery's second heyday was in the early 18th-century when Christoph and K.I. Dientzenhofer rebuilt the complex. Today it is considered one of their greatest works. After years of misuse and neglect, the Benedictines returned in 1990 and have begun the process of restoring the complex. No longer secluded, the monastery now stands surrounded by 20th-century suburbs, yet its pleasant little park and pretty cream and red-tile roofed church evoke the bucolic place it must have been for centuries.

Visitors are free to wander the grounds, including the orchard garden, where legend says Boleslav and Adalbert met

to found the monastery. The principal attraction, however, is the graceful **Abbey Church of St. Margaret** (sv. Markéty), built by Christoph Dientzenhofer between 1709–1721. The tightly composed exterior is lined with massive pilasters and columns, pierced by oval and arched windows, and crowned by gables with undulating pediments and an onion-domed spire. The aisle-less interior is composed of intersecting transverse ovals with piers jutting diagonally into the nave, as in another of Christoph's creations, St. Nicholas in Mála Strana. Trompe l'oeil frescoes line the walls of the nave, blurring the line between image and architecture. The ceiling frescoes by Johann Jakob Steinfels (finished before 1721) depict the founding of the monastery by St. Adalbert. The guided tour includes a visit to the church's crypt, which includes remains of the Romanesque and Gothic structure, and the monastic buildings which were completed by K.I. Dientzenhofer after his father's death in 1722.

Continuing along Bělohorská on tram 15, 22, or 25 will take you to the former royal game reserve and uniquely star-shaped Renaissance hunting lodge/summer palace of **Hvězda** (Czech for "Star"). Getting off at the Vypich stop, cross over to an open lawn—on summer weekends busy with kite-flyers and cricket-players—which leads into a wooded park that was laid out in 1797 on the former hunting reserve founded by Ferdinand I in 1530. The original landscape design can be considered one of the most unique in 16th-century central Europe. The grounds were laid out on a eight-point star-axis with the six-point star hunting lodge placed to the back of the grounds as a *point de vue*; a picturesque vista to be appreciated from a distance (which it can still be today, although the effect was lessened after the 1950s reconstruction reduced the height of the roof by half). Follow along the double pathway to the stellar hunting lodge built by Hans Tirol and Bonifác Wohlmut in 1555–1558 for Archduke Ferdinand of Tyrol. It later became a residence of the archduke's wife. The exterior was austerely restored by Pavel Janák after World War II, but the interior still contains some original decorative work. Now a museum of Czech literature (open Tuesday to Saturday from

9 AM to 4 PM, and on Sunday from 10 AM to 5 PM), concerts are often held on the top floor.

Fans of Jan Santini-Aichel, or those simply curious to see the famous White Mountain (Bílá hora), spot of the pivotal 1620 battle where the Catholic Habsburgs trounced the Protestant Czechs, will want to continue on tram 22 to the end of the line. There isn't much to see on the site itself (found at the along Nad višňovkou Street), but at the foot of the hill sits the pretty, onion-domed **Church of Our Lady of Victory** (Panny Marie Vítězné). It was built from 1710–14 by Jan Santini-Aichel and was once a former pilgrimage site commemorating the dead and the Catholic victory at White Mountain.

Trail 7:
Day Trips out of Prague

T his final chapter covers three sites of particular interest to art travellers, all of them easy day trips from Prague: Nelahozeves, Karlštejn, and Kutná Hora.

NELAHOZEVES CASTLE AND THE LOBKOWICZ COLLECTIONS

Location: Nelahozeves is 16.5 miles/27 km north of Prague off of highway E55. Trains leave from Masaryk train station (Masarykovo nádraží) several times daily and take about one hour. For train schedules see www.cd.cz/static/eng/. Take the train for Roudnice nad Labem and get off at Nelahozeves Zámek station at the foot of the castle.

Contact information: Address: Nelahozeves Castle, 277 51 Nelahozeves, Czech Republic. Tel: (420) 315 709 138. Fax: (420) 315 709 133. www.lobkowicz.org.

Opening hours: 9 AM–5 PM Tues–Sun. Closed Mondays, Christmas, and New Years' Day. The collections are only accessible by guided tour, available in several languages, including English (call ahead for times).

Sitting high on a bluff overlooking the Vltava, less than an hour north of Prague, is the majestic Renaissance castle of Nelahozeves, which holds one of central Europe's finest private art collections. Masterpieces by Bruegel, Canaletto, and Velázquez hang within its historic halls, and the paintings alone merit the short journey from the city. However, the story of the castle and its collection is also a fascinating tale of aristocratic collecting, communist confiscations, and

returning princes, adding layers of modern politics and patronage to its considerable art historical interest.

Florián Griespek of Griespach, an influential official of the court of Ferdinand I, commissioned the castle around 1553. His position as the overseer of all royal building in Bohemia allowed him to use the best of builders, such as court architect Bonifác Wohlmut. The resulting castle is like an Italianate palazzo on the Vltava, blending Italian and Bohemian architectural traditions. With corner bastions, rusticated stonework, and an actual moat, the building incorporates elements of earlier fortified medieval structures, suggesting strength and a long, powerful lineage. However, it is also lavishly decorated with superb sgraffito work of allegorical scenes, reflecting its principal function as an impressive noble residence.

Not long after the castle's completion, the Griespek family found themselves on the losing side of the 1618 Czech Estates' revolt, and all their property was confiscated. On the winning side were the princely Lobkowicz family, and Polyxena of Lobkowicz (1566–1642) purchased Nelahozeves in 1623. The Lobkowicz family went on to become one of the most powerful families in Bohemia and later in the modern Czechoslovak state. Maximilian Lobkowicz (1888–1967) was ambassador to Britain in the 1930s and later the foreign minister of the exiled government during World War II, during which the Nazis seized the Lobkowicz's many estates and art collections, with the intention of incorporating the best pieces into Hitler's Reichsmuseum. Most were restored in 1945, but only three years later the Communists took over and the Lobkowiczes were forced to flee the country with nothing. It wasn't until the 1990s, under the restitution of property acts signed by President Václav Havel, that the Lobkowiczes were able to reclaim much of their property. Generations of the Lobkowicz family had been major art collectors, and their confiscated masterpieces, which had hung since 1948 in the Czech National Gallery or languished in storage, have now been reunited at Nelahozeves.

Access to the castle is via a moat bridge that leads to a courtyard containing a restaurant, gift shop, and ticket office. To visit the collections one must take a guided tour. Two are

offered. Guided Tour II takes visitors to the elegant Renaissance Knights' Hall, as well as to nine galleries decorated with family portraits, landscapes, furniture, and tapestries. The masterpieces of the Lobkowicz collection are seen on Guided Tour I in a permanent exhibit entitled "The Lobkowicz Collections: Six Centuries of Patronage."

The exhibit was designed by British art expert John Somerville; each room is organized to underscore the relationship between artwork and collector and to tell the political and cultural story of Bohemia and the Lobkowicz family chronologically from the Renaissance to the 1940s. Paintings are displayed with contemporary furnishings, with some rooms presented as formal picture galleries, others as drawing rooms or traditional cabinet picture rooms; all in an attempt to recapture the character of the former Lobkowicz residences where these works once hung.

The following descriptions highlight several of the exceptional paintings and objets d'art found on Guided Tour I, following from room to room.

FAMILY PORTRAIT ROOM

It was Polyxena of Lobkowicz (1566–1642), daughter of Czech noble Vratislav Pernštejn and a Spanish noblewoman, who united several powerful Bohemian and Spanish families under the Lobkowicz title and set the stage for the family's meteoric rise to the elite inner circles of the Habsburg court. She accomplished this through two marriages: the first to powerful Vilem of Rožmberg (1535–1392), the second to the first Prince Lobkowicz (1568–1628). Polyxena is also credited with first amassing the Lobkowicz painting collections, including one of the largest collections of Spanish portraits outside of Spain. This room presents 16th- and 17th-century portraits of the principal members of the Lobkowicz family; all of the portraits were intended as displays of wealth, status, and lineage.

Several works are by important court painters. Vratislav Pernštejn's portrait (to the left on the west wall) is by Jakob Seisenegger (1504–1567), court artist of Ferdinand I. Bartholomeus Spranger, court painter to Rudolf II, painted

the first Prince Lobkowicz, the chancellor of Bohemia, in the year of his marriage to Polyxena (1603), wearing a curled moustache similar to Rudolf's; the portrait hangs in the center of the south wall.

TREASURY AND MAJOLICA ROOM

The Lobkowicz collections also include precious secular and religious objects dating from the Middle Ages to the 18th century. Of particular note in these rooms are the richly embroidered **Hassenstein Altarpiece**, completed in 1574 to celebrate a Lobkowicz marriage; the **Jezeři Reliquary** (c. 1300) of the head of a female saint, an exceptional piece of goldsmith work made at the Břevnov Monastery (see western Prague); and some wonderful 17th-century polychrome Italian **majolica** (ceramics) from Deruta.

COURT PORTRAIT GALLERY

This gallery presents portraits of the 16th- and 17th-century members of the imperial court or European royal houses associated with the Lobkowiczs, which would have been received as gifts or purchased and used to display the family's lofty connections. Look for portraits of several recognizable rulers, such as Rudolf II, Henri III of France, and Catherine de' Medici. Two of the best Spanish portraits in the collection are by Phillip II's court painter, Alonso Sánchez Coello (1531–1588), one of the pioneers of Spanish portraiture. His formal, stylized court portraits of the siblings of Rudolf II (Anne, Archduchess of Austria, painted c. 1575–1580, and Wenzel, Archduke of Austria, painted 1577 and wearing the white cross of the Order of the Knights of Malta) hang on the west wall and reflect the sober yet refined (note the jewels and rich embroidery) style of the Spanish court.

VELÁZQUEZ ROOM

Devoted to the rulers and dignitaries associated with the 17th-century Lobkowicz family, the most magnificent image in the room is that of a five-year-old girl by one of Spain's greatest painters.

Diego Velázquez (1599–1660)

Infanta Margarita Teresa of Spain, 1656

The court connections of Prince Václav Eusebius of Lobkowicz (1609–1677) brought this portrait of the Infanta Margarita Teresa (1651–1673) into the Lobkowicz collections. The first-born child of King Philip IV of Spain and Maria Anna of Austria, the infanta was promised at an early age to her cousin and uncle, the future Emperor Leopold I (the Habsburgs often married relations to maintain their sizeable empire and to link the Spanish and Austrian family branches). Before the wedding took place in 1666, the Madrid court sent portraits of the infanta at regular intervals to Vienna, including this formally posed court portrait. In it, the child wears the cumbersome corset and skirts of 17th-century fashion, which Velázquez portrays with sparkling richness. Painted near the end of his celebrated career, the painting shows Velázquez's subtle naturalism, with detail subordinated to overall effect. Velázquez painted five portraits of the infanta (including the famed *Las Meninas*, 1656, today in the Prado). She died at 22 after giving birth to several children.

CANALETTO ROOM

Giovanni Antonio Canale, called Canaletto (1697–1768)

The River Thames on Lord Mayor's Day and *The River Thames with Westminster Bridge*, both 1746

It was fashionable for 18th-century English tourists in Venice to bring home a Canaletto painting as a souvenir of their Grand Tour. In a twist to this scenario, the Bohemian Prince Ferdinand Philip of Lobkowicz (1724–1784) bought two Canaletto views of London on his journey to England, where he had come to buy horses. His visit is mentioned by Walpole, who describes him as "a young man of around twenty on his travels," and notes his purchase of the paintings, which Canaletto would have begun soon after his arrival in England in

1746. During his years in England Canaletto produced grand vistas of rigorous clarity and detail that suited his clients' demands for accuracy. These two images are amazing documents of 18th-century London seen through Venetian eyes, capturing details of life in the northern city. The first painting presents the pomp and ceremony of the lord mayor's barge as it makes its annual procession from the city past St. Paul's Cathedral to the Palace of Westminster. The second panorama, taken from the Archbishop's Lambeth Palace opposite Westminster (note St. Paul's in the distance), includes such everyday details as a gardener trimming a hedge and scaffolding on the just completed Westminster Bridge.

NETHERLANDISH CABINET ROOM

Organized in the style of a period Netherlandish cabinet, this room displays many 17th-century and 18th-century Netherlandish, Flemish, and German paintings, including landscapes, still-lifes, religious, allegorical and genre scenes, including Jan Bruegel the Elder's (1568–1625) *St. Martin* (1611). Many of these paintings came into the collection with the marriage of Ferdinand August of Lobkowicz (1655–1715) to the daughter of Duke William, Margrave of Baden, whose portrait by Samuel van Hoogstraeten (1627–1678) hangs at the center of the north wall.

BRUEGEL ROOM

Here in the former castle chapel are several masterful works, including the collection's most renowned painting, *Haymaking.*

Pieter Bruegel the Elder (c. 1525/30–1569)

Haymaking, 1565

Painted for the dining room of an Antwerp merchant, *Haymaking* was originally part of a series of six panels following through the seasons of a year; this painting is of the busy and fruitful months of June and July. All six panels were presented to the Habsburg governor of the Netherlands in 1594 and later ended up in Vienna. At some point, perhaps in the early 18th century,

Pieter Brueghel the Elder (c. 1525/30–1569), **Haymaking,** *possibly the months of June and July, before 1566 (oil on panel), Lobkowicz Collections, Nelahozeves Castle*

Haymaking entered the Lobkowicz collections. (Of the others, three now hang in the Vienna Kunsthistorische Museum, one is in the New York Metropolitan Museum and one is lost.) Bruegel often depicted peasant life in keen detail (as attested to by the workers' costumes and tools) but not as simple recreations of everyday life. His brilliantly organized, panoramic compositions suggest an insightful and ideal vision of the world. This cycle was originally like a continuous frieze linked by a sequence of colors and, though rooted in the legacy of calendar scenes in medieval manuscripts, Bruegel's emphasis was not on the labors that mark each season but on the atmosphere and transformation of the landscape itself. In this idyllic painting, with its warm colors, gentle lines, and the round, kind face of the young girl who gazes out of the picture, he suggests the joy of a bountiful

season, particularly meaningful to 16th-century viewers who may have experienced the hardships resulting from a bad season.

Peter Paul Rubens (1577–1640)
Hygieia and the Sacred Serpent, 1614/5

Prince Ferdinand August is considered the first true connoisseur of paintings in the Lobkowicz family, collecting art beyond portraiture, such as this mythological scene by Rubens, which he acquired in the 1680s. One of the most influential painters of the 17th century, Rubens had an energetic, expressive Baroque style that blended his native northern European sense of realism with the grandeur and monumentality of Italy. Worldly and well-educated, Rubens had a scholarly interest in ancient coins, from which he could have taken this image of Hygieia, the Greek goddess of health. In it she nourishes a serpent, representing the god of healing, Asclepius. Like most of Rubens's female figures, Hygieia is distinctly "Rubenesque": a rosy-cheeked, petal-lipped beauty of robust proportions portrayed in a state of partial undress.

Ferdinand August also acquired *David* and the *Head of Goliath* by Venetian Paolo Veronese (1528–1588) and Lucas Cranach the Elder's *Virgin and Child with Saints Barbara and Catherine,* which both hang in this room.

The tour continues through a re-created 19th-century dining room decorated with Meissen porcelain and family portraits and leads into the Beethoven Room. The Lobkowiczes were great patrons of music, fostering the careers of Gluck and Beethoven, among others. There are several original handwritten scores by these and other composers, numerous period orchestral instruments, and, in the southwest corner of the room, Bernardo Bellotto's painting *The Lobkowicz Palace in Vienna* (1760) where many first performances by Beethoven took place. The adjacent Croll Gallery is lined with pictures by Dresden-born landscape painter Carl Robert Croll (1800–1863), whom the Lobkowicz family commissioned in the 1840s to

depict all of their castles in Bohemia, including Nelahozeves. The tour ends in the 19th- and 20th-century Portrait Gallery, the most striking of which is a 1925 photograph of Maximilian Lobkowicz by avant-garde photographer František Drtikol. A diplomat and politician who campaigned for an independent Czechoslovakia who voluntarily renounced the title of prince in the new democratic state, the picture captures his air of aristocratic modernity.

KARLŠTEJN CASTLE

Location: 17.5 miles/28 km southwest of Prague. There are frequent trains from the Hlavní nádraží (main train station) or Smíchovské nádraží (Smíchov train station) taking about 40–45 minutes; see www. cd.cz/static/eng for departure times. The castle is picturesquely located at the top of the hill, so be prepared for a good 0.80 mile/1.5 km climb up from the station through the tiny, touristy Karlštejn village.

Contact information: www.hradkarlstejn.cz.

Opening hours: Open Tues–Sun (closed Mondays) year-round. Opening hours from November to March 9 AM–noon, 1 PM–3 PM; April and October 9 AM–12 noon, 1 PM–4 PM; May, June, and September 9 AM–12 noon, 12:30 PM–5 PM; July and August 9 AM–12 noon, 12:30 PM–6 PM.

Other information: Entrance to the castle is by guided tour only. The most art historically interesting is Tour #2 (70 minutes), which includes the Chapel of St. Mary, St. Catherine's Chapel, and the extraordinary Chapel of the Holy Cross, which, for preservation reasons, is limited to 12 visitors per hour, so reservations must be made in advance. Call: (+420) 274 008 154 or 274 008 155 or 274 008 156. Fax: (+420) 274 008 152 or e-mail: rezervace@stc.npu.cz. Reservations are not required for the less remarkable Tour #1 (maximum 55 people, 50 minutes), which takes in such rooms as the Imperial Palace, Hall of Knights, Chapel of St. Nicholas, Royal Bedroom, and Audience Hall.

High on a hill over the Berounka River, the romantic silhouette of Karlštejn Castle evokes images of chivalric knights, beautiful damsels, and maybe even a dragon or two. And indeed it dates to Bohemia's medieval golden age, the reign of Charles IV, when it was the treasure house of the

kingdom's most sacred possessions. However, historical purists beware; its present state is the result of the often imaginative 19th-century restorations of Josef Mocker. While Mocker had an expert's knowledge of medieval engineering, he also had his century's romantic sensibilities and Karlštejn is a mix of the two. Nonetheless, it is a fascinating structure for both its historical origins and remodelings and holds one of the most beautiful composite pieces of medieval art anywhere: the gilded Chapel of the Holy Cross, covered in paintings by the eminent Master Theodoric.

Because Karlštejn Castle is one of the most popular excursions out of Prague, on a Saturday in July you must be prepared for countless busloads of tourists to share your experience. On a snowy January day or a Tuesday in October, however, when the leaves of the pretty Berounka Valley are a fiery hue, the crush is greatly reduced. Regardless of when you go, remember to book your castle tour several days in advance.

The Castle

Karlštejn Castle was part of Charles IV's visionary dynastic plan to transform his capital into a worthy reflection of his spiritual and temporal power as king of Bohemia and Holy Roman Emperor. Begun in 1348, Karlštejn was conceived as a sort of sacred fortress to hold the crown jewels and the most sacred holy relics of the empire that Charles IV himself had collected, the most hallowed being a fragment of Christ's cross.

It is not known who designed Karlštejn castle; the French architect Matthew of Arras, whom Charles had invited to Prague to built St. Vitus Cathedral, is one possibility. The castle complex is a succession of buildings up a steep slope, both a defensible and symbolic design. Like an ascending pilgrimage, the buildings rise from the Royal Palace (representative of secular authority) to St. Mary's Tower (Mary being the intercessor between God and man) to the Great Tower, which held the lavish, relic-filled Chapel of the Holy Cross, the holiest of holies in Bohemia (representing celestial authority). The emperor himself is said to have spent many

hours there in mystic contemplation. All structures were decorated by the best artists of the day. More secular concerns necessitated fortification walls about 20 ft/6 m thick and lined by a huge ditch.

These precautions proved useful against the anti-royal zeal of the Hussites, who besieged the castle for seven months in 1420. However, it was all downhill for Karlštejn for several centuries after that. Habsburg architect Ulrico Aostalli extensively rebuilt the castle from 1575–1597; but, after the castle was attacked in the Thirty Years' War, the Bohemian royal jewels were permanently moved to St. Vitus Cathedral. Stripped of its principal function, it fell into ruin, only to be revived in the 19th century by the growth of romantic historicism.

The first repairs were made for the visit of Emperor Franz Josef in 1812; however, major work did not begin until the 1860s when Austrian architect Josef Schmidt drew up plans

Medieval Relics

In the Middle Ages, the collecting of relics—the physical remains of a holy site or holy person—was almost a competitive sport for monarchs, for whom possession of important relics reflected their honor, piety, and divine authority. Relics were seen as a link between life and death, man and God, and often believed to have healing powers. Relics could be bits of body parts or items related to a saint's martyrdom, but those associated with the Virgin and Christ were the most valuable, none more so than items relating to Christ's death on the cross. That there were enough pieces of the Holy Cross in medieval Europe for a small forest made no difference. Elaborate reliquaries—in the form of a casket or a cross or the shape of the body part it held—were made to store and display each relic, which were often used in medieval processions and worship.

for the castle's total restoration. Accompanying Schmidt was his student, Josef Mocker, who would eventually augment and complete the plans himself from 1888–1897. While Mocker respected the basic features of the original design (i.e., the palace and the towers), he also added his own characteristic embellishments, such as steep hipped-roofs and golden finials, destroyed several surrounding structures, and added new ones to achieve a stylistic unity—a questionable facet of many of his restorations. Mocker was censured at the time for his "imaginative" reconstruction, much as Viollet-le-Duc was critiqued for his no less drastic reinvention of Carcassonne. However, Mocker's work saved Karlštejn from complete disintegration and today it is as much a symbol of the 19th-century Gothic Revival as it is of Charles IV's Bohemia.

Touring the Castle

The long, winding road up through Karlštejn village ends at the castle gates, which lead into the Burgrave's courtyard (Purkrabský dvůr) where the ticket office is found. Of the two tours offered, the more interesting in terms of art history is Tour #2, which must be booked in advance (see page 266).

Tour #2 begins with some 18th-century and 19th-century prints and photographs of Karlštejn showing its condition before and after Mocker's restorations, but the real attraction is the artistry of the medieval chapels. In the Marian Tower (Mariánská věž), the **Chapel of St. Mary** is covered with fragmented 14th-century frescoes often attributed to the French-trained Nikolaus Wurmser of Strassburg. The earliest scenes (from around 1357) are of Charles IV, in a distinctive imperial crown, collecting various relics: from the French dauphin and future King Charles V he receives a piece of the Christ's cross and two thorns from Christ's crown; from the Hungarian King Ludovic he receives what could be a piece of the sponge used to quench Christ's thirst during the Crucifixion; and in a third scene, Charles IV places the relics in a gilded cruciform reliquary. The scenes record Charles's active piety as well as his imperial rank over other

Master Theodoric, St. Elizabeth of Hungary, c. 1360–1364, Karlštejn Castle, Czech Republic

European royalty. Below are slightly askew trompe-l'oeil arcades and above are fragmentary remainders of a picture of the Holy Trinity, which was damaged and painted over during the 16th-century reconstructions. The other walls have almost cartoonish scenes of the life of Christ and the Virgin Mary and of the Apocalypse, complete with a multi-headed beast and visions of hell—popular subjects in the tumultuous 14th century that saw the Black Death spread throughout Europe. Each illustrative picture is framed with relevant biblical text, a format commonly used in medieval pictorial manuscripts.

Adjacent, accessed by a narrow passage once covered in polished stones but today pockmarked with tourist graffiti, is the small but sumptuous private chapel of Charles IV, called **St. Catherine's Chapel** (Kaple sv. Kateřiny), believed

to have held the reliquary of Christ's Passion (today held in the treasury of St. Vitus Cathedral). What it lacked in size, it made up for in opulence: the walls are covered in gilded stucco and polished stones, and the groin-vaulting has golden stars and crosses on a sky-blue background with bejeweled bosses. Lancet windows illuminate murals of the saint: on the south wall in a recessed arch is an image of the enthroned Virgin and Child being worshipped by the kneeling figures of Charles IV and his third wife, Anne of Svidnik. To the sides of the recess are images of St. Peter and St. Paul, and below is the Crucifixion. The niche was most likely used to display important reliquaries. On the north wall above the entrance, is an image of the Exultation of the Cross, referring to an ancient legend in which the Empress Helen, wife of Roman Emperor Constantine, discovered Christ's cross. Here Charles and Anne, holding aloft a golden cross, replace Helen and Constantine.

This small chapel gives but a foretaste of the splendor to come in the Great Tower, which holds the dazzling **Chapel of the Holy Cross**. A covered wooden gallery connects the Marian Tower to the Great Tower and was once the only way into the Great Tower. The chapel occupies one entire floor of the tower and is reached via a winding stairwell covered in frescoes (c. 1365) of the life of St. Wenceslas and St. Ludmila, patron saints of Bohemia, and Charles IV's ancestors. Badly over-painted and damaged in the 19th century, they have been recently restored and, even in their fragmented state, show the first-rate Italianate style of the anonymous painter.

The Chapel of the Holy Cross, consecrated in 1365, was designed as the holiest of holies, the climax of the Karlštejn pilgrimage. Its golden vaulted ceiling sparkles with Venetian glass stars while the walls are encrusted with nearly 2,200 semi-precious stones and 130 colorfully painted wooden reliquary panels. Originally it had a green and brown glazed tile floor and was illuminated by opaque, colored windows and innumerable candles. An awed medieval visitor once gushed that it had "no equal in the world."

Every element has a symbolic theological meaning. For instance, the gilded grate that divides the space symbolizes the gates of Jerusalem. The panels represent saints, martyrs, prophets, popes, and rulers, such as Charles IV's favorite figure, Charlemagne; they were probably considered guards of the holy relics kept within. The painted panels were themselves also reliquaries, with a relic of the depicted saint kept behind the panel or in their frames.

It was Master Theodoric, one of Bohemia's greatest medieval painters (for more on Theodoric, see Trail 1, Convent of St. Agnes), who most likely designed the chapel's artistic program, according to the wishes of his patron, Charles IV. Theodoric and his workshop would have created sketches of the overall plan, but the 130 panels would have been painted in conjunction with three or four other master workshops. Theodoric's workshop painted about 30 panels and of these, there is ongoing debate as to which were painted by Theodoric himself. The *Crucifixion* and the *Suffering Christ* (both above the altar), *St. Andrew* (in blue with an X-shaped cross to the right of the altar), *St. Luke* (bearded and in blue with an angelic cow whispering in his ear) and *St. Elisabeth of Thuringia* (in blue with a white wimple, feeding a tiny poor figure) are a few of those generally agreed to be by his hand (others can be seen in St. Agnes Convent in the Old Town).

For such a remarkable artist, little is known about Theodoric's life or training. He is first recorded in Charles IV's service in 1359 when he is referred to "malerius imperatoris," or the imperial painter. He had a house in Hradčany (where the Schwarzenberg Palace stands today) and in the 1360s was the head of the Prague painter's guild. His work at the Chapel of the Holy Cross dates from c. 1360–1365 and reflects his characteristic style: a synthesis of Franco-Flemish descriptiveness and northern Italian color, expressed in softly molded forms; this style was clearly copied by all those working in the chapel.

KUTNÁ HORA

Location: 45 miles/72 km east of Prague. There are frequent buses from ÚAN Florenc bus station on weekdays, but only infrequent service on weekends. The trip takes about one hour and fifteen minutes. There are also several daily trains from Hlavní nádraží (main train station); a direct train can take about an hour but others can take up to two. Check departure times and trip lengths for both bus and train at www. cd.cz/static/eng. Note that the Kutná Hora train station is near the out-lying town of Sedlec, about 1.8 miles/3 km out of Kutná Hora's center, although local buses (nos. 1, 6) provide a convenient shuttle service.
Contact information: Tel: (+420) 327 512 378, fax (+420) 327 512 378. Tourist Office (Infocentrum) www.infocentrum.kh.cz
Address: Palackého náměstí 377, Kutná Hora

After Prague, Kutná Hora was the largest and richest town in medieval Bohemia, thanks to its vast silver mines, which enabled the town to develop into a showpiece of medieval architecture and urban planning. But as with all gold (or silver) rushes, Kutná Hora's ended, and for centuries it languished as an unimportant regional town, much to the benefit of its heritage buildings, which have eluded most modern developments. This has left intact the essence of the medieval town, which includes structures by the likes of Benedict Ried and baroque-Gothic wunderkind Jan Santini-Aichel. Today Kutná Hora (population 20,000) is an UNESCO World Heritage Site and a wonderful, architecture-filled day trip from Prague.

Prospectors from all over central Europe first rushed to Kutná Hora when silver was discovered in 1275. Ramshackle settlements sprung up between the pits but within decades a privileged royal town developed. Medieval law stated that all land in a kingdom below one foot of earth was legally considered the king's property; so four-fifths of the mine's profits went directly to Bohemia's king, who soon ranked among the richest monarchs in Europe. Wenceslas II invited Florentine minters to found a royal mint here where they produced the Prague *groš* (like the English groat) in the building known as the Vlašský dvůr (Italian Court). As a

royal town, Kutná Hora grew rich and enjoyed the favor of the king, becoming the preferred residence of Wenceslas IV.

This status, however, was not beneficial during the Hussite Wars and the town was sacked in 1421. It revived in the late 15th century but by the mid-16th century its silver deposits were exhausted. As the Thirty Years' War swept across Bohemia, Kutná Hora's population diminished, leaving many of its houses empty. It wasn't until the 19th century and the rise of historicism that picturesquely crumbling Kutná Hora attracted the interest of Czech nationalists, who carried out some drastic neo-Gothic "restorations" in the 1880s and 1890s. These included the destruction of some "undesirable" baroque additions. In the 20th century, particularly during the Communist years, industrialized suburbs grew around the historic center, which survived years of neglect and cheap repair jobs. Today the picturesque historic core is being restored and tourism is becoming a major industry for the town.

The historic center comprises winding streets first laid out in the Middle Ages. It sits above a river valley that once held silver mines, but is today a verdant park. Towering over it all is one of the most remarkable pieces of medieval architecture in Bohemia and all of central Europe, the Church of St. Barbara, whose silhouette suggests a lavish silver jewel-box.

Church of St. Barbara (Chrám sv. Barbory)

Location: Southwest end of the town at the south end of Barborská Street
Opening hours: Tues to Sun (closed Mondays) year-round. November to March 9 AM–11:30 AM, 2 PM–3:30 PM; April and October 9 AM–11:30 AM, 1 PM–4 PM; May to September 9 AM–5:30 PM.

Dedicated to the patron saint of miners, St. Barbara's was set high on a hill above the River Vrchlice and the medieval silver mine that funded its creation. The burghers of Kutná Hora commissioned the church around 1388, placing it just outside of the town limits and out of the jurisdiction of the Sedlec monastery, the local ecclesiastical authority that controlled all churches and chapels in Kutná Hora and had often come into dispute with the local population.

St. Barbara's would not only outshine Sedlec, but was to be second in grandeur only to Prague Cathedral, embodying the town's wealth and privileged ties to the monarchy.

Reflecting this status, St. Barbara's was planned by royal architect Peter Parler's son, Jan, and work was carried out by members of the Prague Cathedral workshop. The design—five aisles, a chevet of eight chapels and a nave of fourteen bays with low double aisles—was inspired by French architecture and by Peter Parler's church in nearby Kolín. When work was stopped by the Hussite Wars in 1421, only eight apse chapels and part of the aisles had been vaulted. Work restarted in 1481 under Master Hanuš of Růže, who had worked at Prague Castle. He began the aisles and the raising of the choir walls. Around 1490, another royal architect, Mathias Rejsek, arrived and completed the choir vaulting. In 1512, the great Benedict Ried was contracted by the town to finish the nave. Ried altered the original massive plan (perhaps because of funding issues) to create a three-aisle hall church, expanding the aisle into galleries. Although reduced in size, the plans were no less majestic. Ried crowned the church with a sweeping tripartite roof resembling an exotic sultan's tent, and added flying buttresses and finales around the exterior to support the large tracery windows in a similar fashion to Prague cathedral. The vaulting was completed in 1547, but only ten years later the cathedral was abandoned as the silver mines dried up. In a final echo of Prague Cathedral, St. Barbara's west end was closed by a provisional wall that would stand for centuries.

After the Battle of White Mountain (1620), the Jesuits built a seminary before St. Barbara's, which they made their collegiate church. They carried out baroque renovations, including replacing Ried's wonderful triple-spire roof by a more fashionable hipped roof. Most of these changes were eliminated in the 19th century by that prolific neo-Gothic restorer, Josef Mocker, who was named "master builder" of the cathedral in 1883. Mocker rebuilt Ried's magnificent roof, added a western bay, and completed the west façade in a pure, but uninspired, neo-Gothic manner. Work finally ended in 1905.

St. Barbara's exterior is dominated by the fantastic roof and the forest of pinnacles that envelope it. Inside, visitors' eyes are also drawn upward to the amazing vaulting, which is both technically and symbolically complex, particularly Ried's virtuoso vaulting in the nave. Articulated freestanding pillars, like tree trunks, sprout a myriad of branch-like ribs, which carve out and intersect to form elliptical shapes, creating six–petal flowers along the length of the nave. The vault ribs unconventionally emerge and disappear into the shafts of the pillars at unusual, almost organic, angles. The effect is light and airy, with the ribs soaring upward and creating a natural ceiling, like forest treetops, that floats rather than responds to gravity. Its intricacy recalls Ried's Vladislav's Hall in Prague Castle, as does its political and social symbolism. Coats of arms dot the ceiling like constellations in a celestial sky, with the royal crest at the center, like a sun, around which the rest of the world (represented by the arms of local guilds and families) revolves. The whole effect is like an architectural reflection of an ideal political universe or microcosmos.

In the choir, Rejsek's comparatively simpler vaults are also composed of elaborate star patterns embellished by coats of arms, with the king's at the center. With its high narrow arches and tripartite elevation, the choir echoes Matthew of Arras and Peter Parler's French-inspired choir at Prague's St. Vitus. Eight chapels encircle the choir, most with stained glass dating from 1898–1923. Following north to south, the first chapel has a statue of the Virgin and Child dating from 1380 that was repainted c. 1700 to fit in with its baroque décor. The sixth chapel has a 15th-century fresco of a huge St. Christopher carrying the child Jesus across a body of water filled with large Bohemian carp. The seventh is the Smíšek Chapel, dating from c. 1490, which was donated by the wealthy mine owner, Jan Smíšek. He is buried in the chapel and is depicted worshiping with his family beneath the window. The chapel is covered with frescoes by an anonymous painter who must have had knowledge of contemporary northern Italian painting, judging from his use of perspective. Other scenes include the *Crucifixion*, *Trajan's Justice*, the *Arrival*

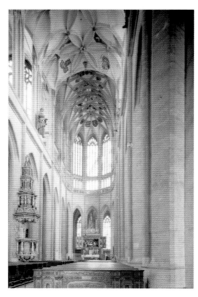

Interior view of the nave of the Church of St. Barbara, Kutná Hora (Bildarchiv Steffens)

of the Queen of Sheba before Solomon and *Augustus with the Tiburtine Sibyl.* The eighth chapel is the Miner's Chapel. Further references to the town's silver mining past are found on the south aisle's west wall where the Minter's Chapel once stood; c. 1463 frescoes of minters and coin makers at work, watched over by angels, are still visible.

Leaving the church, walk along Barborská Street, enjoying the views over the valley and town. The right side of the street is lined with baroque statuary that face the elongated **Jesuit College** on the opposite side; it was designed by Giovanni Domenico Orsi and built by numerous architects, including K.I. Dientzenhofer, from 1667–1750. At present it is closed for renovations and due to reopen in 2007 as the **Kutná Hora Arts Center**, an extension of Prague's Czech Museum of Fine Arts (see page 63). It will be both a modern and contemporary art exhibition space and a multipurpose cultural and education center.

At Barborská 28 is the **Little Castle** (Hrádek), which dates from 1485–1505 and is distinguished by a lovely oriel window held aloft by a twisted pillar and original molded window and door frames. It stands on the site of the oldest building in Kutná Hora and along the line of the early medieval fortifications. In the 15th century, it was rebuilt as the residence of Jan Smíšek, the administrator of the mines, and today is the **Museum of Silver and Medieval Mining**, whose interior still holds some original detail. (In April and October, it is open from 9 AM to 5 PM; May, June, & September, 9 AM to 6 PM; July & August, 10 AM to 6 PM). Just past the Hrádek, turn to the right along the tiny, cobblestone street of Ruthhardská to the **Church of St. James** (Sv. Jakuba). Don't forget to look back for picture-postcard views of St. Barbara.

The hulking St. James (open for services) is comparatively simple in relation to St. Barbara's: a three-aisle hall church with plain stone walls and a single soaring tower. It was originally known as the parish church of St. Mary's (it became St. James in the 16th century) and was one of the first stone churches built in Kutná Hora in 1330s. Close to the royal mint in the Italian Court (Vlášský dvůr), the church's construction was funded by the town and the minters. Work was first carried out by the Sedlec monastery workshop and from the 1380s by another workshop familiar with the contemporary work at Prague Cathedral and Peter Parler's church at Kolín. Work halted during the Hussite Wars and the interior was redecorated in the baroque era.

To the south side of St. James' is the 16th-century **Archdeaconry**. A charming, slightly crooked building as yet untouched by restorers, it has a magnificent Renaissance doorway replete with mining crests and symbols and delicate baroque detailing around its windows and gables. Next door is the imposing and extensively restored **Italian Court** (Vlášský dvůr). First built around 1300 for the Florentine minters invited to Kutná Hora by Wenceslas II, it was remodeled around 1400 as the residence of Wenceslas IV, using the best architects from Prague. Unfortunately, it was badly overhauled in the 19th century and recently was given

a thorough scrubbing by 21st-century restorers, and it now
has the air of a modern bureaucratic building (it is the Town
Hall), belying its romantic name. (It is open for guided visits:
March and October 10 AM to 5 PM; April to September 9 AM
to 6 PM; November to February 10 AM to 4 PM.) Wander into
the Italian Court's pretty back gardens for a spectacular view
over Kutná Hora.

The rest of the town holds many historic buildings. The
tourist office is found in the **Sankturinovský dům** (House)
at Palackého náměstí 377, a grand town palace built by a
prosperous goldsmith, Beneš of Trníčí, in the 1590s. Šultysova
Street has some great old houses such as no. 16, which has
the remains of Gothic arcades with carved capitals, though
it quite incongruously houses a cut-rate leather goods store.
The townhouse known as the **Stone House** (Kamenný dům),
at Václavské náměstí 183 dates from 1485–1495 but was
"re-Gothicized" from 1899–1902 and is today the Regional
Museum. Rejskovo náměstí is named for the architect Mathias
Rejsek, who worked on St. Barbara's and also designed the
twelve-sided sandstone fountain (Kamenná kašna), c. 1495,
which sits in its center. Its remarkable state is owing to 19th-
century renovations that replaced the tracery decoration.
At 288 Jiřího z Poděbrad Street is the **Ursuline Convent**
(Klášter Voršilek), built in 1733–1743 by K.I. Dientzenhofer.
Friedrich Ohmann built the small adjoining church in a neo-
baroque style in 1895–1902.

As with many Czech towns, Kutná Hora's historic core is
intact, but 20th-century suburbs, often with gray communist
housing estates, have developed. This, paradoxically, is where
you will find the **Monastery of Sedlec** (on Vitězná Street),
which was the first Cistercian monastery in Bohemia founded
in 1142. Medieval Cistercian abbeys were generally built in
remote, rural areas where the monks could draw inspiration
from their peaceful surroundings. Now, this once solitary
complex is part of Kutná Hora's urban outskirts and the abbey
buildings are, of all things, a Phillip Morris tobacco factory.
But don't let the uninspiring surroundings deter you from a
stop at its fascinating **Church of the Assumption** (Chrám

Nanebevzetí Panny Marie), very conveniently located on the bus route between central Kutná Hora and the main train station.

Though first founded in 1142, it was under Abbot Heidenreich, a important figure with close ties to the monarchy, and after the discovery of silver on monastic lands, that the monastery church was built between 1282 and 1320 by an unknown builder. The style emulated French Cistercian architecture, which prized simple forms and harmonious proportions with a layout of five-aisles, transept, choir, ambulatory and radiation chapels, all made of ashlar stone. The style strongly influenced contemporary architecture, including St. Barbara's, which was built to rival the grand Sedlec abbey church. The abbey, with its royal connections, was a powerful presence in Kutná Hora until the Hussites era, when it was sacked in 1421. It was not until about 1700 that its church was rebuilt.

Architect Paul Ignaz Bayer began the job, but in 1703 he was succeeded by the most significant figure in 18th-century Bohemian architecture, Jan Santini-Aichel. Born in 1677 in Prague to a family of Italian descent, Santini-Aichel travelled and trained in both painting and architecture in Austria and Italy, returning to Prague around 1700, where his first commission was to remodel the Cistercian abbey in Zbraslav (see Southern Prague, Trail 6). An erudite and technically gifted architect, he drew on both the architectural currents he had learned abroad, such as the Italian baroque style of Guarini and Borromini, but also on the Bohemian architecture he had grown up around, particularly the Gothic works of Peter Parler and Benedict Ried. In his ecclesiastical work he developed a distinctive "baroque-Gothic" style, which reflected his own idiosyncratic sensibilities and the desire of his patrons—who were leaders of the Counter Reformatory church—to stress the continuity and glory of the religious past in Bohemia.

As a former powerful Catholic center sacked by the Hussites, Sedlec was a perfect candidate for this baroque-Gothic treatment. The two styles mingle throughout: for example, on the façade the portal has both baroque undulations

and Gothic pointed arches, and the topping gable features baroque scallop curves and medieval pinnacles. In an almost postmodern reference, non-structural flying buttresses link the nave and aisle, but as symbolic allusions to a Gothic past, rather than architectural supports. Inside (which at the time of writing was closed for restoration) is a soaring, narrow space topped with dynamic rib vaulting that is reminiscent of the swoop and drama of the Italian baroque, but also of the audaciously sculpted spaces of medieval Bohemian architecture, such as Ried's vaults in St. Barbara's. With his architectural mélange, Santini-Aichel articulates multilayers of symbolism that reflect the concerns of the baroque church and the crosscurrent of styles in early 18th-century Bohemia.

Nearby is the small c. 1350 **Chapel of All Saints** that was also reworked by Santini-Aichel around 1703. He added baroque elements such as a gable and spires. The surrounding cemetery was popular for generations, supposedly because it was sprinkled with dirt from the Holy Land by Abbot Heidenreich in the 12th century. The chapel now contains an Ossuary (Kostnice), bizarrely decorated with the bones of some 40,000 burials. A monk in the 16th century first attempted to arrange the bones in a decorative manner, but the present interior, complete with a creepy skeletal chandelier, was the 19th-century commission of the Schwarzenberg family, whose bony crest is also featured. (Opening hours are: November to March 9 AM–12 PM, 1 PM–4 PM; April to September 8 AM–6 PM; October 9 AM–12 PM, 1 PM–5 PM.)

These are by no means the only sites of art and architectural interest outside of Prague. The Czech Republic is filled with historic towns, such as the lovely Český Krumlov, castles like Konopiště or Křivoklát, and unique churches such as Santini-Aichel's work in Žd'áz nad Sázavou. Enjoy!

Czech Artists, Architects and Art Movements

This appendix lists individuals and groups involved in the art world in Prague.

Art Informel: An art style that emerged in the repressive atmosphere of the late 1950s and early 1960s, characterized by lyrical abstraction with powerfully existential tones. Part of the underground "unofficial" art scene (as opposed to "official" art, sanctioned by the communist state), it was initially shown at unofficial studio exhibitions.

Bílek, František (1878–1942): Highly individual Czech symbolist influenced by art nouveau and expressionism, Bílek had a strong interest in mysticism. He worked mostly in sculpture, ceramics, and graphic arts, and designed his own art nouveau villa. His images are often ecstatic and visionary, trying to capture a metaphysical depth.

Boudník, Vladamír (1924–1968): A key figure in the development of post-war abstract art and Art Informel. He was known for his theory of "Explosionism"—the concept that everyone has innate creativity that should be expressed in daily life. His mediums include what we would now call performance art (before the term was coined), graphic techniques, and photographic work.

Braun, Mathias Bernard (1684–1731): One of the great sculptors of baroque Bohemia, this native of Tyrol trained in Italy and worked in Prague from 1710, where he was known for his near painterly, emotional style, which he executed with technical virtuosity.

Brokoff, Ferdinand Maxmilián (1688–1731): One of the best sculptors in baroque Bohemia, known for his monumental realism. From a family of sculptors, his father **Jan** (1652–1718) was a German-speaking Lutheran who converted to Catholicism in 1682 in order to work for Catholic clients.

Czech cubism (active 1910–1914): An avant-garde group inspired by Picasso and Braque's cubist paintings, expanding into decorative arts and, totally unique to Bohemia, into architecture. The cubists believed that an object's internal energy could only be released by breaking up the vertical and horizontal surfaces; this Cubism is characterized by sharp points, slicing planes, and crystalline shapes. Proponents include painters Emil Filla, Bohumil Kubišta, Josef Čapek, Antonín Procházka, Václav Špála, and

Otakar Kubin, sculptor Otto Gutfreund, and architects Josef Gočár, Pavel Jának, Josef Chochol, and Vratislav Hoffmann.

Czech surrealism: The highly influential Czech branch of the Surrealist movement begun by André Breton in Paris in 1924. Surrealism was influenced by Freud and dedicated to the expression of imagination as revealed in dreams, free of the conscious control of reason and free of convention. Key figures include Toyen (Marie Čermínová, 1902–80), Jindřich Štýrský (1899–1942), Josef Šíma (1881–1971), and Karel Teige.

Devětsil: An avant-garde Prague artists group, informally led by Karel Teige, founded October 5, 1920. The group rejected the concept of "high art" and explored a variety of progressive "isms": poetism, constructivism, naivism, dadaism, and more. The obscure name has two meanings in Czech: a hardy plant and "nine forces," from *devět + sil*.

Dientzenhofer, Christoph (1655–1722) and **Kilian Ignaz** (1689–1751): Father-and-son architects of the high baroque who came to Prague from Bavaria sometime in the 1670s. Influenced by Borromini and Guarini, they created dramatic, undulating structures such as St. Nicholas in Malá Strana. Prolific K.I. is considered the more brilliant and innovative.

Fluxus: An international art movement in the 1960s and 1970s that blended various artistic disciplines—visual arts, poetry, experimental music, performance—as part of staged "action" events, often involving pranks or gags with some type of metaphysical or political overtones.

Group (Skupina) 42: A group of artists formed in Prague in 1942 that explored surrealism and existentialism. Members included painters Kamil Lhoták, František Hudeček, and art theoretician and critic Jindřich Chalupecký.

Group of Plastic Arts: see **Osma**.

Kolář, Jiří: (1914–2002): Avant-garde poet and artist known for his inventive collages made from books, newspapers, maps, and art reproductions, using various techniques such as "rollage" (combining long strips of two works of art into one) or "chiasmage" (randomly arranged torn fragments of text in a larger pattern); all designed to disintegrate, and then create, new meaning. A founding member of **Group (Skupina) 42**, he was briefly imprisoned in 1953 for "subversive" writings. From 1979–1998 he lived in France.

Kramář, Vincenc: Respected Czech art historian, critic, avid collector, and former director of the National Gallery, which now holds most of his collection. An early collector of French cubism, his paintings by Picasso and Braque greatly influenced the Czech cubist movement.

Kupka, František (1871–1957): Ground-breaking Czech painter, graphic artist, and illustrator who was a leading figure of the avant-garde and a pioneer of abstract art. Based in France for most of his career, Kupka's style evolved from symbolism and lyrical abstraction to geometric abstraction, all the while developing his belief that color and line were all that were needed for expression.

Mánes Society of Artists: An association of artists founded in 1887 to evaluate and discuss the latest developments in European art. They published a magazine, *Volne smery*, and organized exhibitions. The group

was named after Josef Manes (1820–1871), a founder of Czech national painting style of the new era.

Master Theodoric (active 1350–1360s): Most original figure of Bohemian medieval painting and court painter of Charles IV, he was famed for the softly molded expressive figures in Karlštejn's Chapel of the Holy Cross and in St. Wenceslas' Chapel in St. Vitus.

Mathey, Jean-Baptiste (c. 1630–c. 1695): Born in Burgundy, this early baroque architect originally trained as a painter and spent twenty years in Rome before arriving in Prague in 1675 at the invitation of Archbishop Wallenstein. He employed his classically Roman, French-influenced style in numerous commissions, such as Troja and the Archbishop's Palace in Hradčany.

Matthew of Arras (d. 1352): French architect working in the high-Gothic style of Île-de-France. He worked in Avignon for Pope Clement VI before he was invited by Charles IV to Prague to begin St. Vitus Cathedral.

Mocker, Josef (1835–1899): An architect and civil engineer who rebuilt and restored most of Bohemia's medieval monuments, such as St. Vitus, the Powder Tower, and Karlštejn; a Bohemian Viollet-le-Duc.

Mucha, Alfons (1860–1939): Czech graphic artist, illustrator, and painter who was the leading figure of the belle époque. He was famed for his art nouveau images, first shooting to fame for his Sarah Bernhardt posters in 1890s Paris.

National Theater Generation: The generation of artists and architects associated with the building of the National Theater (1868–1883) including architects Josef Zítek (1832–1909) and Josef Schulz (1840–1917); painters Josef Mánes (1820–1871), Václav Brožík (1851–1901), and Mikoláš Aleš (1852–1913); and sculptor Josef Václav Myslbek (1848–1922).

Osma: The first Bohemian modernist art group (meaning "the Eight") founded in 1907 and influenced by the expressionism and primitivism of Edvard Munch. Many members, including B. Kubišta amd E. Filla, would go on to form the **Group of Plastic Arts** in 1911, which was devoted to Czech cubism.

Parler, Peter (1330–1399): One of the most brilliant architects of his time, he was from a family of Cologne master masons and was invited to Prague by Charles IV where he helped restructure the city, working on projects such as St. Vitus and Charles Bridge.

Plečnik, Josip (1872–1957): Slovenian architect who studied with Otto Wagner in Vienna. He rejected modernist/functionalist trends and instead took inspiration from historical styles, particularly classical antiquity. Today he is considered a precursor to postmodernism. A good friend of T.G. Masaryk, he renovated Prague Castle in the 1920s and designed the idiosyncratic Church of the Sacred Heart (1929–1933) in Vinohrady.

Ried, Benedict (c. 1454–1534): A southern German architect whose style mixes an adventurous late-Gothic style with Renaissance elements. He was invited to Prague by Vladislav II; his works include Vladislav's Hall in Prague Castle and St. Barbara's in Kutná Hora.

Šaloun, Ladislav (1870–1946): Outstanding Czech Secession/symbolist sculptor whose work is marked by a loose painterly style that rejected the tectonic principals of the earlier generation of sculptors led by

J.V. Myslbek. His Hus Monument in Old Town Square is one of most important pieces of the era.

Santini-Aichel, Jan Balzej (1677–1723): A highly original Prague-born baroque architect, grandson of a mason from Como. He developed a unique baroque-Gothic style when commissioned to renovate Bohemia's monasteries. Highly prolific, he designed numerous churches throughout Bohemia (Zbraslav, Sedlec), as well as Prague palaces.

Škréta, Karel (1610–74): One of Prague's most important early baroque painters. From a Protestant family who fled in 1618, he studied in Rome, Bologna, and Venice, converted to Catholicism, and returned to Prague in 1638, where he became known for his altarpieces and portraits.

Skupina 42: See **Group 42**.

Slavíček, Antonín (1870–1910): Czech painter influenced by Impressionism. He created evocative paintings of Prague and the Bohemian countryside in which he sought to record his personal observations of nature.

Spranger, Bartolomeus (1546–1611): Summoned to Prague in 1580, this Antwerp-born artist became Rudolf II's chief painter with studios in Prague Castle and Malá Strana. For the court he produced primarily allegorical and mythological paintings in a sophisticated, and often erotic, mannerist style; his religious subjects also have a great sensuality.

Sudek, Josef (1896–1976): One-armed Czech photographer influenced by symbolism and surrealism and noted for his enigmatic pictures, which are characterized by his use of blurred images and by a unique play of light and shadow. Like Eugene Atget, his counterpart in France, he explored the essence of his environment, but his images are introspective, exploring the soul.

Švabinský, Max (1873–1962): A Czech symbolist painter and graphic artist who founded the School of Graphic arts at Prague Academy, where he taught from 1910–1927. He was noted for his lyrical, intimate images with a strong sense of naturalism and psychological insight.

Teige, Karel (1900–1951): A leading figure of the avant-garde in the 1920s and 30s and co-founder of the group Devěstil. A poet, theorist, and artist, he edited the most influential avant-garde journals, wrote theory and criticism of art and architecture, as well as producing paintings, collages, and graphic arts.

Mythology, History and Religion

This appendix lists events, individuals and groups, whether historic, mythological, or religious, who are often depicted in or associated with Czech art and architecture.

Battle of White Mountain (Bílá Hora): A decisive battle between the Catholic imperial army and the Czech Protestant forces on the western edge of Prague on November 8, 1620. The Protestants lost, marking the decline of the power of Czech nobles, the imposition of Catholicism throughout Bohemia, and the start of the Thirty Years' War.

Czech Estates: Czech noble families

Czech National Revival: The revival of Czech language and cultural in the 19th century after centuries of control by the Habsburg Empire (whose lingua franca was German).

Hus, Jan (1373–1415): Reformist preacher burned as a heretic at Constance in 1415. He began the Hussite movement of Czech Protestants. For more, see page 7.

Jesuits, or Society of Jesus: Founded by Ignatius of Loyola in 1540, the society was centered in Rome and focused on missionary work in "pagan" countries, educating the young and combating Protestantism.

Libuše or Libussa: Mythical founder of Prague. She inherited the kingdom of her father, Čech, but her people did not want to be ruled by a woman. So she married a plowman, Přemysl, and together they founded a city on the spot where a stone "threshold" (*prah* in Czech) was placed (today Vyšehrad), which Libuše prophesied would be "a great city whose fame would reach the stars."

Prague Spring: A brief period in the mid-1960s of increased democratization in politics and society and a flowering in the arts. It ended with the invasion by Soviet forces in August 1968 and was followed by decades of oppression.

Rabbi Löw (1529–1609): A great Jewish scholar and leader who sought to reconcile Renaissance ideas with Jewish tradition. Rudolf II supposedly called him to Prague Castle to discuss their mutual interests in the cabbala, alchemy, and the supernatural. Legends grew of Rabbi Löw's

magical powers, until by the 19th century stories appear of his creation of a golem (a clay figure brought to life by magic) in literature and film into the 20th century.

St. Adalbert (Sv. Vojtěch): Tenth-century bishop of Prague, patron saint of Bohemia, and founder of Břevnov Monastery in western Prague. He died trying to convert "heathen" Prussians.

St. Agnes (Sv. Anežka) (1211–1292): Daughter of Otakar, she refused marriage and followed the teachings of St. Francis of Assisi, founding a hospital and convent of the Poor Clares, the female version of the Franciscans. Though still involved in religious and political affairs, she was known for her abstemious life and was venerated in her lifetime, though not canonized until 1989.

St. Charles Borromeo (1538–1584): Archbishop of Milan and a popular Counter Reformation figure who is often pictured in bishop's robes or caring for the sick. His attributes are a skull and crucifix.

St. Cyril and St. Methodius: Byzantine missionaries who spread Christianity among the Slavs in the 9th century and baptized the first members of the Přemyslid family, Prince Bořivoj and his wife, Ludmila (see St. Ludmila).

St. Frances Xavier (1506–1552): Known as "apostle of the Indies," he was an early Jesuit who pioneered missionary work in the Far East. He is widely represented in Counter Reformation art.

St. George (Sv. Jiří): Legendary warrior saint and martyr from Cappadocia who was popular in the Byzantine Church in the early Middle Ages and later became patron saint of Venice and England. He is most often depicted slaying a dragon, a metaphoric representation of Christianity's triumph over paganism. The 13th-century *Golden Legend* added the chivalrous element of a fair maiden whom he saves from the dragon.

St. Giles (Sv. Jiljí) (8th century): A Benedictine hermit who, legend says, protected a wounded deer from the king's huntsmen and is thus often pictured with a wounded animal. He was also the patron of beggars and the handicapped.

St. Ignatius of Loyola (c. 1491–1556): Founder of the Society of Jesus (Jesuits). His symbols include a book, *IHS* (the monogram of the Jesuits) or a heart crowned with thorns. He is widely represented in Counter Reformation art.

St. Jerome (Sv. Jeroným) (342–420): One of the four church fathers depicted either as a penitent with a skull or hourglass, as a scholar or as a cardinal. In paintings he is often accompanied by a lion, from whose paw he pulled a thorn.

St. John of Nepomuk (Sv. Jan Nepomucký) (d. 1393): Patron saint of Bohemia, protector against floods, often found on bridges. He is portrayed as a bearded capitulary holding a large cross and martyr's palm with a halo of five stars. Another symbol is his miraculously preserved tongue, which was found when his body was exhumed in 1719. He was sainted in 1729 under dubious circumstances. For the full story, see pages 110–111.

St. Ludmila (Sv. Ludmila) (c. 860–921): Wife of Přemyslid Bořivoj. Along with her husband, she was converted to Christianity by saints Cyril and Methodius. Legend says she taught Christianity to her grandson, the

future St. Wenceslas, and was murdered by her pagan daughter-in-law's servants, who strangled her with a veil or rope (her saintly symbols).

St. Nicholas (Sv. Mikuláš): Fourth-century bishop and Christian martyr who was tortured and killed by the Emperor Diocletian. Patron saint of children, maidens, sailors, travellers, and others, he is one of the most popular Christian saints, known for his many miracles. He is the prototype for Father Christmas.

St. Procopius (Sv. Prokop) (c. 980–1053): Bohemian monk and hermit who founded a monastery at Sázava and was canonized in 1204. A patron saint of Bohemia, he is usually depicted as a monk or hermit, and is occasionally shown with a devil, who, legend says, he forced to plow a ditch by his monastery.

St. Sigismund: A 6th-century Burgundian king who converted to Christianity and was martyred by being thrown in a well. His relics were brought to St. Vitus by Charles IV in 1354. He is a patron saint of Bohemia.

St. Vitus (Sv. Víta): Patron saint of Prague as well as of dancers and epileptics. From Roman Sicily, Vitus was a young Christian who could work miracles, but his pagan father had him tortured and imprisoned. Temporarily saved when he cured Emperor Diocletian's son of epilepsy, he was later martyred. He is usually portrayed as a young man.

St. Wenceslas (Sv. Václav) (c. 907–935): A patron saint of Bohemia, son of Vratislav I, and grandson of St. Ludmila, who converted him to Christianity. He built a rotunda to St. Vitus on Hradčany. He was murdered by his brother Boleslav, who later repented and moved his brother's body to St. Vitus. Stories of miracles soon led to his and Ludmila's sainthoods.

Velvet Revolution: Begun on November 17, 1989, by student protesters, this peaceful revolution resulted in the downfall of the Communist regime in Czechoslovakia.

Wallenstein (Waldstein or Valdštejn), Albrecht von (1583–1634): An ambitious Bohemian noble whose brilliant military and political career faltered when he attempted to make himself king and was assassinated by the Emperor's henchmen. See pages 116–117 for the complete story.

Important Bohemian Rulers

The Přemyslids (870—1306)

Princes

Bořivoj I c. 852/53–c. 888/889
Václav I (St. Wenceslas) 921–935

Kings

Vladislav II 1140–1172
Přemysl Otkar II 1253–1278

The Luxemburgs (1310—1437)

John of Luxemburg	1310–1346
Václav/Charles IV	1346–1378
Václav IV	1378–1419

The Hussites (1458—1471)

Jiří z Poděbrad (George of Poděbrady)	1458–1471

The Jagiellons (1471—1526)

Vladislav II	1471–1516
Ludvig (Louis)	1516–1526

The Habsburgs (1526—1918)

Ferdinand I of Austria	1526–1564
Maximilian II	1564–1576
Rudolf I	1576–1611
Mathias (Matyáš) I	1611–1619
Frederick of the Palatinate (The Winter King)	1619–1620
Ferdinand II of Austria	1619, 1620–1637
Ferdinand III	1637–1646, 1654–1657
Maria Theresa	1740–1780
Joseph II	1780–1790

Czechoslovak Republic

Presidents

Tomaš Gargue Masaryk	1918–1935
Eduard Beneš	1935–1938, 1945–1948
Klement Gottwald	1948–1953
Václav Havel	1989–1992

Czech Republic

Presidents

Václav Havel	1993–2003
Václav Klaus	2003–

Glossary of Art and Architectural Terms

ambulatory: The aisle around the apse and choir of a church

apse: A semi-circular projection at the east end of a Christian church

Apocrypha: (Greek, "hidden things") Works that in their title, form, and contents resemble books of the Old and New Testaments, but that are not accepted by the Church as true biblical books

arcade: A series of arches supported by piers or columns (the three levels of most church interiors are, from bottom to top: arcade, triforium, clerestory)

archivolt: One of a series of concentric moldings on a Romanesque or Gothic arch

atlas, pl. atlantes: Heroic male figures replacing columns and supporting a heavy entablature

bailey: Castle courtyard and surrounding buildings

boss: An ornamental carving at the intersection of the ribs of a vault

buttress: A stone or brick support built against a wall to support or reinforce it

chancel: The easternmost part of a church in which the altar is kept

chevet: The eastern end of a church including the choir, ambulatory, and radiating chapels

choir: The space reserved for the clergy in a church, usually to the east of the transept

clerestory: The windowed, upper story of a church interior, which allows light into the church (the three levels of most church interiors are, from bottom to top: arcade, triforium, clerestory)

console: A double-scrolled ornamental bracket

corbel: A support projecting from a wall, often carved or molded

finial: An ornament crowing a pinnacle, spire, or roof

flying buttress: A detached pier or arch supporting the weight of a wall

grisaille: Painted decoration in shades of gray that may imitate sculptural figures or bas-relief

jambs: The side post of a door, window, fireplace or other opening.

keystone: The central block of an arch or vault holding the entire structure in place

nave: The central aisle of a church or cathedral

pediment: A low triangular gable above a cornice; a classical style used over doors, windows, or porches

pilaster: A pier or column projecting slightly from the face of the wall, often decorated

sedilia: A series of seats (usually three) on the south side of the chancel

sgraffito: Technique in which part of an upper layer of plaster decoration is scrapped off to expose a contrasting layer beneath, creating a pattern or figure

spandrels: The triangular surface between two adjacent arches

tracery: The ornamental work on a Gothic window or surface

triforium: The middle story in the wall of the nave of a church or cathedral (the three levels of most church interiors are, from bottom to top: arcade, triforium, clerestory)

triptych: Painting or sculpture composed of three hinged panels that can be folded back

tympanum: In medieval architecture, the area beneath an arch, often in a portal and filled with sculpture

volute: A spiral scroll

Index

Aachen, Hans von 20, 140, 142, 161, 195
Abakanowicz, Magdalena 125
Aleš, Mikoláš 27, 58, 63, 130, 200, 206,
 209, 217, 225, 234, 283
Alliprandi, G.B. 41, 115, 133, 172
Aostalli, Ulrico 148, 244, 267
Archbishop's Palace 172, 283
Arcimboldo, Giuseppe 20, 140
art styles
 Absolutist 21
 abstraction 30–32, 48, 63, 127–129,
 235–236, 239, 240–241, 282
 abstract expressionism 127, 128
 art deco 139, 201, 231
 Art Informel 32, 63, 238, 240, 281
 art nouveau 1, 16, 26, 46, 47, 55,
 77, 80, 82, 127, 198, 199–204,
 207–213, 215, 226, 230–233,
 235, 241, 283
 avant-garde 12, 28–29, 30–31, 39–40,
 125–129, 141, 199, 215, 225, 240,
 265, 281–282, 284
 baroque 21–24, 160–167, 264
 Bauhaus 30
 Beautiful 95–96
 Byzantine 4, 17, 87, 109, 174, 194,
 203, 241
 Civilism 236.
 constructivism 30, 282
 dadaism 30, 282
 futurism 30
 geometric abstraction 30, 63, 282
 Gothic 1, 2, 14–29, 37–38, 41–42,
 44–45, 56, 58, 59–60, 64, 70, 73,
 75, 77–79, 83, 86–87, 89, 95,
 97, 100, 102–103, 106, 108, 120,
 135–136, 147, 152, 154, 156–
 158, 177, 187, 192–194, 210,
 212–213, 220–221, 224–225,
 227, 244, 250, 254, 268, 272–274,
 278–280, 283–284, 289–290
 International Gothic 95, 97
 mannerism 17, 20, 117, 138,
 160–161, 175, 192, 195–196

 modernism 17, 27–28, 31, 63, 283
 National. See rondocubist.
 neo-classicism 25
 neo-Gothic 25, 37, 56, 106, 148, 150,
 158, 225, 244, 250, 273–274
 neo-Renaissance 25–26, 58, 59, 63, 80,
 83, 199, 200, 216
 objective realism 29, 212
 poetism 30, 50, 282
 primitivism 28, 46, 283
 Romanesque 17–18, 212
 Romanticism 25, 26–27, 77
 rondocubist 29, 211–212, 214
 Secession (art nouveau) 17, 26, 28, 54,
 200–201, 241–242, 208–210, 283
 socialist realism 31–32, 77, 238, 240
 Sondergotik 18
 surrealism 30–31, 238–241, 282
 symbolism 27–28, 30, 46–47, 55, 127,
 206, 234, 236, 282
Astronomical Clock 23, 59
Austria 10, 177, 241, 252, 260–261, 279,
 288
Austro-Hungarian Empire 11–12

Balšánek, Antonín 26, 208
Bank of the Czechoslovak Legions 212
Barvitius, Viktor 26, 234
Bassano, Jacopo da Ponte 178
Baťa store 31, 213
Battle of White Mountain 8, 17, 21, 23,
 53, 60, 66, 72, 117, 130, 152, 160, 245,
 255, 274, 285
Bayer, Pavel Ignác 75, 279
Belvedere. See Royal Summer Palace.
Bendelmayer, Bedřich 38, 200
Bendl, Johann Georg 23, 67
Beneš, Edvard 11–12
Bílek, František 28, 46–47, 151, 170, 234,
 249
 Bílek Villa 28, 170
Bohemia 1–29
Bohemian Estates 7, 8
Boleslav 4, 155, 253, 287
Boleslav II 159, 224

Borromeo, Charles 65, 164–165, 286
Bosch, Gerard ter 184
Boudník, Vladimír 32, 49–50, 241
Brahe, Tycho 56, 170
Brandl, Petr Jan 43, 130
Braque, Georges 28, 39, 49
Braun, Mathias Bernard 23, 60, 64, 67,
 109, 111, 112, 130–131, 160, 165,
 221, 281
Břevnov Monastery 253, 260, 286
Brokoff, Ferdinand Maxmilián 23, 43, 75,
 109–112, 119, 121, 131, 160, 164, 188,
 215, 244
Brožík, Václav 27, 60, 119, 217, 244,
 297–298, 283
Bruegel, Pieter the Elder 180, 262–263
Bruegel I, Jan 181, 262
Bruegel II, Pieter 180

Café Imperial, 211
Canaletto (Giovanni Antonio Canale)
 257, 261–262
Čapek, Josef 28, 39–40, 60, 236, 280
Caratti, Francesco 22, 67, 121, 129, 159,
 191
Central Train Station 213
Čermák, Jaroslav 27, 234, 246–247
Čermínová, Marie. See Toyen.
Černín Palace 13, 22, 191
Černý, David 33, 73, 135, 200, 251
Cézanne, Paul 39, 231, 236, 238
Chagall, Marc 238
Chalupecký, Jindřich 31, 34, 240, 282
Chapel of Mirrors 68
Charles Bridge 6, 14, 15, 23, 36, 63, 67,
 68–70, 106–113, 122, 244
Charles IV 5–6, 14, 18–25, 69, 86, 90,
 105–106, 108, 133, 136, 146–147,
 154, 198, 214, 219–221, 224–225,
 244, 265–266, 268–271
Charter 77 13
Chochol, Josef 28, 39, 226, 282
churches
 Assumption of Our Lady 193
 Chapel of All Saints 280
 Chapel of the Holy Cross (Karlštejn
 Castle) 19, 92, 138, 265–266,
 270–271
 Chapel of St. Roch 192
 Church of the Holy Cross 202
 Evangelical, Czech Brotherhood 74
 Holy Cross 202
 Holy Savior 22, 67, 161
 Italian Chapel 22, 66–67
 Our Lady and Charles the Great 221
 Our Lady Before Týn. See Týn.
 Our Lady Beneath the Chain 120–121

Our Lady of the Snows 201, 214
Our Lady of Unceasing Succor and St.
 Cajetan 131
Our Lady on the Lawn 220
Our Lady Victorious 129–130
Sacred Heart 31, 250, 283
St. Barbara 273–276
St. Castulus 103
St. Clement 66–67
St. Francis 68–69, 84–85, 100
St. Gall (sv. Havla) 75
St. George's Basilica 18, 136, 146,
 157–160
St. Giles 74
St. James 23, 42–44
St. John of Nepomuk 189
St. John the Baptist at the Wash-
 House 129
St. Joseph's 120
St. Lawrence 133, 224
St. Ludmila 250
St. Martin's in the Wall 74–75
St. Nicholas, Little Quarter 22, 105,
 115–115
St. Nicholas, Old Town 53, 61–62
St. Thomas 24, 119–120, 182
St. Vitus Cathedral 14, 18–19, 36, 42,
 50, 52, 82, 101, 103, 107–108,
 136–137, 143, 146–155
Týn 45, 52, 55–58
Civic Forum 13, 200
Clementinum 22, 65–68, 161
Coello, Alonso Sánchez 260
Colin, Alexander 152
Convent of St. Agnes. See museums,
 National Gallery at Convent of St.
 Agnes.
Convent of St. Anne 69–70
Counter Reformation 7–9, 17, 21, 43,
 65–66, 68, 108, 160, 286
Cranach, Lucas the Elder 100–103,
 143–144, 186–187, 194, 264
Czechoslovak Crafts Union 215
Czech Group of Surrealists 30
Czech National Bank 38
Czech National Revival 4, 9–11, 15,
 25–26, 55, 137, 159, 216, 226, 285

Daddi, Bernardo 173
Daliborka Tower 139, 146, 167
Dancing House 218
defenestration 7–8, 13, 116, 156, 247
Degas, Edgar 238
Delacroix, Eugene 234, 238
Derain, Andre 238
Devětsil 30–31, 50, 282
Dientzenhofer, Christoph 22, 67–68,
 113–115, 190, 253–254, 282

Dientzenhofer, Kilian Ignaz 22, 41,
 60–61, 68, 72, 113–114, 119–120,
 189–190, 202, 219, 221, 253–254,
 276, 278, 282
Drtikol, František 31, 265
Dubček, Alexander 13, 200
Dürer, Albrecht 21, 102, 140–141,
 185–186, 187, 188

Edict of Toleration 76–77
El Greco 179
Enlightenment 9, 193
Erlach, Johann Bernard Fischer von 22,
 43, 64, 154

Ferdinand I 7, 66, 79, 152, 169, 249,
 254, 258–259, 288
Ferdinand II 8, 116, 288
Ferdinand III 141, 288
Ferdinand V 137
Ferdinand August, Prince 262, 264
Filla, Emil 28, 39–40, 49, 281, 283
Flegel, Georg 188
France 12, 26, 30, 85, 95, 179, 234, 237,
 260, 282–284
Franz Josef, Emperor 139, 267
Fred and Ginger building 34, 218
Fuchs, Josef 31, 231

gardens
 Castle Gardens 167
 Franciscan Garden 214
 Royal Gardens 163, 168, 230
 South Gardens 155–156, 167–168
Gehry, Frank 34, 198, 218
George of Poděbrady 7, 44, 53, 56, 61, 71,
 98, 210, 250, 288
Gočár, Josef 28–29, 38–41, 82, 201, 207,
 211, 225, 282
Godyn, Abraham and Isaac 24, 246, 248
Gottwald, Klement 13, 53, 73, 251, 288
Governor's Summer Palace 25, 244
Goya, Francisco José y Lucientes 179
Grand Hotel Europa 26, 200
Granovský Palace 44
Group 42 31, 125, 284
Group of Plastic Artists 28, 39
Grund, Norbert 24, 161, 166–167

Habsburgs 1, 3, 7–9, 11, 19, 20–21, 25,
 53, 56, 60, 64, 66, 69, 71, 100, 105,
 110, 114, 138, 140, 152, 155, 170,
 177, 180, 185, 195, 245, 247–249,
 255, 259, 261, 262, 267, 285, 288. See
 also under individual names.
Hals, Frans 183
Havel, Vaclav 13, 75, 81, 137, 200, 218,
 258, 280

Helst, Bartholomeus van der 184
Hitler, Adolf 12, 242, 258
Holbein, Hans the Elder 187–188
Holy Roman Empire 5, 14, 17, 94. See
 also Habsburgs.
Horejc, Jaroslav 47, 249
House of the Black Madonna 29, 38–39,
 207
House of the Lords of Kunštát and
 Poděbrady 17, 70
Hrabal, Bohumil 32, 210
Hradčany 3–5, 8, 14–15, 18, 20, 34, 97,
 136, 137–138, 167, 168, 171, 198,
 208, 217, 224, 230, 250–253, 271,
 283, 287
Hudeček, Antonín 27, 234
Hudeček, František 31, 282
Hussite Wars 7, 17
Hvězda 200, 206, 223, 254
Hynais, Vojtěch 217

Italian Court 272, 277, 278

Jagiellons 7, 36, 98, 101, 137, 156, 221,
 288
Janák, Pavel 28, 40, 191, 201, 214, 254
Jan Hus Monument 28, 54
Jesuit College 65, 276
Jetelová, Magdalena 33, 51, 124–125,
 126, 241
Jewish Ghetto. See Josefov.
Jewish Town Hall 77, 78
Jews 12, 77
John Lennon Wall 121
John of Luxembourg 5, 42, 59, 62, 70, 288
Josefov 7, 15, 76–78
Joseph II 9, 66, 77, 85, 138, 141,
 192–193
Judith Bridge 14, 68, 106, 112

Kafka, Franz 28, 41, 49, 59, 137
Kafka, Ivan 33, 241
Kaiserstein Palace 115
Kaňka, František 67–28, 76, 130, 215,
 227
Karlštejn 6, 19, 26, 81, 92, 257,
 265–270, 283
Kinský family 60, 64, 129
Klee, Paul 241
Kmentová, Eva 32, 50, 62
Kohl, Johann Fredrich 114
Kokoschka, Oskar 31, 241, 242, 243
Kolář, Jiří 32, 51, 125, 126, 233, 241,
 282
Kounic Palace 113
Kratina, Radek 126
Kubišta, Bohumil 28, 39, 40, 236, 281,
 283

Kupecký, Jan 24, 146, 160, 165–166
Kupka, František 29–30, 124, 127–129, 233, 235, 241
Kutná Hora 36, 41, 156, 257, 272–280
Kysela, František 151, 148

Langer (or Pachta) Palace 41
Legiobanka. See Bank of the Czechoslovak Legions.
Leopold I 159, 225, 248, 261
Lesser Town Hall 115
Letná Park 170, 223, 229–230, 240
Lhoták, Kamil 31, 240, 282
Libuše 4, 217, 224, 226, 285
Liška, Jan K. 24, 75
Little Quarter (Malá Strana) 7, 14, 104–133
Lobkowicz, Maximilian 258, 265
Lobkowicz Palace 133, 167, 264
Loos, Adolf 31, 215, 223, 252–253
Lorenzetti, Pietro 174
Löw, Rabbi 65, 79, 285–286
Lucerna Palác 74, 200
Lumír and Píseň 226
Lurago, Anselmo 60, 114, 139, 143
Lurago, Carlo 22, 67, 121, 167, 224
Luther, Martin 6, 100. See also Reformation.

Malá Strana. See Little Quarter.
Malá Strana Bridge Towers 112–113
Mánes, Antonín 26, 233
Mánes, Josef 26, 28, 59, 71, 234, 283
Mánes Society of Artists 28, 217–218, 237, 282
Martin's Rotunda 18
Martinic Palace 189
Masaryk, Jan 13, 191
Masaryk, Tomáš Garrigue 11, 31, 137, 139, 141, 146, 242–243, 283
Masaryk Station 15, 213, 257
Mascharino, Ottaviano 67
Master of the Altarpiece of the Knights of the Cross 99–100
Master of the Litoměřice Altarpiece 101, 155
Master of the Třeboň Altarpiece 19, 95–96
Master of the Votive Panel from St. Lambrecht 97–98
Master of the Vyšší Brod Altarpiece 19
Master of the Well of Life 177
Master Theodoric 19, 92–95, 153, 220, 266, 269, 271, 283
Mathey, Jean-Baptiste 22, 68, 131, 168, 172, 189, 245
Matisse, Henri 238

Matthew of Arras 18, 147, 152, 266, 275, 283
Mathias Gate 22, 137–138
Mathias of Habsburg 8, 137, 142–143, 288
Maulbertsch, Franz Anton 24, 193
Maximilian II 140–141, 152, 195, 288
Miró, Joan 241
Mocker, Josef 26, 37–38, 79, 106, 148, 158, 212, 221, 225, 250, 266–268, 274, 283
Monastery of Sedlec 278
Monet, Claude 238
Monogramist I.P. 102
Moore, Henry 241
Morzin Palace 23, 130–131
Mosto, Ottavio 42, 115
Mucha, Alfons 27, 82, 128, 151, 202–208, 210, 231, 283
Müller Villa 31, 223, 252–253
Munch, Edvard 28–29, 39, 235, 241, 283
Municipal House 10, 11, 26, 36–39, 65, 137, 198, 203, 206–211
Municipal Library 65
Murano, Antonio and Bartholomeo Vivarini da 174–175
museums and galleries
 Czech Museum of Fine Arts 33, 63–64, 276
 Dvořák Museum 221
 Galerie Anderle 251–252
 Galerie Rudolfinum 33, 83, 144
 Gambra, Surrealistická galerie 189
 Goltz-Kinský Palace. See National Gallery at Goltz-Kinský Palace.
 House at the Stone Bell 62
 House of the Golden Ring 44–52
 Jiří Švestka Gallery 33, 212
 Josef Sudek Gallery 131
 Kampa Museum 32, 39, 106, 121–129, 235
 Kutná Hora Arts Center 276
 Lapidarium. See National Gallery, Lapidarium of.
 Leica Gallery 167
 Lobkowicz Collections at Nelahozeves Castle 258–265
 Mánes Gallery 33, 217–8
 Museum of Czech Cubism. See museums, National Gallery.
 Museum of Decorative Arts 52, 80–83, 131
 Museum of Medieval Art 83–103
 Museum of Modern and Contemporary Art. See National Gallery at Trade Fair Palace.
 Museum of Silver and Medieval Mining 277

Museum of the City of Prague 59,
 213–214
Náprstek Museum of Asian, African and
 American Cultures 71
National Gallery 25, 28, 32, 39,
 60–62, 85, 116, 118, 121, 160,
 172, 194, 223, 227, 235, 237–238,
 258, 282
National Gallery at Convent of St.
 Agnes 83–103, 194, 271
National Gallery at Goltz-Kinský
 Palace 60–61
National Gallery, Lapidarium of
 52–53, 155, 243–244
National Gallery at Museum of Czech
 Cubism 38–42, 235
National Gallery at St. George's
 Convent 24, 146, 160–166
National Gallery at Sternberg Palace
 21, 34, 101, 116, 140, 171–188
National Gallery at Trade Fair Palace
 31–33, 39, 46, 173, 201, 223,
 230–243, 247
National Gallery at Wallenstein
 Riding School 118
National Gallery at Zbraslav 223,
 227–229
National Museum 199
Prague Castle Gallery 21, 139–146
Prague City Gallery 33, 44–52, 58,
 61–63, 245–249
St. Agnes Convent. See National Gal-
 lery at Convent of St. Agnes
St. George's Convent. See National
 Gallery at St. George's.
Strahov Gallery 192–196
Trade Fair Palace. See National Gallery
 at Trade Fair Palace.
Václav Špály Gallery 33, 215
Myslbek, Josef Václav 27, 153, 199, 210,
 217–218, 226, 233, 250, 283, 284

Národní třída 11, 33, 215
National Monument 250
National Theater 11, 15, 26, 27, 69, 74,
 216–217, 283
National Theater Generation 26, 27,
 199, 217, 234, 283
Nazis 12, 31, 55, 59, 199, 203, 208, 240,
 242–243, 258. See also Hitler, Adolf;
 World War II.
Nejedlý, Otakar 47
Nelahozeves Castle 173, 180, 257–265
Nepraš, Karel 32, 49, 124, 241
New Mint 41
New Town (Nové Město) 6, 10, 14–15,
 26, 36, 39, 105, 197–224

New Town Hall 7, 65, 221
Nostitz Palace 121
Novotný, Otakar 218, 226

Observatory Tower 68
Old-New Synagogue 18, 78–80
Old Royal Palace 134, 146, 155–158
Old Town (Staré Město) 5, 14, 17,
 35–103, 106–107, 109, 136, 161,
 165, 198, 202, 206, 215, 235, 271
Old Town Bridge Tower 36, 106, 113
Old Town Hall 12, 26, 58–60
Old Town Square 5, 8, 15, 36, 41,
 52–55, 58, 61, 63, 70, 76, 202, 244,
 249
Order of Poor Clares 84
Otakar I 84, 153, 158
Otakar II 5, 14, 84, 105, 136, 154, 157

Palace of Grand Prior 121
Palace of the Lords of Hradec 132
Palacký, František 10, 217–218
 Palacký Bridge 218, 226
 Palacký Hall 210
 Palacký Monument 27, 218, 220
 Palacký Square 218
Parler, Jan 274
Parler, Peter 18, 29, 36, 52, 56, 106–107,
 136, 147–158, 160, 244, 274–275,
 277, 279, 283
Pešánek, Zdeněk 30, 201, 233, 240
Peterka House 201
Petřín Park 132–133
Philosophical Hall 193
Picasso, Pablo 28, 39, 49, 128, 230, 232,
 236, 238, 241, 281–282
Pinkas Synagogue 79–80
Platýz House 215
Platzer, Ignác František 23, 60, 113–114,
 138
Plečnik, Josip 31, 137–139, 141, 144,
 155, 168, 250, 283
Pleydenwurff, Hans 98–99
Polívka, Osvald 26, 65, 200–201, 206,
 208, 215
da Ponte, Jacopo See Bassano.
Portheim Palace 215
Powder Tower 36–38, 146, 206, 208, 283
Prague Academy of Fine Arts 25, 28, 284
Prague Castle 18–19, 21–22, 31, 36–37,
 69, 82, 105–106, 118, 130, 135–171,
 180, 244–245, 248, 250, 274–275,
 283–285
Prague Spring 13, 32, 53, 141, 200,
 240–241, 284
Praha Assurance building 215
Preisler, Jan 27, 62, 82, 201, 206,

233–234, 239
Premonstratensian order 193
Přemysl (mythical founder of Prague) 4,
 226, 285
Přemyslid, Elizabeth 62
Přemyslid dynasty 4–5, 63, 84, 85, 135,
 139, 153, 158–159, 160, 224, 226,
 227, 286, 288
Procházka, Antonín 28, 39–40, 281

Ravesteyn, Dirk de Quade van 195
Reformation 56, 72, 100, 102, 186. See
 also Luther, Martin.
Reiner, Václav Vavřinec 24, 42, 69, 74,
 118, 120, 130, 161, 228
Rejsek, Mathias 37, 56, 58–59, 274–275,
 278
Rembrandt van Rijn 24, 179, 181–182,
 184
Renaissance 18–20, 41, 44, 51, 58–59,
 64–65, 74, 76–77, 80, 83, 85, 88, 98,
 102, 113, 115–118, 121, 130, 132, 137,
 148, 151, 156–157, 159–160, 169,
 171–173, 175, 177, 185–186, 188–189,
 194, 202, 217, 221, 223, 244, 254, 257,
 259, 277, 283, 285
Reni, Guido 145
Renoir, Auguste 238
Ried, Benedict 19, 58, 137, 148,
 154–157, 160, 167, 272, 274–275,
 279, 280, 283
Rittstein, Michael 241
Rodin, Auguste 28, 55, 82, 238
Roth, František 38, 65
Rothmayer, Otto 141, 144
Rott Building 63
Rousseau, Henri 237–238
Royal Riding Hall 168
Royal Route 3, 36–52, 63, 69, 105–106,
 130–131
Royal Summer Palace 19
Rubens, Peter Paul 24, 120, 141–142,
 143, 182–183, 246, 264
Rudolfinum 11, 83, 247
Rudolf II 7–8, 17, 20, 79, 115, 118, 120,
 135, 137, 139–143, 145, 155, 157,
 160–163, 169–170, 173, 180, 185, 192,
 195, 244, 259–260, 284–285, 288
Rykr, Zdeněk 30

Sadeler, Aegidius 20, 73, 156
saints
 Adalbert 5, 94, 97, 108, 112, 148, 150,
 199, 253–254, 286
 Agnes 5, 18, 68, 83–85, 99, 100, 158,
 199, 244, 286
 Anthony of Padua 42, 111, 174

Apollinaris 221
Augustine 96, 112, 120, 182–183
Bartholomew 72, 96
Benedict 60
Cajetan 112, 131
Catherine 92, 96, 100, 143, 173, 188,
 221, 264
Charles Borromeo 65, 163–164, 286
Cosmas 4, 112
Cyril 4, 109, 114, 151, 286
Damian 112
Dominic 109, 185
Felix of Valois 112
Francis 42, 68, 100, 110, 286
George 155, 159, 160, 286
Giles 96, 109, 286
Ignatius of Loyola 65, 244, 285–286
Ivan 112
John of Matha 112
John of Nepomuk 9, 65, 108,
 110–111, 154, 189, 218, 286
John of the Rock 219
Jude 111
Ludmila 4, 5, 94, 100, 111, 150, 158,
 199, 250, 270, 286–287
Lutgard 112
Margaret 96, 109, 143, 188
Methodius 4, 109, 151, 219, 286–287
Nicholas 60, 114, 287
Nicholas of Tolentino 112
Ottilie 154
Phillip 96
Phillip Benizi 112
Procopius 5, 94, 97, 112, 150, 156,
 199, 219, 287
Roch 65, 188
Sebastian 65, 188, 236
Sigismund 94, 97, 101, 108, 110,
 150, 287
Ursula 100, 215
Vincent Ferrer 112
Vitus 94, 97, 108, 112, 147, 150,
 153, 287
Vojtěch. See saints, Adalbert.
Wenceslas 15, 27, 58, 65, 73, 94, 97,
 101, 110–112, 131, 147–148, 150,
 154–155, 193, 199, 200, 250, 270,
 287, 288
Salm Palace 172
Sanctuary of Our Lady of Loreto 190–192
Sankturinovský dům 278
Santini-Aichel, Jan Balžej 22, 29, 130–
 132, 148, 221–222, 225, 227–228,
 255, 272, 279–280, 284
Šárka and Ctirad 226
Savery, Roelandt 20, 160–161, 163, 180
Schiele, Egon 241–242

Schikaneder, Jakub 27, 62, 234
Schnirch, Bohuslav 80, 217
Schönborn Palace 132
Schulz, Josef 26, 80, 83, 199, 217, 283
Schwarzenberg Palace 20, 34, 171, 271
Seisenegger, Jakob 259
Sigismund. See saints, Sigismund.
Šíma, Josef 30, 48, 62, 239, 282
Šimotová, Adriena 32, 126, 241
Sint Jans, Geertgen tot 175
Šípek, Bořek 139, 141
Škréta, Karel 23, 62, 114, 120–121,
 160–161, 163–164, 284
Slavíček, Antonín 27, 50, 62, 233–234,
 284
Slavonic Monastery 219–221
Smetana, Bedřich 4, 58, 208–209, 217,
 225
 Smetana Embankment 69
 Smetana Hall 208–209
Smiřický, Jan Albrecht 116
Smiřický Palace 115–116
Soběslav, Hippolyt Pinkas 26
Society of Patriotic Friends of Art
 25–26, 173
Špála, Václav 39–40, 215. See also muse-
 ums, Václav Špály Gallery.
Speiss, Hans 149
Špillar, Karel 209
Spinetti, Bernard 60
Spranger, Bartholomeus 20, 140, 142,
 160–162, 194–196, 259, 284
Steen, Jan 183–184
Steinfels, Johann Jakob 254
Stella, Paolo della 169
Sternberg, Count 245–246
Sternberg Palace. See museums, National
 Gallery at Sternberg Palace.
Story of Prague Castle Exhibition 146,
 157–158
Strahov Monastery 24, 133, 171,
 192–196
Štréka, Karel 56
Stromovka Park 234, 244
Štursa, Jan 212, 214–215
Štyrský, Jindřich 30, 48, 239
St. Agnes Convent. See museums,
 National Gallery at Convent of St.
 Agnes.
St. Peter's Na poříčí 212
Sucharda, Stanislav 27, 65, 206, 218
Sudek, Josef 30–31, 82, 131, 284
Sudeten Germans 11–13
Švabinský, Max 27, 45–46, 151, 206,
 208, 210, 234, 251, 284
Švec, Otakar 77
Sylva-Taroucca Palace 202

Teige, Karel 30, 50–51, 82, 225, 282–284
Theodoric. See Master Theodoric.
Theological Hall 193
Thun-Hohenstein Palace 22, 131
Tintoretto (Jacopo Robusti) 20, 140, 144,
 178
Titian (Tiziano Vecellio) 141, 144–145,
 178
Topič Publishing Company 215
Toulouse-Lautrec, Henri 238
Town Hall. See Lesser Town Hall, New
 Town Hall, Old Town Hall.
Toyen (Marie Čermínová) 30, 48, 82,
 239, 282
Troja Chateau 22, 24, 172, 244–249
Turba Palace 121
Tuscan Palace 189
Tyl, Oldřich 31, 231
Týn Court 14, 44–45, 56

Ungelt. See Týn Court.
Urbánek Publishing House 214
Ursuline Convent 189, 278
Utraquist 6, 61, 66, 72, 73, 220
U Bruncvícka 75
U Nováků 200
U Supa 41

Váchal, Josef 46, 82, 236
Václav IV. See Wenceslas IV.
van Gogh, Vincent 231, 238
Velázquez, Diego 179, 257, 260–261
Velvet Divorce 13–14
Velvet Revolution 13–14, 84, 199, 200,
 215, 287
Veronese, Paolo (aka Paolo Caliari) 20,
 140–141, 144–145, 264
Veselý, Aleš 32, 124, 241
Villa America 198, 221
Villa Kovařovič 226
Vinohrady 15, 31, 249–251, 283
Virgin Mary 8, 42, 56, 58, 72, 91, 92,
 121, 150, 153, 161, 177, 185, 188,
 267, 269
 and Child 62, 65, 86–87, 90, 94,
 96–97, 143–144, 154, 173, 176,
 180, 264, 270, 275
 Graceful Madonnas 87–88, 90, 194
 Marian Cult 86, 158, 190–191
 statues of 39, 43–44, 87, 89, 109, 191,
 234, 275
 structures dedicated to 53, 120,
 190–191, 193, 219, 220, 266
Vítkov Hill 7
Vladislav II 5, 7, 19, 36, 120, 137, 143,
 148, 154–156, 192, 283, 288
Vladislav's Hall 19, 155–158, 275, 283

Vltava River 4–5, 14–15, 33–35, 69, 77,
 84, 105–106, 108, 110, 122, 124, 126,
 129, 135, 198, 215–216, 219, 223,
 227, 229–230, 242, 244, 257–258
Vouet, Simon 178–179
Vratislav, Jan, of Mitrovice, 43
Vrtba Palace 130
Vries, Adriaen de 20, 118–120
Vyšehrad 4, 6–7, 14, 18, 66, 136, 198,
 209, 218, 220, 223–229, 285

Waldstein. See Wallenstein, Albrecht von.
Wallenstein, Albrecht von 64, 116–118,
 287
Wallenstein Palace 116–118
Wallenstein Riding School 118
Wenceslas Chapel 19, 101, 153
Wenceslas I 4, 42, 84
Wenceslas III 5, 272, 277
Wenceslas IV 6, 19, 58, 72, 94, 108, 136,
 208, 273, 277, 288
Wenceslas Square 26, 31, 198–202, 214
Wiehl Building 26, 200
Willmann, Michael 24
Wirch, Johann Josef 172
White Tower 167
Wohlmut, Bonifác 20, 137, 148,
 150–151, 157, 169, 221, 254, 258
World War I 11, 28, 39, 127, 200, 201,
 251
World War II 11–12, 15, 213, 218, 240,
 254, 258

Záboj and Slavoj 226
Zbraslav 22, 88, 223, 227, 279, 284. See
 also museums, National Gallery at
 Zbraslav.
Ženíšek, František 210, 217
Zítek, Josef 26, 83, 217, 283
Žižka, Jan 7, 210, 250–251
Žižkov 15, 74, 250–257
Zrzavý, Jan 47, 236